The ——
NEWPORT BRIDGE

JAMES M. RICCI

Foreword by former Governor Lincoln Chafee

THE
History
PRESS

Published by The History Press
Charleston, SC
www.historypress.com

Front cover: Aerial view of the Newport Bridge looking east toward Newport from Jamestown. *Courtesy of the Rhode Island Turnpike and Bridge Authority*; bridge worker Joe Muldoon, high above Narragansett Bay's East Passage. *Courtesy of Joe Muldoon*; Governor Frank Licht congratulating the first bridge crosser, Paul Cummins, of Friendship, Maryland, whose family were on their way to Cape Cod. *Photo by Jerry Taylor, courtesy of Mark Taylor*; the final steel, dressed with the traditional American flag, being lifted into place, closing the last remaining gap between Newport and Jamestown. *Courtesy of the Rhode Island Turnpike and Bridge Authority. Back cover*: The Chilean freighter *Antiparos* cruises under the bridge in 1968, while the suspenders await sections of roadway. Providence Journal *photo/Thomas D. Stevens, courtesy of the* Providence Journal; Rhode Island Turnpike and Bridge Authority Chairman (and major bridge proponent) Francis "Gerry" Dwyer was the master of ceremonies on opening day, June 28, 1969. *Courtesy of the Jamestown Historical Society.*

First published 2018

Manufactured in the United States

ISBN 9781467139588

Library of Congress Control Number: 2018936094

Notice: The information in this book is true and complete to the best of our knowledge. It is offered without guarantee on the part of the author or The History Press. The author and The History Press disclaim all liability in connection with the use of this book.

Courage and perseverance have a magical talisman, before which difficulties disappeur and obstacles vanish into air.

—John Quincy Adams

To Victor C. Ricci,
1919–1995,
World War II Veteran, Airport Engineer, Father

CONTENTS

CONTENTS

FOREWORD

Rhode Island is a small state with sizable populations living full time on islands—Aquidneck, Conanicut, Block, Prudence, and Hog. Ferries served as early means of transportation—and to some islands still do. When possible and over time, bridges have been erected.

Jim Ricci has told a wonderful story about the building of the most magnificent of these bridges. The Newport Bridge is now a fifty-year-old symbol of our state. Mr. Ricci colorfully shares with us all the challenges: cost; engineering; route; U.S. Navy requirements; politics, state and local; and union issues, to name a few. The building of this monument was a monumental task!

My father, John Chafee, fought for our country on Guadalcanal, on Okinawa, and in Korea. He was secretary of the navy and an influential U.S. senator. But he always said he most loved being governor and that his proudest achievement was the successful resolutions to all the myriad difficulties in constructing the Newport Bridge. As Mr. Ricci accurately writes, he not only wanted the structure to be beautiful to behold, but also, for the drivers and passengers crossing it, to be able to view from on high our beautiful East Passage of Narragansett Bay. For fifty years now, people's breaths have been taken away by the vistas. My father would be smiling that this story has been written.

Jim Ricci's book is meticulously researched, which makes reading it enjoyable. It is a drama set in a state known for its character and characters. Mr. Ricci's writing reflects the tenacity of the main characters with

his attention to detail. The bridge rose from the bedrock deep beneath Narragansett Bay to become a proud symbol of our beautiful state. Thank you to Jim Ricci for writing this fascinating book.

—LINCOLN CHAFEE

PREFACE

This is the story of the Newport Bridge from its conception following World War II to its opening on June 28, 1969. (Most Rhode Islanders refer to the structure as the Newport Bridge, despite its subsequent renaming in 1992 by the state legislature to honor Senator Claiborne Pell; this story uses its original name.) Spanning the East Passage of Narragansett Bay, the bridge connects the islands of Conanicut and Aquidneck and links their primary towns of Jamestown and Newport. Prior to the bridge, ferries had delivered passengers to and from Newport for three centuries. That service became obsolete the day the bridge opened.

The bridge's history can be traced back to the years leading up to World War II. In 1940, the Jamestown Bridge was completed between the Rhode Island mainland and Conanicut Island. Momentum soon grew for a Newport Bridge, but the war relegated efforts to the back burner. After the war, proponents advocated for a bridge. They encountered initial resistance from the United States Navy bent on protecting its well-established and extensive operations in and around Narragansett Bay. The navy subsequently relented but placed conditions on the bridge's location and navigational requirements. Proponents and opponents sparred from 1945 to 1965, when the bridge was finally approved by Rhode Island voters. Upon completion, the 2.13-mile-long Newport Bridge became the longest suspension bridge in New England, as well as fourteenth-longest nationally. It employed several new technologies and construction techniques, demonstrating the autocatalytic nature of the technology and drawing the engineering community's attention.

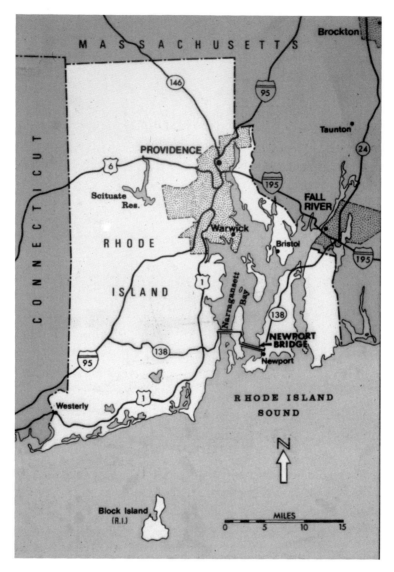

The many proposals for a Newport Bridge had one thing in common: a continuous link from the Rhode Island mainland to Newport. *Courtesy of RITBA.*

This study pieces together the quarter-century-long struggle that proponents endured before the bridge was finally built and grew to become an iconic symbol of Newport and the state of Rhode Island. The Newport Bridge is truly a monument to their perseverance.

ACKNOWLEDGEMENTS

I t is essential to have a good mentor when tackling a project such as this. In Dr. John Quinn, chairman of the history department at Salve Regina University, I had a great one. His enthusiasm and constructive suggestions contributed significantly to this story from start to finish.

Dr. Michael Budd, director of Salve Regina University's Humanities Graduate Program, and Dr. Robert Russell, professor of cultural and historic preservation at Salve Regina University, provided much-needed recommendations that shaped this book.

During this work, Dr. Eric Shaw passed away. He was a professor at the Naval War College and Salve Regina University. He was an early advocate of researching the Newport Bridge and urged me to make the story my own. I hope I came close to fulfilling his advice.

Dr. Susan Turner spent hours closely reading this document. Her keen eye improved its quality by leaps and bounds. Kate Wells, Rhode Island Collection curator at the Providence Public Library, captured and delivered an abundance of material. Peter Janaros, former director of engineering for the Rhode Island Turnpike and Bridge Authority, patiently explained the technical methods used in building the Newport Bridge.

I am very grateful to the generosity of time and resources of Rosemary Enright and Sue Maden of the Jamestown Historical Society, repository of a treasure-trove of information, artifacts, and photos about the Newport Bridge, the Jamestown Bridge, and the Jamestown ferries. Joe Muldoon, who worked on the bridge as a young man, shared stories and photos about his experience.

I would also like to thank Buddy Croft and Eric Offenberg of the Rhode Island Turnpike and Bridge Authority and Debra Moolin of WSP (successor of Parsons Brinkerhoff) for their valuable contributions to this story. Thank you as well to Beatrice "Trixie" Wadson, publisher of *Balancing the Tides*; Sarah Long of the Newport Historical Society; Michael Martins of the Fall River Historical Society; and Carolyn DuPont and Michelle Farias of the Redwood Library and Athenaeum. Many thanks to Jonathan Zins, publisher of the *Newport Daily News*, as well as Michael Delaney of the *Providence Journal*, Michael Hebert and Barry Simpson of the Rhode Island Department of Transportation, and Greg Facincani of the Rhode Island Department of State.

Mark Taylor possesses thousands of photos about post–World War II Newport, including the Newport Bridge. His father, Jerry Taylor, worked as a professional photographer in Newport for more than four decades. His pictures accompany numerous articles and technical journals about the bridge. Mark spent many hours locating and scanning pictures to accompany this bridge story. I am very appreciative of Mark's efforts. I am also thankful to Ed Leand, who generously shared many beautiful photographs he snapped of the Newport Bridge, a number of which are now framed and mounted in our home.

A special thank you to former U.S. Senator and Rhode Island Governor Lincoln Chafee for his interest in this bridge story and for graciously contributing its foreword. Thank you also to Michael Kinsella, acquisition editor at The History Press, for his interest, support, and faith in this story, and to Ryan Finn, senior editor at The History Press, for helping fine-tune this publication. Thanks also to Alex Falconer, who quickly mastered the art of retrieving articles from microfilm.

Finally, my wife, Cheryl Kenney, encouraged me to persevere, helped find information tucked away in libraries, accompanied me over the Brooklyn Bridge at noon one very hot July day and across the Newport Bridge one beautiful October morning and, most importantly, allowed me the freedom to pursue this story.

Thank you, all.

Introduction

AVENUE OF PROGRESS

The Newport Bridge was presented to society today." That was the nuanced lede to the *Newport Daily News'* headline story on June 28, 1969, the day the bridge opened, conjuring up one of Newport society's popular ceremonies: the debutante ball. The special souvenir edition chronicled the dedication ceremonies of the sparkling new bridge spanning the East Passage of Narragansett Bay, connecting the islands of Conanicut and Aquidneck, and linking their major towns of Jamestown and Newport. On this day, the sun shone brightly and the temperatures peaked at a nearly perfect seventy-nine degrees, "the kind of weather that is expected to contribute to making her one of the prime tourist attractions in New England." About six hundred politicians, dignitaries, officials, and interested citizens gathered at Newport's Festival Field to celebrate the opening of the largest suspension bridge in New England, the fourteenth largest in the country.[1]

The dedication of the gleaming $61 million Newport Bridge, festooned in balloons and awash in flags, was delayed about a half hour from its scheduled 10:30 a.m. start, a minor annoyance considering how the three-and-a-half-year construction project was hampered by labor problems and winter storms, not to mention a nearly quarter-century-long approval process. "We did it. We did it. By gosh, we did it," proclaimed Francis "Gerry" Dwyer, the ebullient master of ceremonies, leading bridge advocate, and chairman of the Rhode Island Turnpike and Bridge Authority (RITBA). He borrowed the enthusiasm from his favorite Broadway musical, *My Fair*

Lady. This day was the culmination of their efforts, the bridge a monument to their perseverance.[2]

The speakers struck the right tone. The Newport Bridge personified hopefulness and progress. Senator Claiborne Pell, in whose honor the bridge would later be renamed, exuded that "in its soaring gracefulness," the bridge was "the largest and certainly most prominent single example of the work of man in the state." It opened up a new gateway "to commercial, recreational, economic opportunity, not only to Newport and South Counties, but for our entire state." Former Governor John H. Chafee—on that day serving in his post as secretary of the navy under Richard Nixon and without whose support the project might never have left the starting blocks—recounted that his only request of the engineers was to "design a bridge so that when you drive over it you can see over the water." He noted that "every other bridge gets it worked out so that you just can't see anything." Not this bridge, which in minutes would be the belle of the ball.[3]

Governor Frank Licht, however, delivered the speech that captured the idiosyncrasies of the bridge's history up to that point. He proclaimed opening day a "historic moment in the state's history," marking "the beginning of a new era." It was the fulfillment of the desires of "generations of Rhode Islanders who dreamed of a bridge spanning the East Passage of Narragansett Bay." The new bridge was a tribute to those "who conceived of the idea and fought for its acceptance," as well as "to the imagination of the architects and engineers who planned its design and the skill of the contractors who executed these plans." The governor reserved special praise for "the brave and able men" who built the bridge, whose jobs were "beset with difficulties and dangers every step of the way." Most of all, though, the bridge was "a tribute to the foresight of the people of Rhode Island" who committed the funds to build the structure. This opening day, Licht declared, was a day for congratulations and thankfulness.[4]

The governor supplied a high-level history of the bridge, which, he reiterated, "did not just happen." The timeline dated back to the early 1940s, when Rhode Islanders began "talking seriously about linking Newport and Jamestown." Since then, "dozens of engineering studies were made. Plans were drawn up and then discarded. An Authority was finally established by law. Each succeeding state administration inched slowly forward." But in 1960, just when it looked like "work could at last begin," the voters of Rhode Island rejected a referendum to fund the bridge. The proponents did not give up. Instead, they worked to "convince their friends and neighbors of the importance of the span." In 1964, the Rhode Island General Assembly

again approved the bonding proposal, and this time, the statewide resolution passed. Of course, that was "just the beginning":

> *Now came the problems of design and construction, the mastery of the latest in modern technology, the dangers of the sea to the men who worked beneath its surface and far above its shores—the unforeseen delays caused by the vagaries of man and nature. But for every problem a solution was found. And now, the bridge is finished—a monument to those who persevered.*

More than a monument to themselves, however, the people who built the Newport Bridge "opened a potential new avenue of progress" that would provide "a potential boost to our overall economic expansion." And now, the governor proclaimed, it was everyone's responsibility to realize that potential.[5]

At this point, Licht voiced his disappointment in the results of the previous Tuesday's special election. Rhode Island voters had rejected funding $30 million of transportation bonds. Those bonds would have helped pay for a westerly bypass, an extension of Route 138, and modern access roads. The new bridge, he said, "does not stand by itself. It is an integral part of an overall transportation network." The defeat of the bonds meant that some projects could not be started. He had already met with his budget officer and the director of the Department of Public Works to prioritize projects. The governor promised "to do whatever possible to minimize the impact and prevent delays." Taking the high road, Licht stressed that the visitors drawn to the state by the new bridge should enjoy "equally modern highways… ever increasing recreational opportunities and up-to-date accommodations." The people of Aquidneck Island had already stepped up; now the rest of the state must become "equally progressive and farsighted." That is what would be "necessary to make Rhode Island not only the nation's first vacationland but its finest vacationland." Just as the challenges of building the bridge were surmounted by "citizens of conviction and courage," it would take "citizens of commitment and concern" to do the same. And in so doing, "we will conquer the obstacles that arise and go forward to meet our new challenges." The governor concluded, "This is the real meaning of today's ceremonies."[6]

The participants had a lot to think about as they moved on to the next part of the ceremonies. At about noon, they poured into limousines, while the press loaded into a British double-decker bus, and headed out across

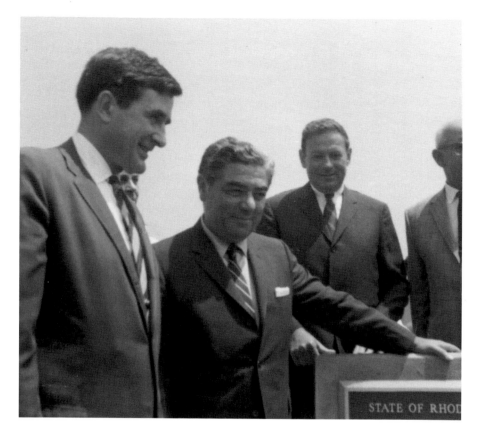

Governor Frank Licht and Secretary of the Navy John H. Chafee admire the plaque dedicating the bridge. *Courtesy of the Jamestown Historical Society.*

the flag-draped bridge toward Jamestown. At the center span, some 215 feet above the bay, Governor Licht cut a ribbon that officially opened the bridge. The motorcade continued to the western terminus, stopping just before the Jamestown toll plaza. They were greeted by Jamestown officials, a crowd of several hundred people, the Navy Band, and the Newport Artillery Company. A bronze plaque listing those responsible for the bridge was unveiled. Jamestown Town Council President William S. Sheehan echoed Licht's sentiments, the key notes being hopefulness and progress. He also hinted at the historical and ongoing contention between the two towns concerning the bridge, saying, "Everything will work out all right eventually" and that "Jamestown and Newport have a great future. It will take time and won't be without problems." Odd remarks for a festive occasion, but not far removed from the challenges of which the governor spoke. The inclusion of

the Navy Band added a bit of irony to the occasion. For decades, the navy had withheld approval of the bridge and dictated requirements of potential structures as if Narragansett Bay were its private realm. Mr. Sheehan also introduced the elephant in the room: the end of the ferry service, which had continuously shuttled residents and visitors across the bay for the past three centuries. "It's sad to see the ferries go."[7]

This first day for the bridge was the last day for the Newport-Jamestown ferries. They did not go quietly. At exactly high noon, the final ferry left Newport almost empty, carrying twelve cars and fifty people. It "made its last revenue-producing run with dignity," with "its whistles blasting their defiance at the cars already passing over the nearby Newport Bridge." An armada of boats saluted this last trip by jumping waves, blasting horns, and waving hands. On board, the passengers lamented the ferry's demise. Myrtle Sidney of Jamestown felt very sad about the whole thing. "The trip was always so relaxing," she said. Joan Anderson, also of Jamestown, chimed in that "you always had time to fix your hair in the mornings on the ferry." Another Jamestown resident, William Glen, would often meet old friends on the ferry. One Jamestown resident, Mrs. Howland Hammond, seemed more upset than the others. She was disappointed that this was the end of an era. She said she "could care less for that monstrosity of a bridge over there." Deborah Anderson Swistak of Jamestown lived near the ferry landing and "never needed a clock in the living room because the houses would shake every time the ferry came in." Joseph Sheehan of Newport summed it up after a passing cabin cruiser blasted his horn: "That whistle couldn't be sadder." The governor's avenue of progress signaled the end of a previous way of life.[8]

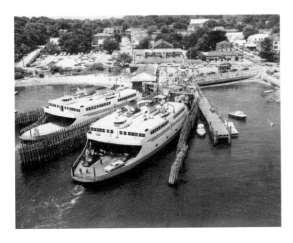

The Jamestown Ferry *Newport*, with the VIP motorcade neatly stowed, pulling out from Jamestown on its ceremonial last run. *Courtesy of Rhode Island Department of Transportation.*

The motorcade advanced to the Jamestown ferry landing, where the dignitaries and accompanying press boarded the ferry for a ceremonial trip back to Newport. The Navy Seabee band serenaded the guests from the second deck. The press bus got stuck while boarding and had to be extricated by the deck hands. On board, Congressman Ferdinand J. St. Germain and his wife danced the "Lindy." Senator Pell summed up the double-edged emotions of the day. "It's sad and nostalgic," he said. "I'll miss it today, but I won't from now on." Rhode Island Turnpike and Bridge Authority (RITBA) member John Nicholas Brown, of Providence and Newport, retorted that he "was not going to miss it at all." Ferry pilot Captain Clark Champion, whose livelihood was about to be swept away by technology, was asked his thoughts. "What's to comment," he said. "I've been boating for 50 years. We just gave way to progress, that's all. There's no comment." The band launched into "Auld Lang Syne" as the ferry full of VIPs reached Newport and then played "The Party's Over" as the boat "slammed for one of the last times into the wooden walls of its piers." The festivities continued with a reception at one of Newport's famous mansions, the Elms.[9]

Meanwhile, a controversy unfolded on the newly christened bridge. It was toll-free from the time of the dignitaries' initial crossing until 1:00 p.m., after which it would cost travelers one dollar per axel, two dollars per passenger car. After crossing the bridge from Newport, many turned around in Jamestown to head back home. This caused a major traffic jam at the lone open toll booth. Exactly at one o'clock, authorities began collecting tolls. Three of the first ten drivers had no money and became irate at the imposition. One man complained that he was invited to make the trip by the governor and had "never expected it to turn out like this." What, he asked, did they expect them to do when they invited people on a free trip, "go one way and not come back?" The driver was detoured to the toll plaza, where he was handed a return envelope for RITBA in which to send back the two-dollar toll. The procedure continued, and within seconds three more cars sat at the toll plaza, where they received similar envelopes. "This is the damndest thing," one well-dressed woman with gray hair said as she paid her two dollars. A Newport resident proclaimed from the back seat of a convertible that he wouldn't be crossing the bridge again, while a carful of children driven by an unhappy woman cried out, "Robbers, gyp, you cheated us." The violation signal continued to ring as cars sped through the gate. Perhaps it would have been better had officials proclaimed the entire day toll-free. They were anxious, though, to start collecting fees as soon as possible; after all, they had bondholders to pay back.[10]

The festivities continued well into the evening with more parties and VIP ferry rides. The opening ceremonies of the Newport Bridge presented a microcosm of the complexities associated with understanding Newport. Here was a modern bridge, built with new technologies, carrying visitors to a city that would soon be admired for its centuries of preserved and restored antique charm. Here was a convenient way to traverse the East Passage of Narragansett Bay in a matter of minutes, while ringing the death knell to an inconvenient yet nostalgic ferry crossing that had existed since at least 1675. Here was a roadway capable of depositing unlimited numbers of automobiles into a town ill equipped to handle them, exacerbating the community's long-standing love-hate relationship with cars. Here was a convenient way for visitors from the population centers to the south and west to enter or leave Newport twenty-four hours a day, 365 days a year, without depending on a scheduled boat service that ended before midnight. Missing that last boat meant an hour-long ride through Providence and East Bay communities. Here was a replacement to the inconveniences of a ferry service that evoked romantic sentiment from a dedicated ridership but was far from self-sustaining, losing hundreds of thousands of dollars each year. The ferries would no longer control access to Newport. That influence ceased on opening day.

The June 28, 1969 *Newport Daily News* op-ed page captured the mood in words and sketch. The editorial was simply titled "The Newport Bridge." It was accompanied by a drawing of the new bridge leading toward a setting sun over the Jamestown horizon. A ferry was puffing its way into oblivion. The setting sun has a label indicating the ferry is headed to the same fate as the Fall River Line, which was rendered obsolete by the automobile in the late 1930s. The artwork reinforced the editorial writer's message:

Thumbing back through history and lore of many generations we find the recordings of the dream of some firm link across Narragansett Bay. Many had the dream, but only a few had the determination and the skills needed to make it the reality it is today. And because of their determination and skills of these few we have a magnificent bridge, the first solid link between Aquidneck and Conanicut Islands since the Ice Age....

Even with the bridge soaring high over our bay, inviting the world to our door, there are some who feel a bit of sadness at the passing of the Jamestown ferry, a service that has gone on almost without interruption for at least 300 years. The ferry was a relaxing, pleasant mode of transportation that, once gone, will be seen no more. Like the old Fall River Line steamers that

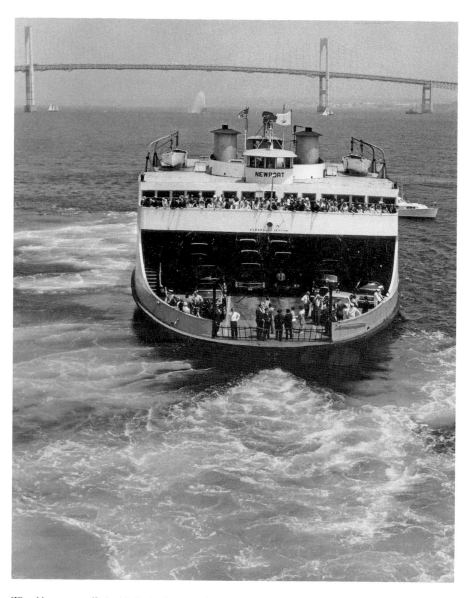

The *Newport*, stuffed with invited quests, heads toward the new $61 million Newport Bridge on one of its last runs on Opening Day. Providence Journal *photo/Lawrence S. Millard, courtesy of the* Providence Journal.

vanished 32 years ago, the old ferry boats will be recalled mistily through the years by the present generation for the generation to come.

It is remarkable to ponder that only thirty-two years separated the decline of the steamship era and the construction of the bridge. At the same time, the Newport Bridge was long overdue. Yet, these are only a few interesting bits in a town whose history and culture are steeped in dualities.[11]

Newport is a curious blend of old and new. Its charm is rooted in its natural splendor and built environment. Both are as old as Newport itself. Newport's special geographic advantages have lured visitors since its inception. They have been cited by commentators on the Newport scene throughout its history. These natural advantages include but are not limited to (in no particular order): the Atlantic Ocean, Narragansett Bay, majestic vistas, rolling farmlands, and salubrious weather. Yet the town has had dramatic historical shifts in fortune and esteem. Some of its highs include its role as a pre–Revolutionary War mercantile center, a premier post–Civil War watering hole, a Gilded Age playground for high society, and a center of naval activity during the twentieth-century world wars. Some of its lows are its British occupation during the Revolutionary War; its prolonged post–Revolutionary War depression, which lasted well into the mid-nineteenth century; and its post–World War II transition from a sailor town to its current status as a highly desirable seaside community. This story is concerned with the latter, especially the role the Newport Bridge played in the city's transformation and the cultural influence it continues to have on Newport.

AMERICA'S FIRST RESORT

THE NEWPORT SCENE

The Newport Bridge's eastern piers are anchored on the Newport side of Narragansett's Bay East Passage. The bridge is most associated with that community. It has become a central architectural and cultural symbol of the town itself, as well as a dominant part of the Newport scene. Yet Newport remains a difficult place to describe. Like all modern entities, it is full of contrasts and contradictions. It is simultaneously ancient and modern, preserved and lost, cosmopolitan and quaint, open and inaccessible, democratic and aristocratic, beautiful and besmirched, spiritual and profaned. As Maud Howe Elliott, long-term Newport resident and daughter of noted physician Samuel Gridley Howe and author Julia Ward Howe, observed, "Legend, fancy, history; all mingle in Newport's story."[1] Trying to make sense of it has confused some of America's best thinkers.

In *The American Scene*, Henry James had a hard time pinning down what he called "the aspect" of the place. To him, Newport was a conundrum. By the turn of the twentieth century, Newport had always seemed to possess a certain charm, "unmistakably, the little old strange, very simple charm." Newport simply lays there, "like a little bare, white, open hand, with slightly-parted fingers, for the observer with a presumed sense of hand, to take or to leave." It has always had a sense about it that makes it impossible to capture, "that benign little truth that nothing has been less possible, even in the early,

ingenuous, infatuated days, than to describe or define Newport." Nothing less possible! The reason James claims this is because Newport had "nothing in it to describe or define, so that one's fondness has fairly rested on this sweet oddity in it." He spoke too soon. By the early twentieth century, Newport would certainly have enough in it to elicit fondness, perhaps even retaining some of its sweet oddity-ness, or at least more than other contemporary communities have been able to sustain.[2]

A few years earlier, William Cray Brownell, a New York art and literary critic and contemporary of James, came to a similar conclusion: "A beneficent fairy of aesthetic predilection could not have arranged a composition containing more efficient contrast and balance than Newport presents in its combination of old and new, of the quaint and the elegant, picturesqueness and culture." Such contrast and balance, Brownell declared, "makes Newport what it is." He was interested in the balance maintained "between a self-respecting, organic, and permanent community and the artificial, decorative, and more or less transitory element that makes it our chief watering-place." Brownell claimed that Newport possessed "the loveliest, the serenest and most smiling, the most obviously cultivated civic *ensemble*" in the country.[3]

Thornton Wilder viewed the entire community as a complex web. In his 1973 novel *Theophilus North*, the eponymous schoolteacher resigns his position to see the world. He spends the summer of 1926 in Newport assuming different roles while interacting with the town's diverse citizenry. Wilder divided Newport into nine cities in an attempt to get to the bottom of its complexity. There was first the "vestiges of the early seventeenth-century village, containing the famous round-stone tower…long believed to have been a relic of the roving Vikings, now generally thought to have been a mill built by the father or grandfather of Benedict Arnold." The second was the eighteenth-century town, "containing some of the most beautiful public and private edifices in America." The third was the bayside of Thames Street, housing "what remains of New England's most prosperous seaports…with its wharves and docks and chandlers' establishments, redolent of tar and oakum." The fourth belonged to the army and navy, there having "long been a system of forts defending Narragansett Bay." The fifth was the nineteenth-century summer resort, containing one of the beauties in which the protagonist of the story, Mr. North, "was able to engage the pentagonal room in a turret above the house," which at night offered up a view of "the beacons of six lighthouses" and the sounds of "the booming or chiming of as many sea buoys." The sixth was for "the very rich, the empire builders…

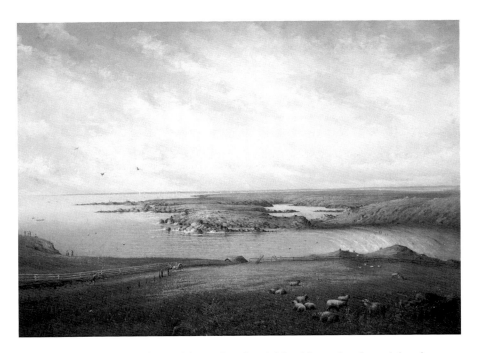

In Newport, "A man can farm with one hand and fish with another," proclaimed *Harper's* in 1854. George Champlin Mason captured the sentiment in his painting *Rocky Farm and Cherry Neck, Newport, RI*. *Image Courtesy of the Redwood Library and Athenaeum, Newport, Rhode Island.*

suddenly awakened to the realization that New York State is crushingly hot in summer" and who brought with them "fashion, competitive display, and the warming satisfaction of exclusion." The seventh was for the servants, "who never enter the front door of the house in which they live except to wash it." The eighth contained the "camp-followers and parasites," those "half-cracked aspirants to social prominence" like journalists, detectives, and fortune-hunters. And, finally, the middle-class ninth, "buying and selling, raising its children and burying its dead, with little attention to spare" for the other eight cities. Newport's various ages and cultures left their mark on the city and its people. They all contribute to its sense of place.[4]

Maud Howe Elliott lived in a mansion she called Lilliput, at 150 Rhode Island Avenue, for thirty years, from 1918 to 1948. At age ninety, she published a monograph simply titled *This Was My Newport*. It is intriguing because it was written in the 1930s and published in the second half of 1944, just as World War II was reaching its conclusion. A peculiar uncertain tone about the city's future envelops her introductory chapter.

The town was like the patchwork quilt she created as a child, "made up of scraps of many colors and different textures." Her prose described what remained from Newport's colorful and storied past. The streets that were laid out on May 16, 1639, are still there, spreading out from the founders' spring, including Marlborough and Thames. Hanging Rock, where Bishop George Berkeley wrote the *Minute Philosopher*, "commanded a view of extraordinary charm; three ridges, rocky and wooden, projecting into the ocean like the fingers of a man's hand… an unparalleled view, and unchanged today." There was the Redwood Library, Market Square, Touro Synagogue, and the Jewish Cemetery. "All this time above the tumbled chimney-pots of Newport, the spire of Trinity Church has been looking down—the loveliest wooden church steeple that was ever built….A landmark for mariners in the past; for Newport of the present, no less a focal point, seeming to hold within it all the tradition of the old town."[5]

There were the old houses, "the great many-flued chimneys, the small-paned windows set high under the corner, the lunette above the door, the sturdy break of the gambrel." On the heels of the Great Depression and World War I, some "would like to hide their dirty faces and apologize for their peeling paint and their unlovely state." A far cry from when they once housed the "prosperous and great. When gardens and orchids ran down from Spring Street to the harbor, and merchants counted their own ships swinging at anchor." There stood the homes of Jaheel Brenton, William Brenton, Dr. William Hunter, the Robinsons, the Nichols and the Mawdsleys, along with the Pitts Head and White Horse Taverns.

All these and many more still stand; others are ghosts and memories. Besides the many whose names and histories are known, there is the great nameless company—some lost utterly, some still struggling with encroaching signboards and filling-stations. The old, old houses, here trying to tell of Newport's grandeur and glory—a glory that reached its height two hundred years ago; a grandeur different from that of marble palaces in a fashionable watering-place. He who reads between the lines that the twentieth century has scribbled on the face of this fair island may recapture something of the Newport that was.[6]

A DESIRABLE PLACE

Newport has long been a curious blend of new and old—in that order, oddly enough. In its earliest days, the town could accurately be described as modern. It was arguably the first modern town in the colonies. Like Providence, Newport was founded by dissidents who preferred freedom of conscience over Puritan oligarchy. It quickly became a haven for Quakers and Jews. Shortly after its founding, Newport blossomed into a desirable place to live and visit. Resting on a foundation of religious freedom and fueled by mercantile capitalists, the city rose to such prominence that by the mid-eighteenth century it was on the cusp of becoming one of America's leading centers of commerce and culture—so much so that the era is now called the "Golden Years." Newport's tolerance, commerce, and cultural institutions contributed to its modernity. Soon, the entrepreneurial founders gained much wealth through shipping, shipbuilding, and ancillary trades. Prominent among these was transporting slaves, of which Newport served as the middle leg, turning molasses into high-quality rum that was exported to Africa in return for human cargo. Between 1700 and 1770, Newport was one of colonial America's five most important towns, along with New York, Boston, Philadelphia, and Charleston.

Throughout its history, Newport has been considered an enlightened community, which lends credence to the notion of the town's modernism. It is so modern, in fact, that it lured thinkers like James Franklin, Ben's brother, who established a printing concern as early as 1720, as well as the aforementioned influential philosopher George Berkeley. The Redwood Library and Athenaeum was one of the first subscription libraries in the colonies and is now the longest-surviving lending library in the country. Redwood's original 1747 charter hints at its lofty aspiration of "propagating Virtue, Knowledge and useful learning" and "having nothing in view but the good of mankind." Trinity Church is perhaps the finest example of Christopher Wren–inspired buildings in the region. As Flora Deland, Thornton Wilder's fictitious society columnist in *Theophilus North*, proudly proclaimed, "Newport was—and always has been…one of the most enlightened communities in the country, the foster home of George Bancroft, Longfellow, Lowell, Henry James, Edith Wharton, and of Mrs. Edward Venable, author of that moving volume of verse, *Dreams in an Aquidneck Garden*."[7]

Newport has also been acknowledged as a cosmopolitan place. From its earliest days, the city was home to people of different backgrounds, including

but not limited to British Puritans, Quakers, Spaniards, Portuguese, East Indians, and Hebrews. The latter, lured by Newport's tolerant embrace, established and nurtured the first Jewish community in the New World before the end of the seventeenth century. Such an unlikely settlement prompted Longfellow to contemplate intolerance elsewhere by exalting Newport's welcoming nature in his poem "The Jewish Cemetery at Newport," which he penned following his 1852 visit to Touro Synagogue. Quakers were also welcome. They, too, had established a thriving community by the mid-seventeenth century. From the safety of Newport, the Quakers confronted and tested the patience of other New England Puritan communities. Earlier, Newport had served as a fortress from which Mary Dyer could venture from and be banished to—before she poked the Boston magistrates once too frequently and finally found herself dangling from a hangman's noose. Both sects, Jewish and Quaker, unwelcome elsewhere, contributed mightily to the development of Newport and the broader Rhode Island. They left a blueprint for the rest of the country about how to assimilate successfully. And both left behind permanent legacies on the built environment in the form of stunning colonial-era architecture.

Newport is a famous city. People worldwide identify it as such. If it does not have the same recognition as New York, Philadelphia, and Boston, it is only half a rung below. Being mentioned in the same breath as those metros has a historical connection. These were the four largest cities in the colonies as late as 1720. But twenty years later, Newport fell behind Charleston, South Carolina. By 1800, Providence had surpassed it as Rhode Island's largest city. By 1830, it had slipped out of the top twenty. Yet its boundaries remain sequestered within a seven-square-mile area. No skyscrapers block its vistas. Its tallest buildings are church spires and modest hotels. The closest thing to a highway is four-lane Memorial Drive, with a divided landscaped median. The remaining roadways are not far removed from the colonial footpaths that once defined the seaport or the carriageways that once sported Gilded Age royalty to their spectacular cottages. They are so modest they can barely handle the strolling tourists on the wharves along Thames Street or the autos and bikes cruising Ten Mile Drive in the summer, when the population swells threefold. Regardless, most would agree that much of Newport's colonial-era charm remains intact, as it has since its antebellum renaissance of the 1850s.

With virtually similar natural advantages to trade and industrial opportunities as its sister cities, though, Newport went in a different direction. As other cities extended their reaches upward and outward, Newport remained close to the area where it was founded. Certainly, Newport could

have become filled with skyscrapers and expanded up Aquidneck Island all the way to Portsmouth. With little imagination, it is not hard to envision a metropolis stretching from Newport to Fall River, much the way New York reaches across its five boroughs. Newport once had designs on modern grandeur. In an 1873 *Harper's Weekly* article simply titled "Newport," Theo Davis proclaimed that "[t]he magnificent situation of Newport on the shores of its commodious harbor created in the minds of its early founders visions of future greatness. They expected it to become the metropolis of the country, and for many years its prosperity seemed to justify this expectation."[8]

Yet Newport successfully avoided what Marshall Berman identified as the "tragic irony of modernist urbanism whose triumph helped destroy the very urban life it hoped to set free." Newport somehow sidestepped what is "so often the price of ongoing and expanding modernity...the destruction not merely of 'traditional' and 'pre-modern' institutions and environments but—and here is the real tragedy—of everything most vital and beautiful in the modern world itself." The destruction Newport suffered through the British invasion and occupation during the Revolutionary War tipped it off its tracks. Many American cities, however, have been ravaged by war or natural disaster and returned to become thriving modern urban centers. Providence itself was burned to the ground during King Philip's War. Richmond and Atlanta jump to mind, and the atrocities visited on them were much more recent. Certainly Newport could have been one of these. Rather, it remained enamored of its mercantile and romantic historical past.[9]

It seems strange that the city with early designs on becoming the metropolis of America did not embrace and participate in the Industrial Revolution as did other urban centers, especially its larger contemporary colonial cities, as well as those that emerged because of industrialism and immigration. Perhaps Newport's historic focus on tourism contributed to the desirable city it remains, or the relationship may simply be the inverse—Newport is desirable so it attracts tourists. Newport *really was* America's first resort, and in both senses of the word: *first* in a chronological sense and *first* in a premier sense. One colonial-era timeline indicates that a spa established in 1730 was a "hot tourist spot for the colonists." Newport may well have been the dandiest of all colonial towns.[10]

The first view of the city to many visitors was its rough-and-tumble waterfront. Just prior to the Civil War, the visitor confronted "a range of ill-conditioned barns, or stores, or fish houses, or other antediluvian remains which look upon the water." But it is clear that "he looks upon the seat of past prosperity, and his imagination and curiosity are teased by the intimation of

vanished splendor." Newport, he believes, has "seen its best days." By the turn of the twentieth century, the "strongest impression one receives on visiting Newport to-day is a confused sense of splendor and slouch that would be sad if it were not laughable." By 1923, the town possessed a dichotomy between expectations and reality: "the dwellers inland who visualize Newport as a place of white-marble palaces and wide streets crowded with multicolored feminine life…are shocked when they journey there and slide down the rickety gangplank of the old *General*."[11]

Yet for more than 350 years, people have been coming to Newport. The Newport scene remains alluring. Preservation groups have helped retain important tangible links to the city's past that contribute to its present quality. Large public works projects, like the bridges that link the island to the mainland, are additive rather than destructive. As Cleveland Amory said in 1948, "The generations pass, values and standards change, there is a vast reshuffling of the social deck, but the queen of American resorts remains at the same old stand. Newport, there she sits."[12]

GETTING TO NEWPORT

It didn't take long for Newport to become a desirable place, but without question, the city has always been a difficult place to reach. Narragansett Bay is the most distinctive geographical feature of Rhode Island. From a bird's-eye view, the bay consumes its southeastern quadrant. Aquidneck Island sits in the middle of the bay, flanked by what locals refer to as the East Bay and the West Bay. It was called Rhode Island by explorer Giovanni da Verrazzano because it reminded him of the Greek Isle of Rhodes when he explored the region while searching for a passage to India in 1524. Roger Williams called it that in 1637, possibly because he was familiar with Verrazzano's observations. Newport is situated on the southern tip of Aquidneck Island. For the first three hundred years following its establishment in 1639, there was no convenient way to get to Newport by land. Ferryboats shuttled southbound passengers from the southernmost tip of Bristol to the northern end of Aquidneck Island at Portsmouth. From there, travelers made their way overland through Middletown to Newport. From the south and west, ferries crossed from the mainland in South County (Saunderstown) to Jamestown, and a second ferry brought them from Jamestown to Newport. But the earliest residents traversed Narragansett Bay by canoe.

Native Americans used the bay as a highway. They hollowed out birch tree trunks, forming wooden dugouts to travel around Narragansett Bay. Roger Williams marveled at the Native Americans' maritime skills, especially their ability to make long voyages in small canoes. During King Philip's War between 1675 and 1676, Native Americans accessed colonial communities in southeastern Massachusetts by crossing the bay from their settlements at Mount Hope and canoeing up the Taunton River. In fact, legend proclaims that King Philip formulated attack plans in 1675 on the uninhabited spit of land known as Conspiracy Island just offshore from Assonet Point, about twelve miles north of where the Taunton River dumps into Mount Hope Bay.[13]

Roger Williams, the founder of Providence, traveled by canoe throughout Narragansett Bay, including Aquidneck and Conanicut Islands. Shortly after settling in Providence, he and John Winthrop of Massachusetts purchased Prudence Island and raised cattle there beyond the reach of predatory wolves. Williams described the perils of one trip to visit with Narragansett tribe leader Canonicus on Jamestown: "The Lord helped me immediately…to ship myself all alone in a poor canoe, and to cut through a stormy wind, every minute in hazard of life, to the Sachem's house." On August 8, 1672, at age sixty-nine, Roger Williams canoed twenty miles from Providence to Newport to debate George Fox, the leader of the Quakers, on the merits of Quakerism. By the time he arrived in Newport, the visiting Fox had left, so Williams sparred with three other Quakers, as he "judged it incumbent upon [his] spirit and conscience to…give public way against their opinions."[14]

A ferry system between Aquidneck and Conanicut began operating in the second half of the seventeenth century. Most stories about the ferry place its origin around 1675, when Caleb Carr initiated a service between Jamestown and Newport. Soon thereafter, service was also established across the West Passage from Jamestown to Saunderstown. These early ferries were sailboats fitted "with a sloop rig, mainsail and jib." They were around thirty-five feet long by fourteen feet across and built with a wide beam of oak planking two inches thick. The early boats were neither comfortable nor reliable. According to one historical account, "The passengers sat in the open cockpit at the stern. Forward of the mast was another cockpit for horses and cattle, and between these two was a little covered cabin for passengers during rough weather." When there was no breeze, "passengers just sat there and wondered when they would get to shore," while in rough weather "they got drenched and wondered why

THE FERRYBOAT OF 1846.

This above represents the old sailing packet or ferryboat which ran between Ferry wharf Newport and Jamestown. The plate of the wharf was cut down to accommodate passengers and freight to the rising and falling tide.

Getting to Newport has never been easy. Ferryboats connected Newport and Jamestown for three hundred years. Sailboats carried passengers and freight in the first half of the nineteenth century. *Courtesy of the Jamestown Historical Society.*

they ever left shore." When the bay froze, commuters and livestock would walk across East Passage, not needing the ferries.[15]

While travel within the bay was accommodated by the local ferryboats, getting to Newport in the first place was always challenging. Land travel relied on stagecoaches to the water's edge and then ferries from the mainland to the island. The coaches had a top-end speed of about eight miles per hour. The two-hundred-mile trip from New York to Boston by stagecoach took four to five days. It was far from comfortable. The route was heavily traveled, as it linked the textile-producing region of New England with the market places of the Mid-Atlantic. In the summer of 1807, Robert Fulton demonstrated that steam-powered nautical transportation could be successful. He and his partner, Robert Livingston, initiated a steamboat service between New York City and Albany, securing exclusive rights for the route from the New York legislature. Within a few years, New England sea captain Elihu Bunker had convinced Fulton that steamboats could reduce the time between Boston and New York by two days. Bunker's plan was to implement steamboat service from New York via Long Island Sound to New Haven, Connecticut, which he did on March 16, 1816, on the 150-foot craft appropriately christened *Fulton*. It was a more pleasant trip and became quite popular. Bunker added a second steamboat, named *Connecticut*, the following summer.[16]

The attempt by Fulton and Livingston to monopolize the New York market had an adverse impact on their Long Island Sound operations. In 1822, the Connecticut legislature retaliated by enacting legislation that prohibited New York steamboats from operating in Connecticut ports. Bunker's solution was to establish service from New York straight to Providence. The trip took roughly twenty-four hours. Passengers boarding the steamboats in New York in the early morning would arrive the following morning in Providence. Stagecoaches

waiting in the port shuttled them north to Boston sometime that same day. Bunker's service to Providence shortened the trip from New York to Boston from four days to two days and one night. The route caught on, so Bunker added newer and faster steamers. By the 1830s, the trip took only fifteen hours.[17]

In mid-1835, Boston and Providence were connected by train, vastly improving on the steamship-stagecoach connection from New York to Providence to Boston. On June 25, a three-car locomotive joined the waiting stagecoaches ready to deliver travelers to Boston. The railroad reduced the time between Providence and Boston to two hours. Travelers could board a steamship in New York in the morning and arrive in Boston before noon the next day. Two years later, the line shifted its termination to Stonington, Connecticut. This connection cut time even further. Travelers left New York at 5:00 p.m. and arrived in Boston by 8:00 a.m. the following morning. It also avoided the open ocean off Point Judith. One drawback to the route was that the steamship would arrive in Stonington at 2:00 a.m., awakening passengers as they shifted to rail. This method remained popular for about ten years.[18]

In the 1840s, cotton mills began proliferating in Fall River, Massachusetts. Fall River needed direct access to New York markets. In 1847, Colonel Richard Borden and a group of Fall River businessmen initiated steamship service from New York to Fall River, with rail service to Boston. The first of the Fall River Line steamers was the *Bay State*. It was "beyond question the largest, fastest, and most elegantly appointed steamer on Long Island Sound." A second steamer, the *Empire State*, joined the fleet the following year. The Fall River Line's boats departed New York at 5:00 p.m., stopped at Newport at 3:30 a.m., and made an early morning stop in Fall River, where passengers took a train to Boston arriving at 8:00 a.m. It quickly replaced the Stonington Line in popularity. More importantly, however, it brought passengers directly to Newport, which was in the early stages of becoming an attractive watering hole for the leisure class.[19]

After the Civil War, a railroad line was extended down the East Bay to Newport. The Fall River Line established a termination point in Newport. The steamers became more elegant and faster. The four-stacked steamer *Newport* and the *Metropolis* reigned supreme. In 1867, James Fisk Jr. and Jay Gould, who had made money profiteering during the Civil War, initiated service between New York and Bristol. Their steamers, the 370-foot *Bristol* and *Providence*, were even faster and better appointed than the Fall River Line's newest entries. The two lines merged in 1869 and became known as the Old Colony Steamboat Company, a subsidiary of the Old Colony Railroad. Eventually, the powerful mill owners demanded that the steamboats continue on to Fall River rather than terminating in either Newport or Bristol. The stop in Newport, however, remained on the itinerary.[20]

With service to Newport firmly entrenched, the Fall River Line continued to add faster and finer boats. These included the *Puritan* and the *Pilgrim* in the 1880s and the *Providence* and the *Plymouth* in the 1890s. Also during the 1890s, the Fall River Line merged with the New York, New Haven, and Hartford Railroad. Throughout the first few decades of the twentieth century, the line continued to introduce show palaces such as the *Providence (II)* and the *Commonwealth.* By then, there were two competing lines vying for business in Narragansett Bay. The Fall River Line's dominance began to erode in the 1920s and 1930s, though, as gasoline-powered trucks picked up and delivered freight door to door. In addition, the Cape Cod Canal, which was fully opened as a toll route in 1916, was purchased by the U.S. government in 1928 and opened as a toll-free waterway. It provided another alternative for nautical traffic on the New York–Boston trade route. The Great Depression slowed business, and the death knell came in 1937 as a series of sit-down strikes canceled service. This provided the owners with the opportunity they were looking for to end the service. It shuttered its doors in the spring, and

From 1847 to 1937, Fall River Line steamships linked New York and southern New England, making it easier for passengers to get to Newport. *Photo by L.N. Frazee, courtesy of the Fall River Historical Society.*

its boats were towed to Baltimore to be scrapped, thereby marking the end of "one of America's most durable institutions."[21]

Whereas Narragansett Bay promoted transportation during the early settlement of the state, "it hindered the development of land transportation throughout Rhode Island and the southern New England states" during industrialization. As the largest "indentation" in New England's southern shore line, Narragansett Bay was an early facilitator of waterborne travel and commerce. It provided nautical access to the region's two prominent cities, Providence and Fall River. Then, as water travel ceded to railroads and subsequently automobiles, "the presence of this large body of water became the major hindrance to both railroad and highway development along the south shore of New England." Prior to the advent of the automobile, the three largest cities in southeastern New England—Newport, Fall River, and New Bedford—benefited from water travel and commerce. All three cities grew steadily from 1850 to 1920. Fall River and New Bedford actually reached their peak populations in 1920, while Newport regained population during the 1950s—thanks, in part, to an increase in naval activities during the Korean War. Meanwhile, the city of Providence, the fourth major city in the region, continued to grow throughout the 1930s but stagnated during the 1940s and 1950s. The three cities nestled along the shores of Narragansett Bay, its tributary rivers and its sister city on Buzzards Bay did not experience the same surge in post–World War II population that occurred in many other American cities. Rhode Island's population, for example, grew 11 percent between 1940 and 1955, while the rest of the country grew at 14.5 percent.[22]

By 1950, Rhode Island was an urban state bolstered by manufacturing. About 81 percent of Rhode Islanders lived in cities. Only three states had a higher proportion of urban dwellers: New Jersey, New York, and Massachusetts. Nationally, six and a half out of ten people resided in cities. Textiles occupied 35 percent of the state's manufacturing workers. Metal products engaged 20 percent and jewelry 16 percent. Construction employment was expanding rapidly, doubling between 1945 and 1952 and tripling in the three years prior to 1955. Meanwhile, farms in the state decreased by 39 percent between 1945 and 1950, falling from 3,603 to 2,598. Rhode Island city dwellers produced products that required moving raw materials in and finished products out. By the middle of the twentieth century, this meant adequate highways.[23]

And the highways were also needed to realize ambitions to remake the state into a tourist destination. "Rhode Island has long been famous because of the attractiveness of its coast line and specific recreation areas, such as Watch Hill, Narragansett, Block Island, Weekapaug, and Newport." South County,

named for its relatively temperate climate, was home to fifty beaches, sixty yacht clubs, and twenty-five harbors. Newport, a report points out, had attractions and events of "nation-wide significance." At the time, tourists contributed $70 million each year to Cape Cod. Tourism was New Hampshire's largest industry and the second largest in Vermont and Maine. Because Rhode Island lacked adequate highways, not because it lacked attractions, it failed to lure tourists as successfully as other New England states. This was probably not the best news for Newport, which was trying to reinvent itself as "America's First Resort."[24]

NEWPORT IN 1960

In May 1962, the Newport Planning Board received a Master Plan prepared by Candeub, Fleissig & Associates of Boston. That document presented a snapshot of Newport at the beginning of a pivotal decade. Throughout the twentieth century, a steady stream of planning studies focused on Newport. Frederick Law Olmsted presented a study in 1883. George B. Post produced one in 1906. In 1913, Frederick Law Olmsted's son developed a plan, as did Arthur Shutleff in 1926. The Newport Chamber of Commerce produced plans in 1935 and 1937. These were followed by Walter Maitland's 1942 effort, Alfred Edwards's 1951 report and a Blair Associates plan for Ocean Drive in 1958. The Candeub, Fleissig & Associates report contains similar observations and reemphasizes many of the principles and recommendations contained in the earlier plans, noting, however, that "relatively few of the proposals in specific form have been undertaken." Their report lays out the dilemmas confronting the city and potential solutions at a crucial turning point in Newport's history just as the forces of preservation and urban renewal were contributing to the city's reincarnation as a tourist town. In fact, the authors called for close coordination between the Redevelopment Agency of Newport and the Newport Planning Board, emphasizing that the former agency had "at its disposal a tool for the effectuation of planning proposals."[25]

Like many American cities in 1962, Newport was feeling the impact of suburbanization. Newport County, of which Newport is the county seat, was in the midst of a population boom. It had jumped from roughly 47,000 people in 1940 to 61,500 in 1950 and had reached 82,000 by 1960. The county had almost doubled in two decades. The major factor was the navy, which had "an increasing influence in the life of the East Bay islands and now occupies extensive shoreline land on the western shore of Aquidneck Island." During the

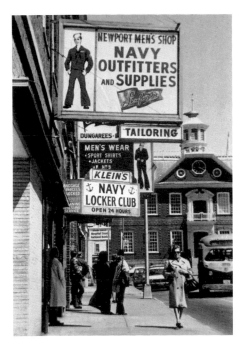

After World War II, Newport leaders made a conscious decision to transform their city from a sailor town to a tourist center. Much of Newport, like this section of Washington Square, catered to the needs of navy personnel. *Courtesy of the Newport Historical Society.*

same period, the city of Newport grew from a population of 30,500 in 1940 to 37,500 in 1950 and to 47,000 by 1960. Yet its share of the county's population was shrinking. The city held 65 percent of Newport County's people in 1940. By 1960, that had dropped to 58 percent, thanks largely to suburbanization.[26]

Newport represented a microcosm of a nationwide post–World War II trend. "What was taking place," according to historian David Halberstam, "was nothing less than the beginning of a massive migration from the cities, to the farmland that surrounded them." Between 1950 and 1980, eighteen of the country's twenty-five largest cities lost population, while the nation's suburbs gained 60 million people. More than 80 percent of the country's growth was occurring in the suburbs, so much so that by 1970, for the first time ever, more Americans were living in suburbs than in cities. The migration changed not only the landscape but also "the very nature of American society itself." The transformation of Newport, though, had a "peculiar character," being "heavily influenced by the dominant role of the Navy."[27]

While Newport grew almost 25 percent between 1950 and 1960, from 37,564 to 47,049, almost all of it could be attributed to an increase in military personnel and their families. In 1950, the number of military in Newport hovered around 7,000. By 1960, that number had jumped to 17,000, meaning the civilian population remained fairly static. After considering the amount of

natural increase (the excess of births over deaths), "indications are that there was a net out-migration of approximately 5,000 members of Newport's civilian population" during the decade, and "it would have been somewhat higher still if it were not for the expansionary effects of increased government civilian employment, which for the most part was concentrated in navy-related activities." So, the navy bolstered Newport's population during the 1950s, even as many civilians migrated to the nearby suburbs of Middletown and Portsmouth. The planners projected that Newport's population would continue to grow from 47,000 in 1960 to 52,800 by 1982. The rosy prediction fell well short. In fact, the early 1960s represented the high-water mark of Newport's post–World War II population. With the 1973 announcement that the navy was relocating its North Atlantic fleet to Virginia, Newport's population plummeted to 29,259 by 1980 and to 28,227 by 1990. The optimistic 1962 Master Plan projections, however, led the consultants to reinforce the importance of sound planning. After all, an "increased population demands more and better streets, community facilities, consumer goods and services, and an integrated pattern of living."[28]

By the time Candeub, Fleissig & Associates had penned its report, "the character of the Newport area [was] changing from agriculture and open space to more dense residential development." Between 1940 and 1960, density rose from forty-four people per square mile to seventy-seven, a 75 percent increase. While the growth of the navy contributed heavily, the city itself possessed alluring assets. These included its recreational resources, scenic beauty, and ocean-tempered climate. "Its extensive shore line includes a fine deep water harbor and affords excellent facilities for yachting, deep sea fishing, as well as extensive beaches for bathing." The planners recognized that the region's long-term prosperity did not rest solely on one industry but rather on "its ability to fuse, in the proper proportions, the major factors which have dominated its development at various times in the past—Newport Harbor, the city's historical associations, its resort atmosphere and the presence of the U.S. Navy."[29]

It was clear that this was going to be an uphill battle. By 1960, Henry James's prophecy about "white elephants" dotting Newport's cliffs was coming to fruition. Whereas before 1930, half of the city's real estate values were concentrated in the estates and landholdings of the prominent and wealthy families who summered there, such valuations had dropped to 15 percent by 1960. Yet Newport was blessed by its historical past and remained "a fascinating Colonial town" with numerous historical structures. "This abundance of historic buildings of genuine architectural interest, which reflect deeply the early years of the American Republic, give[s] Newport a unique advantage in the competition for the fast expanding tourist trade."[30]

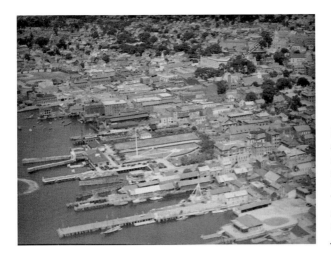

Preservationists, planners, and renewalists faced numerous challenges to reestablish Newport as "America's First Resort." The Newport waterfront after World War II was no exception. *From the National Archives.*

What giveth, of course, also taketh away. From a 1962 planning perspective, "the physical facilities and street patterns of the downtown area" were basically obsolete. The problem confronting the Newport planning community in 1962, then, was "one of formulating a strategy and a plan by which Newport's historic charm, with its clear potential for tourism, [could] be retained but which will permit it to function as a modern city." The remaining sixty pages of the document described the proposed solutions. Common themes reverberated, foremost among these being preservation, redevelopment, and renewal.[31]

Newport's central business district, once Aquidneck Island's hub of commercial activity, needed immediate attention. The shopping areas along Washington Square and Thames Street were in decline due to parking issues, traffic congestion, competition from regional shopping centers, and suburban flight. The solution was to revitalize the business district through redevelopment and rehabilitation, as laid out in the yet-to-be-completed General Neighborhood Renewal Plan for the Thames Street Area. Executing the "traffic, parking, and land uses improvements" proposed in that plan "will once again provide Newport with a modern, attractive business district."[32]

In post–World War II Newport, the use and misuse of its treasured waterfront along the harbor received much consideration. It was underutilized and lacked modern facilities. The plan called for developing Goat Island, Fleet Landing, and Thames Street for commercial and residential use. This redevelopment would stimulate downtown business and other unnamed local economic activities. "Development and redevelopment of the entire waterfront will be a major tool in strengthening the city's tax base during the next two decades."[33]

The planners believed that Newport needed urban renewal. Two areas in particular required immediate attention. The Thames Street Renewal Area was then under the microscope of the General Neighborhood Renewal Plan, which was establishing a framework for urban renewal projects throughout the following decade. While the area contained some seventy-four acres, the first project was expected to focus on twenty-one acres between West Marlborough Street and Market Square. The Goat Island Renewal Area contained the thirty-five acres of Goat Island and the fourteen acres of Fleet Landing. Both were then being sold by the General Services Administration. Studies were underway to determine potential uses for both properties.[34]

These fledgling projects would only scratch the surface, however. The 1960 census had identified that 1,057 out of the total 11,354 (9.3 percent) of Newport's dwelling units "were either dilapidated or did not contain adequate plumbing facilities." The vast majority of these units were located in the blighted areas of the Urban Renewal Map. The planners called for immediate action "in order to halt the spread of blight to areas now in sound condition." A 1960s-era city plan would not be complete without such a call for urban renewal, even in a city like Newport, which had already demonstrated the value of preserving buildings and neighborhoods and had active preservation programs engaged in a number of areas, including Oldport, the Point, Historic Hill, and the Mansion district. Urban renewal provided a solution to cleaning up much of the mess. In New York, Robert Moses had elevated urban renewal to an art form. If it worked in New York and other cities, certainly Newport could benefit. The introduction of urban renewal as a viable planning tool in Newport, however, would have long-term consequences.[35]

The need for a well-thought-out approach to traffic was obvious and long overdue. The planners anticipated "significant increases in traffic volumes" over the next decade. The city's streets had retained much of their original character. Unfortunately, they were carrying more volume than they could handle. The future promised more of the same. In 1962, many of the streets were deficient, as evidenced in "the central section of the city where street patterns were formed in colonial times." Bellevue Avenue, Spring Street, and Thames Street, it seems, have been congested for so long that their arteries have hardened. Despite their post–World War II confidence, the planners declared that it was inadvisable to redesign existing street patterns, primarily because of high land and building values. The problem could be solved by regional and arterial highways.[36]

The regional highway section of the plan focused on the need for a bridge, which, the authors noted, had been under consideration for a number of years. The proposed bridge would replace the existing ferry system and provide direct

access to Newport from the Rhode Island mainland, Connecticut, and New York. When built, the bridge would "help to attract more people to Newport. The tourist and recreational attractions in Newport would bring many visitors to Newport from the New York area and as a side trip for persons bound for Cape Cod." The best location for the bridge remained undetermined and required careful studies to minimize disruption to existing properties. It would, however, facilitate traffic to other places "quickly and directly" in and out of the central business district. "Connections with arterial streets can be constructed so as to route incoming traffic away from residential neighborhoods."[37]

Newport also needed to improve its arterial roadways. The planners recommended purchasing the "little used" railroad right-of-way from Admiral Kalbfus Road to West Marlborough Street, "which could become an arterial road connected to the proposed Jamestown Bridge." Arterial highways could improve the situation. J.T. Connell Highway could serve as the primary access road into Newport from the north. The proposed waterfront road and the extension to run from the waterfront via Memorial Boulevard would provide access to the east. Together, these streets would form "an integrated arterial loop surrounding the major sections of the city and by-passing the main residential and congested areas," while providing access to the central business district.[38]

The picture of Newport presented by the planners in 1962 and their suggestions for improvement were not much different than they had always been. Like most urban plans, the Candeub, Fleissig & Associates' study produced a clinical examination of its subject with accompanying recommendations.

It didn't take such a study for William Leys, head of Newport's then fledgling Redevelopment Authority, to understand the challenges the city faced in the early 1960s. One day, he and an economic development consultant were examining the former torpedo station buildings abandoned by the navy on Goat Island. "What you have here," the advisor proclaimed, "is Fall River with a great view." Leys recalled that this consultant and many others were advising Newport to move to a recreation economy. This was difficult for some of the natives to envision because of the dominance of the navy and the state of the waterfront. The businesses fleeing from Newport cited by the planners were well known to Leys and his neighbors. Sears, W.T. Grants, and Woolworth's packed up and moved to the suburban shopping plazas springing up in Middletown, "leaving a wake of concern that no one would shop on the once thriving Thames Street." Meanwhile, downtown Newport "suffered under clogging traffic in its midsection, the result of an abundance of cars embarking and debarking at the Ferry Landing." Something had to be done:

Travelers between Newport and Jamestown were dependent on the ferry schedule, like these motorists queuing on the Newport side. *Photo by Jerry Taylor, courtesy of Mark Taylor.*

Newport's postwar struggle cast its historic personality in a harsh light. In the boom economy of the 1950s, the city hadn't found an identity; its economy, fueled by wartime production, had slowed to a crawl. It couldn't compete with shopping centers that offered fewer traffic tie-ups and better parking conditions for car-happy shoppers.

One such something would turn out to be the Newport Bridge, which, in the early 1960s, was ironically "almost disconnected from the city's eventual plan for redevelopment."[39]

Chapter 2

THE STRUGGLES FOR APPROVAL

EARLY MOMENTUM: THE NEWPORT-JAMESTOWN BRIDGE COMMISSION

The early history of the Newport Bridge travels a route similar to the wooden roller coasters that graced amusement park midways in the 1960s and 1970s. Those thrill machines would inch their way up the initial mountain, slowly building excitement in anxious riders. As the cars crested the peak, gravity took control and dropped the riders down the other side of the mountain. Fast. Next, the cars entered a series of twists and turns under full heads of steam, bodies almost lurching out of their seats, first left, then right. Finally, there was a controlled pause as the coaster clicked steadily up an even bigger mountain. Then, *whoosh*, to the bottom, followed by more head-snapping left and right turns. Finally, the coaster glided to the finish line. Safe and sound and on firm ground, even the least courageous riders puffed up their chests and were willing to give it another go. Rhode Islanders took many rides on the Newport Bridge roller coaster between 1945 and December 1965, when construction finally commenced.

Stirrings for a bridge began as early as 1935, when the original Jamestown Bridge was being considered by the Public Works Administration (PWA). Theodore Francis Green, then governor of Rhode Island, requested plans and cost estimates for a bridge from Jamestown to Newport, thereby completing a path for automobile traffic from Saunderstown on the mainland to Newport

on Aquidneck Island. The proposed crossing was to land at Gould Island, well north of navy property. The Jamestown Town Council had appointed a bridge committee in 1933, and by 1935, hearings had progressed to the PWA. Final approval for the Jamestown Bridge was ultimately obtained in 1938 following federal legislation signed by President Franklin D. Roosevelt stipulating that the bridge must be toll-free within forty years. The infamous hurricane on October 21, 1938, hurried Jamestown residents to approve the structure by a vote of 240 to 43. The bridge was christened on July 27, 1940, and a three-day opening ceremony extravaganza was staged the very next weekend, beginning on August 2. By that time, Green's desires for a crossing to Newport had long since disappeared somewhere in the prolonged approval process and the inevitability of the coming war.[1]

The Jamestown Bridge connected mainland Rhode Island to Conanicut Island. Travelers could cross over the West Passage without being constrained by a ferry schedule. They paid a one-way toll of ninety cents for each crossing. The revenue from the tolls was being used to pay off the $3 million worth of bonds that financed the bridge. The bridge was under the control of the Jamestown Bridge Commission. This was all well and good if Jamestown was a traveler's final destination. Most, however, wished to continue on to Newport or Cape Cod. These folks were delayed until they glided across the East Passage on a ferry debarking from the Jamestown Ferry Landing. The ferries were managed by the Jamestown Ferry Company. From a financial standpoint, the ferries were a losing proposition. Every year, beginning in 1936, a bill to build a bridge across the East Passage of Narragansett Bay was introduced in the Rhode Island General Assembly, and every year the proposed legislation died in session. Any momentum to build a span across the East Passage dissipated when the nation entered the war.

Support for a bridge was reignited as World War II ground to a conclusion. Led by Green, who had left his governor's post to become a United States senator, Rhode Island sought approval from the navy to proceed with a bridge. Green surfaced the idea for consideration as a postwar construction project. Newport Mayor Herbert E. Macauley was also interested in the bridge and had engineers from Parsons Brinkerhoff prepare designs and cost estimates for three potential crossings. The proponents had successfully petitioned the PWA to fund the preliminary engineering work. (Parsons Brinkerhoff's lineage during this era included Parsons, Brinkerhoff, Hogan & Macdonald, 1943–47; Parsons, Brinkerhoff, Hall & Macdonald, 1948–59; and Parsons, Brinkerhoff, Quade & Douglass, 1960–78.) A bill was submitted to the state legislature to expand the remit

of the Jamestown Bridge Commission to include responsibility to build the bridge, but it died in session. In September 1944, the navy objected to a proposed bridge, noting that even the least objectionable location would interfere with national defense and naval operations.[2]

Then, less than one year later, on August 30, 1945—just fifteen days after the Japanese announced their surrender to the United States and three days before MacArthur accepted it aboard the USS *Missouri*—the navy withdrew its strategic objections to a bridge. The announcement followed an hour-long conference between Secretary of the Navy James V. Forrestal and a Rhode Island delegation headed by Governor J. Howard McGrath, Newport Mayor Macauley, and Congressman Aime J. Forand. The withdrawal of the navy's objections cleared one major obstacle blocking pursuit of the bridge. The navy offered assurances that, despite known issues, "it would exert every effort to work out those problems." The navy also confirmed the following: Newport would remain the primary site for torpedo research and development; it was receptive to renting out unused facilities at the torpedo station to private industry; it would return Long Wharf to the city and rent or sell the New England Steamship Company; it was considering expanding the Naval War College; and it would try to base a good portion of the fleet in Newport. Colonel Thomas F. Kern of the United States Corps of Engineers, however, said the War Department would not support the proposed bridge until authorization for such a project was voted on by the Rhode Island legislature or Congress. To that end, the War Department would hold hearings to determine if such a bridge would hinder water navigation.[3]

The Newport-Jamestown Bridge Commission trumpeted the navy's announcement and disclosed that plans had been in the works for some

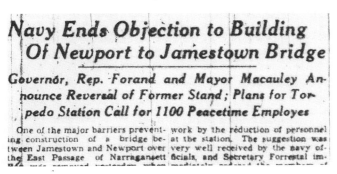

At the conclusion of World War II, the navy dropped its opposition to a bridge across Narragansett Bay's East Passage following a visit from a Rhode Island delegation led by Governor J. Howard McGrath. *Courtesy of the* Newport Daily News.

time. The bridge would have two sections: one from Jamestown to Gould Island and the other from Gould Island to Coddington Cove near Chase Lane. The eastern section would be one and a half miles long, with a central span of 1,600 feet. It would rise to a clearance of 135 feet above the water. A sketch of this section ran across four columns on page four of that day's *Newport Daily News*. It was a cantilever truss design with an elevated roadway in its central span, somewhat similar in architectural style to the original Jamestown Bridge. New York–based Parsons Brinkerhoff served as engineers on this design, as it had for the Jamestown Bridge. A. Hartley G. Ward, chairman of the bridge commission, announced that the State Planning Commission had also approved the bridge.

The next step was to obtain approval from the State Commission on Coordination and Execution of Postwar Programs. Chairman Ward noted that the new bridge would be built "provided the necessary permission, federal grant, and private capital are obtained, as was the case in the Jamestown–Saunderstown Bridge." The early promoters, it appeared, were optimistic that approval and funding would materialize. They began promoting their cause within weeks of the good news. On September 2, 1945, the influential *Providence Sunday Journal* published an editorial supporting a bridge, but its editors questioned whether the state "could afford to include the bridge in its immediate postwar highway and improvement program."[4]

Within three weeks of the announcement that the navy no longer objected to a bridge, boosters rallied support at the Rhode Island Hotel Association's annual meeting at the Hotel Viking. Secretary of State Armand J. Cote represented Governor McGrath at the meeting. Cote highlighted the need for southern Rhode Island to "acquaint the travelling public with the physical properties for recreation and relaxation with which nature has endowed this section if it is to take its rightful place as a mecca for tourists." Incoming hotel association President C.B. Thool, owner of the Beechwood Inn in Wickford, focused on new highway construction and relayed what other New England states were doing along those lines. Newport Mayor Macauley welcomed the audience to what he hoped would be the vacation land of the future as it had been in the past. He pointed out that the commodity on which the city had depended for so long, the torpedo, was gone forever. The mayor described the transportation problem that confronted the region and urged that bridge construction start soon. There were no boats or trains and not enough buses, he said, calling for expressways because tourists were bypassing Rhode Island.[5]

Bridge Commissioner Ward also addressed the meeting. He described the bridge and its proposed location. The ferries, he declared, were obsolete. Ward outlined the challenges associated with the state financing a bridge, especially a favorable vote by its citizens on a bond issue. He urged statewide support for getting the bridge built. Samuel Burchiel, manager of the American Automobile Association of Rhode Island, added that the state needed an adequate transportation system if it was to realize its great postwar future in recreation. Cote stated that during the war years, he had tried to sell the public on the beauty of Rhode Island to people both within and out of the state. He called for funds from the state legislature to promote the state's recreational facilities. Guy P. Butler, executive manager of the State of Maine Publicity Bureau, declared that recreation in New England was big business, bringing in between $400 million and $500 million annually, which he expected to be further fueled by the automobile. If the New England states cooperated, he implored, prewar revenues from recreation could double within a few years.[6]

The arguments proved persuasive. The hotel association agreed to request a series of improvements intended to bolster travel to and tourism within Rhode Island: acquiring land and building a fishing pier in Narragansett at the mouth of the Narrow River; encouraging the state to take over the Jamestown Bridge and make it toll-free; speeding the construction of Route 1 from Charlestown to the North Kingstown village of Hamilton; favoring an ocean parkway from Charlestown connecting Green Hill, Point Judith, and Ocean Road in Narragansett; starting construction of the super highway through North Kingstown, East Greenwich, and Warwick; encouraging the New England states to make the opening date for schools no earlier than the second Monday in September; and requesting the governor to place a representative from the recreation industry on the State Planning Board. All these proposals epitomized the confidence Americans possessed following World War II. No job was too big. No number of jobs was too many. Money was rarely an issue that couldn't be resolved. They also fostered the growing consensus among Rhode Islanders that the future of the southern half of the state depended on tourism and recreation and that significant infrastructure was needed to make that happen, including a bridge over the East Passage of Narragansett Bay.[7]

The optimism generated at the Rhode Island Hotel Association's September meeting was soon deflated. On December 21, 1945, news broke that the Navy Department had not approved the proposed bridge or its location after all. Secretary of the Navy Forrestal informed Senator Green in

a letter that was released via special dispatch to B.F. Linz, *Newport Daily News'* Washington correspondent. The navy might consider a bridge at a different location, though. Its suggestion was to place the bridge from Bull Point in Jamestown's Dumplings neighborhood directly across to Newport Neck near Fort Adams. Forrestal's letter, which was dated December 14, 1945, drew immediate reaction from bridge proponents. Bridge Commissioner Ward did not consider the decision final, as that rested with the War Department. "The navy would not and did not approve the San Francisco Bridge, but the War Department gave permission, and it was constructed."[8]

Green was most likely becoming exasperated at the navy's inability to provide a definitive response. He had been formally requesting one through a series of letters with Forrestal for months. The navy's correspondence was far from concise. Apparently, the navy had previously communicated its preferred location. In a letter dated November 23, 1945, Forrestal wrote to Green that he could not understand Green's impression that the navy had changed its views. The navy had not received any further presentations since the one it had deemed unacceptable. In his current missive, Secretary Forrestal informed Green that the navy was holding off any decision until the alternate Bull Point–Newport Neck (Dumplings–Fort Adams) path was examined.

The back-and-forth between proponents and the navy would continue for another decade. The boosters and engineers would conduct many studies and develop various designs, most of which accommodated the navy's desires. The navy's presence and activities in and around Narragansett Bay ultimately influenced the design and placement of the Newport Bridge. Immediately following the war through the 1960s, it was important to consider the navy's strategic position. It is ironic that the need for such strategic plans would soon diminish as the navy redeployed its Atlantic fleet to Virginia in the mid-1970s. Nevertheless, the navy held much sway in 1945, and bridge promoters continuously and unsuccessfully attempted to reach consensus with their military neighbor. Then, with momentum beginning to build, President Harry S Truman tapped bridge advocate Governor McGrath, the man who led the successful conference with Secretary Forrestal the previous August, to become United States solicitor general. McGrath would subsequently become a senator from Rhode Island, chairman of the Democratic National Committee, and the United States attorney general. The void left by McGrath in the Rhode Island Governor's Office was filled by the thirty-eight-year-old Lieutenant Governor John O. Pastore.[9]

THE SECOND WAVE: THE NARRAGANSETT BAY BRIDGE AUTHORITY

Bridge activity slowed during 1946 and then picked up with a bang on February 28, 1947. On that day, Representative Charles L. Walsh introduced a bill to the state legislature with the intent of creating the Narragansett Bay Bridge Authority. The bill recommended empowering the authority to build a bridge across the East Passage of Narragansett Bay, assume control of the Jamestown Bridge, and run the Newport-Jamestown Ferry until the bridge was completed. It prescribed the appointment of members to the authority by the governor, two from Newport and two from Jamestown. In return for the ferry service, the bill called for paying the Town of Jamestown $150,000 for retiring the outstanding bonded indebtedness of the Jamestown Bridge. The bill precluded other bridges from being built and other automobile-carrying ferries from operating between the two islands. The income and assets of the Narragansett Bay Bridge Authority would be free from state taxes, as it was a benefit to the people of Rhode Island "for the increase of their commerce and prosperity." After the bridges had been paid for, they would become toll-free, except as needed for maintenance. The authority would be vested with the power to select the location for the new bridge and to condemn necessary property. The credit of the state, Newport, Jamestown, or any political subdivision of the state could not be pledged as payment for any of its indebtedness. At the time of the bill's submission, the projected cost for the bridge was $10 million. The bill emanated from the "recently-appointed city bridge commission" and was "a continuation of the active efforts made a year ago to have the necessary legislation passed by the Rhode Island Assembly." Walsh's bill died in the General Assembly.[10]

Meanwhile, the early promoters were still organizing grass-roots campaigns to mobilize support for a bridge. On October 9, 1947, at the Hotel Viking, the fires were stoked again through the first meeting of the Newport-Jamestown Bridge Association. The group's mission was "to get the ball rolling through the islands of Conanicut and Aquidneck and through South County that will not stop until the long-sought Newport Bay bridge is under construction." The thirteen attendees elected Mason Weedon of Jamestown as chairman and P. Frederick Albee Jr. of Newport as secretary. Seven more attendees joined a committee to draft a plan to pursue its goal, including A. Hartley G. Ward, president of the chamber of commerce, and W. Ward Harvey, state representative from Newport. The communities of Middletown, Tiverton, and Narragansett were also represented. The organization would form an

executive committee "along geographical lines," under which legislative, publicity, and finance subcommittees would operate. The association's "plan of action," according to meeting organizer Representative Harvey, "would be to go to civic and fraternal organizations, to town councils and to chambers of commerce and to present resolutions to them indicating their support." The group intended to make the proposal for the bridge a reality in 1947, a tall order given its October formation date.[11]

The committee was bolstered by a letter from Albert Purcell, president of the Narragansett Bay Commuters Association, an organization composed of Newport residents who commuted to mainland jobs at Quonset and Davisville. The group's members would be the first to benefit from the bridge, as well as its "largest single financial backers, contributing roughly $63,700 in annual toll revenue." The association could count on the commuters' support. The situation in Jamestown during the summer added urgency to the group's efforts. Despite having two ferries in service, cars waited in long lines, sometimes up to two hours. Jamestown citizen Ross Harrison dubbed the Jamestown Bridge a "dead end bridge," as traffic zipping across it was stymied when it reached the ferry landing.[12]

Striking while the irons were hot, the group agreed to meet the following evening at the chamber of commerce building. The next night, it elected Weedon as permanent chairman and Ward to the post of vice-chairman. They formed an executive committee of three members each from Jamestown, Newport, Portsmouth, Tiverton, and South County. The elections were scheduled for the next week. On October 24, 1947, the Newport-Jamestown Bay Bridge Association elected its three-section executive committee members and its legislative committee chairperson. Fred C. Clarke, John Lyons, and John B. Foley were elected to represent Jamestown. Ernest Denomme, Elliot Crafts, and Dennis Collins were chosen from Newport. And C. Harold Throll, Albert Weibel, and Frederick Wilson were selected from South County. Tiverton businessman Crafts was tapped to head the legislative committee, while a Newport resident whose name was withheld pending his acceptance was voted to chair the finance committee. There was no mention of the publicity committee.[13]

The association also held an off-the-record discussion concerning the political and financial obstacles facing the bridge. It had not adopted any particular bridge proposal. Chamber President Ward presented the outline of the failed Walsh bill designed to create a state bridge authority. In a surprising twist, Weedon, who had been elected permanent chairman less than three weeks earlier, attempted to resign. He was anticipating a job

change in November that might cause him to miss a number of meetings. The members rejected his resignation, deciding to have him serve as long as he could. The history of the Newport Bridge contains elements of both the sublime and the ridiculous.[14]

The push for bridge legislation did not take long to get restarted in 1948. On January 6, during his annual message, Governor Pastore proposed two bridges, preferably built through private investments, one in Providence and the other between Jamestown and Newport. Newport Representative Charles Walsh rushed to reintroduce his Newport Bridge bill minutes after the governor finished his address. It was sent to the House Corporations Committee. Newport Senator John F. Fitzgerald introduced a companion bill in the Senate. The debates that followed were far from harmonious. Now that the navy appeared once more to have removed its objections, proponents from Newport faced stalwart opposition from their Jamestown neighbors. Jamestown State Senator Alton Head Jr. and Jamestown Town Council President Henry C. Armburst were particularly visible leaders of Jamestown's attempts to forestall the bridge. Faced with the proposition of losing control of their bridge and ferry franchises to the potential Newport-centric Narragansett Bay Bridge Authority, Jamestown politicians argued that control over construction of a new bridge would be better placed within existing organizations. They had the experience and the resources already under their watchful eyes. On top of that, they could arrange more favorable financing than a new entity.

Senator Fitzgerald clashed with Senator Head in mid-February 1948. Fitzgerald charged Head with "having prevented the erection of a Jamestown-Newport bridge for the last seven years." During that time, Fitzgerald noted, Head had not introduced any legislation for a bridge, and his contributions had been "destructive and insignificant." Fitzgerald claimed that Head had caused delays in the recent bill's hearing from early February to February 26, moving consideration close to the legislature's adjournment. Fitzgerald laid out a series of potential motivations driving Head's opposition, including protecting the ferry company's employees, preserving the antiquated ferry system itself, or preventing the construction of the bridge. Fitzgerald could not put his finger on the reason. He predicted, however, that public opinion would eventually win out: "One man cannot forever obstruct forward progress."[15]

Meanwhile, on the eve of a pivotal hearing by the State Corporations Committee, the Jamestown Town Council voted to defer indefinitely its endorsement of the proposed Narragansett Bay Bridge Authority Bill. Town

Council President Armburst told the seventy-eight taxpayers overcrowding the small council hearing room that any decision would result from "private conversations." Senator Head played a significant role in the dialogue. He was opposed to the bill and would remain so until it included more favorable provisions for Jamestown. He compared the legislation to a loan for a house, the details of which the borrower knows nothing about. No bank in the world would make such a loan, he declared. Jamestown citizen Mason Weedon spoke in favor of the bill, urging unanimous approval. Weedon predicted that the proposed bridge would attract vacationers to the island and lure new business and industry to Jamestown. With the townspeople calling for action, Armburst declared that "no compelling force can make us act for or against the measure." Once the town council conferred in private and made a decision one way or the other, all would be notified.[16]

The town fathers acted quickly. The following evening, the Jamestown Town Council plotted a scheme to take over the bridge project. It already had control of the ferry system and the Jamestown Bridge. It did not want to lose its hold on those franchises. It would support the legislation for the Narragansett Bay Bridge Authority, but only under the condition that it be folded into the existing Jamestown Bridge Commission. To that end, the Jamestown Town Council authorized its solicitor, M. James Vieira, to present an alternate bill at the state house hearing the following day. The Jamestown substitute bill would make the proposed Narragansett Bay Bridge Authority a subsidiary of the existing Jamestown Bridge Commission, as that body had funds available to complete engineering and traffic surveys and would be in a better position to secure funding at favorable interest rates to build the new bridge. The proposed legislation did not provide Jamestown with assurances that made it comfortable. Meanwhile, the legislature had amended the bills submitted by Fitzgerald and Walsh to increase authority leadership to five members and to make it mandatory that three goals be achieved: acquiring the Jamestown Bridge, acquiring the ferry service, and building the bridge. All three steps had to be executed as a single project. One could not happen without the other two.[17]

"You Can't Stop Progress"

The meeting at the State Corporations Committee hearing on the proposed Narragansett Bay Bridge Authority at the Rhode Island State House in

Providence on February 26, 1948, was contentious. More than 250 citizens crowded into the hearing room. The vast majority favored the bridge. The proponents comprised down-state "merchants, businessmen, workmen, and housewives." They made their feelings clear by applause and cheers. They wanted a bridge, "not sometime but 'now.'" They registered their displeasure for opponents speaking against the bridge legislation by booing loudly, so much so that Corporations Chairman Senator Clarence H. Horton of East Providence had to continually plead for order and demand that partisans allow their fellow citizens to speak.[18]

Newport State Representative Harvey led a cavalcade of proponents speaking in favor of the Fitzgerald-Walsh bill by describing its provisions. John Pershing of the New York bond firm Mitchell & Pershing, which apparently authored the bill, followed Harvey. Pershing explained the bill's financial elements. Pershing claimed that he was not biased. He interjected that he had paid for his own hotel room. "The bill before you," Pershing said, "has been prepared on the basis of many years experience." It now included the necessity for completing each of the three phases of the project because otherwise the bonds would not be attractive to investors. Likewise, Pershing proclaimed, it would not be viable to have two separate commissions operating the two bridges for toll collection and application purposes. The two bridges must be controlled by one body.[19]

Senator Head, a sitting member of the Corporations Committee, commenced to cross-examine Pershing. He asked Pershing how much he thought the bridge would cost to construct. Estimates ranged between $12 million and $20 million, Pershing recounted, but said he believed it could be built for $18 million. When Head followed up by asking Pershing whether there would be sufficient traffic to support the project, Pershing said that based on experience with other projects, this one would attract traffic "beyond the dreams" of the engineers. Head asked Pershing if he believed the bridge could be built without linking it to the Jamestown Bridge, prompting Pershing to further explain that revenue from the Jamestown Bridge tolls was necessary to pay the interest on the bonds while the Newport Bridge was under construction. Head then quizzed Pershing as to whether the new bonds would have a higher interest rate than the current remaining Jamestown Bridge bonds. Not necessarily, Pershing responded. In fact, a combined bridge issuance might result in a lower rate. Head said a New York banker named Mr. Hull told him the rate would double. "He does not know anymore than I do now," Pershing proclaimed. Finally, Head cornered Pershing into agreeing that bondholders could pressure the trustees to raise

tolls on the bridges, but Pershing clarified that "bondholders would be just as eager for low rates because that attracts traffic."[20]

Bridge booster John Lyons followed Pershing's testimony by discussing the Jamestown Ferry Company. The ferries were losing between $500,000 and $1 million annually. The proposed bridge, Lyons asserted, would provide commuters with twenty-four-hour service at lower rates. "And, there is a possibility that a bridge will be built elsewhere," he added, apparently alluding to a potential crossing in Providence. "The people will not put up with the bottleneck in Jamestown forever." Newport Alderman John J. Dannin testified that the citizens of Newport wanted and needed a bridge. J. Fred Sherman, a former state senator from Portsmouth, called attention to the bridge's importance "to the whole state and the whole of New England." State Representative Ulysses G. Cooper of Narragansett added that all southern Rhode Island would benefit from the bridge. The people had been looking forward to it for years. Ferries from Maine to Florida were giving way to toll bridges, Cooper observed, and this bridge would be "the outlet to northern New England."[21]

Newport resident and businessman Ernest F. Denomme, local agent for the Portsmouth-based Weyerhaeuser Sales Company, noted that lumber trucks could not use the ferry. They had to go through Providence to deliver material to South County, adding thirty dollars to the price of a six-room house. Weedon of Jamestown believed that the growth of Jamestown's natural facilities was being constrained by lack of accessibility to the island. He chided those who said they favored a bridge but not this particular bill. Newport restaurateur Nathan Fleisher confessed that he could understand opposition to the bridge because some people might lose their jobs, but he favored the greatest good for the greatest number. He emphasized that the Newport job picture had been hurt by the loss of the Naval Torpedo Station. Others speaking in favor of the bill included Middletown Representative Arthur A. Carrellas; Director of the Newport Chamber of Commerce George Harrison; Newport Development Authority member Otis Ganong; Jamestown housewife Mrs. Tapper Tollefson; and Narragansett Bay Commuters Association leader Purcell, who estimated that his 250 members currently paid $45,000 annually to get to and from work. He had previously estimated that his organization paid $63,700 yearly in tolls, which he had included in his October 1947 letter of support to the Narragansett-Jamestown Bridge Association. Finally, Matthew J. Faerber of the Newport Chamber of Commerce presented the commission with two petitions in favor of the Fitzgerald-Walsh legislation, one signed by 2,000 Newport

residents and the other by 500 Jamestown citizens. All of this was greeted favorably by the raucous proponents in attendance.[22]

Vernon C. Norton, a Pawtucket newspaperman, spoke as a private citizen. He favored a bridge but told the Corporations Committee that it was its job to ensure that Fitzgerald-Walsh was the best bill possible. Norton claimed that 750,000 Rhode Islanders would be negatively affected if the committee approved an inferior bill that benefited lawyers and bond brokers over the interest of the people. Fitzgerald-Walsh, he said, was a scheme to bypass the Rhode Island Constitution, which required approval by referendum before the state could borrow $75,000 or more. He also calculated that the proposed $20 million bridge would need to generate $1.4 million annually in tolls to pay off the debt. Norton wanted the state to build the bridge itself by issuing its own tax-exempt bonds at cheaper interest rates than what the proposed authority could command. He concluded by supporting Head's request to hold out for a better bill, for which he was loudly booed. "He has had seven years to produce a better bill," yelled one proponent from the crowd. Norton counterattacked, claiming that a member of the House involved with the bill was also an associate of the law firm representing the legislation. This provoked a skirmish between Faerber and Norton, with Faerber suggesting that Norton should "get a subpoena." When Alderman Dannin asked Norton whether he thought the referendum would have a "Chinaman's chance," Norton pointed out that the very essence of the question indicated that there was a scheme to bypass the constitution.[23]

Erich A. O'D. Taylor, a former state representative from Newport, joined Norton in opposing the bridge. He had seen one toll bridge "put over by enthusiasm." Speaking of the Mount Hope Bridge, Taylor declared that it was "a sore, a disgrace" and did not live up to its expectations as far as Newport was concerned. Furthermore, he predicted, Newport would be "despoiled by the hideous stretch the Newport-Jamestown Bridge" would make on southern Rhode Island's natural beauty. As boos rained down from the proponents, Chairman Horton rapped the gavel, pleading for order. Taylor continued, arguing that the Fitzgerald-Walsh bill failed to provide public utility administration control of rates, and he produced examples of similar mistakes. When he concluded his remarks by declaring that he did not object to bond brokers making a fee, a heckler cut him off by retorting, "How about a lobbyist?" A chorus of boos followed Taylor to his seat. Richard Corey, a Jamestown resident and Providence-based investment broker, calculated that the bridge would need to generate two thousand motorists for every one hundred automobiles that were currently using the

ferry to cross. W. Forster Caswell, acting manager of the Jamestown Ferry Company, pointed out that its assets were worth $400,000 and that this is what the company should receive from the bond issue. The highest number in either bill for the ferry company was $250,000.[24]

M. James Vieira, counsel for the Jamestown Town Council, introduced the substitute bill that would confer control of all bridges across lower Narragansett Bay to the existing Jamestown Bridge Commission. In addition, the Jamestown bill would not compel the commission to build a bridge. Faerber immediately opposed Vieira's substitute bill. Just two years previously, on March 30, 1946, the *Providence Evening Bulletin* carried a story in which Vieira proclaimed that he could build a bridge quicker. "How is it," Faerber wanted to know, "that in the past two years he has not been able to introduce legislation to get the bridge built?" Vieira replied that he and Senator Head "had not been able to get together on legislation agreeable to Head." Once the derisive laughter quelled, John Lyons, president of the Newport-Jamestown Bridge Association, questioned Vieira's sincerity, noting that Vieira and Head "have been talking ever since they have been in Jamestown." Vieira observed that Fitzgerald-Walsh was an example of "a big town gobbling up a little town" and that it "tramples over the equity of Jamestown." Horton concluded the two-hour hearing without hinting one way or the other on the potential fate of the Fitzgerald-Walsh bill, but he promised that his committee would give the bill its "full consideration."[25]

The House of Representatives was controlled by the Democrats. The day following the contentious hearing, the majority party's members voted in caucus to pass the bill that Walsh had submitted at the conclusion of Governor Pastore's annual address. Democratic majority leader James H. Klernan of Providence initiated the move at the caucus to rally the approval of Democratic legislators. Meanwhile, the Republican-led Senate provided no indication of how Fitzgerald's bill might fare in that body.[26]

The sniping between Newport-centric proponents and Jamestown-based opponents continued unabated beyond the halls of the Corporations Committee's hearing room. Newport-Jamestown Bridge Authority President Lyons characterized the Jamestown Town Council's substitute bill as an "illegal, impossible and abortive bill that will never accomplish erection of the bridge." Lyons criticized the substitute as "a direct challenge to the intelligence of the Jamestown people." He found it difficult to fathom how the town of Jamestown could devise a substitute bill overnight despite knowing about the Corporations Committee hearing

well in advance. Jamestown Town Council President Armburst stated that the town's objection was based primarily on finances, especially the low payoff amount for the ferry service. Armburst said that the town was also concerned about what would happen to the ferry service if unforeseen circumstances derailed the bridge—like future objections by the navy for security reasons, for example. Armburst said that is why the town council approved the bridge with qualifications.[27]

The proposed legislation was still under consideration by the Corporations Committee as St. Patrick's Day approached. The protagonists in the General Assembly adhered to party lines. The Democratic-led House favored the bill; the Republican-led Senate questioned it. The chief opponents of Fitzgerald-Walsh remained Jamestown's Senator Head and town solicitor Vieira, who was also treasurer-secretary of the Jamestown Bridge Commission. Meanwhile, the Fitzgerald bill had been amended to provide the Corporations Committee chairperson a seat on the board of the proposed Narragansett Bay Bridge Authority in an attempt to wrestle the bill out of committee. By March 17, 1948, as the General Assembly prepared to adjourn its session, opponents of the legislation were willing to back the bill if the existing Jamestown Bridge Commission were designated as the agency in charge of building the bridge. The potential compromise had the immediate effect of delaying Senate leadership from discharging the bill from the Corporations Committee and denying the full Senate the opportunity to vote on the measure.[28]

The potential compromise apparently never materialized, and on March 18, 1948, a second competing bill to the Fitzgerald-Walsh legislation was introduced in the General Assembly. Its sponsors were Jamestown native sons Senator Head and Representative Lewis W. Hull. This bill contained the major feature of the hoped-for compromise that conferred responsibility for the proposed Newport Bridge to the extant Jamestown Bridge Commission. Head presented the rationale for the new bill in terms similar to his long-standing opposition to Fitzgerald-Walsh. Unknown out-of-state bankers were attempting to hijack Jamestown Bridge toll revenues to pay the interest on bonds that would be floated to pay for building the new structure. They proposed to pay $1.8 million for the Jamestown Bridge, which would cost at least $7 million to replace. Also, the bill was offering only $250,000 for the Jamestown Ferry franchise, which Head claimed was worth $1 million. Jamestown might need to provide ferry service for another twenty years, Head feared. It would have its hands tied by the indebtedness and could end up with obsolete equipment and its $1

million investment lost all because "this unknown banking group wants to put over a scheme which will permit them to sell revenue bonds to investors." Head's arguments that the impetus for the new bridge was the bond company's greed ignored the fact that state officials, local legislatures, town commissions, chambers of commerce, citizens groups, commuters, and southern Rhode Island businessmen were desperately seeking a continuous link to the South County mainland and, ultimately, the rest of New England and Mid-Atlantic states. Not to mention that without a convenient crossing to Newport, the existing Jamestown-Saunderstown span remained a "bridge to nowhere."[29]

On April 8, 1948, for the first time in the twelve years that bridge legislation had been submitted for consideration, not just one but *two* bills made it through the General Assembly, where all previous bills had died in committee. The Democratic House pushed out the Walsh bill, which passed on a voice vote with no audible dissenters. The Republican Senate shunned the Fitzgerald bill in favor of the substitute legislation recommended by the Jamestown Town Council and put forth by Head. The roll call vote ended in favor of the Head bill by twenty-two to fourteen. All twenty-two votes were from Republican senators. Three Republicans senators—West Warwick's Raoul Archambault Jr., Westerly's Arthur M. Cotterell Jr., and Newport's Fitzgerald—broke party lines and opposed the Head bill in an attempt to kill the legislation. They did so because they favored Fitzgerald's proposal, as did the Democrats.

Senate Democratic minority leader Raymond McCabe made it clear that he and his fellow Democrats were not fond of Head's delaying and substituting tactics, saying that it was evident Head still preferred the ferries, "but you can't stop progress. A bridge is inevitable." Fitzgerald followed by questioning the motives of Corporations Chairman Horton. He wanted to know what chances his bill had of being recommended out of committee. "Have you ever been to Beavertail?" Horton asked. "It's a beautiful place in the summer." And without a new bridge, travelers crossing from Saunderstown to Jamestown may have had enough time to visit the lighthouse as they waited their turn on the ferry. Each bill was submitted to its opposite chamber, where the fight for control of the bridge would continue. It seemed unlikely that either bill would survive a concurrent vote and be enacted into law.[30]

IT BETTER BE BEAUTIFUL

In politics, sometimes the least conceivable events occur. That is what happened on the morning of Thursday, April 29, 1948, when the Rhode Island legislature "approved construction of a $30,000,000 toll bridge between Jamestown and Newport." There was little hoopla accompanying the bill's passage, especially considering the "weeks of wrangling" over proposed bridge bills. Senator Fitzgerald said that the bill did not include everything that bridge advocates desired. He called the legislation a concession bill rather than a compromise bill considering that the proponents "made all the concessions."[31]

Rhode Island Public Law Chapter 2152, "An Act Creating the Narragansett Bay Bridge Authority and Prescribing Its Powers and Duties," was somewhat similar to the bill Walsh had submitted fourteen months earlier. It established the authority as a "body corporate and politic," with powers to "sue and be sued, plead and be impleaded, contract and be contracted with and have an official seal." The authority would have nine members: five from the Jamestown Town Committee, two members from Newport appointed by the governor, the chairman of the House Corporations Committee and the chairman of the Senate Corporations Committee, with both of the latter serving *ex officio*.[32]

The bill empowered the authority to build the Newport Bridge and acquire the Jamestown Bridge and the Newport-Jamestown Ferry franchise. It could issue bridge revenue bonds to pay for the project, as well as accept grants from any federal agency or contributions from any source for the construction of the bridge. The authority was also granted the power to collect tolls on both bridges and could acquire, hold, and dispose of personal property to perform its duties. The Jamestown Ferry Company would continue to operate the ferry service until the Newport Bridge was opened to traffic. The price of the ferry service was set at $250,000. The authority would also pay Jamestown for any deficit incurred in operating the ferry, up to $10,000 each year until the bridge was opened to traffic. It was vested with determining the location of the new bridge, "subject to the approval of the director of public works and of the chief of engineers and the secretary of war of the United States." Nearly one-fifth of the fifty-one-page act addressed the purchase and condemnation of property, while six pages were dedicated to bond issuance and bridge revenues. As previously proposed, the Narragansett Bay Bridge Authority could not pledge the credit of the state or its towns, and the bonds would be exempt

from taxes. No ferry carrying automobiles could operate between Newport and Jamestown after the bridge was built; only pedestrian passenger ferry service would be allowed. Tolls were to cease once the bonds had been paid in full.[33]

On May 10, 1948, the *Providence Journal* published a tongue-in-cheek editorial under the banner, "In Perspective: It Better Be Beautiful." In it, the author claims that the passing of the bill paving the way for construction of the bridge "creates a cultural crisis in Rhode Island." The editorial pokes fun at the proponents' claims:

> *Such a bridge, adding to those already existing, will enable a citizen of any part of Newport County, except Block Island, Prudence, Patience, Hope and Despair Islands, Dyer, Dutch and Hog Islands, the two Gould and Gooseberry Islands and divers rocks and reefs, to go direct and dry shod for the first time ever to any part of Washington, or South County except Fox and Cornelius Islands, the islands, the salt ponds and certain offshore obstructions to navigation such as Whale Rock and vice versa.*

A breakdown in transportation barriers, the author claims, will be historic. It may even result in a tolerance of Newport County residents to the stiff-batter South County johnnycake, as well as a tolerance of South County residents to the thin-batter Newport johnnycake.

> *The bridge will draw foreign traffic including some from Providence, Bristol and Kent Counties. Sooner or later practically all of us up here will ride over it, to admire, envy and pay toll. By paying toll to cross Mount Hope Bridge, the East Passage bridge, and the West Passage bridge from Conanicut to North Kingstown, we shall make the grand circuit of Narragansett Bay and become enriched in spirit.*
>
> *The citizen of the industrial north will encounter the panoramic splendors and the phonetic subtleties of the southern clime and come to realize how truly tremendous is the geography of Rhode Island, and how uniquely varied the culture of the state. From the expenditure of a day and a few dollars, including the price of a snack en route, he will gain as much experience as if he toured from Detroit to Atlanta. What other state can offer such an attraction.*

The author leaves off without reiterating the headline that the bridge, after all, better be beautiful.[34]

In retrospect, however, while the editorial attempted to parody the arguments being proffered for a crossing, it was not far off in capturing some of the Newport Bridge's numerous contributions to the state once it was built. Indeed, riders making the "grand circuit" from Newport could hardly help but "become enriched in spirit" by the inherent beauty of Narragansett Bay and its East Passage islands as they crest the top of the bridge and slope gently toward Jamestown. It is doubtful, though, that the bridge helped close any of the "phonetic" gaps between Rhode Islanders in, say, Woonsocket and their fellow taxpayers on Bellevue Avenue.

The Narragansett Bay Bridge Authority did not wait for the ink to dry on the new bill, holding its first meeting on July 20, 1948, in the offices of the Jamestown Bridge Commission, on East Ferry Wharf. The nine members included some familiar names: Earl C. Clark, M. James Vieira, Thomas E. Hunt, Herman D. Ferrara, William Foster Caswell, Clarence H. Horton, Charles L. Walsh, M. Thomas Perrotti, and Edward R. Barry. Only Barry missed the opening session. The body elected Clark as chairman, Vieira as vice-chairman and general manager, Ferrara as secretary, and Hunt as treasurer. They also elected Robert J. Conley of Warren as general counsel and dispatched him to draft the association's bylaws, which would be considered for approval at the next meeting.[35]

Less than two weeks later, on August 2, 1948, the Narragansett Bay Bridge Authority called a special meeting. It approved Conley's bylaws and a bond contract submitted by Malvern Hill of Stranahan, Harris & Company of New York. The bonds would be exempt from federal income taxes, bear an interest rate of 4 percent, be denominated for $1,000, and mature in thirty years from their issuance, while being subject to redemption with thirty days' notice. The bonds were conditioned by subsequent plans, specifications, and estimates prepared by Parsons Brinkerhoff, the authority's consulting engineers, and "approved by the War Department, Navy Department, and Air Force Department." The pieces were beginning to fall into place, and on October 1, 1948, the Narragansett Bay Bridge Authority convened a second special meeting. Parsons Brinkerhoff had delivered its plans for a bridge. The authority's members voted to accept the plans and agreed to release them to the press.[36]

On October 2, 1948, the authority submitted two alternate plans for bridges over the East Passage to Rear Admiral J.J. Manning, chief of the Bureau of Yards and Docks at the Navy Department in Washington, D.C. One plan was $5 million more expensive than the other. If the navy approved either or both, they would be forwarded to the War Department

for formal consideration. Both plans, however, intruded on navy property and had the possibility of affecting navy activities. Plan A called for a bridge from Taylor Point in Jamestown to Coasters Harbor Island in Newport and then to the Two-Mile-Corner rotary in Middletown. Coasters Island is the site of the Naval War College. The proposed bridge would land just north of the college's Pringle Hall. It would cost $20 million to build. Plan B would emanate from Eldred Avenue in Jamestown, cross over the $500,000 Navy Landing, angle up to the southern tip of Gould Island (home of the navy's seaplane base), and then drop southeast into Coddington Cove, where another navy station was in operation. Plan B would, in essence, "tangle with Navy installations every step of the way." Its estimated cost was $25 million.[37]

The Narragansett Bay Bridge Authority did not submit a third plan, the one the navy favored just a few years previously, from the Dumplings in Jamestown to just north of Newport's Castle Hill, because Parsons Brinkerhoff estimated that it would be too expensive at $40 million. The engineers favored Plan A: it would interfere less with the navy's aerial torpedo range on the eastern edge of Jamestown; it would be a straight shot from Jamestown to Newport; and its traffic noise would not significantly disturb the War College. In addition, the Jamestown land was coming up for tax sale in the near future. Plan B, on the other hand, would require two central spans, the second to accommodate the turn from Gould Island to Coddington Cove.

The early organizational and promotional efforts by the Newport-Jamestown Bridge Association paid dividends on March 22, 1949, when the U.S. Army Corps of Engineers held a hearing on the proposed bridge conducted by Colonel James H. Stratton at the Rhode Island State House. The proponents from the southern half of the state once again descended on the state capital in droves. A caravan gathered at and departed from Equality Park in Newport at 12:30 p.m., and other delegations left Newport and South Counties in time to make it to Providence for the 2:00 p.m. meeting. The Newport Chamber of Commerce provided a clearinghouse for those needing rides to connect with others who had extra room. The proponents were armed with a sixteen-page briefing document supporting the bridge drafted by the Newport-Jamestown Bridge Association's Harvey and Lyons. Written from the perspective of a Newport County resident, the report declared that the bridge would be the "single most important factor in the future cultural, economic and social development" of the region and "of

enormous benefit to the people of the whole State of Rhode Island and her neighboring states." The authors called attention to the fact that "purportedly" Newport is "the largest city in the United States without railway passenger service." The Jamestown Bridge leads to a ferry service that cannot adequately handle the mounting automobile traffic. The bridge will draw travelers from the mid-Atlantic states through Newport to the recreational sites of Massachusetts. The briefing was endorsed by fifty-four county agencies. At this time, the promoters were advocating the Plan A bridge.[38]

A long line of supporters addressed the hearing. After delivering the brief and a letter of support from Senator John O. Pastore, Harvey introduced the speakers. Fall River sent its executive planner, Alfred Edwards, who spoke of the bridge's importance to the Spindle City. Albert A. Fournier, president of the Newport Central Labor Union, pledged the full support of the eighteen locals he represented. Jamestown Town Council President Henry Armburst, now onboard, asked for favorable consideration of the bridge. Ernest Dynomme, local sales manager for the Weyerhaeuser Lumber Company, which had a facility in Portsmouth, spoke for that town's chamber of commerce, once again emphasizing the significant change from rail to trucking following the war. Elliot Crafts, weighing in for the Tiverton Chamber of Commerce, as well as its Lions Club, stressed the necessity for the bridge, comparing its potential value to the San Francisco bridges during wartime. Representative David Laurie of Westerly spoke for that community's desire for a bridge. Newport Aldermen Henry de Costa and Charles E. Mahoney called the bridge an economic necessity. Picket Grieg, president of the Jamestown Forum, described the bridge as vital. Jamestown Mayor Alfred Bowser cited the Jamestown Bridge as an example of what a bridge contributes once built.

Newport Chamber of Commerce President Farber declared the bridge an "essential link" in the state's highway system. Nathan Fleisher said that the bridge was for the betterment of the eastern part of America. Mrs. Tapper Tollefson of Jamestown and J. Fred Sherman of Portsmouth added their names in support. Edward C. Adams cited Newport's inaccessibility and lack of transportation as reasons for the declining value of the town's summer estates. Senators J. Merrill Sherman (representing Middletown), Herbert A. Edwards Jr. (representing South Kingstown), and James H. Donnelly (representing North Kingstown) voiced each community's support for the bridge. Harvey noted that there were many others there he could call to speak, but that would "only be accumulative."[39]

Rear Admiral Thomas Ross Cooley, Naval Base commander, provided a long list of ways a bridge over Coasters Harbor Island would affect the navy. In a prepared statement, Cooley said the navy had multimillion-dollar plans to develop the island. He could not disclose the plans at a public hearing, though, saying only that the proposed bridge would interfere with them. Cooley warned that the bridge as planned would require relocating current ship moorings. He also introduced the possibility of sabotage to the bridge, which could also affect naval ships in the bay. Narragansett Bay Bridge Authority President M. James Vieira characterized the navy's objections as "suggestions of needs for adjustment."[40]

The Pocahontas Steamship Company of New York submitted a letter requesting that the main span be increased to 1,500 feet and improvements to navigational lights and horns be made. The Atlantic Refining Company sent a letter asking for the span to be 2,000 feet. William Lederer, representing the American Merchant Marine Institute of New York, stated that they did not oppose the bridge but were interested in protecting shipping. They, too, recommended a 2,000-foot span. The institute represented sixty-five leading steamship companies. Colonel Stratton declared that he would keep the hearing open pending further developments, which could include alternate site proposals.[41]

Vieira must have had one in his back pocket. Two days later, on March 23, 1949, he announced that his organization was proposing another option. This one would cross north of Rose Island, with terminations on Taylor Point in Jamestown and Van Zandt Avenue in Newport. It would bypass all of the navy's property and would hopefully ameliorate much of the navy's concerns. Vieira said the Narragansett Bay Bridge Authority would first try to reach an agreement with the navy on the Coasters Harbor Island site. If they could not agree on a site, he would ask the navy to propose one. Meanwhile, Vieira had asked Parsons Brinkerhoff to develop plans for this new proposal that would take advantage of the shallow waters north of Rose Island.

The authority would soon have three proposed sites in play. This one would be closer to the center of Newport, "appreciably adding to its traffic problems." It would also be near the center of Jamestown, as it would be located at the south end of Taylor Point instead of the north end. The length of the bridge and its estimated costs would be similar to the authority's preferred Taylor Point to Coasters Harbor Island crossing. Vieira claimed that the army engineers favored this location. He warned, however, that "they would hesitate to approve any bridge that would actually cross or take

any navy-owned property." It was odd, then, that the two plans Vieira had submitted to the navy as recently as six months earlier overtly violated that cardinal rule. Vieira was also prescient about the potential traffic issues of terminating a bridge near Newport's Point neighborhood.[42]

The authority also followed up on Admiral Cooley's suggestions and analyzed further the navy's long-preferred Dumplings–Fort Adams route. The original rough estimate for this bridge was $40 million, double the $20 million price tag of the Taylor Point–Coasters Harbor Island crossing. It was also 30 percent more than the $28 million for the Taylor Point–Van Zandt Avenue path that Vieira suggested on the heels of the army engineers' hearing earlier that spring. The Dumplings–Fort Adams site, it was feared, could come in as high as $50 million upon completion of more detailed studies. Rather than a cantilever bridge, it would be a suspension bridge supported by six-hundred-foot towers "crossing the bay in one jump, with a 2,000 foot span."[43]

Although shorter in length than the proposed cantilever bridges, which would have one-thousand-foot spans, the Dumplings–Fort Adams suspension bridge would be much higher and require ramp-style approaches that would

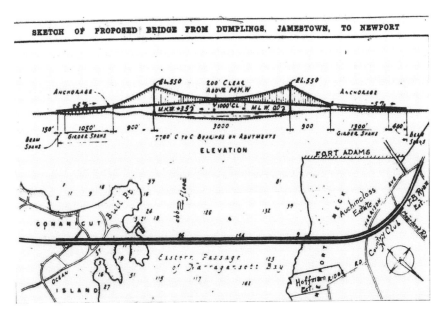

In 1949, the navy objected to proposals by the Narragansett Bay Bridge Authority, insisting on a bridge from Bull Point (the Dumplings) to Newport Neck (Fort Adams), even taking a few holes from the prestigious Newport Country Club. *Courtesy of the Newport Daily News.*

add significantly to its cost. Admiral Cooley stated that this crossing would be "the least objectionable" but that "any bridge would be subject to some honest objections." One curious element of the navy's preferred solution was that it would be "in the area of some of the wealthier estates." Maps indicate that it might possibly have even take out a few holes of the historic Newport Country Club. Nevertheless, on June 14, 1949, the Narragansett Bay Bridge Authority trumpeted the news that the navy found its most recent plan acceptable. The authority would pursue the Dumplings to Fort Adams suspension bridge.[44]

The Narragansett Bay Bridge Authority's annual meeting convened at 1:30 p.m. on Tuesday, July 19, 1949, at its offices on Jamestown's East Ferry Wharf. The highlight of the meeting was Vieira's submission of the "Annual Report of the General Manager." It recounted the authority's formation, its bond contract with Stranahan, Harris & Company, and its engineering agreement with Parsons Brinkerhoff. The report summarized the history of the placement of the bridge since 1935 and presented in clinical fashion, without mentioning Cooley's insistence, the authority's newfound support for a suspension bridge from the Dumplings to Fort Adams. All in all, Vieira declared the authority's first year a success, "considering the magnitude of the project and the inherent difficulties thereby involved."[45]

NOT NECESSARILY A NECESSITY

The Narragansett Bay Bridge Authority would not meet again until it called a special meeting on March 15, 1950. It was held in the House Corporations Committee room at the Rhode Island State House in Providence. This time there was positive movement to report:

> *Conferences were held with Admiral Cooley at Newport, with regard to this new location, and after various talks and back and forth between the Navy Department at Boston and the Office of the Army Engineers, also at Boston, the petition for a permit at this location was finally forwarded to the Navy Department at Washington to go through the various bureaus.*

It is easy to imagine Vieira emphasizing the "finally forwarded" portion of the last sentence. The petition began to wind its way through the Washington bureaucracies on January 13, 1950, and by March 1, Senator

Green's office was able to advise that Captain Harding of the Bureau of Ordnance had signed off on the project. The proposal was now with the Bureau of Aeronautics and the Bureau of Ships. Their comments were to be forwarded to the Bureau of Operations, which would subsequently confer with the army engineers. The communication concluded that the senator would wire information to the authority as it became available. In closing the meeting, Vieira reaffirmed that the Narragansett Bay Bridge Authority had done everything in its power to further the project and had "made good progress, considering the great variety of interests that must be taken into account."[46]

A lot happened before the authority's next annual meeting. On July 17, 1950, the navy issued its approval for a 7,700-foot bridge from the Dumplings to Ocean Drive near Fort Adams. Vieira, ecstatic about the news, pledged to take steps immediately that would make the bridge a reality within three to five years. Vieira had received a telegram from Cooley, breaking a long-standing stalemate. The message stated that the chief of naval operations, Admiral Forrest L. Sherman, had approved construction over the lower East Passage, thirteen long months after Cooley and the authority agreed on that location. The revised cost of the span had been adjusted down from $40 million to $32,310,000. The first step, Vieira said, was to apply to the General Services Administration (GSA) for a loan for construction plans and preliminary surveys. The Eighty-First Congress had established the Community Facilities Service of the GSA to assist state and non-federal public agencies with public works projects. The funds would be repaid once construction started. Plans were expected to take a year to develop.

In July 1950, the authority applied for the advance of $965,000 from the GSA for the development of plans and specifications for the bridge. The application seemed doomed almost from the outset. Federal officials called a loan that size for a single project in Rhode Island as "just about a mathematical impossibility." The loan program Congress authorized totaled $100 million. If all applications were for as much as the Newport project, only one hundred could be funded. In addition, Congress had only appropriated $25 million, of which Rhode Island was earmarked $96,758. The request from the authority was ten times the entire state's share. Of the state's allocation, $44,100 had been approved for a new Fox Point elementary school in Providence, and additional loan requests were pending totaling more than $250,000. Congress was expected to release more funds, but there was a possibility that it could "alter the program because of the Korean War, with an emphasis on the planning of defense public works."[47]

Despite the pessimism from unnamed federal officials concerning the loan request, favorable results were trickling in. On October 10, 1950, the State of Rhode Island approved the bridge, which was valid for three years. November 27, 1950, was a red-letter day, as the authority received the permit from the U.S. Army Corps of Engineers. It stipulated that construction of the bridge must start within five years and be completed within ten.[48]

Disappointing news, however, arrived on February 14, 1951, in a letter addressed to the authority secretary, Herman D. Ferrara, from William D. Jones, GSA division engineer. Jones had previously notified the authority on November 8, 1950, that the president had imposed restrictions on public works "which do not contribute directly to defense or essential civilian requirements." The Korean War was consuming the administration's attention and resources. The authority needed to demonstrate that the proposed bridge qualified for funding. On December 29, 1950, Alfred Hedefine of Parsons Brinkerhoff submitted copies of the approvals to the Army Corps of Engineers and the State of Rhode Island's Division of Harbors and Rivers. He followed up on January 26, 1951, with a "Statement of Necessity." Jones's letter to the authority summarized the situation:

> In the supplemental data you state "This work will contribute to the National Defense in that it is an essential proposed public work for military needs due to the fact that the great military installations of Narragansett Bay will be given a necessary link for the movement of personnel, materials, and supplies. The Naval Air Base at Quonset Point will thereby receive a necessary and most urgent highway to the Naval facilities located at Newport....Naval equipment, personnel material and ambulances are constantly moving across the necessary route, and unless it is kept properly open our military efforts will be seriously hampered and curtailed."
>
> I note the stress that is placed on the need for the proposed bridge by the Navy although there is no evidence that the Department of the Navy has approved the project and requested its construction as an urgent defense measure. I understand that the Applicant requested such statement from the Navy but it was not obtained.

Apparently, the number of times the word *necessary* is used in a "Statement of Necessity" does not guarantee success. Jones informed the authority that in order for him to recommend the application, he would need written approval from the Department of the Navy. Until then, he was placing its application in the deferred category.[49]

Hedefine held discussions with the GSA on the heels of Jones's letter. No matter how persuasive Hedefine may have been, the project would remain on the shelf until the navy or the Department of Defense declared it a necessity. There was a small ray of hope: the application could move forward "if the national defense activity is decreased to a point where civilian projects again appear to be desirable." Meanwhile, the project might be addressed if the authority "could get the Navy people at Newport to take a strong stand in favor of the proposed bridge." Vieira informed the authority that prospects did not appear probable. He ended his report with a note of dejection and uncharacteristic grammatical lapses: "It is evident, therefor [sic], that the Authority has pursued every possible angle in furthering this project in spite of the unfavorable conditions that exist with regard to it's [sic] immediate realization."[50]

With the project on the shelf, the Narragansett Bay Bridge Authority ran out of steam. It could not gather a quorum for the next annual meeting, which was scheduled for May 1952. It would be another fourteen months following that canceled meeting before the authority would meet again. The final meeting convened on July 21, 1953, at the Jamestown Bridge Commission's offices at 22 Narragansett Avenue. It lasted only forty-five minutes. The members voted for officers, selecting C.W. Magruder as chairman. By this time, Vieira was completely missing from the authority's board. Its only business for the evening beyond the election of officers was to agree that members "who could do so conveniently" would attend a meeting on July 28, 1953, "concerning the possible development of the Tri-State Southern New England Thruway." The authority's fate seemed cast when it closed its meeting by voting to adjourn and "to await the call for the next meeting at the discretion of the Chairman." Apparently, that call was never forthcoming.[51]

The hearing that Chairman Magruder urged authority members to attend had been commissioned by the governors of Rhode Island, Massachusetts, and Connecticut to study the feasibility of building a highway that would connect New York to Cape Cod. In October 1953, the Technical Sub-Committee submitted its findings to the broader Interstate Study Committee. The Technical Sub-Committee was led by Director of Rhode Island Department of Public Works Philip S. Mancini and included Commissioner of Connecticut Department of Highways G. Albert Hull, and Commissioner of Massachusetts Department of Public Works John A. Volpe. In their transmittal letter to the three governors, the subcommittee concluded that construction of a South Shore Highway in the near future was more than

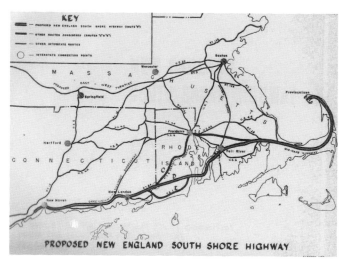

In October 1953, the governors of Rhode Island, Connecticut, and Massachusetts supported the development of a New England South Shore Highway from New Haven to Provincetown. The accompanying map was included in the recommendation from the Interstate Study Committee. *Courtesy of the Rhode Island Department of State, Secretary of State.*

justified. Such a highway was necessary. In fact, it was "vitally needed to stabilize and encourage development in eastern Connecticut, Rhode Island, and southeastern Massachusetts."[52]

The Technical Sub-Committee examined four possible routes and recommended one that ran from New Haven, paralleled the southern coast of Connecticut, passed through New London, bisected Washington County to Saunderstown, crossed the Jamestown Bridge, traversed the East Passage of Narragansett Bay, angled north through Aquidneck Island to Fall River, traveled through New Bedford, and then ran the length of Cape Cod before terminating at Provincetown. Their reasons for selecting such a route were logical. Most obvious, it would serve the "major share of the retarded and underdeveloped sections" of the Shore Route Area better than the alternatives considered, accomplishing exactly what a South Shore Highway should. When completed, it would enhance economic activities and job opportunities. More importantly, it would "attract an estimated 43 percent increase by 1970 of tourists and vacationers, and thus insure stability for the growing recreation business." The Technical Sub-Committee highlighted the necessity of a bridge between Jamestown and Newport, it being "a key link in making the New England Shore Highway at all possible along the recommended route." The proposed highway would cost $74 million:

Connecticut would contribute $17 million; Massachusetts would pitch in $20 million; and Rhode Island would need $37 million, $20 million of which would be used to build the Newport Bridge.[53]

The proposed New England South Shore Highway would become part of Route 95. Rather than veering off to Cape Cod, however, the interstate highway would bypass Route 138 to the Newport Bridge in favor of delivering passengers to Providence. The Rhode Island segment would not be fully completed until November 1969, four months after the opening of the Newport Bridge.

THE RHODE ISLAND TURNPIKE AND BRIDGE AUTHORITY

The Birth of the RITBA

By early 1953, it was evident that the Narragansett Bay Bridge Authority had run out of steam. In March of that year, new initiatives were introduced in the Rhode Island General Assembly to eliminate two water barriers that divided the state and isolated Newport County. The first would create a committee to negotiate for a state lease of the Mount Hope Bridge with the goal of reducing the "unwarrantably high" tolls then in effect on that span, "making it easier for traffic to flow between Aquidneck Island (Newport) and the Providence area." The second would be a five-member panel appointed by Governor Dennis Roberts called the Southern Rhode Island Parkway Authority. Its objective would be to build a highway from South County across Narragansett Bay to the Massachusetts line. Such a highway would require a bridge across the East Passage. The governor's plan would supersede a bridge-only authority bill submitted by Representative W. Ward Harvey on February 3, 1953.[1]

The Jamestown Bridge and the Mount Hope Bridge were both intended to improve access to Newport from the mainland; however, "both bridges proved disappointing to those who were called upon to pay substantial tolls for the privilege of using them." The only way to get from Providence to Newport without paying a toll was through Fall River. Past efforts to build the bridge had been thwarted by objections from the navy and private

landowners. Now it seemed "inevitable that the ancient southern route across Rhode Island someday will be revived for motorists," and when that day arrives "Newport and Narragansett will again be close neighbors as they were in early times," when "waterways knitted the state."[2]

Sometimes it takes the inevitable a long time to turn into reality. Spanning the East Passage was no exception. As Governor Roberts's proposal for a turnpike and bridge authority made its way through the General Assembly, Rhode Islanders tackled the weighty issue of choosing a state bird. On March 25, 1954, voters selected the Rhode Island Red. The tally was closer than one might expect. Of the 20,783 ballots cast, 8,423 preferred the rooster. The hummingbird gathered 6,900, the osprey 2,648, the bobwhite 2,193, and the towhee 619.

That same day, Public Works Director Phillip S. Mancini and Director of the Rhode Island Development Council Thomas A. Monahan announced that an engineering study to determine the proper location, cost, and traffic value of a Jamestown-Newport Bridge would soon commence. The study would cost between $15,000 and $20,000. It would be funded by the federal government matching a contribution by the state. "The bridge, if built, would close the last water gap in the southern Rhode Island cross-highway system, and would provide a link in the through interstate route approved by the governors of Rhode Island, Connecticut, and Massachusetts," said Monahan. The results of this study would quietly emerge eleven months later.[3]

However, before the engineering study was released, the Rhode Island General Assembly passed a landmark bill. On May 3, 1954, the enacting legislation for the Rhode Island Turnpike and Bridge Authority (RITBA) became law with the stroke of Governor Roberts's pen. The authority would "have the power to build and operate a toll expressway from the Tiverton-Fall River line southwest across the state to the Connecticut line at Westerly, including construction of a bridge or tunnel from Newport to Jamestown." Its enabling bill, Public Law 3390, would prove to be a keystone in the ultimate construction of the Newport Bridge, even though the opening ceremonies for that structure were still fifteen years away.[4]

The definition of Newport Bridge in the enabling legislation included a bridge or tunnel, or combination of bridge or tunnel, built over or under Narragansett Bay connecting the islands of Conanicut and Aquidneck. The bill created a body corporate and politic composed of five members, four of whom would be appointed by the governor. The director of Rhode Island Public Works would serve *ex officio* as the fifth member. RITBA was

empowered to construct an East Passage crossing, acquire the Jamestown Bridge, operate the properties, and issue revenue bonds to finance its projects. The revenue bonds were not to constitute a debt or a pledge of faith and credit of the state or any of its political subdivisions. Likewise, the state and its subdivisions were not to use any tax revenues to pay off the principal or interest of the bonds.[5]

The legislature's intent was clear on two points: no public funds were to be used to build the structure, and once built, it was to be self-sufficient. During construction, toll revenues from the Jamestown Bridge would pay the interest on the bonds. Thereafter, toll revenues generated from the bridge or tunnel itself would be used to pay off the debt. The proposed East Passage crossing was not going to become a financial burden on the people of Rhode Island.[6]

The newly created entity was endowed with a broad range of powers, especially to determine the location and design of a bridge or tunnel, the turnpike, and any additional facility, subject to the approval of the director of public works. The "turnpike" was defined as "the controlled access highway or any portion thereof to be constructed from time to time." RITBA could set, revise, and collect tolls on the turnpike, the Newport Bridge, and the Jamestown Bridge. It had the power to purchase, hold, and dispose of real and personal property, along with the power of eminent domain. RITBA could employ and establish compensation for consulting engineers, attorneys, accountants, construction experts, superintendents, managers, and other employees and agents necessary in its judgment. It could accept grants from any federal agency for constructing the Newport Bridge and the turnpike, as well as funds from the state, municipalities, or political subdivisions.[7]

Chapter 3990 empowered RITBA with broad powers. It could build and pay for grade separations at intersections of the turnpike and at the approaches and highway connections of the Newport Bridge. It could relocate any portion of any public highway or public utilities. RITBA could enter any lands, water, or premises to make surveys, soundings, borings, and examinations, as well as pay for any damages caused by these activities. It was authorized to enter into contracts or agreements with other boards, commissions, or states to make connections between the turnpike and other public highways, whether existing or built in the future. Likewise, it could enter contracts with the State of Rhode Island Public Works Department for maintenance and repair work and with the State of Rhode Island Police for policing any of its projects.[8]

An entire section of the bill, five pages in length, laid out the process for eminent domain proceedings. The following section, another five pages'

worth, addressed revenue bonds, the proceeds of which could be used only for the payment of the projects for which they were issued. The initial issuance was to pay off the Jamestown Bridge indebtedness for the transfer of that bridge to RITBA. It also specified that RITBA would acquire the Jamestown-Newport ferry franchise for $250,000, which was to be reserved in a bank account and transferred to that town's treasurer upon the opening of the Newport Bridge to traffic. Until then, the Jamestown and Newport Ferry Company was to maintain the ferry service. The ferry service for automobiles was to end when the bridge opened but could continue for passenger service. The $250,000 was to retire any bonded debt incurred by Jamestown for operating the ferries. The money, and any proceeds from the sale or lease of ferry company assets, could also be used to establish a pension fund for retired ferry company employees.[9]

The final sections of the bill focused on revenues. As mentioned previously, RITBA was empowered to collect tolls from traffic on the Newport Bridge, the Jamestown Bridge, and the turnpike. Such tolls could be used to pay for maintaining, repairing, and operating RITBA's projects. They could also be used to pay the principal and interest on the bonds, create reserves, and, ultimately, retire the bonds. The tolls would be controlled by RITBA. Because the projects undertaken by the authority would be "in all respects for the benefit of the people of the state of Rhode Island, for the increase of their commerce and prosperity and for the improvement of their health and living conditions," RITBA would not have to pay property or income taxes on the projects. Likewise, the revenue bonds would be tax free. In addition, RITBA could issue revenue bonds for the purpose of any outstanding bonds or for paying for additional projects. The bill specified that any person who failed or refused to pay a toll would be subject to a $100 fine or imprisoned for not more than thirty days, or both.[10]

The bill also set forth the conditions under which RITBA properties would be transferred to the State of Rhode Island. Traffic over the Jamestown Bridge would be toll-free after December 31, 1970, at which time the bridge would become property of the State of Rhode Island, "free and clear of all encumbrances." The legislature did not intend for RITBA to be evergreen. Once the project was completed and all bonds either paid off or set aside in a trust for the benefit of the bondholders, RITBA was to be dissolved and its properties transferred to the state's Department of Public Works and the state treasurer. Likewise, RITBA was to be dissolved if it failed to issue any bonds within five years of the act's effective date. Finally, the RITBA bill

repealed Chapter 2152 of the public laws of 1948, the Fitzgerald-Walsh bill that created the Narragansett Bay Bridge Authority.[11]

On that same day, May 3, 1954, Governor Roberts also signed a bill creating a Mount Hope Bridge Authority. That legislation established a five-man panel to purchase the Mount Hope Bridge, which was at the time privately owned. If negotiations failed, the Mount Hope Bridge Authority was vested with the power to take the bridge through condemnation. When owned by the state, federal income taxes of $350,000 would be avoided, and the state could lower tolls on the bridge.

Roberts clearly wanted to build a complete highway, not just a bridge. He knew that building the South Shore Highway across the state depended on whether an East Passage bridge or tunnel could be self-supporting. "If it is not susceptible to tolls," Roberts proclaimed, "it is prudent to say we would not be able to afford the highway." Department of Public Works Director Joseph M. Vallone and RITBA Chairman Ray B. Owen were confident that the engineering study would validate the turnpike. The results were expected in mid-February 1955. In the meantime, the navy had once again declared that it would not approve any bridge or tunnel that would touch its property along the Newport shore. In fact, the only crossing the navy seemed to now favor was a tunnel from Jamestown to Prudence Island and then a bridge from Prudence to Portsmouth. It was déjà vu all over again.[12]

THE TUNNEL

On February 17, 1955, Parsons Brinkerhoff delivered the report that Governor Roberts was awaiting to Public Works Director Vallone. In the transmittal letter, Hedefine informed Vallone that his firm had completed its agreed-upon work of "an engineering and economic study and report to determine the costs, traffic service, and economic value of a crossing of the East Passage." The report attempted to solve the problem that had been under consideration for many years: "the determination of the actual crossing of the waterway involved." It built on plans and facts gathered during previous studies. Compiling the results of those reports into proper perspective, according to Hedefine, "presented an interesting challenge." The accompanying document concluded that traffic tolls alone could not support the construction costs of an East Passage crossing.[13]

The report was one of the more interesting artifacts developed on the proposed span up to that time. It was issued virtually halfway between the end of World War II (1945) and the start of construction on the proposed bridge (1965). In it, the engineers summarized the history of the bridge up to the mid-1950s and presented a conclusion that would never be realized. It is remarkable that bridge proponents shifted course during the middle of the 1950s and recommended the feasibility of a tunnel, primarily to accommodate the demands of the navy. It is equally remarkable that the tunnel proposal was abandoned so easily in favor of the bridge.

Throughout the report, Parsons Brinkerhoff repeatedly emphasized the U.S. Navy's influence in delaying the bridge. The navy's insistence on the Dumplings–Fort Adams crossing in the early 1950s "nullified the project for all practical and economic purposes." Hedefine's report declared that the navy's stance "precluded further consideration at that time of any other crossing at a more desirable location and less costly location" and was "not the answer to the problem." Finding answers to problems, though, is exactly what engineers do. If the client says design a bridge, they design a bridge. If the client calls for a tunnel, they design a tunnel. Hedefine's firm had its fingers in every plan for a Newport Bridge up to this time. In mid-1955, it explored a tunnel, mainly to accommodate the navy's intransigence on alternate sites.[14]

Hedefine's report provided a brief assessment of the other sites considered up to the mid-1950s. Each had distinctive advantages over the navy's preferred crossing but interfered with navy operations, activities, or installations. These included crossings at Taylor Point to Coasters Harbor Island and Eldred Avenue to Coddington Point. The current study examined three additional options, all with the goal of disrupting the navy as little as possible. One explored a span crossing at the northern point of Conanicut Island to the southern end of Prudence Island and a second bridge from Prudence Island to north of Melville, "skirting most of the naval establishment" and with bridge clearances over the main shipping channel that complied with the navy's requirements. The estimated cost for that crossing ranged between $29.3 million and $35 million.[15]

The second option contemplated a bridge and tunnel scheme at the same location. Rather than a second bridge from Prudence Island to north of Melville, this plan incorporated a tunnel from Prudence Island terminating at an artificial island on the Newport side. The engineers estimated that it would cost between $31 million and $36.9 million. Then, after years of proposing bridge plans to span the East Passage at various locations, the 1955 report drew a logical recommendation: a tunnel

crossing directly from Taylor Point to Coasters Harbor Island. Hedefine's team felt that "a tunnel crossing at this location is the proper solution to best serve the needs and economy of the State of Rhode Island."[16]

The engineers favored the solution because of its "relative lack of interference with naval facilities," along with its favorable costs compared to the Dumplings–Fort Adams alignment. The proposed tunnel would stretch nine thousand feet, almost half of which would be covered by a minimum of sixty feet of water. It would be two lanes, with twenty-three feet between curbs. Its ceiling would rise fourteen feet. The tunnel would be constructed using sunken-tube technology, with short sections of cut-and-cover tunnels at each end. A man-made peninsula on the Jamestown side would be built a few hundred feet offshore to accommodate the western portal and ventilation building. The tunnel would cross under Coasters Harbor Island, surfacing on its Newport side. On the eastern terminus, a man-made peninsula would be constructed a short distance offshore just south of the navy's personnel landing dock. A roadway would extend from the eastern end of the tunnel to Aquidneck Island by a small bridge and embankment. The road would cross over Third Street, the railroad tracks, and Farewell Street, turning northwest, where it would connect with Farewell Street. It would cost $30.8 million to build.[17]

The proposed tunnel would not interfere with the navy's fuel depots, air station, carrier berthing facilities, supply depot, fixed mooring, boat landings, or other facilities using the harbor. It would diminish the threat of sabotage, especially relative to a target as accessible as a bridge. Likewise, it would not disrupt aerial torpedo testing in Narragansett Bay or be a nuisance to the War College. The engineers were "strongly hopeful that the factual consideration and elimination of the U.S. Navy's objections to this project, as presented in the past," would result in its acceptance.[18]

The engineers had not yet conducted a subsurface investigation of the tunnel's path, but based on previous studies, including their experiences in building the Jamestown Bridge and a report on the "Bedrock Geology of Rhode Island," Parsons Brinkerhoff believed that the bay's floor would "enable construction of a tunnel at reasonable cost." The report presented details about major elements of the proposed tunnel's features and systems, including the sunken tube methodology, flood protection, ventilation, electric power, lighting, fire protection, drainage, signal/communications, toll collection, crash trucks/service vehicles, operating personnel, approach highways, and right-of-way requirements. The report included a complete breakdown of cost estimates.[19]

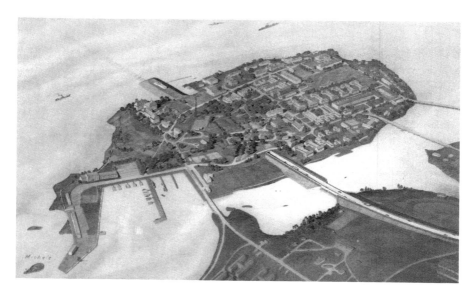

In 1954, enacting legislation establishing RITBA passed the Rhode Island General Assembly. In February 1955, engineers delivered plans for a tunnel under Narragansett Bay's East Passage. If built, it would have had a very different look and feel than the majestic suspension bridge. *Image from Parsons, Brinkerhoff, Hall & McDonald, Engineers, "Narragansett Bay East Passage Crossing, Preliminary Engineering and Economic Report, February 1955." Courtesy of RITBA.*

Hedefine's report emphasized the need to build adequate highways leading to and from the proposed tunnel. "Completion of this new Tunnel," the engineers concluded, would, of course, replace a very "weak link" in the present system but would also focus attention on other potential "weak links" or bottlenecks in the overall South Shore route across Rhode Island. Connecticut was in the process of accumulating land to build by 1958 a four-lane divided highway from the New York state line along the shore to New London. A highway between New London and Mystic, with an extension to the Rhode Island border, had been built a decade earlier and was still serviceable. Rhode Island was building Route 3 from the Connecticut state line to Route 138 in Hope Valley. The Sakonnet Bridge was under consideration to replace the Stone Bridge, the victim of underwater damage sustained in hurricanes. Massachusetts was planning a stretch of highway from Fall River to Brockton and another portion from Brockton to the circumferential Route 128. Both lengths contemplated a 1956 construction schedule. Route 6 was being built from New Bedford to Wareham. Improvements to Route 6 on Cape Cod, known as the Midcape Highway, between the Cape Cod Canal in Bourne and the tip of Provincetown, were anticipated to be finished in 1957.[20]

The section between the Connecticut/Rhode Island line and the Jamestown Bridge, designated as Route 138, was "a narrow winding 2-lane highway built a number of years ago" and was inadequate "by present day standards." According to the engineers, it was "a very weak link," and it would be "imperative to replace" to make the proposed tunnel feasible. Parsons Brinckerhoff laid out two potential highway routes to solve the problem. Both ran west–east across the center of Washington County. The North Line would shoot from the junction of Routes 138 and 3 at Hope Valley and run directly east into Saunderstown, where it would connect with the Jamestown Bridge. A two-lane version would cost $10 million and a four-lane highway would require $14.3 million. The South Line would angle slightly north and east from Ashaway at the junction of Routes 84 and 3, before turning directly east in western North Kingstown to the Jamestown Bridge. Construction costs for a two-lane highway were estimated at $13.4 million, while the four-lane roadway would be $19.8 million. Ultimately, Route 95 would carry traffic from the Connecticut state line to Route 138, but that would not be fully completed until late November 1969.[21]

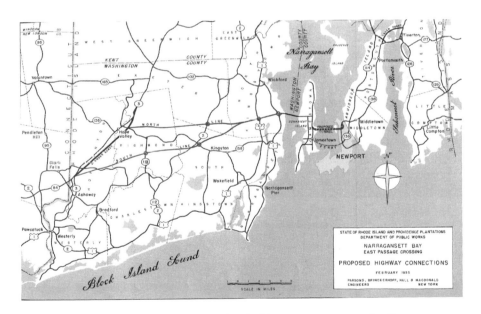

The proposed tunnel would not have interfered with navy property, crossing from Jamestown's Taylor Point to Newport's Coasters Harbor Island. *Image from Parsons, Brinkerhoff, Hall & McDonald, Engineers, "Narragansett Bay East Passage Crossing, Preliminary Engineering and Economic Report, February 1955." Courtesy of RITBA.*

The heart of the Parsons Brinkerhoff tunnel plan was the traffic survey and earnings estimates. The study concluded that the proposed tunnel could be self-sustaining if the state also purchased the Jamestown Bridge, built a connecting freeway across South County, built a highway approach across Newport, and obtained a subsidy of $500,000 from the state for maintaining the structures. In lieu of the state subsidy, the engineers suggested that the state could raise tolls on the Mount Hope Bridge, which was anathema to Roberts's administration given that it had recently justified the acquisition of that bridge by promising to lower its tolls.

The study borrowed on previous reports, including the 1954 RITBA enabling legislation; the 1953 New England South Shore Highway reports; the Report on Providence Expressways; the 1952 Jamestown Bridge Commission Administrative Report; Traffic Records and History of the Jamestown Ferry; the Report of the Governor's Committee to Study Toll Roads; Toll Schedules from the Jamestown Bridge, Jamestown Ferry, and Mount Hope Bridge; Schedules of Jamestown Ferry operations, winter and summer; and the 1953 State of Rhode Island Traffic Flow Map. The engineers used the information from these reports to develop tables and graphs depicting ferry traffic by season, average daily traffic by months from 1947 to 1954, an analysis of fares by vehicle class, and an assessment of fares by one-way versus commuter trips. The Mount Hope Bridge data provided insight on daily and seasonal traffic patterns in the Narragansett Bay area, as well as a facility that was open all day, every day throughout the year.

The engineers conducted point-of-origin and destination surveys for traffic crossing the India Point Bridge and the Red Bridge, the two extant bridge crossings of upper Narragansett Bay and the Providence River. This stop-and-ask survey provided data on the potential traffic that may have used a lower East Passage crossing if one had been available. Likewise, a stop-and-ask point-of-origin and destination survey was also taken on the Jamestown Bridge. These surveys were conducted on Wednesday, August 25, 1954, and Sunday, August 29, 1954, for twenty-four hours each.[22]

The engineers tabulated state registrations for all vehicles using the Jamestown Ferry for the seven-day period beginning on August 24, 1954. Of the 7,180 vehicles that crossed, 75 percent were from out of state. Zone-to-zone analysis of the Providence bridges surveys provided additional insight on the amount of traffic that could have taken advantage of a lower bay crossing had there been one in place. Parsons Brinkerhoff calculated that the average daily traffic using the proposed tunnel would be 2,833 vehicles, almost 91 percent being passenger cars. If this traffic were headed to the

Cape Cod Canal, each would save approximately thirteen miles, or thirty-three minutes, from established Providence routes.[23]

The engineers reckoned that the average fare for crossing the proposed tunnel would be about $0.75 per vehicle, which compared favorably to the Jamestown Bridge at $0.65, the Mount Hope Bridge at $0.53, and the Jamestown Ferry at $1.50 for a one-way fare or $1.00 per ride with a twelve-trip ticket book. This would generate $2,150 per day or $790,000 in 1954. If the bridge had been in place, the engineers projected that traffic volume would be at least 25 percent greater. They also factored in that traffic would grow at an annual rate of 4 percent. The engineers calculated that Jamestown Bridge revenues would have benefited by 130 percent, from $235,694 to $541,440, had an East Passage been in place in 1954. They also factored in that the proposed tunnel would not be up and running until 1958.

Parsons Brinkerhoff estimated that the cost of building the tunnel and acquiring the Jamestown Bridge would be $36.8 million. It would need net revenues of $2,180,000 to support the project. The traffic study predicted that net revenue would average $1,915,000 over the thirty-seven-year life of the bonds, leaving an annual shortfall of $265,000. Put another way, toll revenues could only support a structure costing $25.1 million. The tunnel would need supplemental funding.

Parsons Brinkerhoff suggested two methods. The first was for the Rhode Island Department of Public Works to assume $550,000 of the annual maintenance and operating cost of the structures. With this burden shift, the net revenues from tolls would accommodate the $36.8 million. There was already precedence for this, as the state had been absorbing the Jamestown-Newport ferry deficits since 1951. The second method was for RITBA to purchase and operate the Mount Hope Bridge. The engineers calculated that the net revenues from the proposed tunnel, Jamestown Bridge, and Mount Hope Bridge would cover $42 million of bonds.[24]

In the 1955 report, Parsons Brinkerhoff concluded that the construction of a tunnel as described in its report was "entirely feasible." It would complete "the most vitally needed link in the South Shore Highway" and "undoubtedly foster both industry and recreation throughout the areas affected." Not only that, but it would also strengthen national defense by improving communication and transportation between navy facilities separated by Narragansett Bay and "physically tie together vital military and industrial areas." There were caveats, however. First, the unknown subsurface of Narragansett Bay could result in additional costs. This would

not be known until geological studies were conducted. Second, a new highway needed to be built from the west. The "simultaneous construction of a new highway between Route 3 and the Jamestown Bridge" was essential to realize traffic estimates. The engineers were adamant that "the inadequate condition of the existing highways in this area would seriously reduce the predicted traffic." Finally, additional revenues were needed. The shortfall could be realized if the state picked up $550,000 in maintenance and operation costs or if the authority hijacked the Mount Hope Bridge revenue stream. Despite the well-reasoned and conservative study, the general perception was that the bridge could not support itself; therefore, it should not be built.[25]

Before the year was out, the Mount Hope Bridge Authority released a study predicting that neither a bridge nor a tunnel would be built across Narragansett Bay's East Passage in the upcoming fifteen years. The Mount Hope Bridge Authority was issuing bonds to purchase the structure between Bristol and Portsmouth. It claimed to have learned through reliable sources that "expressed opposition" from the navy at any feasible position "makes the construction of such a bridge completely unlikely for all practical and economic purposes during the life (15 years) of the bonds." This may have been a theory to promote traffic estimates on the Mount Hope Bridge to support the economics of acquiring that structure or a defense against RITBA from gaining control of the bridge. The Mount Hope Bridge had seen traffic increase from 305,088 in 1932 to 1,411,719 in the year ending May 1, 1955. Regardless, its prognostication and root cause proved remarkably accurate.[26]

By the end of 1955, the South Shore Highway was on life support. So was the proposed tunnel. State of Rhode Island administrators insisted that the crossing would have to be supported entirely by its users. Thwarted by negative publicity about the prospects of Rhode Islanders funding a proposed toll road, some proponents latched on to a more northerly crossing from Warwick to Barrington as a last-ditch attempt to save the highway project. The span would traverse from Conimicut Point to Nayatt Point. It would then proceed to Rumstick Road, through Hampden Meadows, and on to a yet-to-be-built east–west highway. The northern crossing would take advantage of existing traffic centers in the middle of the state, especially Providence, Cranston, and Warwick. It would complete the shore highway plans approved by Rhode Island, Massachusetts, and Connecticut, although not where originally intended. The crossing could be completed by building a bridge on a tidal dam, although that would be accompanied by its own

set of complications. Such a scheme would not be popular with Newport supporters, who were seeking "a route to bring tourists to their city." Likewise, the project could not be managed by RITBA, which was formed to build a crossing from Jamestown to Newport. RITBA itself was facing the prospect of running out of time to fulfill its five-year mandate.[27]

A Fortuitous Appointment

Interest in a bridge spanning the East Passage of Narragansett Bay took a hiatus from the doomed South Shore Highway plans and the ill-fated Warrick-Barrington scheme for three and a half years. Then, in June 1959, three New York banking groups surfaced and expressed their desire to fund the long-dreamed-of Newport Bridge. The news was passed from Governor Christopher Del Sesto to newly appointed acting RITBA Chairman Francis G. Dwyer. In fact, Del Sesto announced the bankers' interest in a bridge and Dwyer's appointment simultaneously on June 15, 1959. Del Sesto also coordinated the information with the "thrilling news" that Raytheon would be establishing its new anti-submarine warfare and sonar center on one hundred acres near Lawton's Valley in Portsmouth. The governor called the Raytheon announcement "the best news Rhode Island has had in years."[28]

The two announcements together, Del Sesto said, "indicated the opening up of Newport County." The governor said he would recommend to the General Assembly the actions needed to satisfy the bankers' demands, which included that the state "assist in building access roads and approaches to the bay crossing" and make a contribution equal to the ferry deficit that it is now underwriting, which then ranged between $80,000 and $90,000 per annum. The bankers were interested in a lower bay span, but all options would be considered—including, interestingly enough, a tunnel. Del Sesto said he had turned over RITBA's "materials, reports, and studies" to Dwyer.[29]

During its previous session, the state legislature revived the moribund RITBA. With financial assistance from Governor Del Sesto's contingency fund, the resurrected authority would seek legal advice and engage engineering consultants "to plan a connecting link between Newport and Jamestown." Dwyer said that RITBA would reorganize within the following ten days. In the meantime, the authority's offices were located in Dwyer's Bellevue Avenue insurance company, a rather inauspicious rebirth

for the agency charged with building the bridge that would help breathe life into Newport's transformation from a sailor town to its rightful place as America's First Resort.[30]

The appointment of Dwyer was fortuitous. He was thirty-six years old when he assumed leadership of RITBA and was treasurer of the Gustave J.S. White insurance agency. His father, James W. Dwyer, was the head of the firm. The younger Dwyer attended De La Salle Academy and graduated from Portsmouth Priory in 1941. He entered Georgetown University. In 1943, Dwyer enlisted in the United States Marines. He served with the Fourth and Sixth Marine Divisions in the Pacific and China. Following the war, he returned to Georgetown, where he graduated in 1947 and was honored as class marshal. Dwyer was recalled in 1950 during the Korean War. He served twenty-two months and was promoted to captain.

Returning to Rhode Island in 1952, Dwyer entered the political arena by becoming the chairman of the Middletown Committee for Eisenhower. In 1954 and 1956, he was elected from Middletown to serve in the Rhode Island House of Representatives. Then, in 1958, Dwyer ran as the Republican candidate for lieutenant governor on the same ticket as Del Sesto. Dwyer lost to John A. Notte Jr. but became secretary of the state's Republican Party. Notte would subsequently defeat Del Sesto in the 1960 gubernatorial election. Dwyer would play a major role in John H. Chafee's election as governor in 1962 and would lead Chafee's successful reelection campaign in 1964. He was an avid golfer at Newport Country Club. When he was a toddler, Herbert W. Smith, whose real estate office was a few doors away from Dwyer's father's insurance company, envisioned a bridge from Bristol to Portsmouth. Smith, who became acknowledged as the "father" of the Mount Hope Bridge, "wore himself out in a lengthy struggle by the Mount Hope Bridge Commission, which he headed, to bring it to fruition." Dwyer was about to embark on a similar experience.[31]

Within three days of his appointment, Dwyer began publicizing the revised interest in the bridge. Paul A. Kelly, a *Providence Sunday Journal* staff writer, took Dwyer's public relations bait. Within a month of Dwyer's proclamations that big city bankers were interested in the bridge, Kelly reported that "Newporters are getting up another head of steam for a new push toward Jamestown via a Narragansett Bay east passage bridge....The latest burst of optimism has come just when hopes for a bridge or tunnel appeared to have been almost counted out." The impetus for the sudden burst was propelled by the New York bankers and Dwyer's timely proclamations to the press.

Yet the project still faced big obstacles. Kelly summarized them for *Providence Journal* readers, as follows.

- First, the financiers' offer came with certain requirements. RITBA had to demonstrate to the bond buyers that the bridge could be sustained by toll revenues, as already specified in the 1954 formative legislation. However, the 1955 Parsons Brinkerhoff tunnel study, which conducted detailed traffic scenarios, concluded that the anticipated toll revenue would be insufficient without supplemental state aid to support the cost of the project.
- Second, the enabling bill also gave the authority five years to make things happen. If not, it was to shutter its operations. By 1959, RITBA had not sold a single bond within the specified timeframe; nevertheless, the state extended its deadline for two additional years.
- Third, the investors demanded that the state build access roads and approaches to the new crossing, but they did not designate whether they should be part of a major highway or simply on/off ramps. Again, the enabling legislation was much more specific. It stipulated that such access be an extension of the proposed southern Rhode Island turnpike. The cost of the turnpike was estimated at between $10 million and $15 million and was never built.
- Fourth, the bankers were looking for state subsidies that were not included in the RITBA enabling legislation.[32]

The engineers did conclude that the tunnel project would be feasible if the authority built a highway across South County, purchased the Jamestown Bridge, and either received a state subsidy of $500,000 per year for maintenance or raised the tolls on the Mount Hope Bridge. The state could also apply for federal funds to split the cost of the bridge, but such federal programs prohibited tolling. The proposed bridge or tunnel was to be part of the South Shore Highway from the New York–Connecticut border to Provincetown, which was originally proposed by Rhode Island. The two other states, Connecticut and Massachusetts, were well on their way to fulfilling their ends of the bargain. Only Rhode Island had yet to make any progress.[33]

Kelly's article was illustrated with a cartoon by renowned *Providence Journal* war correspondent and artist Paule Loring. In it, a Ben Franklin lookalike in full colonial attire and sporting a tricorn hat reclines under what could be one of Newport's famous copper beech trees. He is dreaming of a bridge between Jamestown and Newport that looks remarkably similar to

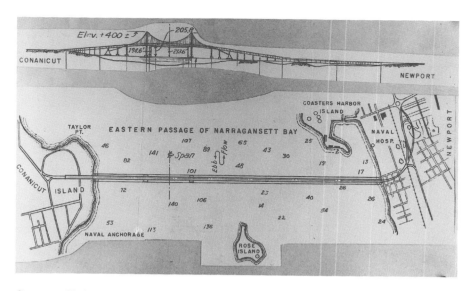

Governor Christopher Del Sesto appointed Gerry Dwyer as RITBA's chairman in June 1959. Within six months, Dwyer had suggested a bridge from Taylor Point to Cypress Street in Newport's Point section. *Courtesy of the* Newport Daily News.

the one that was ultimately built. The caption reads, "He Lies and Dreams of Things to Be...."[34]

As the 1950s turned into the 1960s, bridge proponents kick-started a renewed campaign to build a Newport Bridge. RITBA Chairman Dwyer was its chief protagonist, ringleader, and spokesperson. Less than a fortnight into the new decade, Dwyer held a meeting with Governor Del Sesto armed with another Parsons Brinkerhoff study. The report was dated December 1959, but Dwyer did not release it to the public until January 26, 1960. This time, the engineers had altered their suggestions from a tunnel to a bridge running from Taylor Point to Cypress Street, just south of the Naval Hospital. The tunnel was recommended in "consideration of Naval operating requirements." By the end of the decade, however, the navy had changed its operating patterns and was in the process of abandoning facilities on Rose and Goat Islands. A bridge had become a possibility once again.[35]

That wasn't the only change between 1955 and 1960. The cost of the bridge was now pegged at $35.4 million—$4.6 million more than the $30.8 million estimated for the tunnel. Some elements remained consistent. Like its predecessor report, the 1959 study also deduced that toll revenues from the new structure, which would average $2,217,000

over thirty-seven years, were insufficient to support its construction and ongoing maintenance costs. The project could be accomplished, the engineers projected, if RITBA assumed control of the Jamestown and Mount Hope Bridges. It would cost $640,000 to retire the bonds on the Jamestown Bridge and $2.3 million for the Mount Hope Bridge bonds. As always, the engineers reiterated that the Rhode Island Department of Public Works should pledge to complete four projects necessary to attaining their traffic estimates and opening up the lower half of the state. These were the $10 million limited-access highway from Hope Valley to the Jamestown Bridge, a new $3 million highway from the Sakonnet River Bridge to the Massachusetts line, a $1.6 million approach from the east to the proposed Newport Bridge, and a $1 million grade separation at Two Mile Corner in Middletown.[36]

Dwyer was going to ask the state legislature to amend the RITBA enabling act to allow the bridge to be built even though it was not self-sustaining. He hoped to have legislation introduced by late February that would grant RITBA permission to acquire the other two bay bridges. While it had authority to oversee the Jamestown Bridge, RITBA needed additional power to take control of the Mount Hope Bridge. He would also ask the state to guarantee $20 million of the bonds. Dwyer disagreed with the traffic studies, saying that they were "ridiculously low." He also emphasized that the bridge would unburden the state from the deficit associated with operating the Jamestown Ferry, now estimated at about $300,000 per year. Dwyer acknowledged that the proposed plan would require approval by some form of statewide referendum. So, for spending very little, Rhode Islanders would be getting a $40 million bridge. Ever the pitchman and optimist, Dwyer noted that construction could begin in the spring of 1961 and that a bridge would be in place by the summer of 1963.[37]

On March 30, the Senate Finance Committee held an open hearing on the merits of the proposed changes to RITBA's remit. In a case of history repeating itself, a caravan of Aquidneck islanders trekked north to the state house, just as they had in February 1948 to the Corporations Committee hearing and in March 1949 to the Army Corps of Engineers session. Once again, the caravan included prominent promoters of the bridge. RITBA led the delegation, which also included Louis L. Lorillard of the Newport Jazz Festival, Albert A. Fournier of the Central Labor Union, Robert E. O'Neill of the Newport Chamber of Commerce, and Newport's Mayor James L. Maher. One major difference this time was that, unlike the 1948 episode, the navy supported the project. Commander F.L. Forshee of the

On March 30, 1960, the Senate Finance Committee held an open hearing on the merits of changes to RITBA's remit. Proponents urged supporters to descend on the state capitol. *Courtesy of the* Newport Daily News.

navy's legal staff traveled with the proponents. Once more, a contingent from the Town of Jamestown led the dissenters. Jamestown Town Council Chairman Francis R. Costa pleaded their case. Jamestown residents hated the tolls on the Jamestown Bridge, and it was scheduled to be toll-free within a few years. The Jamestown Town Council portrayed the proposed bridge-building scheme as a "rape" of their community.[38]

Despite the heightened rhetoric from opponents, the bill had made it out of the finance committee and on to the floor. Newport County senators invoked the long-standing litany that the bridge would promote tourism and industry in the southern part of the state, as well as complete the necessary link in the highway system. Senator Harvey S. Reynolds of Little Compton supported the bill, even though residents of his town would still incur tolls on the Mount Hope Bridge longer than originally planned. Portsmouth Senator Frank Almeida said that his community supported the bridge because "they believed the project is good for all of Newport County." Senator Edward P. Gallogly of Providence was surprised the bill made it out of committee but supported it with reservations that state voters needed to approve the financing scheme and specified that its complications should be made clear to voters. Finance Committee

SENATE HEARING ROOM JAMMED — This is part of large gathering, mostly-backing new bridge between Newport and Jamestown, at State House hearing conducted yesterday afternoon by Senate Finance Committee. In foreground are W. Ward Harvey, left, bridge attorney, and Francis G. Dwyer, chairman of the Rhode Island Turnpike and Bridge Authority.

The March 1960 hearing proved contentious. As always, RITBA's chairman, Gerry Dwyer, was front and center. *Courtesy of the* Newport Daily News.

Chairman John G. McWeeney wondered where the money would come from. He declared that "people expect progress and they are willing to pay for it." In a surprise move, on April 26, the Rhode Island Senate passed the proposed legislation by unanimous roll call vote, thirty-four to zero. More hurdles remained, however, as the House and governor each needed to approve the bill before it could be put to referendum in the upcoming fall election. It was unknown whether Governor Del Sesto would back the legislation wholeheartedly.[39]

It didn't take the *Providence Journal*'s editorial board long to weigh in against the proposed bridge. Just three days later, in the spirit of doing first things first, the paper recommended the legislature delay the bridge bill while acting on the proposed primary, secondary, and urban roadways initiative (known as ABC), along with completing the interstate highway system. All these projects added up to a lot of money, approximately $35 million for ABC and the state's contribution to the interstate system and another $54 million in short-term notes to speed construction of the expressway. The federal government would eventually reimburse the state for funding the latter. On top of that, Rhode Island would need to pitch in an additional $20 million for the Newport Bridge. It was necessary to prioritize. It seemed logical to focus on the projects that would most benefit the state's economy and better serve the greatest number of people.

The editorial characterized RITBA as "an active lobbyist on behalf of the toll bridge bill" and "its declarations, unfortunately, are more in the form of pious hopes than in specific documentation based on scientific studies." After all, two engineering studies concluded that anticipated tolls could not support the proposed bridge. Not only that, but the proposed legislation would also result in public money to support private investors. "This mixture of private and public financing of a structure from which private profits would be derived" seemed incongruous. The paper urged the state's House of Representatives to shelve the project until a more appropriate time.[40]

Despite the editor's plea, the bill marched forward to Governor Del Sesto, who pushed it through to a state referendum without much enthusiasm. Del Sesto was concerned that RITBA was independent of state government. The state guarantee would, in effect, benefit a private entity—and "without any supervision on the part of any state official." Del Sesto observed that state oversight would only come from the general treasurer, who would have input into the bond maturity dates. Looking ahead, the governor suggested that if the voters approved the referendum in November, the General Assembly should review the law during the following year's session and build in safeguards designed to better protect the state. Del Sesto was not convinced that the bill would pass. He proclaimed that the data was insufficiently developed "to determine if the proposed financing is sound." Del Sesto's lukewarm support for the bridge would play a key role in the drama that played out leading up to the statewide referendum. But before that, a controversy brewed about whether RITBA could continue to collect tolls on the Jamestown Bridge once the bonds were paid off.[41]

A HIGHLY EXCITABLE CONTROVERSY

On June 28, 1960, the bridge debate moved four hundred miles south to Washington, D.C., where the U.S. Senate Subcommittee of Public Roads of the Committee on Public Works convened a hearing on S. 3681 at 10:00 a.m. in room 4200 of the New Senate Office Building. The bill under consideration would authorize RITBA to combine the Jamestown Bridge with the Newport Bridge for financing purposes. The bill was introduced by Rhode Island Senators Green and Pastore. This particular hearing was requested by Senator Pastore. It was chaired by Senator Pat McNamara of Michigan—a state, by the way, that was home to the majestic David

Steinman–built five-mile-long Mackinac Bridge, a suspension bridge that had opened only three years earlier. The "Mighty Mac" had a long gestation period itself, finally being approved after private bond bankers took interest in the project and the state supplemented operating and maintenance costs from gasoline and license plate taxes in 1953.[42]

Senator Pastore's opening remarks summarized the situation. The purpose of the bill, he said, was to allow RITBA to extend the tolls on the Jamestown Bridge "beyond the period when they would automatically expire by effective law." The action required U.S. Congressional approval because the Jamestown Bridge was originally constructed with federal funds before opening to traffic on June 27, 1940. Pastore stated that the situation was not unusual and had happened many times before. This bill, however, had "become somewhat controversial," Pastore declared, mainly because "the Jamestown Bridge Commission and the Jamestown Town Council and some of the people in Jamestown are opposed to this measure," as well as to the legislation passed by the state's General Assembly. Pastore read a letter into record from Del Sesto to Dwyer, dated June 13, 1960. In it, Del Sesto stated that since Dwyer assured him that RITBA would not act on taking over either the Jamestown or Mount Hope Bridge before the November referendum, he was "in accord" with RITBA "taking all necessary steps to have the Federal legislation enacted." Del Sesto further authorized and directed Dwyer to "take whatever action you may deem necessary to accomplish enactment of the Federal legislation, including notifying the Rhode Island congressional delegation of my feelings in this matter." Before turning over the microphone to Dwyer, Pastore noted that a companion bill introduced by Rhode Island Representative Forand was pending in the House.[43]

Dwyer presented a history of the Jamestown Bridge and efforts to build the Newport Bridge since 1938. He emphasized that the urgency for the Newport Bridge had grown each year. "Now," Dwyer declared, "it is absolutely necessary for the economic welfare of the southern part of the State and the entire State as a whole, otherwise, it will produce economic stagnation if we do not get that bridge." RITBA did not want tolls on the Jamestown Bridge, he clarified, but Rhode Island needed the new bridge, and the only way it could be built was with toll revenues from the two existing bridges. Tolls will not be raised on either the Jamestown Bridge or the Mount Hope Bridge, Dwyer reported, and once the Newport Bridge was opened, Jamestown residents would cross the Jamestown Bridge toll-free. Those provisions were stipulated in the Rhode Island legislation.[44]

That bill had virtual unanimity within Rhode Island. The state Senate passed the bill unanimously, while one dissenting vote was cast in the House. The sole objection emanated from the town of Jamestown. Dwyer pointed out that Jamestown had a population of 2,600 people and that maybe only half of them opposed the bridge, a very small minority compared to the 100,000 people throughout the rest of the state who were for it. He agreed that even if one person objected, of course, that individual should receive a fair hearing. "These people have been given that." Dwyer concluded his remarks with a plea to Congress to approve a bill that the state had already passed. Such actions are so common, the RITBA chairman noted, that Congress voted for the General Bridge Act in 1946 "to eliminate the need for this act of legislation, and it turned back to the several states the right to put tolls on bridges, as they saw fit."[45]

Senator Pastore then introduced RITBA attorney W. Ward Harvey, who advocated for state over town jurisdiction of the various authorities and bridges. He said that the Jamestown Bridge Commission was created by the state legislature in 1937 as an agency for the state, not for the town. The Jamestown Bridge was constructed for the benefit of the people of Rhode Island and "for the increase of their prosperity and the improvement of their health and living conditions." Funding of the Jamestown Bridge required a Public Works Administration grant to the Jamestown Bridge Commission, to the State of Rhode Island, not to the Town of Jamestown. The purposes for the grant to build the Jamestown Bridge were "to promote interstate commerce, improve postal service, and to provide for military and other services." RITBA was also created by the state and was empowered to supersede the Jamestown Bridge Commission. The Jamestown Bridge, Ward deduced, was now the property of the State of Rhode Island. And when constructed, the Newport Bridge "will promote the original purposes of the Federal Legislation: that is, the promotion of interstate commerce and the improvement of postal and military and other services." So, it would be routine for Congress to approve an act of the State of Rhode Island, especially one that was backed by its government.[46]

State Senators John Lyons of Jamestown and Joseph A. Savage of Newport rounded out the roster of speakers in support of S. 3681 and reinforced the backing of the bill by the State of Rhode Island. Lyons's testimony was particularly interesting. As a longtime resident of Jamestown and an elected official, he was in an awkward position. After all, these were his lifelong colleagues. His opinion, however, was "completely and 100 per cent" different from theirs. Lyons believed that the proposed Newport Bridge

would be a tremendous economic benefit to Jamestown. He also believed that "a great majority" of Jamestowners felt as he did, especially since they would be exempt from paying tolls on the bridge. Senator Savage reinforced that it took three years to pass the bill through the General Assembly, with many public hearings along the way. Savage claimed that "the people of the State of Rhode Island had spoken through their legislature," and he hoped Congress would look favorably on their wishes.[47]

Pastore then introduced the opponents of the bill, starting with Jamestown Town Council President Francis R. Costa. Costa began by presenting a resolution passed during a special public meeting in Jamestown on May 28, 1960, outlining their objections to the bill. The resolution presented a series of particulars that painted the townspeople of Jamestown as victims of a scheme to bolster the attraction of potential bond buyers by pledging the revenue of two, and possibly three, bridges rather than one. The theme of Jamestowners being burdened by taxes was hammered home. The Jamestown economy was "severely depressed, its people burdened with heavy taxes, property values are depressed, and opportunities on the island are few." These people had already "suffered" an "arduous burden of tolls" when they consented to the Jamestown Bridge with the promise that the bridge would be toll-free once the bonds were paid off. Those bonds would be retired in the next three or four years. The proposed Newport Bridge was accompanied by the specter of continued tolls for Jamestown's residents. In addition, toll revenue from the Jamestown Bridge was only about $100,000 per year. That was a drop in the bucket relative to the $41 million needed to build the proposed bridge. Including the Jamestown Bridge in the financing package for the Newport Bridge was "nothing more than a sales 'gimmick' to permit a salesman selling the bonds of the Rhode Island Turnpike Authority to make a better 'pitch.'" Therefore, the town of Jamestown was against this bill. Costa urged "any members of the congressional delegation in the interest of justice to oppose any attempt to amend the said congressional act."[48]

Echoing the opponents' rhetoric from 1948, Costa made it clear that they were not opposing the proposed Newport Bridge. Quite the contrary, they were for it. In fact, Costa himself planned to vote for it in November. Not only that, but he would also urge others to vote for it as well. What they were trying to stop, Costa declared, was "the extension of tolls for four generations." His plea was a passionate call for mercy: "No consideration has been given to that aspect of the adversities that we suffer. We seek relief in that direction." Costa concluded his speech by shedding light on the bills

passed in the Rhode Island General Assembly to amend the enabling act. That was accomplished through "legislative blackmail" that "led to the legislative rape of my small community." He was asking for justice.[49]

Following a confusing dialogue between Pastore and Costa concerning bridge tolling schemes and their impact on Jamestown residents, Costa introduced John B. Foley, chairman of the Jamestown and Newport Ferry Company. Foley's testimony centered on the agreement that Congress made with the townspeople of Jamestown when the Jamestown Bridge was built. That was in the mid-1930s, when Jamestown was seeking a PWA grant to help fund that bridge. It needed the grant to get the bonds. "We made an agreement right here in Washington. We had to obtain money to build the bridge. We had to operate it efficiently, and pay off the bonds. And that this bridge would be free when this bridge was paid off." Now, all that the people of Jamestown were asking for was for Congress to "go along with the original contract with us."[50]

Daniel J. Murray, the attorney for the Town of Jamestown, followed Foley and delivered the same message. He submitted a lengthy written statement that was entered into the record. The sixteen-paragraph document reiterated the themes of Jamestown's burdens and Washington keeping its promise. "To pass S. 3681," Murray wrote, "would be equivalent to saying to a GI who has just a couple of years to go on the mortgage on his home after 18 years of struggling to make monthly mortgage payments, that the United States is sorry but he must make payments on his mortgage for another 20 years before it is paid off." Murray dug deeper in his appeal. "Equity, good conscientious plain ordinary American fairness requires that the rules of the game be not changed, and our little community of Jamestown be saddled for another generation with arduous tolls." Murray closed by questioning the legality of the contemplated toll exemption for Jamestown residents. He claimed that he and like-thinking Jamestowners feared that "after the harm has been done, we will be told we cannot enforce the no-toll provision."[51]

Pastore reiterated to both Foley and Murray that the bill before the Congress represented the wishes of the Rhode Island government. He made it clear when questioning the gentlemen from Jamestown that neither he nor Senator Green introduced the legislation but that they were obligated to initiate this hearing before the subcommittee. Pastore wanted to make it clear for the record that this legislation was something the State of Rhode Island desired. In a back and forth with Foley, Pastore asked him if he refused to go along with the General Assembly. "Absolutely," Foley retorted in defiance.[52]

Discourse between Pastore and Murray took over the hearing. Pastore said the economics of the bridge had bothered him for a long time. Murray replied that it was not feasible. Murray said all the talk about economic benefits was "pie in the sky for Jamestown" and that he believed a study by experts would bear him out. He reiterated the sacrifices made by the people of Jamestown to build the Jamestown Bridge. Pastore asked Murray if he knew that he was the chairman of the Rhode Island General Assembly's Corporations Committee when that bill was passed. "Then you know," Murray countered. "I know all about this," Pastore replied. Murray then submitted the resolution passed at a "Special Town Meeting of the Qualified Electors," dated September 26, 1938. This constituted a contract, Murray proclaimed. He said he did not believe that the Rhode Island General Assembly considered this contract when it passed the bill. He himself had just recently dug it up and uncovered its ramifications. He asked for three weeks to investigate further the cases cited in RITBA's testimony of package finance plans for highway construction. That would be too long to complete the hearing during the current session. The subcommittee gave him a week.[53]

Pastore and Murray then debated whether Governor Del Sesto supported the proposed legislation. Murray produced a letter Del Sesto delivered to Rhode Island Secretary of State August P. LaFrance on May 16, 1960. In it, Murray pointed out, the governor stated that he hoped the Rhode Island legislature would defer consideration of S. 520. It was premature, Del Sesto wrote. More data was needed concerning the feasibility of the project, and it was contingent on Rhode Islanders passing a seven-year highway and bridge program, which would be decided by a vote scheduled on May 24, 1960. Nevertheless, Del Sesto allowed the bill to become law without his signature.

Murray submitted a second letter from Del Sesto to RITBA, also dated May 16, 1960. Del Sesto directed RITBA to "maintain the status quo" and that he was not authorizing the $50,000 appropriation specified in S. 520 until the voters approved the $20 million guarantee in November. He also advised RITBA not to proceed with any actions to acquire the Jamestown Bridge until Congress approved. Pastore pointed out that the May 16 letter contradicted the June 13 letter that Dwyer had cited earlier, authorizing and directing him to pursue approval from Congress and encouraging Dwyer to convey his feeling on the issue. Murray and Pastore disagreed on which letter constituted the governor's position. Pastore acted on the only letter he had, the more recent one, when he asked for this Congressional hearing.[54]

Andrew P. Quinn, the attorney for the Jamestown Bridge Commission, testified next. He, too, submitted a statement before speaking. His major points hammered home the same theme as his fellow opponents: the taking of the Jamestown Bridge was unfair to the residents of Jamestown, who sacrificed much to build the bridge and were now on the cusp of having toll revenues extended beyond the original legislation. Quinn worked in questions fundamental to democracy and of interest to Constitutional scholars everywhere. He implored Congress to consider how minorities should be treated by majorities and questioned the power of central governments over local mandates. "The unfairness to the residents of Jamestown of the request of the turnpike authority for the passage of this bill must be apparent to you," Quinn wrote. "It is difficult to picture more unfair treatment of a small Rhode Island Town. The turnpike authority is making a desperate and, in our opinion, a futile effort to build up the economy of Newport by trampling on the economy of the people of Jamestown." He also mentioned that Congress should remember that the voters of Rhode Island might reject guaranteeing half of the bonds to be floated to build the bridge. In that case, Quinn noted, if Congress passed S. 3681, it would be unnecessarily transferring ownership of the Jamestown Bridge to RITBA.[55]

During his oral testimony, in answer to Senator McNamara's question as to whether the Newport Bridge would be self-liquidating, Quinn was resolute: it would take Jamestown twenty-five years to pay off the $1.8 million it floated to build the Jamestown Bridge. "Where in the world are you going to get the traffic to go over the Jamestown Bridge and then over the Newport Bridge to pay off $20,000,000?" he asked. Besides, fewer people will be using the bridges once the new highways are built. "You have your choice of going 57 miles from the town of Kingston to Fall River over a beautiful non-access freeway or you can pay $2 to go over bridges." Quinn summed up the conflict bluntly: it was "the people of Newport versus the people of Jamestown." And Newport was no big attraction. "The economy of Newport is shot," he said. "Newport has no industry at all—never will have—it is not big enough, there is no more area for any industry." Plus, the rich people that used to contribute 70 percent of the city's taxes have left. They only pay 15 percent at this point. People from New York and Ohio would not stop in Newport. He should know. "I was born there," he cited to bolster his credentials.[56]

Newport Mayor James L. Maher followed Quinn's testimony by submitting into the record a letter he wrote to McNamara "strongly favoring" the construction of the bridge. The Bureau of Public Roads

and the U.S Army Chief of Engineers both submitted statements without objections. Dwyer asked for permission to rebut the opponents' statements. He pointed out again that the people of Rhode Island had spoken their desires to Congress through their legislature, which passed the bill that prompted their plea for Congressional approval to transfer the Jamestown Bridge to RITBA. As far as Congress reneging on previous promises, that was contemplated in the original bill that gave the federal government the "right to alter, amend, or repeal [the] Act," the authority of which was "expressly reserved by Congress."[57]

What will RITBA do, Pastore queried, if the voters reject the appropriation in November? They would be unable to build the Newport Bridge but would continue to run the Jamestown and Mount Hope Bridges as profitable entities. Pastore said he would want a review of the whole matter before anybody did anything. Dwyer agreed that he would, too, but he was convinced the traffic would be sufficient to retire the new bridge bonds in ten to fifteen years. "We need the legislation," Dwyer concluded. Pastore thanked McNamara and stated the obvious: "This is a highly excitable controversy." The proponents' arguments eventually carried the day, even though the dispute lingered throughout the summer. On September 14, 1960, President Dwight D. Eisenhower signed S. 3681 into law.[58]

The 1960 Referendum

Following the Congressional hearing at the end of June 1960, proponents of the Newport Bridge hit the campaign trail to whip up enthusiasm for "yes" votes on the upcoming November referendum. The question at hand was whether the state would guarantee $20 million in bonds. As early as mid-July 1960, Dwyer addressed the Newport County Chamber of Commerce. He said that a twelve- to fifteen-member committee was about to be named to push for approval for the referendum. He also told the businessmen that the bridge had encountered no concrete opposition outside of Newport County. Dwyer claimed that Governor Del Sesto's attitude had changed completely on the bridge, going from "lukewarm" to "most cooperative." The issue would play a role in the upcoming elections, Dwyer trumpeted. "We're going to hold a gun to the head of every candidate for office. If he's against the bridge, he's not going to get our vote regardless of his party." The line in the sand was drawn.[59]

Dwyer had to keep his eye on the United States Congress until the legislation became law. On August 8, 1960, Jamestown Bridge Commission attorney Quinn delivered a letter to Senator Green decrying that the financing for the Newport Bridge would be illegal. Dwyer dismissed the allegations as "gross misrepresentations." He would deliver a formal rebuttal letter to Green within a few days but sprang to action immediately with S. 3681 still pending before Congress. Dwyer explained that the bill was prepared by T.W. Sneed, legal expert for the Senate Committee on Public Works, "who was much more familiar with this subject than Mr. Quinn." Quinn claimed that RITBA was asking the state to pay $300,000 for fifty years to operate, maintain, and repair the new bridge. Dwyer placed the range for such costs at $160,000 to $170,000 for forty years. He said Quinn had rolled together the costs for the proposed Newport Bridge, the Jamestown Bridge, and the Mount Hope Bridge and left out the fact that the state would have to maintain the two latter bridges regardless of whether the Newport Bridge was built. Quinn also "conveniently" left out that the state would be saddled with the "ever-increasing" annual deficit associated with operating the ferry service between Jamestown and Newport, which was $319,000 in the red in 1959. If Quinn had been sincere, Dwyer said, he "would have mentioned the ferry deficit and its adverse affect on our economy."[60]

After President Eisenhower's approval of S. 3681, the navy issued a statement supporting the project. On October 6, 1960, Rear Admiral Charles B. Weakly, commander of the Atlantic Fleet Destroyer Force, delivered a strong written endorsement to the Newport County Chamber of Commerce. He listed a number of advantages the proposed bridge would deliver, including "safer driving for Navy men, once they are relieved from the need of meeting a ferry timetable on returning from leave or liberty; [it] would open additional areas for housing and recreation, would make more convenient the trip between installations at Newport and New London, and would improve access between Newport and industrial areas to the west." The ringing endorsement from their once ardent foe must have been welcome news to bridge advocates.[61]

The opponents did not take long to fire back. Richard M. Goodrich, the Rhode Island Public Expenditure Council's executive director, rolled out some heavy ammunition. He said that his agency would be publishing a study the following week that would demonstrate it was "perfectly obvious" that the tolls over the new bridge could not support its $40 million price tag, $20 million of which the state was being asked to guarantee. He had met with Dwyer to discuss his findings and seek clarifications, but Dwyer did not

have answers and needed his financial experts to weigh in. The Mount Hope Bridge Authority also published a resolution stating its objection to the plan. Its bridge was about to become toll-free in 1963. The proposed financing plan would extend tolls on the Mount Hope Bridge for an additional forty years. The authority believed that the economy of Newport County would "be better served with access on two bridges that would be free within a few years rather than via three bridges that will be toll bridges for 40 years longer." In a separate statement, Jamestown Bridge Commission Chairman Foley claimed that residents of Rhode Island would be committing themselves to payments of $80 million if they approved the referendum, which included principal, interest and maintenance on the proposed bridge, as well as construction of approach roads. The commission also disclosed that it was appropriating $3,000 for advertising to fight the bill. Senator Lyons, a member of the commission, dissented immediately and initiated an action to curtail that expense.[62]

Meanwhile, Governor Del Sesto had requested the advisory commission of the Rhode Island Development Council to analyze and report on the finances associated with the proposed bridge. The chairman of that commission, Raymond H. Trott, announced that his report would not be ready until the end of October. That would put the release date very close to the November election. They were still waiting for the results of a new traffic study. Dwyer promised that the study would be ready by the end of the current week. He would present the results to RITBA the following Monday and anytime thereafter to Trott's advisory council. Dwyer provided a preview. He believed the reports would show that traffic in the area had increased since the last study. The results, he claimed, "should eliminate objections to the proposed method of financing the bridge."[63]

The following day, October 19, 1960, in Newport, Superior Court Judge Arthur A. Carellas issued a temporary order restraining the Jamestown Bridge Commission from spending $3,000 to fight the upcoming referendum. The injunction was requested by Attorney General J. Joseph Nugent on behalf of Harold C. Petropoulos, a Newport resident who claimed that he was acting as a private citizen. Interestingly, Petropoulos was vice-chairman of the Rhode Island Bay Referendum Committee, a recently formed advocacy group to promote the bill. Two years later, he would find himself sitting on the Newport City Council. Nugent argued that the Jamestown Bridge Commission was authorized with specific duties—hiring a public relations firm to fight the upcoming referendum was not one of them. In fact, it was illegal. The respondents included some

recently familiar names: Foley and attorney Quinn of the Jamestown Bridge Commission, the Rhode Island Hospital Trust and Frank McCabe and Associates, a public relations firm. A hearing for a permanent injunction was set for October 27, eight days later.[64]

It turns out the opponents didn't need the public relations firm after all. The editors of the *Providence Journal* were probably more influential. On Sunday, October 30, 1960, nine days before the referendum, the *Providence Sunday Journal* published an editorial highly critical of the proposed referendum. Under the headline, "The Objections to the Bridge Subsidy," it got right to the point in the opening paragraphs, calling the $20 million state subsidy to help build the Newport Bridge "unjustified at this time from nearly every point of view." The editorial openly hoped that voters would reject the proposal and rattled off a series of problems. Toll bridges are supposed to pay for themselves, and this one would not. The reason the bridge had not been built yet, the editors claimed, was because a bond issue without state backing was not attractive to investors. By guaranteeing $20 million of the projected $41 million price tag for the bridge, the financing scheme would saddle Rhode Island taxpayers for thirty years, as that's how long RITBA believed it would take to pay off the state-backed loan. If the Newport Bridge were built, the editors pointed out, Rhode Island taxpayers would be subsidizing a bridge that would primarily benefit out-of-state travelers. On top of that, the taxpayers passed a $200 million highway construction program the previous spring. "The debt burden" seemed to the editors "to be too great to make the bridge worth it."[65]

Their objections did not end there. The editorial pointed out that the new traffic study would be ready before Election Day. It suggested that it would be worth waiting for the results of that study before committing to a state guarantee. The editors claimed that the new bonds would bear a higher interest rate than the existing Mount Hope Bridge bonds, which would expire in a few years anyway. It also questioned the constitutionality of the provision that would allow Jamestown-registered vehicles to pass over the Jamestown Bridge toll-free until the proposed Newport Bridge was opened. Finally, the proponents had served up little evidence that the proposed bridge would improve the economy of Newport County. The editors concluded by predicting that a bridge would be built someday, but that day had not yet arrived. Hence, they emphatically urged voters to "reject Proposition Number Eight."[66]

None of this sat well with bridge champion Dwyer. He immediately denounced the editorial, claiming that it did not adequately analyze elements

of the proposed project and was based on what he characterized as "unfounded reservations." The editorial confused and disappointed RITBA's chairman. It omitted pertinent information that was available at the time. The editors, Dwyer claimed, knew that RITBA possessed a preliminary traffic study but did not ask for the report, a summary of which had been discussed with the Rhode Island Public Expenditures Council the previous Thursday. He also claimed the editorial "glossed over" information concerning the savings to the state related to the ferry system and the operating and maintenance costs of the bridges. The editorial termed it minimal, while Dwyer estimated that the savings would be $6 million over the forty-year life of the bonds. He also objected to the editorial's use of the word *subsidy*, which he declared was both "inaccurate and misleading," being chosen "because of either ignorance or a direct attempt to misrepresent" the issue. It was not a subsidy, but a guarantee. Dwyer offered to publicly debate the facts concerning the proposed bridge.[67]

With the tide of public opinion potentially influenced by the editorial, the proponents mounted a last-ditch effort to win over voters. Six days before the election, the Rhode Island Bay Bridge Referendum Committee, which had been formed earlier in the fall to stir up the citizens of the state to vote for the referendum, announced that it would drive a model of the proposed bridge around the state on Sunday, November 6, 1960. The caravan would leave Newport at 11:00 a.m. and visit major population centers throughout the state. Committee head Petropoulos also announced that they would sponsor a "wrap-up" rally on Friday similar to one staged the previous Sunday, which he believed had been "extremely successful." The committee also announced that it had reached its goal of selling $5,000 worth of campaign buttons, of which it used the proceeds to publicize the bridge plan.[68]

The next day, however, brought more bad news for the proponents. Trott's Advisory Committee of the Rhode Island Development Council delivered its findings to Del Sesto on November 3, 1960, just five days before the vote. They concluded that Rhode Islanders would have to decide "without information needed to make a fair opinion." The Advisory Committee listed seven unanswered questions that needed further clarification:

1. *Is the estimated cost of the bridge project understated in the amount considered earned surplus of the Jamestown and Mount Hope Bridges?*
2. *What additional financing provisions are necessary to complete auxiliary facilities such as the relocation of Route 138?*

3. *What evidence can be provided to substantiate the assumed "facility increase" in traffic over the 40-year period?*

4. *Are revenue estimates based on preliminary* [information] *adequate or subject to substantial change with the availability of the final survey report?*

5. *What effect on the estimated cost of the bridge will the findings of the subsurface borings have?*

6. *To what extent will new toll-free super highways provide an alternative route that may result in a reduction in revenues for toll facilities and thus impair self-support?*

7. *What assurances can be given that the existing toll rates on existing facilities will remain unchanged for any length of time?*[69]

The report from the Advisory Committee was disingenuous. Many of the questions had been asked and answered a number of times in different forums, including the 1959 Parsons Brinkerhoff study and the Congressional hearing in the summer of 1960. In fact, the *Providence Evening Bulletin* article reporting on the committee's findings provided commentary on each of the seven questions. Nevertheless, by presenting an inconclusive report to Governor Del Sesto, the Advisory Committee raised significant doubt about the feasibility of the proposed financing scheme, especially when combined with the editorial in the previous Sunday's newspaper. Reeling from the combination, Dwyer punched back the following day. He claimed the Advisory Commission never requested detailed data. RITBA had a number of professional reports that supported the original legislation and had since been refined with additional material. Governor Del Sesto declined any further comment, saying that he would let the voters decide.[70]

On the Friday preceding the election, Providence newspapers summarized the issues for astute readers. The article included a graphic representation of Referendum No. 8. It concluded with the statement that both political parties supported the referendum. Also, the Rhode Island Bay Bridge Referendum Committee was busy sending letters to 6,777 upstate voters. It urged proponents to mail form letters to their friends. It held rallies on Washington Square. Nevertheless, RITBA's proposal lost by almost 40,000 votes: 124,942 votes to 85,257, a 60 percent to 40 percent margin. The nation did, however, elect a young and vibrant World War II hero with strong Newport ties as president of the United States. John F. Kennedy personified American postwar confidence and commitment

to getting things done. He pledged to land a man on the moon before the decade was out. That would be accomplished on July 20, 1969, less than one month after the opening of the Newport Bridge. The young president would not be alive to see either.[71]

RITBA Under Siege

Bridge proponents took a few months to emerge from the smoldering ashes of their statewide November defeat. By April 1961, Dwyer was at it again. This time, he took a different approach. Dwyer wanted RITBA to purchase the Jamestown and Mount Hope Bridges. However, before they could make such a move, RITBA sought a declaratory judgment from Newport Superior Court concerning whether it was vested with appropriate powers to issue bonds and acquire the bridges. Dwyer claimed that he was asking for the declaratory judgment with the consent of the newly elected governor, John Notte. For his part, however, Notte owned up to only advising the authority to seek an opinion on its powers from the court. Dwyer did not get off on the right foot with his old adversary and new governor. An aide to Notte described it as the governor "giving eight inches and the authority taking a foot."[72]

RITBA wanted to issue $4 million of bonds to purchase the bridges. Of this total, $1,520,000 would be used to take over the bonds on the Mount Hope Bridge, while $476,000 would be used to retire the Jamestown Bridge bonds. The remaining $2 million and change would be spent on feasibility studies and engineering surveys for the proposed bridge. The bonds would be paid from toll revenues. The state was not being asked to guarantee any portion of the bonds. Dwyer said that he would meet with the Mount Hope Bridge Authority "to give him the courtesy of an explanation" and with members of the Jamestown Bridge Commission if they requested a similar meeting. Dwyer punctuated his remarks by mentioning that the bridge would bring $6 million in jobs to the state and eliminate the deficit associated with operating the ferries between Jamestown and Newport.[73]

Dwyer's forcefulness prompted an immediate reaction from the *Providence Evening Bulletin*'s editorial board, which characterized the action as being tinged with "an unpleasant note of arrogance." This arrogance was evidenced by RITBA's unilateral approach even in the wake of its own defeat. The opinion-makers mentioned that RITBA did not inform the Mount

Hope Bridge Authority of its action until the day after it filed its motion and that it had no intention of proactively reaching out to the Jamestown Bridge Commission. Likewise, it did not consult with the Jamestown Town Council, its longtime antagonist. The latter two bodies intended to file a countermotion. Furthermore, the editors mentioned, the General Assembly, which created RITBA in the first place, had grounds to repeal the enacting legislation given the high-handedness of its leaders. Now it was trying to go around the state voters' wishes. In closing, the editors declared, there was nothing RITBA could do "about surveys and studies on the proposed third bridge that the state Department of Public Works [could not] do equally well," especially since that department "was competent to plan and manage a multi-million dollar highway project." It could certainly handle a bridge. The seeds for RITBA's demise were being planted.[74]

On April 12, 1961, the same day the editorial appeared, opponents began calling for RITBA's elimination. Senator Louis E. Perrault of Richmond introduced a bill to close RITBA, saying he was opposed to the agency taking control of the two existing bridges in light of the November referendum. The next day, Senator William M. Davies Jr. of Lincoln introduced a similar bill. In the House, Representatives William J. Champion of Newport and James A. Gallagher of Jamestown joined forces and introduced legislation to shut down RITBA. Gallagher repeated his constituency's elevator speech: the people of Jamestown were not against the proposed Newport Bridge, just the method of financing it, which included turning over the Jamestown Bridge to RITBA.[75]

Meanwhile, RITBA continued its grass-roots campaign to build support. Dwyer revisited an old ally, the Rhode Island Motel Association, and garnered its blessing. Dwyer pleaded his case before the group at its semiannual meeting at the Tower Hill Restaurant in South Kingstown. The referendum was defeated because the voters did not have the full facts. One reason was that RITBA did not have funds to spend on radio, television, and newspaper advertisements to fully explain its proposal. The proposed bridge, Dwyer reiterated, would not burden Rhode Island taxpayers. The authority was merely asking the state to guarantee construction costs. Over forty years, the bridge would make money for the state, as well as eliminate the cost of running the ferries, which he pegged this time at $300,000. The argument against the proposal, he said, was that the Jamestown Bridge would be toll-free by 1965. Dwyer pointed out that at that time the state would assume the bridge and maintenance and operating expenses would be paid by taxpayer money. The assembly voted to support RITBA's plan.[76]

The legal wheels in Newport's Superior Court continued to grind through the spring and early summer. On June 29, 1961, Judge Florence K. Murray ruled favorably on petitions from the Jamestown Town Council, the Jamestown Bridge Authority, and the Mount Hope Bridge Commission to dismiss RITBA's original request for a declaratory judgment. Murray's decision temporarily derailed the authority's request. Her ruling was based on the technicality that both petitioners and respondents were named individually and as representatives of specific agencies. That was not legal, Murray said. RITBA attorney Harvey promised to refile a new petition that afternoon, hoping it would meet the judge's expectations. On this day, the pleas to dismiss the request for a declaratory judgment proved persuasive.[77]

The complicated nuances of the declaratory judgment petition and counter-petitions further muddled the issue. In December 1961, the Mount Hope Bridge Commission petitioned the Rhode Island Supreme Court to put an end to the Superior Court's activities. This was a reaction to Superior Court Judge Arthur A. Carellas's order to move the case forward by placing it on the Superior Court's docket for a full hearing. Lawyers representing the Mount Hope Bridge Commission claimed that Carellas made an error in moving the case forward on its merits before all pleadings had been concluded. On December 14, 1961, the Supreme Court stayed the case until further notice and set a hearing for January 5, 1962. RITBA's plans were now on hold, held up in court by a process it initiated—hoisted with its own petard.[78]

Despite the pending legal process, yet another bill was submitted in the Rhode Island legislature to abolish RITBA, this time by Jamestown Senator Chester J. Greene. Sent to the finance committee, Greene's proposal would "simply wipe out the authority." Simultaneously, Senators Allen S. Harlow of Middletown and longtime proponent Thomas H. Levesque of Portsmouth submitted a measure that would dramatically reorganize the Jamestown Bridge Commission. That legislation, which went to the Corporations Committee, would restructure the commission in the following areas: remove the current commissioners immediately; abolish the method for selecting commissioners (town vote); establish a new commission consisting of the director of public works plus four members appointed by the governor; cease paying members for their service (twenty dollars per meeting); and eliminate the practice of allowing members of the commission to also be employees. The last provision was interpreted as an attack on erstwhile bridge financing plan opponent Foley, who was both a member of the Jamestown Bridge Commission as well as its paid full-time general manager. Meanwhile, no

bridge was getting built. The cost of building a bridge was going up. Both RITBA and the Jamestown Bridge Commission were under siege. And leadership from Governor Notte was sorely lacking.[79]

With RITBA's petition for an opinion on whether it was legal for it to take over the Jamestown Bridge and issue its own bonds bogged down in Rhode Island's Supreme and Superior Courts, and with legislation pending to abolish RITBA, bridge financing opponents took things one step further. At its meeting on January 12, 1962, the Jamestown Bridge Commission adopted a resolution to draft legislation that would empower it to assume responsibility for building the bridge. Dr. Alfred B. Gobeille, a member of the commission, said that the Jamestown Bridge Commission was more capable of building a bridge than RITBA. Gobeille's proposal caught other commission members by surprise. Gobeille also declared that bridge financing schemes should not include the Mount Hope Bridge. He characterized RITBA's proposals as "weird" and said that "people in this state have been fed a lot of phony financial deals." His was legitimate, he contended. If the study determined that the bridge was not feasible, Gobeille opined, then "we should stick with the boats."[80]

Commission Chairman Foley thought not only that his agency would do a better job building the bridge but also that bond issuers would have more confidence in them than in RITBA, based on its demonstrated experience of operating a bridge on a sound financial basis. Foley criticized RITBA's efforts to date, including that it had yet to even conduct boring tests on the floor of Narragansett Bay before it developed cost estimates. Foley also said that if the Jamestown Bridge Commission were entrusted with building the bridge, it would examine the possibility of federal funding. Commission member and Jamestown Town Council Chairman Harold E. Shippee was dispatched to meet with attorney Quinn to draft a proposed bill. RITBA Chairman Dwyer scoffed at the idea. Instead, he said, the Jamestown Bridge Commission should "clean its own house" before attempting to take over building the Newport Bridge. Dwyer doubted that the commission was serious about building a bridge. He said the commission was "no more than a political plum, controlled by a dual office holder," another direct shot at longtime nemesis Foley. Foley said Dwyer did "not speak for the state of Rhode Island or the people that live in it and the Governor and the Legislature would make such decisions in the best interest of the state and its citizens."[81]

Things were spinning so far out of control that elected officials on Aquidneck Island sensed they needed to act. In early February 1962, they appealed to

Governor Notte to provide leadership and support for the bridge. They also asked the governor to back RITBA. The joint resolution praised Rhode Island for accelerating its highway initiatives but criticized the state for ignoring the constituents of Newport County. The three Aquidneck town councils were "gravely concerned" that the interstate highway system would "completely circumvent" the island. Without a bridge and a rebuilt Route 138, the island communities would stagnate economically. There is little evidence that Notte went out of his way to provide the leadership necessary to sort out the chaos. To the contrary, John H. Chafee and Louis V. Jackvony, who would face off later that year in the Republican primary to see who would run against Notte, declared their support for the bridge within two weeks of the request by the Aquidneck Island town councils.[82]

In May 1962, the Rhode Island Special Committee to Study Government Organization and Operations, known as the "Baby Hoover Commission," delivered a 180-page report to Notte that included a recommendation to abolish RITBA. Dwyer counterattacked the suggestion, noting that committee members did not confer with anyone associated with RITBA, including "its engineers, traffic analysts, fiscal advisors, or legal counsel." Dwyer also claimed that it was incongruous to recommend abolishing the state agency that was authorized to build the proposed Newport Bridge without any other definite plans.[83]

RITBA received more bad news early that summer when the Rhode Island Supreme Court unanimously ruled that it had no right to include the Mount Hope Bridge Authority in its request for a declaratory ruling from the state's Superior Court. Justice G. Frederick Frost wrote the opinion in which the Supreme Court agreed with the Mount Hope Bridge Authority's contention that it could not be made a party in the case. It was an instrumentality of the state. Neither it nor the state consented to being sued. Within the month, four Newport legislators asked Notte to request an advisory opinion from the Supreme Court on whether RITBA could take over the Jamestown Bridge Commission and the Mount Hope Bridge Authority. The Superior Court was already contemplating this question. Notte reiterated that he supported the proposed Newport Bridge but was unwilling to interfere "with the orderly proceedings of the court." Shortly thereafter, Notte held a meeting with RITBA for "a general discussion of the long-standing problem of advancing plans" for a bridge, with no new developments reported.[84]

During the late summer, Notte and RITBA met to map out a way forward. Notte reconsidered his previous stance on interfering with the legal system and, on August 29, 1962, announced that he would ask the

Rhode Island Supreme Court for an advisory opinion to help untangle the legal knots preventing progress. Nothing could be done, Notte said, until the legal questions were resolved. The governor said he favored the bridge and wanted to do everything in his power to "make it a reality." Notte said he hoped the bridge would not become a political issue, seemingly unaware that the proposed bridge had been steeped in politics since at least 1945, if not earlier. Dwyer called Notte's request to the Supreme Court "a vital and necessary step toward what we hope will be the early construction of the bridge." He added that before any bridge could be built, bond underwriters were demanding clear opinions on legal questions concerning RITBA's powers.[85]

The Supreme Court could not respond to Notte's request until the Superior Court granted RITBA permission to discontinue its pursuit of a declaratory judgment. However, Judge Joseph R. Weisberger had ruled that the counter-petitions filed by the Jamestown Town Council, the Jamestown Bridge Commission, and the Jamestown Ferry Company asking the Superior Court to find that RITBA had no authority to take over the Jamestown Bridge and the ferries remained before the court. That cross petition claimed that legislation enabling RITBA was unconstitutional and that RITBA had no right to issue bonds for the purpose of acquiring "other Narragansett Bay installations." That decision complicated Notte's recent request to the Supreme Court for an advisory opinion, as the Supreme Court could not act while there was an active case in the Superior Court. The promise of a proposed Newport Bridge moving forward anytime soon remained entangled in a legal quagmire.[86]

That fall, however, in a hotly contested gubernatorial race, John Chafee defeated John Notte. The prospects for the proposed bridge improved considerably. The Republican Chafee ran as an anti-tax candidate, while the Democrat Notte wanted to establish a state income tax. During the campaign, Chafee launched a grass-roots "Meet the People" strategy in which he worked eighteen hours a day and met almost 100,000 of the 860,000 people in the state. The hard work paid off. Chafee won by the slimmest of margins. On election night, November 6, 1962, Chafee led by only 66 votes. By the time the results were certified on November 30, Chafee had defeated Notte by 398 votes, 163,952 to 163,554. His campaign manager was Gerry Dwyer. The two allies—both former World War II Marine Corps veterans, piping with optimism, self-assuredness, and can-do attitudes—would become partners in moving the bridge proposal forward.[87]

Chapter 4

APPROVAL

The Proponent-in-Chief

Governor Chafee immediately made his position perfectly clear. In his inaugural speech during the first week of January 1963, Chafee declared that he favored the construction of the proposed Newport Bridge. The bridge "must be pressed ahead," Chafee stated with firmness. He elaborated that the structure would be key to the economic growth of southern Rhode Island and would benefit the entire state. Further, Chafee expounded, combining bridge tolls from existing facilities to finance new projects had been successful elsewhere and offered the best prospect for financing this bridge. Chafee concluded by saying the next move was RITBA's, which would immediately begin crafting legislation for submission to the state legislature. The proponents finally had a governor who was an unequivocal advocate for bridging the lower East Passage of Narragansett Bay.[1]

In February, the governor reinforced his advocacy. Bridge proponents hijacked the Washington Day Celebration at the Rhode Island State House to offer their unabashed support for the proposed Newport Bridge. They regaled the captive audience of politicians—including the governor, state officials, and the public—with speeches, poems, and songs favoring the bridge and encouraging support. Former Newport Senator and then Superior Court Justice Florence K. Murray was the principal speaker. She recounted that Washington's 1781 crossing from Jamestown to Newport cost

$288 by ferry, stressing that once a bridge is in place it will never be cheaper to get to Newport. Representative Alexander R. Walsh of Newport and his singing family of ten children presented their endorsement for the bridge to the tune of "I Want a Girl Just Like the Girl that Married Dear Old Dad." It implored:

We want a bridge, we need a bridge,
Across the lower bay.
We want a bridge, we need a bridge,
 Come on now, what do you say?
Poor old fashioned ferries,
 Oh, so slow.
Plowing up the bay,
 On your good dough.
We want a bridge, we need a bridge.
 Across the lower bay.

After enjoying a good laugh during the festivities, Governor Chafee said that his position on the bridge remained the same now as it had always been—he was for it.[2]

Bridge opponents were not abandoning their cause to shut RITBA down. On January 22, 1963, one month to the day before the Washington Birthday celebration, longtime RITBA opponent Jamestown Senator Francis Costa submitted another bill to abolish the authority. Bridge advocates, however, continued to publicize their arguments for the bridge. The bridge had become a life-and-death proposition to Newport. Without it, Newport would "wither on the vine"; with it, proponents had "high hopes of an industrial and recreational boom." They stressed that ferries were not modern methods of traveling. Time schedules limited the number of crossings during the day and completely curtailed them during the night. Modern industry was unlikely to locate to an area dependent on ferries for transportation. RITBA summed it up: "It is axiomatic that industry, the tourist trade, and economic expansion follow the route of the modern highway and, conversely, inadequate highway systems and inaccessibility stifle proper growth and development."[3]

The State of Rhode Island, Dwyer pointed out, could not afford to neglect any part of the state, especially Newport. Yet the state was holding the building of the Newport Bridge to higher standards than other highway projects. So what if the state needs to pick up the difference between toll revenue and bridge costs? That would be minimal compared to the bridge's

1963, Director Henry Ise announced that his organization had approved construction plans for the proposed bridge. Such approval was necessary for all construction within state waters. Next, the proposal needed approval from the New England Army Engineers. Upon Ise's consent, the plan was forwarded to the U.S. Chief of Army Engineers in Washington. Dwyer did not anticipate any delay from this body. In fact, during the thirty-day open comment period, the army engineers received no objections to the proposed bridge from a navigational standpoint, which is the army engineers' main area of concern.

Dwyer reported that RITBA was awaiting two critical pieces of information. The first was a traffic study containing revenue projections. That study was being developed by DeLeuw, Cather and Company of New York, Boston, and Chicago, in conjunction with the Rhode Island Department of Public Works. Dwyer was expecting the final report in February. The second was the final cost estimate from Parsons Brinkerhoff, which was expected in late spring. Dwyer did not mention that Chafee, at RITBA's bond counsel's request, had already asked the Rhode Island Supreme Court for opinions on five questions that the governor had previously disclosed. The questions concerned elements of the proposed financing options contained in the legislation.[8]

The Rhode Island Supreme Court delivered its finding on January 23, 1964. The results were not favorable to RITBA. The Supreme Court ruled that the legislation was flawed in a number of areas. The court pointed out that the financing option involving a lease-back to the state required statewide voter approval, as did the $17.5 million guarantee. The legislation had attempted to use the lease-back option as a fail-safe if the state guarantee was voted down again. Another flaw involved the Jamestown Bridge. The court opined that by taking control of that structure, the state would be assuming a $50,000 debt. Also, although the bill called for removing the tolls from the Jamestown Bridge, the law could not prevent the legislature from adding them back at a later date. It was unconstitutional, the court said, to attempt to interfere with legislative powers granted by the Constitution. The court also said that the act obliged the state to operate and maintain the bridge for as long as the Newport Bridge bonds remained outstanding. This constituted a $50,000 obligation to the state. Since the state was already required to support the ferries at $500,000 per year, the bill claimed it was exchanging one obligation for another. The Supreme Court, however, determined that this was not the case, as "it was within the constitutional prerogatives of the General Assembly to abandon the ferries."[9]

It is never a good thing to receive a Supreme Court opinion calling a bill you sponsored unconstitutional. Dwyer viewed it as a glass-half-full proposition, though, and Chafee agreed. On February 3, 1964, Dwyer trumpeted that the Supreme Court advisory opinion did not preclude RITBA from assuming control of the Mount Hope Bridge. That was exactly what it planned to do without a statewide referendum on the matter. The authority's attorney, W. Ward Harvey, said that the governor did not ask the Supreme Court if RITBA had the power to take over the Mount Hope Bridge, nor did the court offer any advice concerning such remit. Chafee's executive counsel, Ronald H. Lagueux, concurred with Harvey. Accordingly, RITBA declared that it would take over the Mount Hope Bridge in June once the bridge's bonds were paid off. The authority also signaled that it was not going to be troubled by the Supreme Court's adverse opinion and delay awarding a contract to the Giles Drilling Corporation of Berwick, Pennsylvania, for a series of test borings to determine the best locations for pier footings. Giles was awarded the contract by submitting a low sealed bid of $124,054 among five bidders.[10]

Chafee and Dwyer marched boldly forward. The Mount Hope Bridge became RITBA property on June 1, 1964. The official transaction took place at the about-to-become-defunct Mount Hope Bridge Authority's lawyer's office in the Rhode Island Hospital Trust bank building in downtown Providence. Chafee praised Chairman John Nicholas Brown and other authority members for their dedication and effectiveness. The bridge bonds were retired four years ahead of schedule. Rather than becoming toll-free, revenue from the Mount Hope Bridge would help fund the construction of the proposed Newport Bridge, including paying for needed studies that would produce essential facts for moving forward, "without placing any burden on state taxpayers," Chafee added. The engineering and traffic studies were now expected to be delivered in July. "If these studies substantiated preliminary findings," the governor crowed, "construction of the Narragansett Bay Bridge [would] be imminent."[11]

Not everyone was happy, though. Bristol Senator Joseph F. Bruno tried to introduce a bill in the General Assembly seeking the Supreme Court's opinion on the legality of the transfer, but it failed to gather support. Bristol Town Solicitor Anthony R. Berretto claimed to be seeking a declaratory judgment from the Superior Court on the issue, but he was still pulling documents together. So, on June 2, the day after RITBA assumed control of the Mount Hope Bridge, Berretto and Portsmouth lawyer Paul M. Chappell tried applying civil disobedience to force the issue into

Attorney General J. Joseph Nugent's lap. That afternoon, around 4:00 p.m., Chappell crossed the Mount Hope Bridge from Portsmouth. When he reached the Bristol toll plaza, he refused to pay the twenty-five-cent toll. RITBA threatened to call the police. A few minutes later, Berretto passed through the gates without paying. He, too, was warned. Upon reaching Portsmouth, Berretto turned around and crossed back to Bristol, where he ceremoniously paid the twenty-five-cent toll by cashier's check. The two lawyers, along with about twenty newsmen and bystanders, waited in vain for the police to arrive. After twenty-five minutes, Chappell returned to Portsmouth, also paying his toll with a cashier's check.[12]

The two men were convinced that this was the appropriate method to provoke a court test of RITBA's authority to continue charging tolls for crossing Bristol Ferry. They fully anticipated that they would be charged. Berretto believed that continuing tolls on the Mount Hope Bridge was also unconstitutional, and he wanted to test that premise. Dwyer said that toll collectors were instructed to call the police and report toll scofflaws. For their trouble, all the attorneys got were rides over the bridge and some publicity. The state police had been told to ignore these two cases but to prosecute such incidents going forward. On June 19, 1964, Chappell and Berretto appealed to Chafee to ask the Supreme Court for an advisory opinion on the constitutionality of RITBA assessing tolls on a bridge after the bonds had been retired. Chafee refused. Thwarted on two fronts, the attorneys sought a declaratory judgment from the Superior Court. The petition was filed by Chappell on July 1. Superior Court Judge William M. Mackenzie dismissed the request on August 7, concluding that Chappell had no peculiar interest beyond other taxpayers in requesting the judgment, thereby violating the declaratory judgment law. Also, Chappell wanted the Superior Court to compel the police to arrest him for violating the law, which, Mackenzie clarified, was beyond the powers of the Superior Court.[13]

The last remaining hurdle for bridge proponents was the upcoming November election in which voters would be asked, once again, if they would guarantee a portion of the bridge bonds. This time, the proponents were hell-bent on gaining voter approval, no matter how much work it took. For example, the Newport Jaycees solicited support from its sister organizations throughout the state. In September, it landed a big one: the Providence Jaycees. Also, another proponent group, Citizens for the Bay Bridge, hired Fitzgerald-Toole & Company. This was the same firm that helped Governor Chafee's campaign. It planned on sending letters to voters' homes three days before the election. Finally, the governor himself took the opportunity to

plug the bridge whenever the opportunity arose. At the dedication ceremony christening the Portsmouth Expressway, he lamented that Newport County residents willingly contributed to that project but would not benefit from it until a bridge was built across the East Passage of Narragansett Bay.[14]

Opponents immediately raised the caution flags. The editors of the *Providence Journal* articulated their concern once again. Their argument remained the same. Where is the proof, they asked, that the proposed bridge would help the economy of Newport, and more importantly, should the state guarantee $17.5 million of bonds for a project that could not support itself? The editors reminded readers that Dwyer had promised receipt of a traffic study and an engineering study by July 1, 1964. Then, on July 28, Dwyer said that detailed toll revenue studies would be available in six weeks. Just recently, the editors claimed, Dwyer promised that detailed traffic and engineering reports plus a financial analysis for bond managers would be delivered to Chafee between mid-September and October 1. "The emerging pattern is this: Public release of vital information is being pushed closer to Election Day, while the public relations job is being pushed with full energy," the *Providence Sunday Journal* warned readers on September 6, 1964. The editors urged its readership that this was a question that should be informed by pertinent facts "rather than on a basis of emotion heightened by good public relations work." Those facts were about to be released and splashed all over the state's newspapers.[15]

On September 23, 1964, Chafee and Dwyer released the results of the long-awaited traffic study. It was good news. Revenue from the proposed bridge tolls, combined with Mount Hope Bridge revenue, would pay off Newport Bridge construction costs by 1990. The traffic study predicted that more than 1 million vehicles would cross the proposed bridge in its first full year of operation, far more than the skeptics believed. If the referendum passed in November, Chafee declared, Parsons Brinkerhoff would be prepared to let contracts immediately and the bridge could be completed by June 1, 1968. The new study by Chicago-based DeLeuw, Cather and Company calculated that 953,000 vehicles would cross in 1969 generating $1,430,000 in revenue. That would grow to 1,633,000 vehicles by 1995, producing $2,450,000 in income. With the Mount Hope Bridge revenue included, toll revenue would jump to $1,710,000 in 1969 and $2,868,000 in 1995. The State of Rhode Island would not have to pay any of the construction costs. However, if the referendum to guarantee $17.5 million of the bonds were approved in November, a lower interest rate would be available and make the bridge a better deal than without the guarantee.[16]

The engineers estimated that the bridge would now cost $45,358,000 to build. According to Dillon, Read and Company, the New York–based bond underwriters, $42 million in total bonds would be issued, while the Mount Hope Bridge revenue would contribute $2,604,000 and an additional $754,000 would come from interest earned on unspent funds. Of the $42 million worth of bonds, $27 million would come from revenue bonds and $15 million from guaranteed bonds. The additional $2.5 million of the guaranteed bonds was a contingency to cover any margin of error. The revenue bonds would be placed at 4.25 percent, while the guaranteed bonds would be let at 3.75 percent. The rosy outlook from the traffic engineers was bolstered "by rising attendance at such popular viewing spots as the Breakers mansion, plans for a Goat Island marina, and such events as the jazz and folk festivals and yachting races." Other factors included a rapidly growing Newport County population and more navy personnel being stationed in and around Newport to support the development of the Polaris submarine base.[17]

Engineering plans were not yet finalized but were expected shortly. The new bridge would dwarf the Jamestown Bridge and assume the distinction of being New England's longest bridge. It would be "a giant" compared to the state's existing bridges, measuring more than two miles long, with a center span of 1,600 feet. The towers supporting the main cables would rise 400 feet above Narragansett Bay's major channel, and its roadbed would sit 215 feet above the water. It would cross from Taylor Point in Jamestown to Washington Street in Newport, around Cypress and Sycamore Streets. Chafee elaborated on the positive results. Commercial development in Newport would expand once a direct link between Aquidneck Island and the mainland was established. In addition, bridge construction would provide four hundred to five hundred good-paying jobs, boosting the local economy by $20 million during the three-year construction project. The hard facts that the opponents and the *Providence Journal* editors had been demanding were finally rolling in, and they all pointed favorably for the bridge.[18]

The day following Chafee's announcement, the *Providence Journal's* editors reversed their stance—tangible evidence that a shift in momentum had definitely occurred. On Thursday, September 24, 1964, the editors proclaimed that recent traffic studies and financial analysis just released by RITBA had removed "a doubt of major proportions." The bridge now appeared to be self-supporting. The state would not be called on to pay off the debt. The editors acknowledged that a differentiating factor between mid-1964 and four years earlier was the authority's newfound right

to combine tolls from the Mount Hope Bridge with those from the new bridge to pay off the construction costs of the proposed Newport Bridge. The editors noted that the new bridge would be the most expensive project of its kind pursued by a state agency and warned that "[a] high caliber of managerial performance will be required on the part of the authority and its staff." The unwritten message was that the *Journal* would be keeping a close eye on RITBA. Nevertheless, the editorial concluded, the authority "at long last has submitted for public inspection detailed studies supporting the thesis that bridge construction is feasible." Assuming voters approved it in November, "the job at last can begin."[19]

The next day, however, the *Providence Journal* editors tempered their enthusiasm. They wondered aloud whether the residents of Tiverton, Portsmouth, Middletown, and Newport were ready for what was going to hit them. "If they get their bridge," the editorial pondered, "will the communities of Aquidneck Island be ready for their revolution?" Without proper planning and zoning to guide and regulate expansion, the island faced the risk of "pell mell" growth, "like so many other American communities that have been opened up by bridges and highways and other new avenues of exploitation." The editors conjured up images of Newport becoming another Coney Island, with strip malls cutting off "the scenic and country

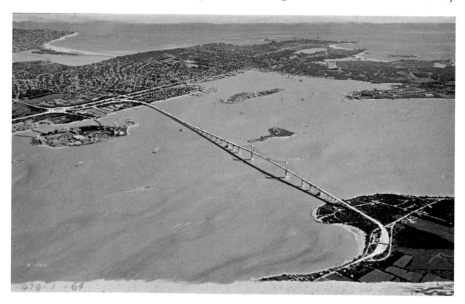

The engineers' 1965 proposal contained an artistic aerial rendering of bridge as it would be built. *Image from Parsons, Brinkerhoff, Quade & Douglas, Engineers, "Proposed East Passage Crossing of Narragansett Bay, Engineering Report of 1965, September 1965." Courtesy of RITBA.*

views that contribute so much to the charm of the island today," honky-tonk encroachment and the wrong kind of factories in the wrong places destroying the charm of the place. Newport did not have a full-time city planner, the editors noted. Past planning efforts had been met with indifference at best and, in some cases, "downright hostility." The bridge could be a boon to the region's economy or it could bring "profit to a few and ugliness and chaos to the rest." To their astute readers, it must have seemed that the editors of the state's newspaper of record were a tad schizophrenic. On Thursday, they declared the bridge was feasible. On Friday, they warned of its dangers. Nevertheless, as the summer of 1964 turned to fall, the proponents of the proposed bridge appeared to have finally captured the high ground.[20]

The push was well on its way to convincing the voters of Rhode Island to pass the referendum. In 1960, Governor Del Sesto wavered when it came to supporting the proposed bridge. His successor, John Notte, also failed to step up at critical junctures. This time, Governor Chafee went out of his way to ensure that his position was crystal clear: he was for it, period, always had been. On October 16, 1964, during a speech in Newport, Chafee urged Rhode Islanders to approve the referendum. His position was bolstered by an opinion from the Rhode Island Development Council's Advisory Commission, which, on October 14, had voted unanimously to approve construction of the bridge. Like the editors of the *Providence Journal*, the Advisory Commission had withheld its approval to Governor Del Sesto four years earlier because evidence favoring a bridge was insufficient.

This time, it had a plethora of information: DeLeuw, Cather and Company's August 1964 "Report on Traffic and Revenue for the Mount Hope Bridge and the Proposed Narragansett Bay Bridge"; Parson Brinkerhoff's September 1964 "Proposed East Passage Crossing of Narragansett Bay Engineering Report"; RITBA's September 14, 1964 "Memorandum with Respect to Its Proposed Narragansett Bay Bridge"; and Dillon, Read and Company's "opinion relative to effect of bond issue on the credit of the State." In a letter dated October 15 and received by Chafee's office on October 16, Advisory Commission Chairman Raymond Trott reassured the governor that the questions raised in 1960 had been "satisfactorily answered." The Advisory Council was now "convinced that the credit of the State will not be impaired" by the guarantee. Chafee said his administration was "interested in getting things done." On the political front, he urged voters to elect more Republicans to the General Assembly.[21]

A few days later, Chafee addressed the officers at the Newport Naval Base. He took the opportunity to support the bridge to a directly affected

constituency. He discussed the backup and delays associated with waiting for a ferry from Jamestown to Newport. Also, he stressed that the ferries operated at a deficit. If the bridge were rejected by voters and not built, Chafee said, they would need to purchase new ferries. The governor stressed that the bridge could be built without voter approval but once again urged its passage. Meanwhile, Chafee was strengthening his position for reelection. The bridge referendum was an important plank in his 1964 platform.[22]

As the election neared, the *Providence Evening Bulletin* devoted a full-page article laying out the facts to Rhode Island voters under the banner, "The Bridge: A Complicated Financial Story." It was so complicated that it took forty-three paragraphs. The reader's attention was drawn immediately to a graphic representation of what "Referendum Number 2—Newport Bridge Guarantee of Bonds Under Turnpike and Bridge Authority Act" was going to look like on the ballot. One had to parse the fine print fairly closely to understand the proposition. Nevertheless, those familiar with the issue were well versed in the question: shall the state and its faith and credit be pledged to guarantee $17.5 million of the bonds that will be issued to build the Newport Bridge? A fairly straightforward proposition.

The accompanying text detailed the issues and controversies surrounding the financing of the proposed bridge for those who may not have been paying attention for the past twenty years. "The whole plan," the article summarized succinctly, "involves considerable effort to read the future, both to the actual construction costs and how many motorists would use the bridge in the long years ahead." Until recently, projections were not in the proponents' favor. By late 1964, of course, the proponents had presented detailed traffic and engineering studies that bolstered their case. The article raised some areas of concern related to basic human nature. Why, the anonymous author asked, would motorists travel over the bridge, pay a toll, and take nine minutes longer than traveling the new overland freeway to Providence? It was seventy miles from Groton, Connecticut, to Fall River, Massachusetts, over the proposed bridge. It was seventy-one via Providence. The traffic engineers were banking on vacationers taking the scenic route. So were proponents Chafee and Dwyer. They were hoping that the referendum would pass and allow a better interest rate on the guaranteed bonds. That benefit, according to Dwyer, would turn the financing plan for the new bridge from "doubtful to a sure thing."[23]

The following Tuesday, Democrat Lyndon Johnson was elected president of the United States over Barry Goldwater. He carried Rhode Island by a whopping 62 percentage points, 81percent to 19 percent. Johnson's coattails

did not extend to the state's gubernatorial race. Republican and bridge advocate Chafee was reelected governor, garnering 61 percent of the vote to Democrat Edward P. Gallogly's 39 percent. Thanks to the statewide public relations campaign, along with the popular governor's endorsement, the Newport Bridge referendum passed with ease, 149,825 to 87,991, a 63 percent majority. The state electorate was in a generous mood, as all six spending measures passed that day. The proposed Newport Bridge was closer to becoming reality than it ever had been.[24]

An Irremediable Mistake

With a state guarantee backing $17.5 million of bridge bonds in hand, Dwyer immediately stirred up a lingering controversy. Just two days after the victory at the polls, Dwyer asked the navy to approve a more northerly route. This one would run from Eldred Avenue in Jamestown, which was located on a straight line from the existing Jamestown Bridge, directly across to Brown's Lane in Middletown. That route, Dwyer speculated, would produce more traffic and thereby further enhance the economics associated with the structure. The release of such news raised a series of questions and called into doubt the transparency of the agency. Dwyer said the authority withheld the possibility of an alternate site until after the election because the bridge issue was complicated and he didn't want to further "muddy the waters." Besides, he reasoned, the authority was criticized for its unsubstantiated estimates before the election and would have received additional scrutiny if it had surfaced the location issue. RITBA was going to seek approval from the secretary of the navy. Dwyer admitted that he did not know how the navy would react to the request.[25]

The authority had always preferred the northerly route, Dwyer said, but the navy rejected that option because it would disrupt its operations in and around Narragansett Bay. Dwyer projected that the northern route would not cost that much more to build. The substructure of the bay under the newly suggested route was more favorable. At the terminus, Brown's Lane was a narrow rural roadway leading to Wanumetonomy Golf Club and St. Columba's Cemetery. Neither would be encroached on, Dwyer said, although the lane would have to be widened. "This isn't going to be the Triboro Bridge," he asserted, attempting to reassure the community that extensive property taking would not be necessary. If RITBA did not receive

a favorable response from the navy by January 1, 1965, Dwyer said, it would commence with the Taylor Point–Washington Street crossing.[26]

The navy went about its job of studying the proposal. It checked with the Newport Naval Base. It asked the district public works office in Boston, as well as the chief of naval operations in Washington, D.C., and the office of the secretary of the navy. On November 9, 1964, a spokesman for the navy's First District replied to inquiries from the media that the request was "under study and review." A spokesman for Wanumetonomy Golf Club could not say one way or the other if the proposal would affect the property.[27]

The editors of the *Providence Sunday Journal* immediately questioned the proposed shift. After finally gaining support from the newspaper on the referendum days before the election, the opinion makers were caught by surprise at the revelation that RITBA was seeking a new path for the proposed structure. They recounted that in the runup to the referendum vote the authority specifically stated that the bridge would cross from Taylor Point to Washington Street. Before the vote, RITBA had stressed that "the location and clearance of the bridge had been approved by the Navy Department and the Department of the Army." The editors accused the authority of treating voters "casually," citing as evidence Dwyer's explanation that he did not introduce the possibility before the election because he did not want to confuse an already complicated issue. "It is a chilling thought to imagine," the editors noted, "that the bridge authority is going about a 40-million-dollar project with an attitude of let's not 'muddy the waters' in deciding whether to tell the public what's going on or what might be going wrong." The editors hoped the authority had learned its lessons from the "storm in Newport" at the recent Newport City Council meeting—that is, such a policy of concealment "comes to no good."[28]

The controversy raged into the following week. Newporters were upset that the terminus might be switched from their city to Middletown. Lieutenant Governor Gallogly voiced concern that Rhode Islanders approved a Jamestown–Newport bridge, not a Jamestown–Middletown bridge. Dwyer's response claimed that the authority was established to build a bridge to Aquidneck Island, not specifically Newport. Dwyer had already met with the navy. It did not want a bridge to go any farther north than the tip of Gould Island. Also, if it gained necessary approvals, the authority would have to pay to relocate some naval facilities, including the degaussing range, an area used to demagnetize ships, thereby reducing their sensitivity to enemy explosives, at a cost of about $400,000. It remained to be seen if the reduced costs of building a bridge in shallower water would save enough

money to cover the cost of relocating naval operations. Engineering reports were anticipated within two weeks. Newport Mayor Charles Hambly pitched his own seemingly tongue-in-cheek idea. He suggested that the bridge go from Jamestown to Gould Island, turn abruptly south to Rose Island, extend to Fort Adams and then turn north to Goat Island. A causeway would bring travelers to Newport.[29]

One thing was certain: the authority had opened the door to alternatives, and just about everyone held an opinion. The Preservation Society of Newport County was for the northerly route. The Middletown terminus would avoid property taking and congestion in the historic colonial Point section. The society believed that the Washington Street terminus would "trap" tourists and exemplified the "insular thinking that we indulge in much too often." It would "jeopardize valuable property and a large segment of our scenic attractiveness, besides dumping traffic into a stable residential area." Senator Pell backed RITBA wholeheartedly. He said that he would stand by the authority for whichever route it thought best. The senator did not believe that RITBA deceived voters by suggesting an alternate route. He said that voters were mainly interested in bridging the two islands.[30]

Fourteen Newport County citizens delivered a statement that was published in the *Newport Daily News* on November 27, 1964. Like the preservationists, they, too supported the more northerly Eldred Avenue to Brown's Lane crossing and for similar reasons. They characterized the Taylor Point to Washington Street crossing as "illogical...destructive and expensive" and an "irremediable mistake." Citing projections of four thousand cars and one thousand trailer and four-wheel trucks per day, they noted that the completed bridge would "dramatically alter the entire traffic pattern of southern New England." Such twenty-four-hour traffic should not be directed through a built-up city, they declared. Newport's Point section "would be seriously damaged by the mass scale and the noise of a bridge," including "the down shifting of trucks," which would create "an incessant din audible [at] a great distance." The approved southerly route would impair the "habitability of the Naval Hospital," and "one of the liveliest harbor views in America would be forever lost." The signers included an architect, a planner, a rear admiral, a minister, a rector, a financial consultant, an artist, and a U.S. Navy commander, among others. They backed Dwyer's efforts, who, at this point, had probably wished he had never proposed an alternate site.[31]

On the other hand, the recently formed Newport Bay Bridge Committee favored the Washington Street terminus and had signatures from 2,500 people who agreed with it. The result was from petition sheets posted in

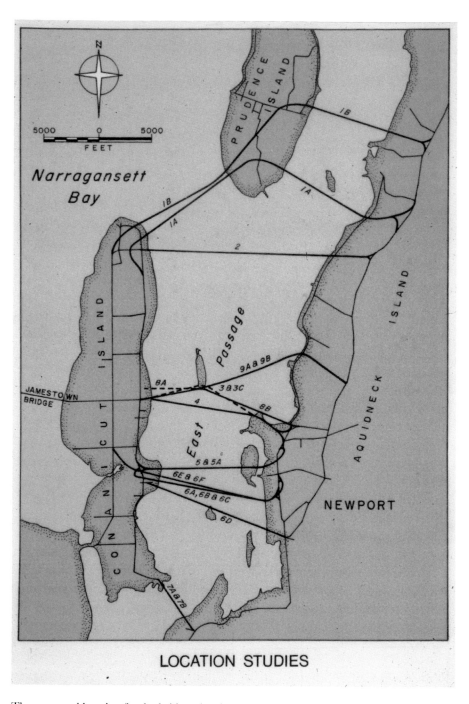

LOCATION STUDIES

The proposed location for the bridge stirred many controversies. The engineers documented on one map the sites that had been considered over time. *Courtesy of RITBA.*

thirty Newport businesses for just two days. The committee's coordinator, John McCann, said that it would conduct an "all-out campaign" over the upcoming weekend "with several youth groups circulating petitions in residential neighborhoods." The committee, which had formed the previous week, used the same argument as the northern route advocates but to support its own belief: the northern route would divert traffic from Newport, hampering economic development and tourism. McCann owned a tavern on Connell Highway just north of the proposed approach to the Washington Street terminus. In addition, the Newport City Council objected to "any change in the eastern terminus" of the bridge from its long-planned Washington Street site. It passed a resolution to that effect on November 12 and directed copies be sent to the secretary of the navy, Governor Chafee, and Chairman Dwyer.[32]

On December 1, 1964, the navy sent a letter to RITBA giving it the nod to build the proposed bridge over the northern route if certain conditions were met. The letter was authored by Navy Undersecretary Paul B. Fay Jr. Dwyer and Fay had previously discussed the conditions under which the navy could accept the Eldred Avenue–Brown's Lane route. These included relocating the degaussing range, dredging to thirty-five feet a shallow area north of the bridge, granting easement rights for underwater electric cables and water lines running from Gould Island to Middletown, relocating the navy's incinerator and dump from Brown's Lane, relocating the navy's air torpedo drop range, and reimbursing the navy if the bridge affected any governmental facility on the island. The navy identified these issues as early as November 10, and on November 23, RITBA and its consulting engineers discussed it with the Newport Naval Base commander and other navy officials. Dwyer began signaling that the decision to locate the bridge would be determined by cost.[33]

Dwyer penned a letter to Fay on December 4, 1964. Since the November 23 meeting with the navy, RITBA's engineers had worked up cost estimates to meet the navy's conditions. The Eldred Avenue–Brown's Lane route would cost $9,575,000 more than the Taylor Point–Washington Street route, or 25 percent more than the $39,085,000 estimated for the southern crossing. The main reason was that the northern bridge would be 4,788 feet longer than the approved southern alignment and would cost that much more to build. RITBA engineers also developed estimates for other routes, but they, too, were approximately $9 million more than the Taylor Point–Washington Street path. The only exception was a crossing that ran one thousand yards north of Gould Island, which was dismissed because it would interfere with

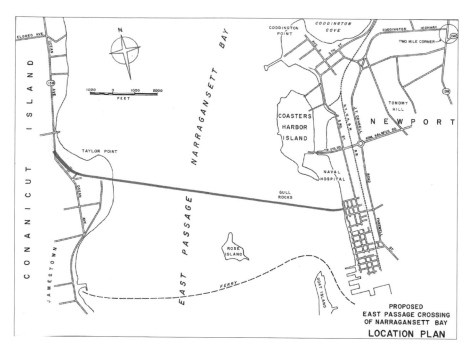

In 1965, RITBA endorsed plans for a crossing from Taylor Point to Washington Street. Days later Dwyer suggested a route farther north. *Image from Parsons, Brinkerhoff, Quade & Douglas, Engineers, "Proposed East Passage Crossing of Narragansett Bay, Engineering Report of 1965, September 1965." Courtesy of RITBA.*

Quonset Air Base flight patterns and torpedo testing activities at the Naval Underwater Ordnance Station. Dwyer indicated to Fay that the results of RITBA's studies "dictate[d] that the alignment originally approved by the Navy will be the site of the Narragansett Bay Bridge." Dwyer asked Fay to keep the information confidential until the authority was able to formally announce its decision.[34]

The *Providence Journal* foreshadowed the outcome to its readership in an editorial that appeared on December 5, 1964. They reported that the chance the northern route would prevail was "about as remote as ever" given the cost estimates associated with building a bridge much longer than its alternative. They closed with the thought that once the economic reality was confirmed, "the air should be cleared of controversy over the bridge's location." On December 8, 1964, within days of the editorial, Dwyer held a press conference at the Sheraton-Biltmore Hotel in Providence to reaffirm the Taylor Point–Washington Street route. The decision was based solely on cost, Dwyer said, "not for any political considerations or in deference

to pressure groups that were either for or against the ultimate choice of location." Dwyer also announced that tolls on the new bridge would be $1.70. That was a nickel less than the cost of crossing the bay via the Jamestown Bridge and ferry at that time. Commuters could purchase ten one-way tickets for ten dollars. According to Dwyer, construction on the new bridge would start in the late spring of 1965 and be completed sometime in the summer of 1968. It appeared that the debate about the bridge's location had finally been concluded.[35]

Despite Dwyer's pronouncement on the bridge's location, the issue occupied Governor Chafee throughout the winter. The evening prior to Dwyer's press conference, State Representative Thomas Edwards of Newport criticized RITBA's cavalier attitude. He directed his remarks to the Motel and Hotel Association meeting in Newport. "The casual way of treating the voters and the members of the General Assembly" after it empowered RITBA "points out the fact that now that they have the authority to do anything they want, the public be damned." He promised that the General Assembly would take a "long hard look" during its upcoming January session that "could lead to a delay in building the bridge or possibly no bridge, period." By December 16, Chafee declared acceptance of the Taylor Point–Washington Street route. Even though he preferred a more northerly route, Chafee said that the southern route "would have to do."[36]

Behind the scenes, Chafee was handling a barrage of suggestions from constituents concerning the bridge's location. The most interesting and comprehensive communication was a letter from Wallace Campbell III. It is instructive on many levels about the inner workings of Rhode Island in the mid-1960s and the activities surrounding the Newport Bridge's location. Chafee's office logged the letter on December 14, 1964. Campbell knew the governor personally, addressing the letter to "John" and signing it as "Wally." He was an advertising executive and investment agent, a member of the Hope Club and a founder of the Dunes Club. Campbell attended Milton Academy and Yale University, where in 1941 he earned a degree in English. During World War II, he served as a naval aviator, for which he was awarded the Distinguished Flying Cross and the Air Medal with three stars. Three days earlier, he had met with Tom Benson and Eugene J. McNulty to discuss the proposed Newport Bridge. Benson's family had long been associated with the Newport Art Museum. Benson himself was a sculptor, restored antiques, was an authority on historic preservation, and founded the Newport Museum of Yachting. McNulty was an architect and city planner. He was against

the Washington Street terminus, as it would "pretty much ruin a vital historical section of Newport."[37]

Campbell's letter to Chafee contained a lengthy and detailed document from McNulty describing his efforts to influence a northern crossing dating back to the fall of 1963. McNulty had approached Dwyer and suggested that the Washington Street terminus "seemed extremely illogical and would seriously damage Newport and Middletown in several ways." Dwyer agreed and said that the engineers were also unenthusiastic about the alignment. So, too, were other informed people, including Senator Pell. The navy, however, was "rigid and had rejected all applications for a northerly alignment." Dwyer showed McNulty a chart of routes suggested by RITBA's engineers that the navy turned down. This led McNulty to speculate about the sophistication of RITBA: "Apparently the Authority and its engineers refused to do their homework about the Navy['s] use of Narragansett Bay, and ha[d] no understanding and little sympathy for the Navy's problems in the Bay."[38]

McNulty contacted Dwyer again in July 1964. The navy was still balking at a northern path. McNulty drew a map of the area and suggested an alignment north of Gould Island, wrote a defense of his proposal, and sent it to Dwyer and Hedefine. A copy of the letter was also attached to Campbell's letter to Chafee. McNulty then contacted "friends at the Naval Base." They shared McNulty's concerns about the Washington Street terminus and agreed to help identify another crossing. McNulty then organized a meeting with acting Newport Naval Base Commander Captain Oliver D. Finnigan, Dwyer and two other concerned citizens. Finnigan was "wholly sympathetic" and agreed to help. A meeting was held on September 17, 1964. It included Fay, Pell, Finnigan, Dwyer, Hedefine, William Wharton of Jamestown, and McNulty. The navy said that it was amenable to a route over Gould Island, even though it would "cost the Navy some inconvenience and about $500,000." Fay said he would push for an approval through Washington. He was leaving office on January 15, 1965, so he had to hurry.[39]

McNulty and three others, including Benson and Wharton, met with Dwyer several times during the first week of December 1964. McNulty believed that if RITBA was interested in a "socially responsible alignment" it had two choices: the one running north of Gould Island, which the authority had already examined, or McNulty's path crossing over Gould Island. The authority's engineers pursued McNulty's option with Captain Pratt of the Newport Naval Base. McNulty characterized Pratt as "newly arrived," little qualified on the subject, and "quite junior." Pratt rejected the proposal "out

of hand" for the obvious reason that the span would make it "awkward" to maneuver carriers heading to and from Quonset Point. McNulty contacted Fay without Dwyer to discuss further his proposed Gould Island crossing. Fay believed the navy could make compromises, including adjusting the Ground Control Approach to Quonset Point. Once more, Fay "urged greatest haste." At that point, for reasons unknown to McNulty, Dwyer announced that RITBA had decided on the Taylor Point–Washington Street path. McNulty summarized his conclusions:

> *1. Successful dealings with the Navy can be conducted only at the highest level both here and in Washington. The Command here has reiterated, "Take it to Washington, we'll do as they tell us."*
>
> *2. Negotiations with the Navy must be done by those who have a thorough understanding of the Navy's needs in Narragansett Bay, and must be conducted in a frank "give and take" manner.*

McNulty proffered three enlightening recommendations:

> *1. A member of the Authority together with someone who understands both the Navy and the Island's problems be sent to confer this week with Secretary Fay to work toward developing a profile on or near* [the Gould Island] *alignment that is acceptable to both Rhode Island and the Navy.*
>
> *2. Exploit fully "the old boy net." Our "old boys" will be gone shortly— Captain Finnigan and Secretary Fay.*
>
> *3. In case* [the Gould Island alignment] *falls short, start a study to make* [the north of Gould Island alignment] *workable by 1. Making the bridge cheaper and 2. Devise another financing arrangement.*

McNulty concluded his two-and-a-half-page, single-spaced history of the controversy by declaring the Washington Street site "socially, wholly irresponsible. It would wipe out any hope of developing this island in an orderly manner, and render ludicrous the plans of several devoted and leading citizens to restore the 18th Century waterfront town." Campbell and McNulty, acting in unofficial capacities, thrust the bridge location controversy squarely on Chafee's shoulders.[40]

Campbell was not the only one to contact the governor in the wake of Dwyer's announcement selecting the Taylor Point–Washington Street crossing. Highly regarded architectural historian and preservationist Antoinette Downing sent a letter to Chafee on Providence Preservation

Society stationery on December 31, 1964. In between Campbell's missive to Chafee and Downing's, the governor had arranged a meeting with Dwyer, Public Works Director Marcello, McNulty, and preservationists Mrs. Goddard, Mrs. Allen, and Downing. Following the meeting, Downing was happy to hear that McNulty had scheduled an appointment with navy officials in Washington. Downing acknowledged that many Newport merchants favored the Washington Street terminus. She disagreed. "Newport is the one city in the state that has everything to make it a historic tourist attraction.… Unfortunately, the city [had] been slow to recognize the importance and potential of its several hundred small Colonial buildings."[41]

Downing warned Chafee that if the connector road were built along Fourth Street on the water side of Thames Street between John Street and Levin Street as planned, it would derail efforts by Operation Clapboard, an organization recently formed to save Colonial Newport, especially the Point section. "All the coherence of the Colonial city and many of its buildings will be lost," Downing said, "and Newport and the state will suffer an irreparable cultural and historic loss." In talking with Marcello, she learned that he agreed with the growing national sentiment that cities were better off when larger arteries were located away from the city center and connected with feeder routes. If such a philosophy were followed in this case, it would save the colonial city from unnecessary destruction and allow the "restorationists the time needed to show to the country an absolute dazzling eighteenth century town." Downing demonstrated her argument by including a map of the area taken from her *Architectural Heritage of Newport* with a red line depicting the route of the connector and illustrating the number of colonial-era houses that would be affected. Such opinions from a well-respected authority as Downing could not be taken lightly.[42]

McNulty would subsequently meet with Assistant Secretary of the Navy (Installations and Logistics) Kenneth E. BeLieu's executive assistant, William J. Gregg, and his staff. The meeting occurred on January 7, 1965. McNulty documented the meeting in a cover letter, précis, and detailed meeting minutes, which he mailed to Governor Chafee on January 16. The meeting, according to McNulty, was conducted in an informal, friendly, "give and take" climate. Gregg said that he was assuming responsibility for the bridge since Undersecretary Fay was leaving Washington. He questioned if RITBA had any engineers and, if so, why they had not visited with him in Washington. He said that such discussions should take place in Washington, as local commanders had limited knowledge of the navy's overall policy and plans. In what could have been a threat, Gregg said that 30 percent of

Rhode Island's income derived from the navy and that his office continually examined bases that were eligible to be shut down. One can't help but wonder if the controversies surrounding the bridge's location between 1948 and 1965 might have played a role in the decision to relocate the fleet to Virginia in the early 1970s.[43]

Gregg examined a map of proposed crossings and declared that it was apparent that the Washington Street terminus "would do serious damage to Newport." It was obvious that the required highways would cost much more than the $9 million needed for a more northerly span. He asked, since this were so, whether RITBA should attempt to obtain money from the state or perhaps federally. Gregg continued to lecture the Rhode Islanders. He was unconvinced that Rhode Island had explored all potential means of funding, noting that it was surprising how often sources are overlooked. Gregg said the navy never wanted any bridge over Narragansett Bay. It remained skeptical that a tunnel solution had been adequately examined. The towers of any bridge represented a hazard to Quonset flight patterns. A bridge south of the navy piers posed a problem for shipping and "seriously reduce[d]" the utility of the Newport Naval Base. Upon McNulty's urging, Gregg agreed to invite officials to Washington to discuss the problems associated with potential sites for the bridge. McNulty closed his letter to Chafee by stating his willingness to continue to help.[44]

Letters continued to flood Chafee's office. McNulty was urging people to write to the governor. Dwyer must have anticipated the deluge because on December 16, 1964, he sent a memo with a form letter for the governor to use as a template when replying to inquiries about RITBA's selection. Chafee personalized each response but generally included one or more of Dwyer's recommended arguments, particularly pointing out that he, too, favored a northern crossing.[45]

On December 18, 1965, Chafee's office received a letter from George M. Simpson of Newport. Simpson wanted Chafee to pursue a bridge to Tiverton and Little Compton. Why create a cul-de-sac in "Little Newport," he asked, when we "could at least locate the bridge where it would best serve the interest of the Atlantic Seaboard Route and the development of our state." Granting that a Sakonnet crossing was not something the state should consider at that moment, Simpson suggested the navy might approve a route south of Gould Island. He said the people had lost confidence in the sincerity of the present commission, most likely referring to RITBA, because of the many conflicting statements of late. His postscript added that he delayed sending the letter because he "feared that nothing would be done

to remedy the situation." After all, we had "been stampeded into this thing within the past month" and it was "quite evident that it was cut and dried for sometime past."[46]

On January 4, 1965, Chafee received a letter from Lewis Arnow, MD. During the election campaign, Arnow was "a Doctor for Chafee." He was "terribly upset" with the Washington Street location that would "needlessly bring heavy traffic, din, and danger" through his "beautiful city of Newport." Arnow told the governor that "traffic should by-pass Newport, not trisect it" and that the city's future depended on its "priceless historical, architectural, and cultural heritages, its natural beauty and resort opportunities," not its traffic congestion. The location of the Newport Bridge, Arnow declared, is "one of the most critical problems for Rhode Island in a long, long time, and it will affect Newport and the State for generations to come." The decision must be made by you, he told Chafee, not delegated to others.[47]

On January 12, 1965, Chafee received a letter from Lester J. Millman, chairman of the Urban Center of the Rhode Island Chapter of the American Institute of Architects. Millman also advocated for a northern crossing. Chafee handwrote two phrases on the letter signaling to his assistant to include them in his response: "4800 ft longer" and "9½ million $ more." Chafee told Millman that he was working with the navy "to see if a more satisfactory solution" could be worked out, but he had nothing conclusive to report.[48]

On January 26, 1965, Governor Chafee's office logged a two-and-a-half-page, single-spaced letter from Nadine Pepys, president of Operation Clapboard, a recently formed private organization dedicated "to encourage the revival of moribund neighbourhoods throughout the city with emphasis on the 'Point Section' of the city." Interestingly, it was on the same letterhead and address that McNulty's letters used, 11 Berkeley Avenue in Newport, the location of the Pepyses' mansion, Holly House. Pepys was writing to inform Chafee about Operation Clapboard, which, since its formation six months earlier in July 1964, had arranged the purchase of twenty-three "18th and early 19th century houses" in Newport's Point Section. Pepys cited the widespread support and accolades Operation Clapboard was receiving as a leader "in reversing the blight spreading through this unique city." The organization's efforts were a first step in Newport's "renaissance as a vital city developed both along the best principles of modern planning and retaining the heritage of the past." The proposed Washington Street terminus for the bridge would isolate the

core of the city from its historic waterfront and divide the town in half "in exact contradiction to all qualified thought in city planning."[49]

Pepys said the urban redevelopment plan submitted to Newport's Planning Board was also "harmful to the historic heritage of Newport and will destroy much of its scenic beauty without providing much improvement other than wide roads and large areas of black-topped car parks." It would do little to attract tourists, she predicted, and emphasized that tourism was, or should be, the city's "soundest industry." Pepys complained that the people of Newport had received only partial explanations of the likely results of a bridge terminating at Washington Street and the urban redevelopment plan for downtown. She then questioned the oft-cited $9 million difference for the Brown's Lane site, adding that there would be significant undisclosed costs associated with the Washington Street terminus. "The public has never been told how much land will be lost for road construction," Pepys warned Chafee, "nor have they been told officially that the medical staff at the Naval Hospital have expressed strong disapproval at the bridge being sighted [*sic*] so close to the hospital."[50]

Newport, Pepys said, was not only a prize for Rhode Island but also a mecca for "history and architecture enthusiasts and tourists." Such an "invaluable asset should not be endangered by a short sighted bridge location or redevelopment plan," she said. Her penultimate paragraph elegantly summed up the dangers of focusing on highways at the expense of the city's greatest assets:

> *Roads alone will not bring the tourist into Newport. Nor will they attract the home owner or the yachtsman, the student or the craftsman. Newport's greatest industry lies in its rich architectural heritage, and Operation Clapboard has shown in the few months since its inception, that this very heritage can, and is now, bringing in to Newport new people and new money, to say nothing of new work.*[51]

Pepys was prescient in her criticism of projects that would carve four-lane highways through the colonial city. She was also advanced in recognizing the benefits of private and public partnerships, along with the cultural and economic benefits of historic preservation. As did Arnow, Pepys pleaded for Chafee's leadership. In his response to her, Chafee felt obliged to add that he had not given up hope for a northern alignment and that he agreed with Pepys that the Washington Street terminus "would not be completely satisfactory."[52]

Wiley T. Buchannan Jr., President Eisenhower's chief of protocol, wrote to Chafee from Washington, D.C., on January 26, 1965. Buchannan touched on all the key points. The Washington Street landing was illogical for many reasons. It would create long "dog-legs" on both sides of the bay. He observed that traffic would have "to traverse three miles of already heavily burdened local streets." You didn't have to be an engineer, Buchannan claimed, "to see that this necessitated additional new highways," complete with "land condemnations and interchanges." The northern bridge would generate 3 to 7 percent more revenue, according to traffic engineers. In Buchannan's opinion, it was the better choice. If directed by their client, the State of Rhode Island, the engineers could trim at least $2 million of "fat" from their cost estimates. He warned Chafee that the social and economic costs of the total bridge complex, including its approaches, could not "be kept long from an ever-watchful and critical public." Buchannan hoped that Chafee could find a way "to arrange for the financing of the better span" and added a personal postscript that "we're all terribly proud of your success" and "know that your family must be bursting with pride."[53]

Chafee's Jamestown constituents also offered suggestions. He received a letter from Dr. William W. Miner on February 10, 1965. Miner was most likely a friend of Chafee's, as he signed the letter "Bill." Miner wanted clarification from the governor as to which northern route Chafee preferred. Two had been discussed: the Eldred Avenue–Brown's Lane alignment and the north of Gould Island route. Miner supported the former. It would be less destructive to Jamestown, and the route across the bay would be straight, even though it may be longer. In early January, he wrote to Dwyer seeking similar clarification and included that letter as an attachment. Miner told Chafee he was doing a good job and deserved his recent reelection. Too bad, he said, "they didn't give you anyone good to work with."[54]

Chafee replied to Miner one day later that the Eldred Avenue–Brown's Lane route was out. The route that made the most sense was the north of Gould Island alignment. Chafee thanked Miner for his kind words and agreed that not only was his life made more difficult by the Democratic-controlled General Assembly, "but worse than that, they seem dedicated to making life as miserable as possible" for him. Despite that, Chafee reassured Miner that he "liked the job" and had "no intention of quitting."[55]

Not all correspondents favored a northern route. On March 8, 1965, Frank E. Smith, president of the Newport Lodge, No. 119, of the International Association of Machinists, wrote to Chafee. Smith represented the 1,300 people employed at the Naval Underwater Ordnance Station complex

(NUOS and NAVUWSEC). He was "gravely disturbed" by the threat the northern route posed to his workforce. The union did not agree that the northern route was preferable for a number of reasons. First, NUOS was the "most outstanding Shallow Water Acoustic Range in the nation." It was conducive to developing and testing numerous weapons. Its shallow depth enabled easy and rapid recovery of prototypes, thereby minimizing the risk of losing research data. A bridge one thousand yards north of Gould Island would shut the range down "from the first day of construction." Second, the navy and voters had already approved the southerly locations. Smith calculated that the state, and especially Aquidneck Island, would lose about $10 million per year in payroll and visitor purchasing power from the loss of 1,300 jobs if the bridge were relocated to a northern route.[56]

Chafee was well aware of the passionate public sentiment swirling around the location of the proposed Newport Bridge when he and Public Works Director Marcello traveled to Washington, D.C., to meet with BeLieu, who had recently been appointed undersecretary of the navy, replacing "good old boy" Fay. Chafee reassured BeLieu that the state did not want to jeopardize NUOS; it was seeking to determine the "best location for the bridge within the framework of the Navy's requirements." The northerly approach was best for Rhode Island from the standpoint "of reduced approach costs and better traffic flow," the governor said. He asked BeLieu to investigate whether that location would be approved by the navy and, if not, whether the objections could be ameliorated by bridge design or relocating facilities, or if they were "of such a fundamental nature that the bridge in that location is completely incompatible with present Naval activities."[57]

The meeting must not have gone well. On February 10, 1965, Chafee wrote to McNulty that he had met with BeLieu and sought approval of the northerly alignment. BeLieu said he would look into it and respond soon. The governor prepared McNulty for the worst: "I hope we succeed but am not too optimistic."[58]

News of the trip leaked, and on February 6, 1965, Chafee had to reassure the press corps that his mission was not because of a "rift" with the navy. Dwyer did not attend the meeting, Chafee said, because RITBA had gone as far as it could with the navy. Chafee felt obliged to speak with the navy himself. He said he had received a lot of mail about different routes. Some suggested that the navy was not firmly opposed to the northern alignment. The location of the bridge warranted further discussions with the navy. It was "something that will be with us a hundred years or more," Chafee said, and he "wanted to make sure that

all avenues were explored." He signaled that he did not believe navy approval of a northern route was likely.[59]

BeLieu must have done a thorough job researching the problem. It took him one month to respond to Chafee. The result of BeLieu's investigation was not what the governor had hoped. The northerly location "would seriously affect the operation of the Naval Underwater Ordnance Station at Newport," BeLieu stated frankly. "Attempts to test in the face of the proposed bridge," BeLieu continued, "would result in the loss of costly experimental torpedoes, manpower, and test data." The range would have to be closed regularly as a result of commercial shipping and other traffic in the area. It would be unusable during construction, affecting development of the Anti-Surface Ship Torpedo, the Fleet Training Target, and a major propulsion research project. BeLieu struck an ominous note when he told Chafee that upon completion of the bridge, the range could only be restored to partial operations, "with programs involving acoustic tests and maneuvering torpedoes transferred elsewhere." The Torpedo Test Range was critical to the navy's operations in Narragansett Bay and had to be co-located with the Naval Underwater Ordnance Station.[60]

BeLieu listed other facilities that would also conflict with a northerly bridge. These were the same installations that the navy covered with Dwyer and the engineers leading to RITBA's decision for the southern alignment: the degaussing range, the navy incinerator, an existing explosive anchorage area, and various electrical, telephone, and water lines at the proposed terminus. The bridge would not hinder flights into Quonset, BeLieu told the governor, but the bridge would be close enough to require altitude adjustments during instrument approaches. For all of these reasons, the northerly alignment of the bridge "would not be acceptable to the Department of the Navy," BeLieu said. He urged the governor to find a solution at "one of the other locations already approved by the Navy." It was time to move forward and build a bridge from Taylor Point to Washington Street.[61]

A GRAVE OVERSIGHT

Newport's economy was steadily improving as the calendar turned from 1964 to 1965, and the proposed bridge contributed to the good news. Construction was anticipated to begin in May. The docket was full of other promising projects. The navy announced in December 1964 that it

would build a $1,136,620 facility to replenish seven Polaris submarines at its Melville facility in Portsmouth. The submarine base was expected to bring in 1,300 navy personnel and their dependents by 1966. The Newport Redevelopment Agency was beginning its first projects in 1965, starting with the causeway to Goat Island, site of the former torpedo station, which closed after World War II. Plans were in place to transform Goat Island into an $8 million boating and resort center. The Redevelopment Agency was also in the process of obtaining local and federal approval for a $4 million project to renovate downtown Newport.[62]

In 1964, the Newport economy was bolstered by the tourism and recreation industries. The Newport County Chamber of Commerce calculated that between April and September, more than 750,000 visitors spent a portion of their vacations in Newport. Some events were particularly successful. The America's Cup trials drew an estimated 75,000 visitors who spent somewhere between $3 million and $7 million. The four-day Jazz Festival drew 26,548 patrons, and the Folk Festival attracted 52,101 people. One estimate projected that the music lovers pumped "no less than $1,000,000" into the local economy. The Newport Preservation Society's three nineteenth-century mansions—the Breakers, the Elms, and the Marble House—attracted a record 110,000 guests.[63]

As usual, the federal government was the largest contributor to Newport's 1964 economy. It maintained more than twenty installations on Aquidneck Island. The federal government pumped more than $92 million into the area through payrolls, allotments, purchases, and construction. This contribution was expected to grow in 1965, especially with more than fifty additional civilian jobs earmarked for the Navy Underwater Systems Engineering Center. Employment during 1964 at manufacturing companies on Aquidneck remained steady or expanded slightly, including Raytheon, Transcom Electronics, Avica, and two General Electric Assembly plants. The proposed bridge across Narragansett Bay would further support the strengthening financial outlook.[64]

So, it must have been very disappointing to the proponents when yet another controversy reared up in early January 1965. Governor Chafee asked the Rhode Island Supreme Court for an advisory opinion on whether or not RITBA could use tolls from the Mount Hope Bridge to help pay for the Newport Bridge. He submitted the request in writing to Chief Justice Frank B. Condon. New York bond lawyers had asked Chafee to make certain that applying tolls from the Mount Hope Bridge did not violate the state's constitutional provision prohibiting borrowing more than $50,000 to

pay off the obligations of another debt without the consent of the people. It was curious that the question was asked so late in the process. In January 1964, the Supreme Court hinted that the voters must approve the use of Mount Hope Bridge tolls but did not say so explicitly because it was not specifically asked to opine on the question. RITBA critics called it a "grave oversight." The authority and its lawyers considered including the question on the November 1964 referendum but believed the likelihood it would be declared unconstitutional was extremely remote. The legislation passed by the General Assembly empowered RITBA to use Mount Hope Bridge toll revenues to finance the Newport bridge; however, the court pointed out, the referendum question did not inform the voters of such plans. RITBA now had to go back to the voters for approval.[65]

The Supreme Court decision curtailed bridge planning activities while RITBA officials worked to pass legislation for a statewide referendum on the use of Mount Hope Bridge tolls. Meanwhile, Dwyer pledged, RITBA would continue to collect tolls on the bridge. The Supreme Court did not prohibit toll collection. The revenue derived from the Mount Hope Bridge would remain in reserve. RITBA had collected about $225,000 in toll revenues since it took control of the bridge in June 1964 and had only spent $8,000, which was used to purchase health insurance for RITBA employees. A more pressing problem involved $500,000 that the authority borrowed from Rhode Island Hospital Trust, of which it had already used between $350,000 and $400,000 for engineering studies, drilling, preliminary plans, and other expenses. A payment of approximately $175,000 was due on June 1, 1965. Dwyer did not know what would happen if the situation were not resolved. Meanwhile, he said that as far as the new bridge was concerned, everything had "come to a screeching halt."[66]

RITBA was closing its Newport office, which it had opened the previous spring. It was suspending Senator Savage, whom it had hired to run its Bridge Division, and was letting his secretary go. James F. Canning, whom RITBA hired in late November 1964 as general business manager and public relations man, was reassigned to the Mount Hope Bridge Division in Bristol. Canning graduated from St. Raphael's Academy in Pawtucket, Rhode Island, Boston University, and Harvard Business School. Before joining RITBA, he worked in the marketing and public relations departments of Sylvania and Westinghouse, as well as the Providence-based public relations firm Fitzgerald-Toole. He would play an important role in building the bridge and then managing RITBA's daily operations as the agency's executive director.[67]

On December 12, 1964, the *Providence Journal* chimed in with an editorial supporting Dwyer's long-held belief that the traffic estimates were conservative. The launching point for the editorial was a line from one of RITBA's reports: "Experience shows that replacing ferry service with a bridge or tunnel usually generates sizable volumes of new traffic." The editors conjured the Verrazano-Narrows Bridge to prove the theorem, especially what was happening on the Staten Island side of that structure. That borough was experiencing boomtown growth, "largely triggered by the handsome hunk of steel and concrete that spans the Narrows." Apparently, Staten Island officials engaged in proper planning and zoning activities to protect it "against the undesirable aspects of tremendous growth."[68]

While the proposed Newport Bridge would not engender growth as large as what was occurring on Staten Island (given its terminus was Manhattan), Newport could learn lessons from New York by having an eye for careful planning rather than waiting "until the day of reckoning has dawned." The upstate newspaper was once more attempting to educate its downstate lawmakers in the art of proper planning. It was the second time the editors used the Verrazano-Narrows as exemplar. The message between the lines, though, was that RITBA's revenue projections might be considerably low. If they were, Dwyer was right: the proposed bridge would pay for itself sooner than the engineers projected.[69]

Dwyer went to work preparing legislation with Newport County legislators and Providence-based lawyers Hogan and Hogan. They were targeting a June referendum. Dwyer said that the three- to four-month delay would have a longer impact on bridge construction due to the loss of work they had expected to accomplish in May and June. RITBA had anticipated advertising for initial bridge projects on March 25. As always, the proponents managed a positive spin. Lawyer Edward T. Hogan said that the upcoming referendum was only a "question of seeking a stamp of approval of the people on the method of financing" the bridge. Dwyer chimed in accordingly:

> *The method of financing is sound. It enables the authority to do what we want to do—build a bridge without its costing the state anything. The people want a bridge, the state needs a bridge and we want to give them a bridge that is financially self-supporting. We're used to adversity. Each time we've been stopped we've managed to go forward again.*[70]

More adversity followed the court opinion. Bristol Senator Joseph F. Bruno and Portsmouth's Paul Chappell were at the forefront. Bruno wanted

the Supreme Court to answer additional questions, including whether RITBA could continue collecting tolls on the Mount Hope Bridge at all—and, if so, which agency should get the revenue. Bruno also said he would introduce legislation prohibiting RITBA from collecting tolls on the bridge. Chappell wanted Governor Chafee to seek an opinion from the Supreme Court concerning the constitutionality of the entire legislation dealing with RITBA. Chappell also favored an idea proffered by Newport Representative Tom Edwards that the State of Rhode Island should guarantee all of the bonds being floated to build the bridge. The interest saved on the lower interest rates for the entire bond issue would save the state as much money as the Mount Hope Bridge would generate from tolls. Other Bristol leaders, including Town Council President William P. Souza and Representative Salvatore Massa, called for suspending the tolls until the issue was resolved. Bruno said that the state would not have been in the current predicament had the resolution he introduced on February 7, 1964, asking the Supreme Court to consider seven questions concerning the Newport Bridge not been killed by "certain influential members" of the Senate.[71]

Savage submitted Dwyer's bill to the General Assembly on March 26, 1965. To remedy the Supreme Court's contention that the scope of the bonds was not made clear to voters in November 1964, the legislation and referendum specifically capped bond sales to $47.5 million. The bridge was expected to cost about $42 million, but RITBA wanted to include a buffer. Without the wiggle room, if costs exceeded $42 million, Hogan said, the "bridge would stop short of completion and we would have a 10-foot ferry." On April 20, 1965, the Rhode Island General Assembly passed the legislation and forwarded it to Chafee for his signature. In addition to calling for the statewide referendum on using Mount Hope Bridge toll revenues to pay down bond issues, the bill also amended existing RITBA legislation by acknowledging that RITBA held title to the Mount Hope Bridge; reaffirming the $17.5 million state guarantee; repealing a provision of the legislation that allowed RITBA to lease the bridge to the state; and clarifying that RITBA could retire the Jamestown Bridge bonds anytime within three months of the opening of the Newport Bridge.[72]

The next day, at a banquet honoring Dwyer as Newport's "Citizen of the Year," Chafee declared that the referendum seemed likely to pass but warned against complacency. The governor pointed out that prospects were favorable because of Dwyer's persistence "despite the great difficulties he has sometimes encountered." He also noted that without Dwyer as his campaign manager he would not be addressing the dinner as governor.[73]

RITBA was not empowered to spend money to promote a "yes" vote on the bridge referendum. Dwyer did offer use of RITBA's files to anyone who wanted to campaign for the bridge. As to the Bristol Town Council's position that the Mount Hope Bridge should be toll-free, Dwyer declared that only seventy-eight Bristol residents used the bridge to commute to work, while Bristol residents that work on the bridge earn a total of $40,000 to $50,000.[74]

On June 22, 1965, Rhode Islanders approved the bridge financing referendum by a three-to-one margin. Despite five spending questions being considered, less than 10 percent (45,000) of the state's eligible voters (472,000) turned out. The people in Newport voted, though, as 45 percent (6,772) went to the polls, compared with 6.5 percent (6,369) in Providence. Close to 90 percent (5,994) of Newport voters approved the measure. Even in Jamestown and Bristol, the historical centers of Bridge opposition, voters accepted the referendum. Chafee was delighted with the results and looked forward to moving ahead with the bridge.[75]

The joy in Newport was palpable. Proponents celebrated at the Viking Hotel, where they had gathered to monitor the voting. Dwyer proclaimed the results as fantastic, adding that he had "never seen such overwhelming support from the people of this island and Newporters in general." Mayor Hambly called the results "the greatest thing that has happened to Newport since its founding in 1639." Francis Holbrook, Newport County Chamber of Commerce executive director, was equally jubilant, calling the soon-to-be-built bridge "one of the greatest advances in this century for the entire state's economy." Wasting no time, Dwyer stated that specifications for the bridge's first contract of between $12 million and $15 million would be released by July 1 and the contract awarded on August 4. He anticipated that work on the long sought-after Newport Bridge would begin on August 13. It would be a suspension bridge.[76]

And its official name would be the "Newport Bridge." Dwyer announced that the name was decided by RITBA members, who quickly and unanimously agreed that the bridge should not be named for an individual, be it Verrazzano, Roger Williams, or John F. Kennedy. Two weeks earlier, the Rhode Island House of Representatives nearly passed a bill naming the bridge after Giovanni da Verrazzano, who explored Narragansett Bay in 1524. It failed by just two votes, the slimmest of margins. Dwyer said that three geographical names made the most sense: the Narragansett Bridge, the Newport Bay Bridge, and the Newport Bridge. They settled on the Newport Bridge. It was the simplest and most correct, Dwyer explained.[77]

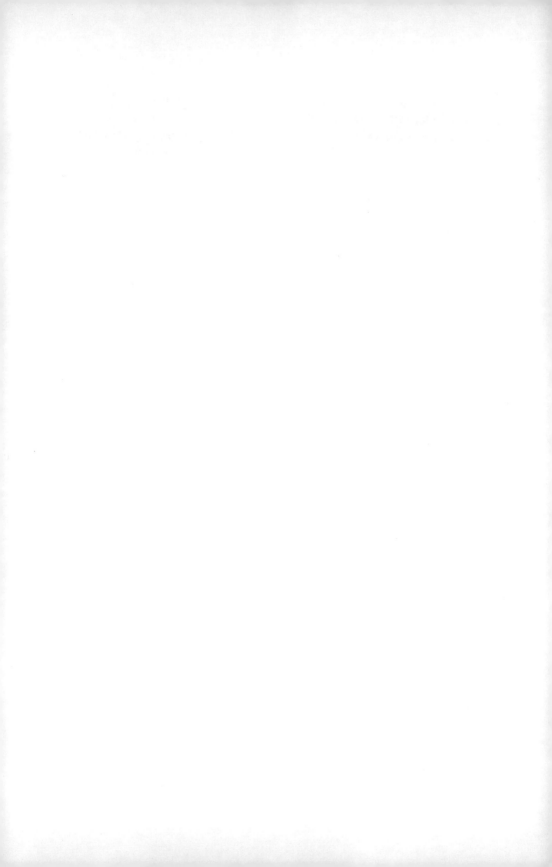

Chapter 5

ANOTHER FINE MESS

The Interest Expense Debacle

RITBA advertised for contracts two days after the referendum passed. On August 11, 1965, it opened the bids for the first phase of the project. This included the construction of the two main tower piers descending into water about 140 and 100 feet deep, respectively. It also included the two massive anchorages that would hold the suspension cables and six other deep water piers. The proposals were immediately disconcerting. RITBA and its engineers estimated that the first contract would cost $15 million. When it opened the envelopes from three bidders, the lowest, from the Perini Corporation, was $18,788,770, almost 25 percent higher than anticipated. The two other bids were significantly higher at $21,718,760 and $24,672,170. The situation was alarming given that RITBA had pegged the total cost of the bridge at $42.5 million and the recently passed legislation and referendum had established a statutory maximum that the bridge could not exceed $47.5 million. RITBA did set aside $3.5 million for contingencies in its estimates. The first phase, it appeared, would consume that entire reserve plus some.

Alfred Hedefine of Parsons Brinkerhoff seemed a bit concerned. "The bids surprised me," he acknowledged. The number of bids was normal for a project the size of the Newport Bridge, he said, because the other two bids were submitted by consortia of four and three companies respectively. Hedefine projected that it would take another two weeks to tabulate and

certify the bids. The contractors had to honor their bids for thirty days. Work had to begin within twenty-five days after the contract was awarded.[1]

Dwyer, on the other hand, was unconcerned that the first bids exceeded estimates, at least publicly. He attributed them to the fact that some elements of the subsurface work were unknown, resulting in caution from the bidders. Dwyer emphasized that Parsons Brinkerhoff had continually warned about such a possibility. The upcoming superstructure estimates, Dwyer declared, should be fairly accurate and close to projections. Dwyer was confident that the bridge could be built for less than the statutory limit and saw no need to go back to the legislature and voters for additional funding. "We could build a different type of bridge; we could cut corners," but he saw "no reason for any alterations" at this juncture.[2]

Remarkably, Dwyer claimed that RITBA would not continue building the bridge if it felt that costs were out of line. Anyone following the struggles for the bridge during the previous twenty years might have doubted the sincerity of that statement. In addition, on the other side of the ledger, Dwyer revealed that revenue estimates would be increased as a result of new traffic reports being conducted that very month. Income from the Mount Hope Bridge was "way above estimates," and projections of revenue from the new bridge would also be adjusted higher following the revised traffic report. The work associated with the first phase was to be completed in stages between June 1966 and May 1967. The target date for the completed bridge remained May 1968.[3]

Governor Chafee, however, was not convinced about Dwyer's glass-half-full assessment. He summoned Dwyer; Marcello; Bob Christie of Dillon, Read and Company; and Hedefine to a meeting in his office on September 1, 1965. According to Chafee's handwritten notes from the meeting, the engineer insisted that "he knew bids for the substructure would be considerably over his estimate" and claimed that "no such variation would be likely for [the] superstructure." Chafee also uncovered that RITBA knew in June 1965 that the bridge would cost $47.5 million, but that figure was never publically disclosed. The governor tried to understand the whole picture: "Original price Sept '64 $42,500,000 with 3,500,000 contingency. Now Sept '65 47,500,000 with 3,000,000 contingency." He also learned that the original estimate for the substructure was $14.5 million, not the $15 million that advocates had been citing, and that the Perini bid was actually $4.2 million over. Chafee wanted to know how the deficit could be made up.[4]

The team believed that it could shave off $2,860,000. The Perini bid would be cut $1.5 million by using a wet pour (tremie method) instead of dry

"with round coffer dams." They would draw $550,000 from the contingency. The west approaches and span costs would be slimmed down by $130,000, and another $680,000 in costs would be trimmed from the superstructure by reducing the size of the cable. Chafee rounded up. This would still leave a $1.4 million shortfall. The governor's notes memorialized the facts: "State originally didn't have to pay any interest on its guaranteed bonds. Now state has to put in 650,000/year for 3 years—about 2 million. This will be paid back—see next page." A handwritten amortization schedule running from 1966 to 1979 detailed how the state would be repaid. It was evident that Governor Chafee was keeping a close eye on project costs.[5]

Other watchdogs in the state were also monitoring the goings-on at RITBA. By December, the *Providence Journal* had learned what Governor Chafee had discovered in September. Leading up to the referendum, Chafee and Dwyer continually reassured taxpayers that they would not have to pay anything for the bridge unless some unforeseen emergency prevented RITBA from paying its bonded debt from revenue streams. On December 18, 1965, the newspaper informed its readers that such promises did not hold much water. The state was going to pay interest on the guaranteed bonds to the tune of $340,000 on June 1 upcoming and $640,000 during fiscal year 1966–67. The funds would be included in Chafee's proposed budget. The governor reiterated that RITBA would pay the state back but did not provide any details on why the state was assuming the financial burden.[6]

The opinion makers declared that the public should get the whole picture. Revenue was coming in from the Mount Hope Bridge at more than $400,000 per year. RITBA was also about to start receiving interest income by investing the proceeds of the $17.5 million guaranteed bond issue until it was needed to pay construction costs. The editorial writers wondered aloud if that interest would go to pay the non-guaranteed bonds of $30 million that were soon to be issued. RITBA, they said, owed the taxpayers of Rhode Island "a full projection of its financing plans so that they will know how long they will be shelling out and when they can expect to get their money back."[7]

The bridge financing controversy would cause a major dust-up in the coming spring, but before that, two notable events occurred. First, RITBA reaped the benefits of its $47.5 million bond issue. The sale was completed on December 21, 1965. Rhode Island General Treasurer Raymond Hawksley signed the bonds in the New York offices of Dillon, Read and Company. They were sold to thirty-one private investors arranged by Dillon, Read. The $17.5 million in state-guaranteed bonds was sold to the public. The bonds were tax exempt. Second, the first signs of physical work on

the new bridge appeared on December 23, 1965. Two cranes mounted on barges were secured to the head of Fleet Landing as Perini Corporation workmen prepared to drive one-hundred-foot "H" beams to the bottom of Narragansett Bay.[8]

On December 30, 1965, Dwyer addressed the issue that RITBA needed the state's help to pay interest rates on the recently let bridge bonds. He said that RITBA could meet the $1.4 million of annual interest to the revenue bondholders, but it could not pay the $640,000 of annual interest to the guaranteed bondholders without jeopardizing the statutory limits established by the General Assembly and approved by voters. The state was going to have to front the cost of about $3 million in interest payments until incoming toll revenues were sufficient to cover the guaranteed bond expenses. Dwyer described the state's assistance as a loan. RITBA would pay the state back in full once the bridge was generating sufficient income, which would happen in 1974. The state would be fully reimbursed by 1980.[9]

Dwyer said that RITBA would have been able to meet its obligations as originally planned if not for a series of events in 1965. First, the Rhode Island Supreme Court decision in March setting a mandatory ceiling of $47.5 million for the bridge resulted in unfavorable terms for arranging for the bond sale. Second, the General Assembly decided that it would no longer pay $160,000 in annual Mount Hope Bridge maintenance and operating expenses, shifting that burden to RITBA. Third, the court-enforced delay in launching the project partially contributed to the overbudget contract to build the substructure. Fourth, if the bonds had been issued in the spring of 1965 instead of the winter, RITBA would have incurred less interest expense.[10]

Dwyer acknowledged that the Mount Hope Bridge was generating a profit of $440,000 per year and that the proceeds over the next few years would be used to establish a reserve account of $1.5 million for the revenue bonds. The financial institutions demanded such. Also, during construction, RITBA would earn at least $2,835,000 in interest on the $47.5 million of funds it had just received from the bond sale. It would use that interest to pay the revenue bondholders while periodically drawing down on the bond proceeds of the $47.5 million to pay for construction costs. It could not, however, also cover the payments to the guaranteed bondholders. RITBA did not expect the cost of the bridge to exceed the statutory limit. If it did, Dwyer said, they would need to go back to the legislature and voters for approval. On a positive note, the next bid packages would be released on February 1, 1966, Dwyer said, and be awarded by the middle of March.[11]

A Shadow on the Credit of the State

If the proponents thought that such announcements would be the end of this brouhaha, they were severely mistaken. It was just the beginning of a major crisis facing Rhode Island. Governor Chafee included the interest payments on the guaranteed bonds in his budget. He included $302,000 in deficiency for the fiscal year ending June 30, 1966. Chafee added an additional interest expense of $680,000 for the fiscal year ending June 30, 1967. On April 20, 1966, Democratic Senator Francis P. Smith of Woonsocket dropped a bombshell. As part of its approval process for the governor's budget proposal, Smith, who was chairman of the Senate Finance Committee, announced that the General Assembly voted not to approve the interest payments on the guaranteed bonds. Smith claimed that RITBA knew when it sold the bonds that it was not going to pay the interest but did not inform the state until two days later. Senator Walter J. Kane of Smithfield, deputy Democratic leader in the Senate, stated that the legislators and voters did not believe the state would be asked to pay the bill while RITBA was collecting interest on the reinvested bond proceeds. The decision not to pay was approved by Democratic caucuses in both the Senate and House. The General Assembly leaders said they would consider giving RITBA additional bond authority if such a request were made, but they objected to the authority "coming through the back door."[12]

Dwyer fired back immediately and unequivocally. He said RITBA would not pay the interest. "We need the money to build the bridge," Dwyer declared. "We are not going to pay it." He said the next move would be up to the bondholders, who might have to take legal action against the state. Dwyer cautioned that the General Assembly's decision not to pay the interest on the guaranteed bonds would damage the state's credit. At a press conference the following day, Governor Chafee said that the state would be paid back in full for any funds it advanced to RITBA for interest payments while the bridge was being built. The governor said that the Democrats claimed "they are for the bridge, but they just don't want to pay for it." He also confessed that originally he did not know that the state would have to pay the interest expense. Dwyer contradicted the governor somewhat, saying Chafee knew about the situation the previous August. Perhaps a bit perturbed, Chafee deflected further comments by saying, "Let's wait until bids come in this afternoon." Chafee was referring to the bids for the superstructure that were scheduled to be opened in Newport.[13]

Dwyer took the opportunity to spell out the situation as clearly as possible. The $2.8 million RITBA was receiving in interest from the proceeds of the bond issues was needed to pay the revenue bondholders while the bridge was under construction. RITBA's major responsibility was to build the bridge. It could not divert construction money to pay the interest on the state-backed bonds. The bank trustees who protected the bondholders would not let that happen. The legislature's suggestion that RITBA should request additional borrowing powers "missed the boat," he said. "The important thing is to start getting revenue." Dwyer restated his dire warning from the previous day. If the General Assembly were to withhold the interest payments, the state would be in default. Smith stood by the General Assembly's position, saying that Dwyer previously promised the legislature that the bridge would not cost the taxpayers anything.[14]

Dwyer's prediction came to fruition the following day when the state's credit rating crashed. On April 21, 1965, the state floated $18 million in highway construction notes. It had no takers—not one. Banks refused to bid, so the state postponed the issue until the following week. The highway notes were part of $81 million in bonds approved by voters in 1960 and 1964 to speed up the completion of the interstate highway. The federal government reimbursed the state annually. Rhode Island General Treasurer Raymond Hawksley sent a message to Chafee saying "not a single bid was received for the issue" because of the publicity concerning the interest payments on the bridge bonds. He told the governor that he had received telephone calls from financial firms in New York, Chicago, Boston, and locally. Hawksley said the bankers appeared to be upset by Dwyer's statement about bondholders needing to seek legal redress for unpaid interest.[15]

Meanwhile, Democratic Representative Michael Sepe of Cranston called for Dwyer's resignation, describing RITBA's chairman as irresponsible. Sepe also said the Democrats would not authorize interest payments as long as the authority had the money. It had received such an opinion from the state's attorney general. Senator Smith reemphasized Sepe's sentiments and contended that there was no question that RITBA had the funds to pay the interest. John Simmen, president of Industrial National Bank, said his bank planned to bid on the bonds but withdrew when it learned that its syndicate partner, the First National City Bank of New York City, had pulled out. Simmen denied that his bank advised the other financial institutions to hold off bidding. That lack of enthusiasm by the banks prompted resolutions in both chambers of the General Assembly to consider requesting a Congressional investigation into the "collusive refusal" of the

financial community to participate. Both were sent to their respective finance committees for consideration.[16]

A second bombshell dropped that morning. It, too, was covered with Smith's fingerprints. Smith called the authority "irresponsible" for how it invested the proceeds of its bond issue. The charges were leveled during a floor debate in which opponents criticized the authority and supported the decisions of the finance committees to withhold interest payments. Smith detailed the rates and terms RITBA received from the four banks it selected. The authority only obtained 5 percent on one short-term issue, Smith said, claiming that the going rate was 5.35 percent. Smith said that was a big spread and blamed RITBA for taking the advice of John T. Fletcher, assistant treasurer at Industrial National Bank—where, by the way, the authority deposited $3 million for sixteen months at between 4.25 percent and 4.5 percent. Smith then shifted gears, saying that the state might be required to front RITBA $27 million in interest expense on the guaranteed bonds before they were paid off. Sounding the familiar refrain of opponents for more than a quarter of a century, Smith declared that he favored the bridge. He was only questioning the actions and sincerity of the authority.[17]

One month earlier, Smith had requested the investment information from RITBA's executive director, James Canning. Dwyer sent Chafee a note on March 23, 1966, so the governor would not be blindsided. The contents contained a detailed breakdown of the expenses associated with the bond issue, salary information for employees of the authority, and a listing of how the $47.5 million bond issue proceeds were invested. Dwyer added that the closing costs of the bond issue were $100,000 less than projected. In fact, he continued, they "were less than $1-1\frac{1}{2}\%$ of the bond issue, which represents a very favorable percentage in an issue of that nature." As to salaries, the authority "kept the number of its employees to a minimum." Not counting the Mount Hope Division, there were only five people on the payroll: Canning, Savage, and three secretaries. Regarding the investments, they had been placed with advice from the Rhode Island Hospital Trust Company and the Banker's Trust Company of New York. Anticipating the eventual criticism from Smith, Dwyer explained to the governor that RITBA had selected certificates of deposits with Rhode Island banks where the yields were fractionally less than if they went elsewhere. Dwyer reassured Chafee that "the Authority felt obligated where at all possible to place monies in Rhode Island banks which would, in turn, be put back into the State's economy in loans, mortgages, etc." It was clear that Dwyer kept Chafee well informed on bridge details, especially those

that might stir the criticism of politicians from the opposite party. Either that or Chafee requested detailed reports.[18]

Smith continued to pile on Dwyer. He said he had become suspicious of RITBA one year earlier when the two finance committees questioned a budget item of $150,000 for RITBA. When questioned, Smith recounted, Dwyer replied he didn't need the funds. Then why did he ask for it? Smith pondered aloud. He asked Dwyer if they would require additional funding for the bridge in the future, to which Dwyer replied that RITBA believed it had secured sufficient funding and would not be asking for more. Yet after the first bids were awarded, RITBA determined that it needed the state to pay the interest expense on the guaranteed bonds. Finally, an unrelenting Smith said that the General Assembly passed bills placing the two finance committee chairmen on the board of RITBA, but Chafee vetoed them. Smith suggested that Dwyer was behind the vetoes. Smith claimed that he was unaware that the bond guarantee bill would put the state on the hook if RITBA had enough money to pay the obligation. That is why the two finance committees scratched the interest payments from the governor's budget. The Aquidneck Island senators backed Dwyer. Senator Allan Harlow of Middletown and Senator Thomas Levesque of Portsmouth both stated that they would vouch for Dwyer's integrity. Senator Kane of Smithfield added that perhaps the Senate should confirm members of RITBA.[19]

Governor Chafee had had enough. During the chaos of the previous days, the governor was a calming influence, declaring that he thought "enough things had been said" and that he was "not going to add any fuel to the fire." The day of the aborted highway note offering, he continued to provide superior leadership on issues related to the bridge, including immediate damage control. He met with legislators without haste on Friday, April 22. Sensing a need to reassure the public, Chafee interrupted the conference with General Assembly leaders to address reporters. His message was simple: bondholders should have no fears about the state's intention to honor its obligations. "No bond holders who ever have or will buy obligations of the state need ever have the slightest worry," he said. "They will be promptly paid." The governor called it an "internal problem" that he was certain would be worked out. Smith and Sepe joined the governor for the announcement to the press. Both said they concurred with the governor's statement.[20]

Chafee was a man of action as well as a down-to-earth communicator. It was clear that he was in charge. This matter was going to be resolved quickly. On Friday, he said he would gather the feuding parties in his office first thing Monday morning. The governor was moved by an urgent, no-

nonsense "expression of concern" voiced by John H. Congdon II, president of the Congdon and Carpenter Company and chairman of the Weekapaug Group. Congdon showed up at the state house as a concerned private citizen. He informed the legislature that the flak might discourage new plants from locating in Rhode Island. Congdon said that "irreparable harm" had already occurred and that the situation needed to be straightened out immediately. Whether the state or the turnpike authority paid the debt, all doubt had to be eliminated. There was enough blame to go around. The Democrats who eliminated the payment from the budget started the problem, Congdon observed, and Dwyer's response made matters worse. One way or another, he said, the problem had to be solved "so that the faith is restored across the nation in the state's credit."[21]

Before the governor's Monday morning conclave, the opinion makers weighed in with an editorial in the *Providence Sunday Journal* titled "A Shocking Business." The editors laid blame for the fiasco at the feet of the General Assembly's Democratic leadership who cut the appropriations from the governor's budget. The editorial leveled the accusation in its opening paragraph:

> *A shadow has been cast on the credit of the State of Rhode Island by irresponsible politicking, and it is impossible at this time to tell how deep and lasting that shadow may be. But no job before the state is more important than the sorry task of repairing as fast as possible the damage wreaked by the Democratic majority in the legislature and its leaders.*

The editorial recounted the issue and joined the refrain for its immediate resolution. It didn't let Dwyer completely off the hook, saying that his "less than skillful" statements added fuel to the fire. However, the editors claimed, the legislature should have fully understood the bridge financing bill before it passed it, rather than questioning it afterward. Now, the editors proclaimed, "Smith and his fellow Democratic leaders have elected to thrash around like bulls in a China shop, without regard for the effect of their actions on the credit of the state." The issue should have been resolved by discussion within Smith's committee. Instead, it "ballooned into a slugging match in the legislature." The editors then questioned the Democrats' wisdom in calling for an investigation of the banks "collusive refusal" to participate in the transportation note issue, characterizing the legislative resolution as "an ineffective smokescreen for responsibility." The opinion makers came down hard on the legislature and, for once,

gave Dwyer some much-needed cover heading into the governor's meeting the following day.[22]

As promised, on Monday, April 25, 1966, Chafee presided over the summit of bridge protagonists in his state house office. The meeting included the governor; Dwyer; Senator Smith; Representative Sepe; Howard Kenyon, fiscal advisor to the House Finance Committee; Paul Choquette, legal counsel to the governor; John Murray, state budget officer; Robert Christie of Dillon, Read, representing the financial advisors to RITBA; Edward Hogan, counsel to RITBA; Andrew DiPrete, counsel to Rhode Island Hospital Trust; Philip Simonds, vice-president of Rhode Island Hospital Trust; William Sloane, also counsel to Rhode Island Hospital Trust; and Frank Mauran of the governor's administration staff. Chafee commanded the head of the rectangular table flanked by Choquette to his right and Murray to his left. Dwyer sat directly across from Sepe, who had called for his resignation twice during the previous week. Kenyon separated Sepe and Smith on the right side of the conference table; Christie and Hogan joined Dwyer on the left. The three-hour meeting must have been as intense as it was productive. At its conclusion, Chafee announced solutions to the problems.[23]

First, the House and Senate Finance Committee chairmen, Smith and Sepe, would recommend that the legislature pay the interest expense that the governor included in his budget. Second, Chafee's administration would submit a bill to the legislature seeking voter approval of an additional $7 million in bonds to finance the bridge. Third, of the new bond issue, $3.5 million would pay off interest on the state-guaranteed bonds until the bridge was opened and generating toll revenues. Fourth, the remaining $3.5 million would be revenue bonds not guaranteed by the state. And fifth, RITBA's legal counsel would submit in writing an opinion proffered during the meeting that the authority cannot legally pay the interest on the state-guaranteed bonds because the trust agreement between RITBA and bondholders declared that the money must go to the construction project. The new borrowing proposal would be submitted to voters in November. If the voters rejected it, the funds due to bondholders for the following year would already have been approved by the legislature and included in the governor's budget.[24]

The agreement meant that the General Assembly would have to find $982,000 to cover the expenses. This included the deficiency payments for the fiscal year ending June 30 and the full payment for the upcoming fiscal year beginning July 1. To do so, it might need to cut something else out of Chafee's budget. Curiously, the governor said the additional borrowing did not signal an escalation in the cost of the bridge. The additional non-state-

guaranteed $3.5 million would be reserved for contingencies. It would only be tapped if needed. Once again, Chafee had saved the day and gotten the project back on firm footing.[25]

The controversy the governor thought had been put to bed on Monday morning did not remain tamped down. On the floor of the House, Representative Howard Duffy, a Democrat from Providence, introduced a resolution to create a special legislative commission to investigate RITBA. The commission would probe the turnpike authority's activities associated with the construction of the bridge; the payment of fees, commissions, and salaries; its investments; statements it had made about its finances; and why bonds were issued well before the funds were needed. The commission would be vested with the power to subpoena witnesses and records. The resolution was sent to the finance committee for consideration.[26]

Meanwhile, Senator Smith could not contain himself from responding to the *Providence Sunday Journal*'s editorial blaming the Democratic leadership for the fiasco. At the Monday morning summit, Chafee had urged participants not to make any more critical comments about the issue. The governor hoped that the announcement following the meeting would be the final word. Seething over the editorial, Smith told Chafee he could not let things rest as they currently stood. He took advantage of the introduction of the special commission legislation to air his grievances, calling the editorial writer a "knucklehead." Smith claimed that the opinion piece did not mention Dwyer's "stupid statement" that the bondholders would have to seek legal redress against the state. Smith also said the editorial failed to criticize RITBA for its subpar investment strategies. He called the piece a "whitewash, poorly, hastily prepared to get certain people off the hook."[27]

The cauldron would never have boiled, Smith said, had the governor not vetoed the bill that would have added the Senate and House Finance Committee chairmen to RITBA's board. He questioned aloud whether anyone thought the problems would exist if he and Sepe had been appointed. The editors needed their heads examined for trying to make him the patsy, Smith railed. The Senate Finance Committee chairman said the issue never even reached his committee. Rather, it was discussed by the "leaders of the Democratic party and…Democratic members of the House and Senate, who took the position that the interest was an obligation of the authority." The very next day, the editors of the *Providence Journal* made one final parley. In response to Smith's claim that they did not include any mention of Dwyer's statement in their editorial, they republished their original paragraph:

Francis G. Dwyer, authority chairman, ineptly and tartly replied that the authority couldn't pay the interest charges and that bondholders could go to court to get their money. The national money market reacted immediately as indicated by the failure of national banks to bid on the state's own 18 million dollar highway bond issue last Thursday. [28]

As always, there was enough blame to go around. Regardless, Chafee, who handled one issue after another with aplomb and statesmanship, must have been appalled at the post-summit bickering in the most visible of public places, the chambers of the General Assembly and the editorial pages of the state's major newspaper. In the month that followed, the legislature passed the bill Smith and Sepe had agreed on at the Monday summit. It reached the governor's desk in May. Chafee signed the legislation authorizing the additional $7 million for the bridge on May 24, 1966. The voters would have their chance to approve or reject the measure in November. [29]

On April 21, 1966, as the chaos surrounding the interest payment reached a crescendo in Providence, two sealed bids arrived at RITBA's office in Newport. Both were too thick to fit through the slot in a locked wooden box the authority built to accept the proposals. A wastebasket was set up on the table next to the box. It did the trick. The two envelopes contained proposals to build the bridge's superstructure, which included the two four-hundred-foot towers, the road deck, cables, and steel. About forty people crowded into a small room at RITBA's headquarters to witness the event. The contingent included turnpike authority members, representatives from the bidding companies, consultants, and local officials. RITBA Vice-Chairman John J. Gill opened the bids amid excitement and trepidation. RITBA's leaders could not weather another blow like the one they absorbed from the substructure bids. Their fears were soon dismissed. Bethlehem Steel submitted a proposal for $18,945,541. The American Bridge Division of United States Steel delivered a package for $19,993,504. Both were within range of the engineers' estimates that pegged the phase at $17,940,000. [30]

Dwyer was elated. It was now clear that the bridge would be built under the statutory limit of $47.5 million. Dwyer said the bid would "completely dispel forever" the fears being circulated by the "prophets of doom" who "without any basis in fact predicted the cost would be tens of millions of dollars above estimates." The engineers would commence certifying the proposals and make a recommendation. Dwyer said that the engineers could authorize him to award the bid before they had finished their tabulation. "The main thing is to get the bridge completed so we can start

getting cars across and start collecting tolls to pay off the bond holders and the state of Rhode Island."[31]

RITBA and Parsons Brinkerhoff asked the bidders to submit two proposals: one using the traditional on-site aerial cable spinning method that John Roebling had invented before the Civil War and the second using the recently developed method of prefabricating the parallel wire cable strands at the factory. Bethlehem Steel determined that the new method could save $601,950. U.S. Steel calculated that it could save $246,200. J.K. Conneen, Bethlehem Steel's sales manager, who came to the bid opening from Pennsylvania with a contingent of nine colleagues, said that his company was "very anxious" to try the new method. It would be the first time it was used. On April 25, the same day the governor summoned the disparate parties to resolve the interest expense controversy, RITBA announced that it had selected Bethlehem Steel's proposal to build the superstructure. The bridge builders said that the work associated with the contract would start in the fall.[32]

THE NO-BID CONTRACT

Before the people of Rhode Island had the chance to vote on the interest expense measure, yet another issue surfaced. On September 26, 1966, RITBA awarded the Perini Construction Company a $6.5 million contract to construct the remaining piers for the bridge. The problem was that it happened without a bidding process. Horace E. Hobbs, the Democratic mayor of Warwick who was running for governor, raised the alarm. He said the contract looked like "political shenanigans." Hobbs noted that the contract "appears to be an all-time record for the award of a public contract without sealed bids." Hobbs was "gravely disturbed by the award" and asked Chafee to seek a restraining order to stop the contract from taking effect. Chafee did not respond, withholding comment until a press conference two days later.[33]

The General Assembly was recessed but could be reconvened by Lieutenant Governor Giovanni Folcarelli and House Speaker John J. Wrenn of Providence. Folcarelli was contemplating calling a special session to investigate the contract. He believed that Chafee's administration had been "too loose in its practice of giving contracts without bids." Wrenn was more restrained. He suggested that Folcarelli might have more information on the

subject than he had and that he would confer with the lieutenant governor before making any decisions. He did say he considered the contract award "highly improper and certainly most irregular." Long-standing bridge foe Joseph Bruno, state senator from Bristol, chimed in. He felt it was "high time that Governor Chafee called in the entire membership of the authority to straighten out their thinking when it comes to the matter of the public interest being served." Representative Anthony J. Brosco, a Democrat from Jamestown, sent a telegram to Chafee, Folcarelli, and Wrenn asking them to convene a special session to investigate whether any laws had been broken.[34]

The contract was the second awarded to Perini Construction Company. The first was for the six main towers then underway in the middle of Narragansett Bay. This contract was for building the thirty-seven smaller piers from the main towers east to Newport, completing the two anchorages that would secure the bridge's main cables, and building an abutment at the bridge's landfall in Newport. Herbert C. Mandel, of Parsons Brinkerhoff, explained the process. He said four other companies were asked to bid. None did. Chicago-based Case Foundation Company expressed interest but in the end did not bid. The fact that Perini had its equipment already deployed in Newport gave it a distinct advantage. Mandel said the engineers did not make an estimate on the work. Dwyer piped in that the engineers had an idea of what the cost should be, knew Perini could do the job, and believed the contract price was "within their thinking" and "generally on target."[35]

State purchasing agent William T. Broomhead said that RITBA's actions were contrary to practices for state agencies but that the authority did not fall under the jurisdiction of his department. RITBA Executive Director Canning declared that no law required the authority to seek competitive bids. Canning could not say if the new Perini contract would push bridge construction costs over the current budget or whether the upcoming $7 million referendum would be sufficient to finish the bridge. As of this new controversy, the bridge budget stood at $47.5 million, of which $44.7 million had already been let. Three major and two smaller contracts remained, with only $3.3 million available in authorized funds.[36]

At his weekly press conference on September 28, Governor Chafee attempted to quell the storm by asking RITBA to rescind the Perini contract and request sealed bids for the work. The governor did not think that any impropriety had occurred, but because substantial public funds were involved, he wanted Rhode Islanders "to have complete confidence that they [were] getting the lowest price for the work." Chafee acknowledged that his requested actions might set bridge work back five weeks. Such a delay

was trumped by his desire for the public to have "complete confidence with everything concerned with the bridge." For his part, Dwyer said he would recommend RITBA members abide by Chafee's request. He was confident that "the entire authority will go along with this," he said, sounding a cautionary and somewhat ominous note that he couldn't speak for them. Dwyer did add that he did not want to "stack the deck" against Perini, as its bid was already known.[37]

Canning clarified the events. Perini and Case conferred on the work before Perini submitted its bid. Perini wanted to use Case's drills, and Case was interested in buying concrete from Perini. RITBA got the two together, and Perini was able to lower its bid from $7,550,000 to $6.5 million. "Everything we did was aboveboard," Dwyer said. At Dwyer's request, Perini had returned the contract to RITBA in an effort to cooperate. Nevertheless, Perini Vice-President Charles A. Richardson warned that a reopened bid offering would slow down work on the bridge. He also signaled that future bids by Perini might not be as low as the current offering. Richardson agreed with Dwyer that his firm would be disadvantaged since its current bid was already public knowledge.[38]

Despite Dwyer's stated hope that RITBA would follow Chafee's wishes and rescind the Perini contract, the authority's members voted to uphold the contract by a three-to-two vote. In a mixed-up political jumble, the three Democrats on the board—John J. Gill of Cranston, John Nicholas Brown of Providence, and John C. Rembijas of Jamestown—voted against the measure, while the Republican Dwyer and Public Works Director Marcello, who served *ex officio*, were for it. The Democrats certainly did not want to contradict the Democratic leadership of the General Assembly, who initially called for pulling the Perini contract back and putting the work for the piers out for sealed bid. Likewise, they stated they did not want to embarrass Chafee, but they had a bridge to build. "Our reputation, judgment, honesty and integrity has been questioned and I resent it," Gill said. "This is the typical example of why distinguished, honest businessmen don't get in to public service." Brown added that with "a great deal of trouble and skill, this authority made it possible for Perini and Case to get together." He noted that the two companies would not have gotten together under a competitive bid process. Rembijas cited the urgency to get the bridge built. "History dictates that waiting means money," Brown said. The governor was disappointed. He had appointed all of the members save Rembijas. Since the authority was an autonomous body, Chafee had little recourse beyond his powers of persuasion. Chafee reiterated that the sealed bid process was an excellent

method and was "followed by all departments and agencies under this administration's jurisdiction."[39]

During the meeting, Public Works Director Marcello shed light on RITBA's selection of Perini's controversial bid. Marcello and two engineers from the Rhode Island Department of Public Works spent two days combing through the bid with Parsons Brinkerhoff engineers. Marcello said they could not find any way to get the price below $6.5 million, especially because Perini was already operating concrete plants at the site. "It isn't an ordinary bridge job of building piers that many contractors are capable of doing," Marcello explained. This was not like building highways, where there would be a lot of competition for a job. Only a few firms would be able to respond to a bridge pier bid. Marcello emphasized the urgency of getting the bridge built. "We're fighting against time," he warned. "We have no revenues and we have bonds outstanding." Yet he backed Governor Chafee's call for a rebid.[40]

Democratic leaders pounced on the issue the next day, as they immediately moved forward with plans to establish a commission to investigate RITBA. They would do so without calling a special session of the General Assembly. The members of the commission would be appointed by Folcarelli and Wrenn. If the commission was successfully created without legislative approval, it would not be vested with veto powers but could request the authority's records. If the authority did not cooperate, Folcarelli said, it would "indicate that something was suspicious." Hobbs, Chafee's opponent in the upcoming election, laid it on thick. "The members voting against rescinding the bids may be very fine gentlemen," Hobbs said, "but I could not disagree more with what they did." Democratic State Chairman John F. Capaldi joined the crescendo of voices calling for an investigation. As a former director of public works who was in the construction business, he knew that the competitive bidding system worked. Senate Democratic majority leader Frank Sgambato believed there should be some kind of investigation of RITBA. "They are a creature of the General Assembly," Sgambato said, and as such he thought the General Assembly should look into the authority's entire operation. All of this was unfolding less than forty-five days before Rhode Islanders would be voting on the $7 million referendum to pay for the interest expense on the guaranteed bonds.[41]

The opinion makers weighed in with a well-thought-out editorial in the *Providence Sunday Journal* on October 2, 1966. The editors informed the readership that Governor Chafee had failed to convince RITBA to "change its ways....And that was that." There was nothing more Chafee

could do. "Once an authority is created by law and sells bonds, it acquires an autonomy that is exceedingly difficult to break." The bonds "constitute a contract with investors that even the legislature and the courts may not jeopardize." That is why such agencies should be established with great care. They ridiculed Folcarelli's claim that not complying with the special commission's requests for records would be an admission of guilt, stating that it would be "unwarranted to assume" such refusal "would be an indication of wrong-doing." They warned against the unintended consequences of political witch hunts. "If an investigation is warranted," the editorial pointed out, "care must be taken to see that its motives are not political. A political investigation could do more harm than good." The editors believed that, at this point, the best that could happen was that RITBA "would use better judgment in awarding any future contracts."[42]

The Democratic leaders successfully established the investigatory commission. Folcarelli and Wrenn appointed the seven committee members. The breakdown was five Democrats and two Republicans. Representative Eugene Cochran, a Providence Democrat, served as the commission's chairman. The other Democrats included Senators Bruno of Bristol and Thomas Levesque of Portsmouth and Representatives Crist Chaharyn of Woonsocket and Joseph Thibault of Cumberland. The Republican members were Senator C. George DeStefano of Barrington and Representative Robert H. Breslin Jr. of Warwick. The commission held its first meeting on October 11, 1966. The Perini contract was the center of attention. All five RITBA members testified, as did Hedefine, Dillon, Read and Company's Christie, authority legal counsel Hogan, Perini Construction Vice President Richardson, and Mount Hope Bridge Commission Manager Savage. The bridge proponents made four major points. All of them had been made previously:

- *While public sealed bidding is "ideal" and is being followed by the authority in every other instance, the negotiated bid with Perini was a necessity because no other bidders could be found.*
- *The final price of 6.5 million dollars was more than a million dollars under Perini's first offer, because the design was altered and a Chicago firm specializing in drill work was brought into the picture.*
- *The authority actually sought competitive bids from individual firms, although not on an advertised, sealed basis, but got only one.*
- *Such "competitive negotiation" is commonplace on large public projects elsewhere, particularly where an authority and revenue bondholders are involved.*[43]

Christie testified that he had been involved with many authorities around the country and that RITBA conducted its business in a more professional way than most others. When asked what the bridge would finally cost, Dwyer responded "in the general vicinity" of $50 million. The five RITBA members said they were completely satisfied that the arrangement with Perini was proper. They based this on their consultant's advice. Also, the process saved $1 million and enabled the project to continue without delays.[44]

In the end, all seven members of the special investigating commission cleared RITBA of any wrongdoing. DeStefano summed it up. The authority presented a good case. "We should say nothing was found that indicates any impropriety." Fellow Republican Breslin agreed that the authority had "acted in good judgment on this award." Cochran was keeping the investigation open, however, in case anyone wanted to add testimony. There was no need to rush to judgment. Not only could the commission not find any wrongdoing in the Perini matter, but it also endorsed the upcoming referendum. Cochran declared that RITBA vitally needed the additional $7 million in financing and that the upcoming November 8 referendum should not be affected by the commission's investigation, whatever the outcome.[45]

On October 23, 1966, the *Providence Journal*'s editors clearly stated the case for a "yes" vote on the upcoming referendum. They boldly concluded that the "additional $7,000,000 in bonding power" was expected to be enough to finish the bridge. Given RITBA's track record, the editorial writers were going out on a limb. It would also avoid further delays. "A vote of approval for the fifth item on the referendum column to the extreme right of the voting machine will provide reasonable assurance that the bridge will be built on time."[46]

As the votes rolled in on November 8, 1966, it was clear that Chafee had drubbed Hobbs. The count was 210,202 to 121,862, a margin of 63 percent to 37 percent. Rhode Islanders were enamored of their public works–minded chief executive. Chafee carried Newport County by more than two to one. It was also good news for Dwyer, who once again served as the governor's statewide campaign manager. What was good for the two Republican leaders was also good for the Newport Bridge. Bond Referendum No. 5 passed with 117,689 votes in favor and 76,154 against, a margin of 61 percent to 39 percent. Newport voters delivered an eye-popping 92 percent victory margin, 6,994 to 619. Statewide voters were very good to Newport. They also approved $493,000 in bonds for the $1.4 million Cliff Walk Restoration by a count of 108,907 to 87,584. The thorny issue of paying the interest expense on the guaranteed bonds had finally been put to bed.[47]

THE APPROACH ROADS

On October 28, 1966, Rhode Island Public Works Director Marcello released plans for the eastern approach to the bridge through Newport. The proposed route cut a path through the northern section of the historic Point, beginning at Washington and Sycamore Streets, crossing Bayside and Second Streets, and ending at Third and Cypress Streets. The area consisted of 91,180 square feet of land. It would affect eighteen pieces of property owned by sixteen individuals. Marcello confirmed that appraisers would be assessing the value of each property before condemnations would start, which, he estimated, would take two months. The plans did not yet include provisions for the highway extending from the bridge approach to Two Mile Corner in Middletown. The engineering firm of C.E. Maguire & Associates was engaged in designing that roadway. Its specifications were due in a few weeks. Marcello emphasized that the right-of-way presented for the eastern approach was exactly the same as shown at a public hearing in Newport on June 29, 1965, sixteen months earlier.[48]

That same day, the Newport Redevelopment Agency received approval from the United States Urban Renewal Administration to demolish seventy structures along Thames Street between Market Square and West Marlborough Street. It awarded the $135,000 contract to Kidd Construction Company of Tiverton. The buildings between Long Wharf and West Marlborough Street would be razed first. New buildings would be built, and some of the affected businesses would relocate to the new development. Newport's downtown area was about to undergo a major face-lift.[49]

On December 1, 1966, Marcello announced that a new freeway-style road would replace the winding Route 138 and connect the bridges across the bay with the mainland at Tower Hill Road. The improvements were anticipated to be finished in the fall of 1968, coinciding with the proposed completion date for the Newport Bridge. Marcello estimated that the job would cost between $4 million and $5 million. The state needed to acquire a swath of land two miles long and three hundred feet wide. This required condemning thirteen dwellings and one restaurant, mostly in the area of Tower Hill and Boston Neck Roads. The state planned to build the road in two phases. Two eastbound lanes would initially serve two-way traffic. The westbound lanes would be built later, when traffic demands increased and financing was established. Marcello scheduled a public hearing for the proposed roadway for December 16 at North Kingstown High School.[50]

The C.E. Maguire & Associates plan for the Newport landing hit the front page of the *Newport Daily News* on February 24, 1967. It was a divided highway with two lanes and a shoulder running in each direction. It would extend 2.7 miles from the proposed access road at Washington Street to the Valley Road area in Middletown. The extension would require an average of three hundred feet of right-of-way, necessitating the state to acquire forty-three structures that were home to one hundred families, including nineteen units and seventy-six families in the Tonomy Hill Public Housing Development. Also, twenty-seven businesses would need to be condemned, twenty of those in the Connell Highway area near the bridge terminus. The proposed route was one of four the engineers considered. Marcello scheduled a public hearing for March 10 at Middletown High School. The plans would be displayed at Newport City Hall on March 9 and before the hearing at Middletown High School on March 10. Marcello was no doubt preparing for a lively discussion.[51]

Marcello got what he expected. About six hundred people packed Middletown High School and "almost unanimously" criticized the state's proposed access route. The Department of Public Works favored Maguire's Route C. Marcello surprised the audience when he announced that the state would alter the recommended route three hundred feet to avoid Miantonomi Memorial Park and a school maintenance building in Tonomy Hill. Newport residents cheered when Marcello said the change would send the highway right through Festival Field, many happy to be rid of the annual nuisance in their neighborhood. The cheers turned to groans when Marcello added that enough land would remain for the music events. A member of the festival staff was in the audience but reserved comment pending additional review. Marcello said the project would cost $7,499,000.[52]

Some 30 people spoke out against Route C. Jean Vaas, secretary of an opposition group, held a petition signed by 1,270 people. Their concerns included that the route would increase traffic in an already congested area, divide the town of Middletown, and eliminate two potential shopping areas. Many lamented the tax loss on potential business property in Newport. Newport Senator Erich Taylor wanted the state to avoid Tonomy Hill because eventually children would try to cross the highway "and we will have dead children around our necks." Taylor challenged Marcello's statement that the recommended route would clean up Two Mile Corner. Not without "dumping dirt under the rug at Valley Road," Taylor said. Besides, Taylor claimed, residents had already approved the Coddington Highway route when they voted for the bridge.[53]

Jerome Kirby, chairman of the Middletown Planning Board, claimed that the recommended route "decimates Middletown's area for potential development," adding that "it would be a dollars and cents disaster." He favored Route D. So did Middletown Senator Joseph Chaves, who noted that the navy and the state airport already consumed much of the town's prime land. Walter Crimmins, an Indian Avenue resident, suggested using the railroad right-of-way that went through the navy base. The navy's representative, George Sullivan, was jeered when he reported that the navy favored the recommended route. Middletown Town Council President Howard Lawton said it was the first time he ever heard the navy take a stand on any local issue.[54]

Three days after the hearing, the state announced that it was abandoning plans for an exit leading directly into the Point. Henry Sherlock, assistant to Marcello at the Department of Public Works, said the elevation of the bridge was too steep for an exit at landfall. Sherlock said traffic would not be routed through the Point whether the proposed Memorial Drive extension was completed or not. That extension was originally pegged to be built in conjunction with the opening of the bridge. Now, however, the extension was dependent on the urban renewal demolition on Thames Street. Sherlock said that the bridge exit for Memorial Boulevard would remain unfinished until the extension was completed. That exit was to handle southbound traffic into Newport's center. As a temporary measure, southbound traffic would exit at the Admiral Kalbfus rotary and be directed south on existing roads. Traffic patterns in the Point section would remain as planned.[55]

Opponents and proponents would continue to square off over access roads well into the following decade. At the opening ceremonies for the bridge, Governor Licht highlighted the problems associated with the access roads and expressed his hope that they would be resolved swiftly. In early 1967, however, access road concerns would be dwarfed by the soon-to-be-unleashed controversy over newly announced cost overruns.

ONE MORE FOR THE ROAD:
SPIRALING CONSTRUCTION COSTS

The bridge builders made progress on the substructure during 1966. As the foundations for the bridge were being built hundreds of feet below Narragansett Bay, Governor Chafee and Dwyer confronted another bout

of bad news. Like the bridge location battle that raged in the fall of 1964 and the winter of 1965, a new controversy flared up immediately following a successful statewide referendum vote. Dwyer would later claim that he did not know that RITBA would need more money before Election Day but found out pretty soon thereafter. He confessed that he knew by November 17, though, and by extension, Chafee no doubt knew shortly after that. So, just one week after formally mopping up the interest expense and competitive bid flare-ups, the proponents knew that they were sitting on another powder keg. Just prior to the November 8 referendum, Dwyer reassured legislators, opinion makers, and voters that $7 million would be sufficient to finish the job. Now, it looked like another cost estimate misstep was about to plague the authority.

Parsons Brinkerhoff delivered the news in a report dated January 7, 1967, and titled "The Rising Costs of the Newport Bridge." In an eleven-page, typewritten document, the engineers presented a history of the bridge's construction costs from September 1964 to date. In the fall of 1964, the engineers estimated that the bridge would cost $39,085,000. That did not include "off-site testing and inspection, subsurface investigations and tests, legal and administrative costs, initial operating expenses, miscellaneous equipment and supplies, financing costs, interest during construction, nor did it include the traffic engineer's report." The figure was based on information available to the engineers at that time, including bids received on similar projects from around the country, estimates from steel fabricating companies, and discussions with other construction professionals. Between then and January 1967, delays resulting from each controversy had a negative impact on the cost of the bridge. First there was the five-week delay between the successful statewide referendum approving a bond issue in November 1964 and the resolution of the bridge location fiasco that followed. A protracted five-month delay began in January 1965 as a result of asking the Rhode Island Supreme Court for an advisory opinion on whether tolls from the Mount Hope Bridge could be used to pay off construction bonds for the new bridge. That request resulted in another referendum on June 22, 1965, that also capped the limits on revenue and guaranteed bonds. Bids on the substructure were delayed until August 11, 1965, "which resulted, for all intents and purposes, in the irretrievable loss of an entire construction season."[56]

The receipt, selection, and subsequent awarding of the substructure work prompted the meeting in Chafee's office on September 1, 1965. The governor asked the engineers if they could "guarantee the price of the

steel for the superstructure." They responded then that they could only do so if the contract was let immediately or in the near future. It was delayed until April 21, 1966, a gap of seven and a half months. Also in September 1965, the engineers revised their estimate for the bridge to $45,010,000. On September 27, 1965, the engineers wrote to RITBA expressing their concern "with what was apparently a developing inflationary trend." They warned the authority that spiraling costs could affect their estimates. In April 1966, this came true, as the superstructure bids came in higher than the engineers' estimate—this despite the engineers' reliance on pricing suggested by Bethlehem Steel in August 1964 and reconfirmed in August 1965. On July 28, 1966, Parsons Brinkerhoff adjusted its estimate to slightly more than $49 million.[57]

By the summer of 1966, costs throughout the construction industry were rising at an alarming rate. On June 30, 1966, the *Engineering News-Record* published an article citing increases in construction costs ranging from 16 percent to 231 percent higher than engineering estimates. This complemented an earlier editorial in the same journal on March 24, 1966, titled "Inflation: We've Got It." Parsons Brinkerhoff attached both articles to its write-up. The point being that the Newport Bridge was not the only project suffering from inflation. The Manhattan and Queens subway under New York's East River was a perfect example. In January 1965, engineers estimated that project at $21.8 million. The contract was awarded eight months later at $56.4 million, an increase of more than 159 percent. The World Trade Center was being built at the same time. In 1963, the original estimate was $270 million. It was subsequently raised to $360 million. In September 1965, the estimate jumped to $525 million, and by December 1966, the figure had gone up to $575 million. State officials were unofficially pegging the final cost at $650 million. The Delaware River Port Authority had similar issues. It was building two bridges in the Philadelphia area. On December 8, 1966, that authority announced that the costs of the bridges escalated from $105 million to $129 million in thirteen months "because of increased labor, materials, and financing costs." Part of the blame for these rising costs was the Vietnam War, which had elevated the demand for material and human resources.[58]

The engineers summarized the general picture: "Civil and structural materials, electrical and other material components, construction equipment, and labor wages and fringes, when studied, in retrospect, all show big jumps that few persons, if any, really anticipated." For example, wages for job categories working on the Newport Bridge—such as laborers, carpenters,

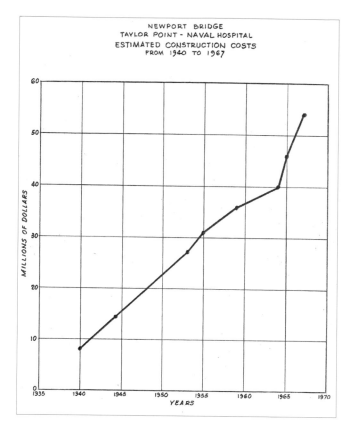

NEWPORT BRIDGE
TAYLOR POINT - NAVAL HOSPITAL
ESTIMATED CONSTRUCTION COSTS
FROM 1940 TO 1967

In December 1966, engineers prepared a report detailing the rising costs of construction. The issue required proponents to seek a fifth approval from statewide voters to cover the increase. *Courtesy of RITBA.*

iron workers, electricians, operating engineers, and teamsters—had increased between 21 percent and 25 percent since Parsons Brinkerhoff first estimated labor costs. The engineers illustrated the cost impact of delays on the Newport Bridge between 1940 and 1967 with a hand-plotted graph depicting costs for a crossing between Taylor Point and Washington Street. Parsons Brinkerhoff had delivered eight such studies during that timeframe. The cost in 1940 was in the $8 million range. Twenty-six years later, it was approaching $53 million. The latest climb was most disconcerting. Between 1964 and 1967, the cost to build the Newport Bridge had jumped 2.67 times from what it had been before 1964.[59]

By late January, Dwyer knew that he was confronting another serious challenge. He had no doubt fully digested the engineers' January 7 analysis and delivered the news to Chafee. RITBA presented the governor with a typewritten schedule of costs dated January 20, 1967. The total construction cost was now calculated at $53,257,000. An additional $830,000 was needed for offsite testing, subsurface investigation, miscellaneous equipment, initial

operating expense, and legal and administration costs, boosting the price to $54,087,000. When temporary interest and financing costs were added, the total amount was $59.9 million. About $3.9 million would be offset by interest earned and other paid items. RITBA needed to finance $56 million for the bridge, 18 percent higher than the $47.5 million requested. RITBA had $51 million approved for bonds, $17.5 million of which was guaranteed by the state and $33.5 million in revenue bonds. As of January 20, 1967, the proponents knew that they needed another $5 million to pay for the bridge.[60]

Within two weeks, RITBA received bids for two smaller jobs. These included paving the 2.2 miles of roadway deck and building the Jamestown terminus. The lowest bid from five competitors for the roadway deck job was submitted by Coleman Brothers Corporation of Readville, Massachusetts, at $2,452,150. The lowest offer of several bids for the Jamestown terminus work came from Providence-based M.A. Gammino Construction Corporation at $854,152. The smaller jobs remaining included toll collection equipment, electric wiring, and an administration building. These were expected to be in the $700,000 range.

Dwyer used the opportunity to leak his concerns to the press and drop the bombshell that he knew he would eventually have to disclose: RITBA needed more money to finish the bridge. When asked if there was anything that could be trimmed from the work to lower the costs, Dwyer replied that it would amount "to peanuts." Dwyer planned on reporting the emerging issue to the special investigating commission established the previous fall. That was the appropriate action, he believed, if RITBA needed additional funding to complete the bridge, which was now a "definite possibility." As soon as the authority knew how much would be needed, it would present it to the investigating commission because "its members were well informed on the bridge['s] financial intricacies."[61]

Dwyer held on to Parsons Brinkerhoff's ten-page report for another three weeks before releasing it during the week of February 20, 1967. On February 23, RITBA Executive Director Canning reaffirmed the bad news. He said he did not yet know how much was needed. He anticipated receiving a figure within the upcoming two weeks. RITBA required statewide voter approval to expand borrowing needs. That meant another referendum. RITBA would begin working with the General Assembly within the following weeks to begin the process. It would be the fifth referendum presented to Rhode Island voters on the bridge since 1960 and the third in two years. Canning also said the bridge was running "one month to six weeks" behind schedule.

The new date for the bridge to be completed was moved four to six weeks out from its previous Labor Day 1968 target.[62]

On March 1, 1967, Dwyer announced that RITBA needed an additional $6,665,000 to finish the bridge. He emphasized that all bonds would be eventually paid off by toll revenues, not by taxpayers. The state had no choice but to approve additional funding, Dwyer said. "What's the choice?" he asked. "Stop construction on the bridge? Or even delay it and leave all your construction costs to continue to spiral?" He added, "You've got to have the bridge completed and you've got to protect the state's credit." Dwyer explained the reasons for the additional funds using facts and figures from the engineers' January 7 report. He had met with the Newport legislative contingent the previous evening. They would prepare and submit legislation to the General Assembly for another referendum, which, he hoped, could be scheduled early in the summer and the bond issue let by early fall. "You have a delicate timetable," Dwyer said. "Any delay," he cautioned, would "cause great problems." He did not anticipate any changes to the proposed tolling plan of a one-way trip for $1.70 or ten trips for $10.[63]

Chafee held his tongue on the matter for ten days before finally publicly expressing his feelings during a weekly press conference. He felt "badly let down." He laid the blame on Parsons Brinkerhoff. "To say I am disappointed with the engineering firm that made these cost estimates is an understatement," the governor said. It was the engineers' job to provide them, and they got it wrong. Rising construction costs were not an excuse. "Anyone can tell you what costs will be a month from now," Chafee said. "Their job was to tell us what the costs would be during construction." He was clearly upset and disappointed, especially since the state had just been through the experience of asking voters to approve additional borrowing power for RITBA. "They said they needed three million dollars and we gave them seven," he recounted, "and they came out of here radiantly happy." He added that now, no sooner than the November referendum was over, "they tell us they are short." It was extremely discouraging. However, the governor emphasized, "We have to finish the bridge. We will do what we can to have it passed and approved." Chafee said that he hoped the traffic estimates proved as much understated as the construction costs were underestimated. Speaking for the engineering firm, Howard Mandell admitted that it was wrong. He characterized the inflation of costs on the Newport Bridge as typical of other construction projects. "There have been some very wrong guesses a lot worse than ours," he added. It was unlikely that helped ameliorate the governor's disposition.[64]

Dwyer was also under scrutiny for the numerous and continual underestimates. Some wondered if he intentionally presented lower projections to obtain approval, knowing that the actual costs would be higher. He had been wrong so often. Dwyer himself recognized that some people might think he was wrong intentionally. "Up to now, every figure the turnpike authority has announced has turned out to be badly underestimated," proclaimed *Providence Evening Bulletin* writer Paul A. Kelly. In three years, the amount of financing to build the bridge had leaped from $47.5 million to $61 million. Bridge skeptics could easily have drawn the conclusion that RITBA "did not dare to break to taxpayers originally the real cost of the bridge for fear they would reject the whole thing." Rather, they suspected that the authority broke the news gradually, operating under the premise that once the project was underway it would be difficult to stop. It kept raising the ante from one referendum to the next. Dwyer denied the allegations. He believed the General Assembly and the voters would have approved the bridge at higher original estimates. He maintained that "there was no reason for not putting a higher figure on the cost: if they had known." He remained optimistic that traffic estimates would justify his faith in the project. Dwyer remained adamant. "There is no doubt about it," he concluded. "This still is a project that will pay for itself."[65]

On April 4, 1967, the Rhode Island General Assembly House Corporations Committee approved RITBA's request for a $10 million referendum. The bonds would be guaranteed by the state to enable RITBA to obtain more favorable financing. The bill also clawed back $3.5 million in revenue bonds that the voters approved the previous November. They were no longer needed. The $10 million referendum included $6.5 million to cover the cost of the overruns plus $3.5 million for the revenue bonds being vacated. The vote was slated for June 29.

The Newport Bridge was not the only state infrastructure construction project running above budget that spring. The parallel span of the Washington Bridge between Providence and East Providence was costing $1.6 million more than engineers predicted—25 percent higher. It, too, was long delayed. The estimate of $6,339,000 looked like it would come in at $7,938,123. Ten construction firms reviewed the specifications when the plans were released, but only three firms bid on the job. Public Works Director Marcello planned on discussing the problem with federal officials at an upcoming highway conference in Baltimore in mid-April. Likewise, the state was building a new office complex for the Department of Health. It required voter approval for bonds similar to the Newport Bridge. In June 1966, voters approved bonds

The Newport Chamber of Commerce placed ads urging voters to approve the June 1966 referendum rather than ending up with an unfinished bridge. *Courtesy of the* Newport Daily News.

for $6.7 million. Now they would be asking voters to approve an additional $3 million in funding. The Department of Health request was not the result of a low estimate, though. New federal programs had become available, and the administration wanted to alter its architectural plans to accommodate them. Regardless, publicity about the two projects may have lessened criticism directed at Dwyer and the bridge engineers.[66]

As the referendum date approached, the opinion makers understood that voters had to approve the increased borrowing. Bridge opponents were also in the same camp. A majority in the General Assembly passed the bill for the referendum without much dissent. They accepted "the fact that the bridge, unless rushed expeditiously to completion, cannot earn a cent of revenue, in which case the whole bonding process would collapse and the state would be in a genuine pickle." One long-standing bridge opponent said that the referendum must be passed and approved, otherwise the state would "wind up with the highest diving platform in the world." The editorial writers concluded that "voters had no other practical resources but to approve it" to protect the investment they had already made.[67]

Once again, the proponents claimed that this would be the last time they would be requesting approval for additional funding. Anyway, there was less than $800,000 in contracts remaining. The statewide voters agreed. On June 29, they approved the referendum by a vote of 17,556 to 11,889. Despite near perfect weather, it was the lightest voter turnout in recent years. Dwyer would later point out that more people from Newport voted for the bridge that day than voted in Providence, "and there were six other referendums." For the first time, it seemed as though everyone was on the same page: bridge financing must be approved…no matter what the circumstances.[68]

Meanwhile, in the middle of Narragansett Bay, Perini Construction Corporation was completing the substructure for the magnificent suspension bridge that would finally link Jamestown and Newport.

Chapter 6

BUILDING THE BRIDGE

THE ENGINEERS

As Gerry Dwyer and John Chafee confronted and dispatched one political controversy after another, Alfred Hedefine, of Parsons Brinkerhoff, proved to be a steady and reliable partner. He and his firm dedicated at least thirty years to seeing a bridge over Narragansett Bay's East Passage. They had been involved since the mid-1930s through their work on the Jamestown Bridge. Parsons Brinkerhoff dutifully prepared one design after another to satisfy their client's varying requests. The engineers placed the count at thirty-five. Hedefine directed the firm's efforts on many of them. He was well prepared for the job.

Hedefine was born in Newport News, Virginia, in 1906. He studied civil engineering at Rutgers University, graduating with a Bachelor of Science degree in 1929, and received a Master of Science degree from the University of Illinois in 1931. Deposited into the workforce in the midst of the Great Depression, Hedefine was fortunate to find a job in the construction industry operating a pile driver on a power plant job in Brooklyn. After a year, he landed a temporary assignment checking bridge calculations for the Waddell & Hardesty engineering firm. He promptly impressed Dr. Shortridge Hardesty and was rewarded with a job working on the Mill Street drawbridge on Brooklyn's Belt Parkway. He subsequently worked on the Marine Parkway vertical lift bridge in Brooklyn, the Rainbow

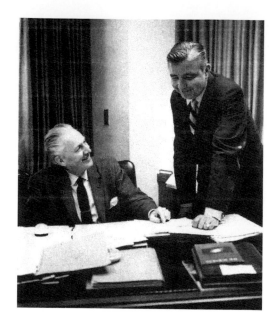

Parsons Brinkerhoff's chief engineer, Alfred Hedefine, and RITBA Executive Director James Canning pore over details of the bridge. *From Parsons, Brinkerhoff, Quade & Douglas, "The Newport, Rhode Island Suspension Bridge: A Better Way to Cross the Bay," courtesy of RITBA.*

Arch over Niagara Gorge, and the St. George's Bridge over the Chesapeake and Delaware Canal, "each of which established new standards of excellence in the bridge design for its type." Later, Hedefine was selected to prepare the structural design for the iconic Trylon and Perisphere for the 1939 New York World's Fair—a seven-hundred-foot-tall spike and a two-hundred-foot hollow globe. It was an unprecedented structure for which Hedefine would receive the 1942 Thomas Fitch Rowland Prize from the American Society of Civil Engineers for documenting the project.[1]

Like Chafee and Dwyer, Hedefine was a member of the "Greatest Generation." He served in the U.S. Army Air Force's Strategic Air Command from 1943 to 1945. On June 21, 1943, Hedefine joined the Bombs and Fusions Selection Subsection of the Eighth Air Force, where he helped convince headquarters that bombing effectiveness could be increased by using incendiaries on specific targets. The subsection also developed and manufactured aircraft improvements to handle increasing loads by clustering bombs on racks. Hedefine later published a report on the raid at Marienburg, Poland, one of the Eighth Air Force's most accurate and damaging missions. Hedefine was subsequently trained to deliver briefings to the morning OPS (operations) conferences, during which one member from his subsection would provide training on the science of selecting bombs and fuses.[2]

After the war, he left Hardesty & Hanover, successor to Waddell & Hardesty, because of a philosophical dispute with his former employer over alternative business development strategies rather than relying on the traditional practice of engineering firms winning assignments based on reputation. Hedefine joined Parsons Brinkerhoff in 1948 as principal associate and head of the Bridge Department. He became a partner of the firm in 1952 and was named president in 1965. During his tenure at the engineering firm, "he was responsible for pioneering efforts in planning, design, and construction of bridges, tunnels, rapid transit systems, airfields, and marine terminals throughout the world." Hedefine's crowning bridge project was the Newport Bridge.[3]

Hedefine's report writing and presentation acumen contributed to a rich trail of engineering reports detailing the design and construction of the bridge. Between 1940 and 1965, Parsons Brinkerhoff continuously analyzed locations and span configurations for a proposed bridge. As we have seen, the U.S. Navy influenced height and placement requirements. The engineers considered tunnels and two- or four-lane cantilever and suspension bridges, as well as a combination of both. In the end, it settled on the suspension bridge to accommodate the 1,600-foot horizontal span and vertical clearance of 212 feet.[4]

The engineers adopted several design and construction innovations. They listed them in their internal publication:

- First use of shop fabricated parallel-wire strands to comprise the main cables;
- New plastic cable covering to protect the main cables from corroding;
- New cable anchorage system using long pipe assemblies encased in each anchorage's concrete piers;
- First use on a bridge of shop-applied, two-component epoxy paint;
- Elimination of most initial field painting except for contact surfaces;
- Use of shop-welding and field-bolting, reducing riveting to less than one percent; and,
- Pile driving in water 162 feet deep.[5]

The engineers became well acquainted with the geographical features of the bay, known as the Narragansett Carboniferous Basin. They knew that glaciers played a formative role in developing the bay and that they would be confronting upper rock strata composed primarily of sandstone, shale, and anthracite. They were also aware that the sedimentary rocks were

"more susceptible to erosion than the crystalline rocks" that surrounded them. Consulting geologist Frank Fahlquist would later tell bridge builder Nate Brownell that the bedrock profile of Narragansett Bay looked like a Scandinavian fjord with steep slopes and deep valleys.[6]

In early 1964, the engineers conducted detailed analyses of the proposed crossing site from Taylor Point to Washington Street, including a geophysical survey and boring program. They used the sparker method to obtain information about Narragansett Bay's subsurface. This entailed sending and receiving high-frequency electronic waves to determine underwater soil and rock formations. They analyzed three parallel paths: one along the proposed alignment of the bridge and the others one hundred feet on either side of the anticipated alignment. The results contributed to mapping out the boring program. Engineers bored sixty-two four-inch holes ten feet apart in the bay's floor to recover split-spoon soil samples. When they hit bedrock, the engineers extracted core samples to a minimum of ten feet into the rock (up to fifty feet in some areas) using a diamond drill and sent them to the laboratory for soil testing. While they were taking the samples, Nate Brownell said, "The deep tidal current pressed so hard against the drill, even though it was encased in eight-inch pipe, it bulged like a bow and could not be raised or lowered until the tide slacked."[7]

The engineers developed an accurate schematic of Narragansett Bay's bottom along the path of the bridge. The most prominent feature was a deep gorge in the vicinity of the bridge's center span. The top of the bay's rock foundation rested 430 feet below sea level just east of the main span's centerline. To the west of the centerline, bedrock sat around 100 feet below the water and rose gradually on a uniform slope toward Jamestown. The soil above the rock foundation was primarily sand mixed with silt and gravel. In the deep gorge, though, an added element of "stiff" clay was sandwiched between the rock and sand. The engineers found the rock on the Jamestown side of the centerline to be "thinly laminated shale with quartz veins." To the east, the bay's bottom dropped from 40 feet below the surface at low tide to 430 feet in a relatively short distance, 1,200 feet. To the Newport side of the gorge, at the top of the slope, the boring program uncovered small deformities in the shale, "indicating folding and crumpling," as well as large amounts of carbon. Farther east, the rock was much harder, composed of sandstone and shale and containing only small amounts of carbon. The engineers tested the rock "to establish allowable bearing pressures and coefficients of friction against sliding." From there

to the Newport shore, the rock bottom "undulates gently," varying between 25 and 50 feet below the surface.[8]

With a good idea of what they were dealing with under Narragansett Bay, the engineers focused their attention on what to build above the water. They focused their attention next on what to build above the water. The determining factors were aesthetics and economics. This continued a Parsons Brinkerhoff tradition established by the firm's founder, William Barclay Parsons. Parsons believed that there "must be a background of culture to produce a mental poise to accomplish such a tremendous task that shapes the lives of persons and nations." Furthermore, the founder declared, "It is not the design that governs [a project] but its adaptability to the economics and social needs of the time." The engineers that designed and built the Newport Bridge understood their responsibility:

The incredible process by which tons of steel, a seemingly unending flow of concrete and other items became a slender, graceful suspension bridge, aesthetically worthy of its environment, and completely capable of doing its assigned job, is the essence of civil engineering. True, planning and

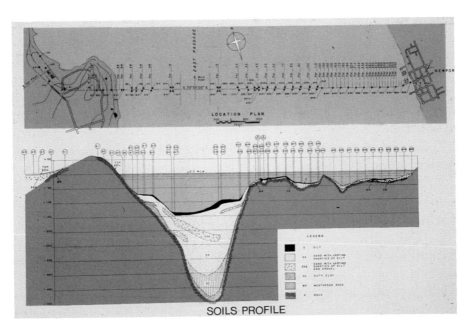

The engineers mapped out the bottom of Narragansett Bay, with its deep gorge dropping to 430 feet just east of the bridge's main span's centerline. *Courtesy of RITBA.*

architecture must cooperate in setting the goal and suggesting how the structure will fit most pleasingly and usefully into its assigned position.[9]

The engineers knew they needed to accommodate a span of at least 1,600 feet. A cantilever structure would not work. That would have been one of the largest cantilever bridges in the world and would have been too costly to build. The engineers decided on a suspension bridge. Hedefine and team considered designing a main span of 2,600 feet. Doing so, they could have avoided the deep gorge and placed the tower piers in shallow water, which would have saved money. A span of such length, though, would demand large anchorages. The costs of the longer span with sufficient anchorages would have outweighed the benefits gained from a shorter span. Hedefine's team also considered and dismissed a span of 2,300 feet, because it, too, would have been more expensive than the 1,600-foot span.[10]

The engineers designed the Newport Bridge with long side spans to achieve "aesthetically pleasing proportions." Each side span would be 688 feet long. On the Jamestown side, the engineers planned three continuous deck truss spans each being 992 feet long. Six shorter deck plate girder spans, each 140 feet long, connected the bridge to three steel stringer spans, each 100 feet long, leading to the Taylor Point terminus. On the Newport side of the center span, the side span was connected to three continuous deck truss spans, each 992 feet long, just like the Jamestown side. Traveling east, two simple deck trusses, each 238 feet long, connected to twelve deck plate girders, each 140 feet long, followed by twenty 100-foot stringer spans rolled into the Washington Street terminus. The engineers designed the maximum grade of the roadway to be 4.8 degrees.[11]

The piers on the Newport Bridge are designated by their position from the center span. On the Jamestown side, the tower pier is 1W. The next pier heading to Jamestown is 2W, followed by 3W, and so on. On the Newport side, the tower span is 1E, and subsequent piers heading east are 2E, 3E, and the like. Suspension bridge cables are secured to an anchorage on one side, travel over one of the main towers, descend toward the roadbed, ascend up to the other main tower, cross over the second tower, and are secured to an anchorage on the other side. For the Newport Bridge, the engineers designed cable bents at piers 2W and 2E and the anchorages at 4W and 4E. Because ships could pass under any of the spans, the engineers were concerned about the vulnerability of the cables between the cable bents and the anchorages, so they designed a barrier of protection around the anchorage. A cluster of three cells filled with granular material would protect each anchorage. The

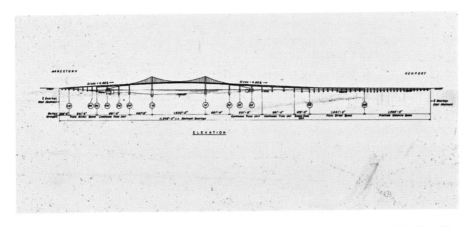

The elevation of the Newport Bridge highlights its 1,600-foot center span and 688-foot side spans. *Courtesy of RITBA.*

interconnected circular cells made it "relatively certain that, in the unlikely event of the cables being struck" by a ship, "damage would be suffered only by the vessel."[12]

The engineers knew well that Narragansett Bay was susceptible to hurricanes and swift floods. They were concerned about potential scouring at the bridge footings, particularly around the main tower piers. At the time, the United States Army Corps of Engineers was developing hurricane protection proposals for Narragansett Bay. To assist the analysis, the army built a model of Narragansett Bay at the Waterways Experiment Section in Vicksburg, Mississippi. The army allowed Parsons Brinkerhoff to use the model to simulate water velocities and scouring effects near the main piers during major storms. It reproduced conditions in the bay of the September 1938 hurricane's peak surge (10.8 feet) synchronized with a spring tide (4.1 feet) to assess the impact of a maximum surge. The engineers used the results of the simulation to design specific criteria for the backfill and riprap of loose stones and cement pieces to protect the pier footings against scour and erosion.[13]

With the design of the substructure in place, Hedefine's team turned its attention to the superstructure. The roadway would be forty-eight feet wide flanked by three-foot safety walkways with one-foot-high curbs. Based on the results of aerodynamic analyses, including wind tunnel tests on a model of the suspended span performed at the applied mechanics laboratories of the Bureau of Public Roads in McLean, Virginia, the engineers incorporated slots in the curbs of the spans six inches high by three and a half feet long,

spaced every four and a half feet. The bridge's railings would be three feet, six inches high. The rail posts would be a slender two inches in diameter and spaced as Chafee had suggested so that travelers would get spectacular views of Narragansett Bay as they crossed. The main cables would be sixty-six feet apart. Each would be fifteen inches in diameter and covered with cable wrapping one-eighth of an inch thick. The cables would sag at a 1:10 ratio at the main span. Suspender ropes were to be placed every forty feet and would consist of four ropes each, one and seven-eighth inches thick. The deck was to be stiffened by trusses sixteen feet deep.[14]

The main towers are the most visible elements of a suspension bridge. The engineers designed the Newport Bridge's towers in the form of Gothic arches, uncannily similar to Roebling's arched towers on the Brooklyn Bridge. Each tower would rise four hundred feet into the sky and be eighty feet wide. Tower saddles, cables, hoods, and aerial beacons would top off each tower. They would be of cruciform cross-section construction for maximum resistance to the forces of nature. The legs would taper from top to bottom, from twelve by twelve feet to twenty-one by fifteen feet, eight inches at the base. The two legs of each tower would be connected by three horizontal struts or panels—one at the top, a second immediately beneath the roadway, and a third between the roadway and the water. The sections could be welded at the shop and applied to the bridge using high-strength bolts. Each tower would have an elevator for access from the deck to all other levels.[15]

The bridge was designed to withstand winds of 100 miles per hour. The main span, however, was prepared for winds up to 150 miles per hour, while some elements, "such as individual panel loads to lateral systems," could handle gusts up to 170 miles per hour. Hedefine's engineers designed the bridge for a temperature of 68 degrees Fahrenheit, accommodating highs of 118 degrees and lows of 2 degrees. They also designed the bridge "to withstand stream flow at velocities resulting from hurricane surge" and from ice pressure ten inches thick. When completed, the bridge towers would be painted silver and the rest light green.[16]

In October 1965, Hedefine presented the bridge's design to the Newport Rotary Club. He estimated that the bridge would consume 47 million pounds of steel and 250,000 cubic yards of concrete. "Enough steel to build a string of automobiles bumper to bumper from Jamestown Ferry through New York City and halfway to Philadelphia." Hedefine was later asked what had impressed him the most about the Newport Bridge. He replied, "Everything, actually—no singular aspect of the project can be said to be

more significant than the other. After many years of interest and active participation in a large work such as this, one acquires, mostly through the process of retrospect, a perspective toward it in which everything is seen in relation to the whole, much akin and harmonious." Hedefine was pleased and proud of his signature work. This was the bridge that was being constructed over Narragansett Bay's East Passage beginning the last week of December 1965.[17]

The rest of the Parsons Brinkerhoff team possessed equally impressive credentials. Herbert Mandel was the project manager. He had twenty years of civil engineering experience under his belt when the Newport Bridge was built. Described as "imperturbable," Mandel had previously been in charge of numerous bridges and other projects, including New York's Grand Central Parkway, Connecticut's Interstate 84, and rapid transit systems in Atlanta and Chicago. Upon completion, he praised the collaboration of the field staff, the contractors, and the client that "worked effectively" to complete "a comprehensive project" like the Newport Bridge.[18]

John W. (Jack) Kinney served as resident engineer. He had just completed chief construction engineer responsibilities on the Verrazano-Narrows Bridge. Kinney was impressed by the innovations employed during the

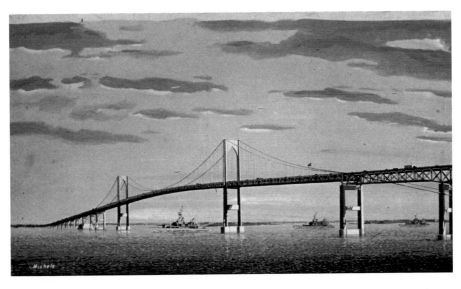

The 1965 engineering report provided a realistic rendition of what the bridge would look like upon completion, replete with a naval convoy. *From Parsons, Brinkerhoff, Quade & Douglas, Engineers, "Proposed East Passage Crossing of Narragansett Bay, Engineering Report of 1965, September 1965," courtesy of RITBA.*

construction of the Newport Bridge, noting that "there have been more new methods used on the Newport Bridge than on several larger bridges; many of them have been entirely successful and will be used again." He lamented that "some will no doubt require further refinement." Nevertheless, he added, "All of the innovations have required a fresh approach and have kept all of us on our toes."[19]

Louis G. Silano was responsible for the design and preparation of contract plans and specifications. He collaborated with Hedefine and Mandel in documenting and publicizing the design and engineering details to fellow professional engineers. Ahmet Gursoy designed the superstructure. Chu-Ping Tu designed the foundation, while Louis J. Benjamin served as electrical designer, which meant he was responsible for lighting, traffic signals, and tower elevators. Gursoy said the project coincided with the "coming of maturity" for some of the team. "The forces of nature that had to be coped with," he elaborated, "were beyond the ordinary." He summed up the experience succinctly: the Newport Bridge was the "kind of challenge that capture[d] the imagination of every creative engineer."[20]

Alfred Hedefine and members of his Newport Bridge team gathered for a photo under the watchful eye of the firm's founder, William Barclay Parsons, chief engineer of New York City's first subway system and the Cape Cod Canal. *From Parsons, Brinkerhoff, Quade & Douglas, "The Newport, Rhode Island Suspension Bridge: A Better Way to Cross the Bay," courtesy of RITBA.*

THE SUBSTRUCTURE

On December 23, 1965, the proponents received an early Christmas present. One of the first visible signs confirming that the Newport Bridge was finally under construction was the sight of Perini Construction Corporation's workmen preparing a barge with one-hundred-foot "H" beams for test piles and a three-legged platform. The barge was docked at Fleet Landing in Newport. On December 28, the bridge builders planted the first of three observation piers for perspective purposes on the Jamestown side of the gorge. Two more would soon follow: one on the Newport side of the channel and the other off Gull Rocks near the Naval Hospital. Material for the bridge was accumulating at Fleet Landing. Two railroad carloads of H-beams had already arrived at the wharf. Perini Construction had established an office there, and a second was planned for the bridge engineers.[21]

The bridge makers soon began driving piles into Narragansett Bay's rock bottom to build the foundations for the main towers. Pier 1E, which would support the tower on the Newport side of the center span, was built at a spot where the Bay's floor was 100 feet deep. The boring tests conducted the previous February revealed that the top of the rock was buried 330 feet farther below layers of sand and silt. The bottom of the footing was placed at 132 feet below sea level. Since it was impracticable to drive piles that were 300 feet long to reach the bedrock at 430 feet, the engineers opted to place the footings on a series of piles driven into a compact sand stratum located at 205 feet below the water. The bridge builders sank 512 friction piles, each averaging 90 feet in length and designed to carry eighty tons of load per pile, to support the 68- by 134- by 30-foot-high footing. The tops of many piles needed to be leveled off by an underwater cutting process.[22]

Pier 1W on the Jamestown side of the center span dropped down 140 feet below sea level before it hit the bottom of Narragansett Bay. The top of the rock that would secure the pier's foundation was another 80 feet below that, or 220 feet below sea level. In between was 60 feet of medium to fine sand with traces of silt and gravel. The bottom of the footing would be placed 162 feet below water level and would be 32 feet in height. Since it was practical to drive 60-foot piles, steam hammers pounded in 326 piles, each designed to carry 135 tons. The pile driving at 162 feet was the deepest ever attempted. These piles also had to be leveled off.[23]

The bridge builders' efforts to cut the tops of the piles was difficult and dangerous because of the deep slope of the gorge, water temperatures

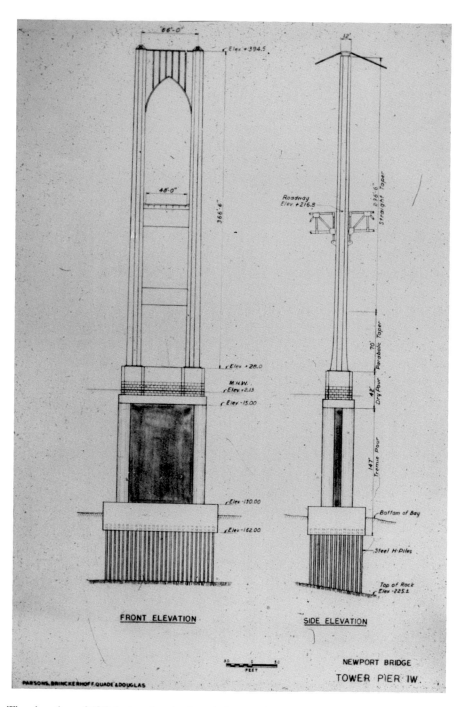

The elevation of 1W depicts the pier foundations and the tower design, channeling Roebling's Brooklyn Bridge's Gothic arches. *Courtesy of RITBA.*

continuously below thirty-five degrees, and water pressure of ten thousand pounds per foot. At first, they tried conventional techniques. The average time a person could work on the bottom of the bay was thirty minutes. The rest of an eight-hour shift was spent ascending and descending. There were 1,286 piles in the five footings. Many required cutting. The bridge makers eventually used a Westinghouse saturation diving unit composed of a diving bell and a connecting chamber that allowed teams of pile cutters to remain under air pressure for a week at a time while working six hours per day. This increased production to cutting 15 piles per day compared to 2 per day by the conventional diving method.[24]

Building the foundations for the tower piers required engineering and bridge building wherewithal. The engineers believed that the usual floating caisson method would be too expensive given the depths to which the forms had to sink. After considerable study, Hedefine's team settled on a floating caisson method, "employing a hollow pier structure with walls and footings of structural concrete—poured by the tremie method and supported by steel piles penetrating deep into the bay bottom." The tremie method places concrete under water through a pipe. The pipe's lower opening remains immersed in the newly poured concrete. As the concrete rises, it fills the form while displacing the water.[25]

Setting the prefabricated footing forms was a massive undertaking. The bridge makers pounded in eight guide pipes to position each footing form. The guide pipes were thirty-six inches in diameter. The forms were rectangle boxes 68 by 138 feet. They weighed four hundred tons apiece. The forms contained built-in sleeves that lined up to the guide pipes. The sleeves were forty-two inches in diameter. The boxes were floated out to the main tower locations. The forms were then lifted onto the guide pipes and lowered slowly to the bay's bottom. The Perini Corporation needed special equipment to lift the forms onto the guide pipes. It called for the Avondale Senior, one of the largest floating hoist machines on the East Coast. It was a twin-boom unit capable of lifting up to five hundred tons. The bridge makers brought the device up to Narragansett Bay from New Orleans.[26]

The next challenge was to place the pier shafts on the footings. The Avondale Senior also came in handy for that job. Each pier shaft was made up of four fourteen-foot cylinders connected together by four-inch-thick walls. The cylinder forms were spaced eighty-eight feet apart in the transverse direction and twenty-two feet, eight inches apart in the longitudinal direction. Pier 1W's shaft was 105 feet high, while Pier 1E's was 77 feet tall. The shaft forms were built by Bethlehem Steel at

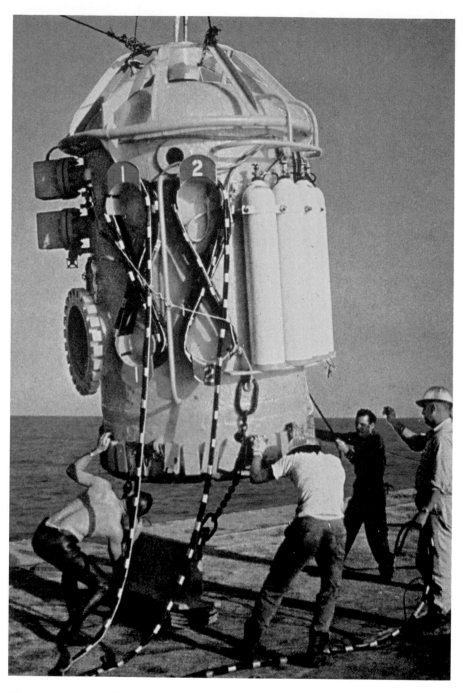

Workers prepare the Westinghouse diving bell that enabled underwater pile trimming efficiency improvement from two per day to fifteen per day. *Courtesy of RITBA.*

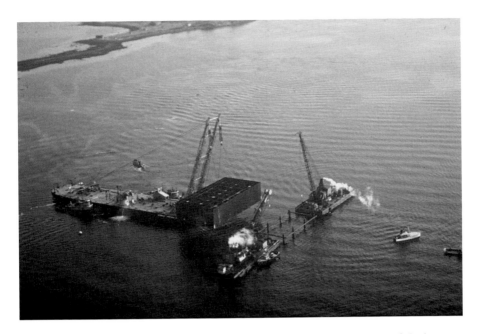

The bridge builders summoned the Avondale Senior from New Orleans, one of the largest floating hoist machines available, to help set the foundation frame and foundation forms. *Courtesy of RITBA.*

its Sparrows Point, Maryland shipyard and towed to the Narragansett Bay bridge site. The forms were braced internally "to ensure rigidity and structural integrity." They were equipped with air and water valves to control the sinking process.[27]

The Avondale Senior lifted the form for Pier 1W as the water valves were opened. At a certain point, the Avondale upended the form to a vertical position. The air valves were opened, and the form descended to its position at a rate of nine feet per minute. When only five feet remained above water, the valves were closed and the sinking stopped. The form was placed over the footing guide pipes and secured to the footing. A cofferdam for the distribution slab was affixed to the top, and the shaft and the forms were released into position. Concrete filled the footing and the shaft up to the cofferdam using the tremie method. The distribution slab was placed above the water line. The same procedure was followed for Pier 1E, as well as the other large footings and shafts. The foundations and anchorages consumed approximately ninety thousand cubic yards of tremie concrete, which was believed to be a record for any single construction project up to that time.[28]

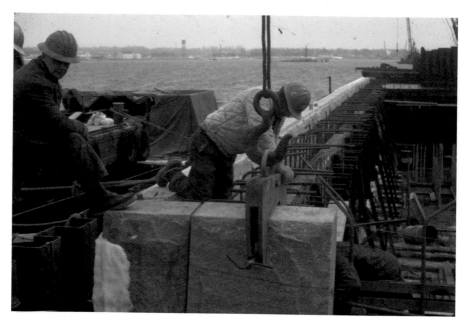

Workers building one of the pier foundations in the middle of Narragansett Bay during the early stages of construction. *Photo by Jerry Taylor, courtesy of Mark Taylor.*

The anchorages also required special attention. By adding the aesthetic side spans adjacent to the center span, the engineers avoided positioning the anchorages in the deepest water. The anchorage on the Jamestown side would be in water 55 to 70 feet deep, while the Newport anchorage would rest in 30 feet of water. The anchorages would serve double duty as gravity anchors for the suspension cables and as pier supports for the approach spans. The west anchorage is located at Pier 4W. The rock surface below slopes downward to the bottom of the gorge at a rate of twelve to one. The bridge builders drilled seventy-two caissons (nine rows of eight) in the bay's bottom to accommodate steel cores thirty inches in diameter. Each hole was inspected using an underwater television camera. The forward six rows of caissons angled away from the center span to enhance cable resistance. The anchorage was built inside a sheet metal cofferdam 110 feet wide by 135 feet long. The tremie pour required twenty-three thousand cubic yards of concrete. At the east anchorage, 4E, a crane with a backhoe attachment excavated ten thousand cubic yards of shale to prepare a proper foundation. A sheet metal cofferdam accepted twelve thousand cubic yards of tremie concrete.[29]

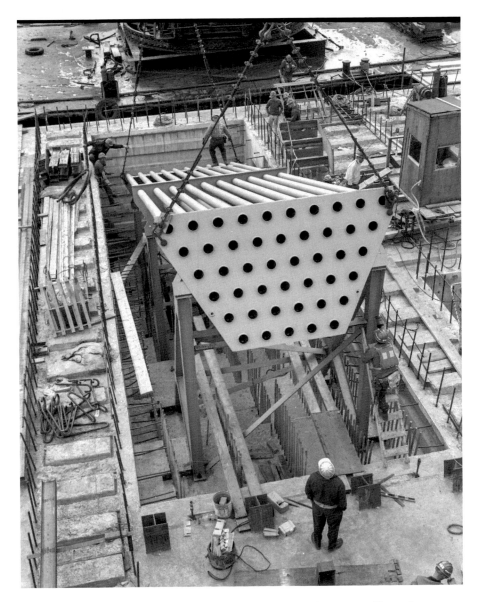

The anchorages of the Newport Bridge employed an innovative system of long pipe assemblies encased in the concrete piers. The main cable strands are attached to the rear wall of the anchorage instead of the traditional front-face mounting method. *Photo by Jerry Taylor, courtesy of Mark Taylor.*

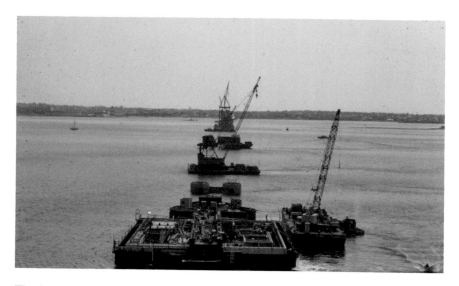

The foundations and anchorages of the Newport Bridge consumed ninety thousand cubic yards of tremie concrete, believed to be a record at the time. *Photo by Jerry Taylor, courtesy of Mark Taylor.*

As the construction moved upward from the foundations, the bridge builders prepared each anchorage for a unique steel tube assembly that would become an integral element of the cable system. These 96-foot-wide by 106-foot-long structures leaned backward following the slope of the cable. Each anchorage had seventy-eight tubes that inclined 45 feet within the anchorage. Each tube would receive the socketed end of a predetermined cable strand. The cable strands would bear against the rear of the anchorage, placing it in compression rather than traditional front-face cable mounting. They were lowered into position and embedded into each of the four concrete anchor blocks. The integrated tube assembly was developed by Bethlehem Steel and fabricated in Pottstown, Pennsylvania. The Newport Bridge was the first application of such an assembly.[30]

MISHAPS AND TRAGEDIES

Building the substructure was difficult and dangerous work. The bridge makers encountered their share of mishaps. On June 29, 1966, Howard A. Curran, twenty-nine, of Central Falls, Rhode Island, and his partner, John Revezzo, thirty-five, of Brockton, Massachusetts, were working on one of the caissons for 1W about 2,000 feet offshore from Jamestown. Curran was working 100 feet below the surface, while Revezzo was near 50 feet. At about 8:30 a.m., one of the bracings collapsed. Both men thought that only their portion of the structure was crashing. The two men sank 162 feet to the bottom of Narragansett Bay. So did tons of steel. Eight piles 175 feet long and several steel frames and I-beams accompanied the workers down. Both men wore underwater suits to keep warm and scuba-type face masks equipped with headlamps and intercoms for communicating with the work barge above. Curran's radio communication and headlamp were knocked out, but Revezzo's remained intact. Air being pumped from the barge to the workers stopped when the divers landed on the bottom because of the tremendous change in pressure from where they were working to the bottom of the bay floor.[31]

"I was exhausted, stunned and without air," Curran said. "I thought of my wife and my children and then I knew I was dead," he added. "It was that simple." Curran described the collapse: "I was working at 100 feet down and John was working at 50 feet. Then everything started shaking. Everything started falling. The steel caught my air hose and I went right to the bottom." Revezzo filled in some details. "I heard a voice yell, 'look out down there,' so I kicked off with my feet, but it was too late." He continued, "Everything came down on top of me. I thought I was going to die." Revezzo remembered falling to the bottom at a rapid speed before blacking out. Then he heard someone calling his name through the intercom, so he "figured things weren't too bad." At least he was still alive. His air hose had wrapped around a steel girder, but he was able to free it and swim to the surface.[32]

The quick reaction of Donald Lasky saved the men. Lasky was a foreman for the Marine Contracting Company out of Southport, Connecticut. Perini had hired the company as subcontractors for the underwater work. Lasky was on the barge above the two divers and happened to be watching the air regulators when the frame collapsed. He quickly opened the valves to allow more air pressure, which he knew the divers would need. Both Curran and Revezzo more than likely would have perished had he not

acted so swiftly. Curran recalled being tangled up on the bottom of the bay. "It happened so fast," he said. "There was no air and I started to black out." He couldn't move. When he awoke, he had air. After Curran realized where he was, he tried to swim. His line was caught, and he tried to extricate it by digging in the mud. It remained tangled. Keeping his wits, Curran went as far as the hose would go, took a few deep breaths, dropped his weight belt and mask, and slowly surfaced, exhaling as he ascended so he "wouldn't blow up like a balloon from the change in air pressure." Curran recounted his dramatic ascent: "Near the top I saw the sky. It was beautiful and I wanted to cry because I was alive. I was alive and I knew I had made it. What a wonderful thing it is….When I hit the surface I couldn't move. I felt like I weighed about 2,000 pounds. So I just lay there floating."[33]

Curran surfaced about one hundred yards from where Revezzo popped up. An ever-present rescue boat picked Curran from the water and raced both men to Fleet Landing. A navy ambulance dashed the divers— including Gary Flood, twenty-seven, of Westport, Connecticut, who had put on gear and dove in to help Curran as he struggled to free himself—to a decompression chamber located in the Naval Underwater Weapons Station at the Newport Naval Hospital. For two hours, a navy doctor brought the divers back 162 feet and slowly returned them to surface pressure attempting to stave off the bends and air embolisms.[34]

Curran felt pain in his back and neck. He feared that he might have an air embolism. Revezzo complained of pain in his right ear. He suffered a punctured ear drum during his rapid ascent. At noon, just three and a half hours after the accident, the men walked out of the hospital and called their wives. Earlier that morning, Revezzo's wife, Cecile, had asked him to quit diving. He told her to stop worrying, as there was no danger. "I guess we will be back to work tomorrow," Curran said, "but we probably won't dive until they figure out what happened." He said they were safety conscious. "Hell," Curran elaborated, "truck drivers get in accidents but they don't stop driving." He described his work as "pretty hairy at times, but so are a lot of other jobs." He happened to like diving. The divers then joked with a few colleagues who had come to visit.[35]

Around 3:30 p.m. the next day, Revezzo began feeling pains in his legs. He had the bends. They placed him back in the decompression chamber without delay. This time, he would be in it until six o'clock the following morning. The doctors slowly brought him back to normal atmospheric pressure, trying to eliminate the nitrogen bubbles from his joints and bloodstream.[36]

By September 8, 1966, the bridge makers had filled the largest cofferdam with cement. They launched the foundation box during the third week of September. Then, disaster struck on September 23, 1966. Raymond V. Savard, thirty-seven, of Kenner, Louisiana, was leveling the piles that had been driven into the footings for one of the main towers. Savard's air hose became tangled in the jungle of steel pilings that would eventually help secure the tower piers. He would not be as lucky as Curran and Revezzo. An unidentified diver in street clothes grabbed a containment unit and dove into the water to help free Savard. He was unsuccessful and needed the decompression unit when he emerged. Meanwhile, Dr. John T. Carr of Newport, the bridge's physician, was summoned to the work barge. A second diver, fully equipped, spent forty minutes trying to free Savard to no avail. A third diver finally brought Savard to the surface at about 3:00 a.m. Dr. Carr ruled the cause of death accidental drowning. RITBA Executive Director James Canning characterized the work as "extremely dangerous" and suitable for only skilled divers. Canning said that Savard had fifteen years of diving experience but this was his first dive on the Newport Bridge. Savard was later described as Marine Contracting Company's top man.[37]

The pile cutting work that cost Savard his life was being done before the bridge builders adopted the Westinghouse diving bell to speed pile cutting. That would begin the first week of October 1966. On October 24, 1966, the dangerous job was completed. The second team of six men emerged from the "cramped metal tank" at about 5:00 p.m. They had spent the previous six days commuting to their job on the bottom of Narragansett Bay in the diving bell. The divers did not need to be decompressed after each dive because the diving bell maintained constant pressure as it was lowered and raised. On the barge, the divers entered a decompression chamber for thirty hours. The bell and chamber allowed the pile cutters to obtain the predicted efficiencies of cutting fifteen piles a day. Most of the divers working on the pile trimming project left Newport that day.[38]

By November 2, 1966, just about one year "since the first frail survey towers dotted a line across Narragansett Bay," the bridge builders had completed about 15 percent of the bridge. RITBA released a report documenting its progress. Of the forty-one piers on the Newport side of the center span, five were underway. The main tower on the east side (1E) was 38 percent complete, the anchorage close to 57 percent done, and the protection cell was 92 percent built. On the Jamestown side, work had started on six piers. The main tower on the west side (1W) was one-third complete, the anchorage over halfway, and the protection cell 95 percent finished. On November 1, the first of the four-hundred-ton footing

Workers lived inside the Westinghouse saturation chamber, which eliminated the need for decompression after each dive. *Courtesy of RITBA.*

box was lowered into place "in a delicate operation that caused even seasoned construction workers to stop and take snapshots." It took the Avondale Senior three hours to properly align the box with its guide posts. The form would soon be filled with cement. Two weeks earlier, a large drill had begun boring holes one hundred feet from Washington Street for roadway support piers. The drill had been used previously to cut through rock for missile silos and was capable of making holes fourteen feet wide.[39]

The Perini Corporation had three hundred workers engaged at the worksite, along with "six tugboats, [thirteen] scows, seven derricks, four

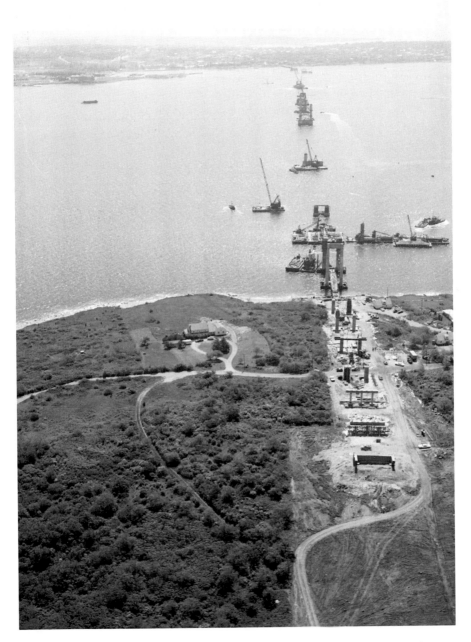

By November 1966, the bridge was about 15 percent complete, with its piers marching across Narragansett Bay. *Courtesy of the Newport Historical Society. From the John T. Hopf Collection at the Newport Historical Society.*

truck cranes, a dredge, pile drivers, drilling rigs and an endless variety of smaller equipment." RITBA Executive Director Canning said the accident that almost killed Curran and Revezzo had set the project back about a month. He credited the Westinghouse diving bell with helping speed up work and was certain the company would be able to "make up lost time in the superstructure work." Canning projected that the underwater piers would be finished by January 15 and the shallow water piers by February 15. He remained hopeful that the bridge would be completed and opened by Labor Day 1968.[40]

THE SUPERSTRUCTURE

With the substructure work underway, the bridge builders turned their attention to the superstructure. This was the contract that was awarded to Bethlehem Steel during the hectic week in April 1966 as the proponents were dealing with the bond interest expense flap. Within one month of the award, the publicity men from Bethlehem Steel had spun out a press release boasting about their victory. "Three major engineering innovations will be employed by Bethlehem Steel Corporation during its steel superstructure work on the new $47.5-million two-mile highway crossing now under construction over Narragansett Bay between Jamestown and Newport, R.I." Its winning bid of $18.9 million included fabrication and erection of the above-water steel.[41]

The publicity men heralded that the Newport Bridge would feature "the world's first use of shop-fabricated parallel-wire strands for the main cables," marking "a significant change in construction cables for major bridges." Bethlehem Steel had developed the process over the previous few years and had announced the innovation in late 1965. Rather than the traditional time-consuming practice of spinning the cables wire by wire, the strands would be prefabricated, banded together, socketed, rolled onto reels, and delivered to the bridge site "for speedy erection." A second innovation was the plastic covering for the cables. It was developed jointly by Bethlehem Steel and E.I. DuPont de Nemours and Company. The protective covering was one-eighth of an inch thick and made of several coats of Lucite acrylic syrup "heavily reinforced with glass fibers," ensuring watertight protection of the cables. The plastic cover replaced the customary method of wrapping and painting the strands, which, like

the cable spinning process, had been used on suspension bridges since the mid-nineteenth century. The third major innovation was the previously discussed cable anchorage system.[42]

Parsons Brinkerhoff engineers knew that Bethlehem Steel was on the cutting edge of the prefabricated parallel-strand cable technology. In January 1964, when the second Delaware Memorial Bridge was being planned between Delaware and New Jersey, Bethlehem Steel "shocked all comers" with an unsolicited response. The proposal included a new method for assembling parallel wire cables more efficiently and for less cost than Roebling's century-old aerial spinning method. Land spinning had been tried on several bridges between 1900 and 1930 but had proven unsuitable for longer-span structures. Experiments with prefabricated helical strand cables in the 1930s required at least 10 percent more wire and proved weaker than parallel strands. Hedefine explained the options in one of his reports on the Newport Bridge.[43]

The new technique being touted by Bethlehem Steel combined the advantages of both methods. The work was led by Jackson Durkee, whose father, engineer L.R. Durkee, had witnessed the Tacoma Narrows Bridge collapse in 1940. The younger Durkee worked on the second Tacoma Narrows Bridge and the Walt Whitman Bridge in Philadelphia. He conceived of the idea in 1959 while standing atop a bridge tower. He began working on the solution at Bethlehem Steel that same year, based on his belief that it would reduce labor requirements by 75 percent and that assembly would not be dependent on the progress of other elements of a bridge's construction. Durkee claimed that shop fabrication "also promised cables of higher quality after compaction." The factory-constructed cable strands would also require fewer wires, preferably fewer than one hundred, and would be carefully reeled to avoid twisting. Smaller strand sizes would mean less weight, which could be handled easier during unreeling.[44]

Bethlehem Steel's surprise bid for the second Delaware Memorial Bridge demonstrated the method's efficiencies. It was 40 percent lower than the engineers' estimates. Bethlehem's solution would reduce sag adjustments from fifty-five thousand to nine hundred, reduce spinning from three months to one, and reduce the number of workers needed for spinning from one hundred to twenty-five. Bethlehem engineers believed the method would be competitive in bridges up to 1,600 feet. The proposal failed to convince the Delaware Bridge engineers, however, due to "insufficient evidence of accurate manufacture and assembly."[45]

Durkee preferred parallel-wire strands over helical-wire strands "because of their superior strength and axial stiffness." Durkee and associates noted that spinning "parallel-wire strands in place on the bridge itself is slow and difficult, and, since it is done under field conditions at a great height, tends also to be dangerous." Not only that, but adjustments had to be made immediately upon placement "to provide a compact strand with minimum length differentials among the wires as they hang in a catenary across the bridge spans." Bridge makers had tried to build parallel-wire strands on the ground at bridge sites, the innovators observed, but were unsuccessful due to twisting and coiling. The Bethlehem engineers solved the problems associated with reeling the wire "to make it conveniently transportable."[46]

By the time Parsons Brinkerhoff was designing the Newport Bridge, the steel company had already invited the engineers "to witness the development of these techniques" and convinced them "that factory prefabrication and field erection of parallel wire strands were predictable." Parsons Brinkerhoff offered the method as an alternative in its request for proposals. Bethlehem Steel submitted a bid to erect the Newport Bridge superstructure, including cables, for $18.9 million. It planned on saving $553,000 on the cost of cable spinning and another $50,000 on cable wrapping. It also proposed a five-week savings in cable erecting time. Coincidently, the bridge's span would be 1,600 feet. It won the bid, and the Newport Bridge would become the first to use shop-fabricated wire strands for its main cables. Bethlehem Steel's work above Narragansett Bay's East Passage was about to "become the focus of engineering interests worldwide."[47]

Upon being awarded the contract for the superstructure and cables in 1966, Bethlehem Steel immediately established a parallel-wire strand production line in Pottstown. Hundreds of coils of cable arrived from its Sparrows Point plant. The strand makers placed one coil at a time on the turntable. The individual wires were "pulled out in straight alignment and placed parallel to one another." They were then bound every few feet in a compact bundle. At the end of the line, an operator wound the strand onto a large wooden reel with the help of a power-driven take-up reeler. Each reel contained one 4,500-foot-long strand and was composed of sixty-one cold-drawn galvanized steel wires 0.202 inches in diameter. Bearing sockets were attached with molten zinc to both ends of each strand. Eventually, at the bridge site, seventy-six of these strands would be compacted into a main cable 15.25 inches in diameter. The sockets at the end of each strand would be secured in the anchorage pipe assemblies.[48]

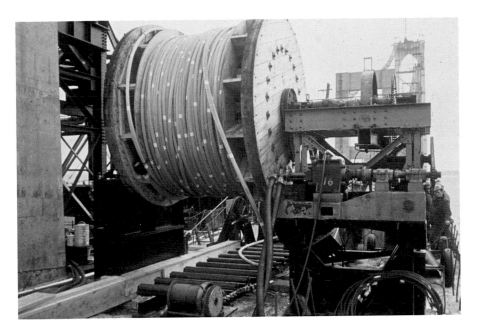

By the mid-1960s, Bethlehem Steel had perfected its innovative shop-fabricated cable method, including reeling and delivering each strand on a spool. *Courtesy of RITBA.*

In another section of Bethlehem Steel's Pottstown facility, steelmakers were busy fabricating the towers. Each would have two legs rising from the foundation and tapering slightly at the top. Fabricated trusses connected the legs. The towers were made up of nine tiers. Each tier was built with four cubical cells made in the form of a cross. A fifth cell formed the center of the cross. The two main towers required 144 cells ranging in length from thirty to forty-six feet. The bridge fabricators welded plates of steel into box-like sections, milled the ends, assembled the sections, reamed holes for field-bolting, and welded connection pieces to the base for anchor-bolting to the piers. They blast-cleaned and painted each cell in the shop using a three-coat epoxy paint system. The component parts were labeled to ensure proper construction and shipped by rail to Rhode Island. The engineers later said the welding contributed to the clean appearance of the towers.[49]

Three struts connected the legs: one below the roadway, a second strut at roadway level, and a third in the form of an arch at the top of each tower. The bridge makers constructed twelve cast-steel saddles at their Bethlehem plant, designed to guide and support the cables.

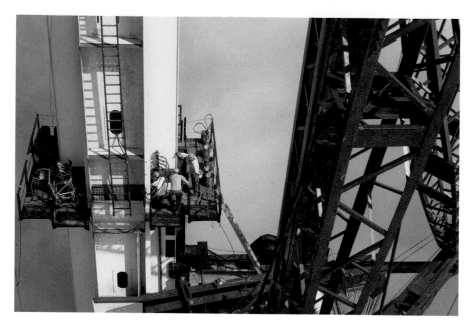

The main towers of the Newport Bridge rise four hundred feet above Narragansett Bay. The sections were prefabricated at Bethlehem Steel, floated to the bridge site, and attached by workers with high-strength bolts. *Courtesy of Joe Muldoon.*

They were placed atop the legs of the main towers, cable bents, and anchorages.[50]

Once the pier foundations were poured and leveled to ensure proper seating, the bridge builders floated the tower components to the bridge and began assembling the pieces on top of ten-ton base plates. On May 27, 1967, the first cell of a tower leg was positioned by crane to its pier foundation and secured by large anchor bolts. The leg was also welded to the base plate. The crane on the floating derrick helped place the first three tiers of the tower legs. It could not reach the fourth tier, so the bridge builders used a creeper derrick mounted to the tower legs to place tiers four through nine. After the third tier was in place, the bridge builders tied the two legs together using the lower strut. Likewise, they applied the roadway strut at tier five and the arched strut at the top of the legs. Finally, the twenty-five-ton saddles were positioned on top of the legs with the help of the creeper derrick.[51]

As work on the towers continued, the bridge makers began the steelwork for the east and west approaches. The high tower derrick barge and the traveler derrick were dispatched to help lift the 7,200 feet of trussing into place on their respective piers. The steel members were towed to the

bridge site from Fleet Landing. The sections were erected piece by piece. They were supported by falsework (temporary framing) until the spans were self-sufficient. Hydraulic jacks positioned the falsework at the exact heights necessary "to control the position and stresses of the cantilevered steelwork."[52]

WHAT'S THE HOLDUP?

On July 17, 1967, Perini Construction Corporation and Bethlehem Steel rented a forty-four-foot cabin cruiser to take Chafee, Marcello, RITBA members, and Parsons Brinkerhoff representatives for an up-close viewing of the bridge. There were eleven dignitaries on the boat leaving no room for reporters. The tour took two and a half hours. After observing the progress on the bridge, Chafee remarked, "When you get up close, you realize how big a concern it is." The governor remained "hopeful and optimistic" that the bridge would open on time during the fall of 1968.[53]

Later in the summer, work on the bridge began to fall behind. Storms in April and May damaged some construction materials Perini was using to build the foundations, causing Bethlehem Steel to delay the beginning of its superstructure work. Then, on August 2, 1967, twenty-four bridge workers went on strike over a dispute between carpenters and laborers. The contention concerned which union's workers should strip the wooden forms of concrete once the pouring hardened. Carpenters Local 176 said it was their job. The laborers, members of the International Hod Carriers and Common Laborers Union 673, voted to walk. On August 4, 1967, Bethlehem Steel announced that it would add more men and equipment than initially planned in an attempt to meet the target opening date. The laborers ended their strike on August 15 and returned to work. The work stoppage did not seriously delay progress on the bridge, and picket lines were never established.[54]

The Newport Bridge continued to take shape throughout the fall. By October 24, 1967, the builders had installed the two four-hundred-foot Gothic towers. Four days later, construction of the wire ropes between the two main towers was started. When in place, these inch-thick ropes would support the catwalks that workers would use to lay the strands for the main cables. The wire ropes would be "played-out" from a barge and lifted into place by derricks on top of each tower. The wood and wire mesh catwalks were prefabricated in one-hundred-foot sections. They were nine feet wide

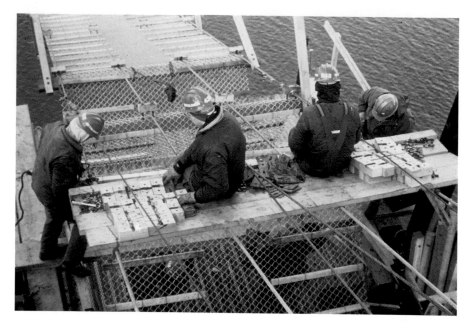

The bridge's towers were in place by October 24, 1967. Four days later, workers began constructing the catwalks that they would use to string the cables. *Courtesy of RITBA.*

and three feet high. They were raised up the tower and slid down the wire ropes into place. Resident engineer Jack Kinney predicted that it would take a month or two to install the catwalks, depending on the weather. Two boats were dispatched from Castle Hill Station to route water traffic around the towers while the ropes were being strung.[55]

Kinney's premonition about potential weather issues came true. From December 22, 1967, through January 16, 1968, the bridge builders lost time on all but four days, and two of the good ones happened to fall on non-working weekend days. The *Newport Daily News* told its readers, who were in the midst of enduring one of the fiercest Januarys on record, to "pity the Newport Bridge workers who fought frostbite, ice coated catwalks 400 feet above the surface of Narragansett Bay and weather conditions more like those of the North Pole than Newport County." Bethlehem Steel engineer Al Siess Jr. recorded day-to-day progress, or the lack thereof, in a neatly ruled logbook. The morning of December 22 was "too foggy to conduct the footwork strand surveys," then it rained beginning around 10:00 a.m. "Blowing snow and poor visibility" curtailed work the next day. During the afternoon of December 24, "work on positioning the footwalk sidespan strands" was stopped. The strands were bouncing two feet in the air. More

snow and wind canceled work on December 28 and 29. It snowed New Year's Eve, and the worksite was covered when the bridge men returned on January 2, 1968. Record low temperatures hampered work from January 5 to January 9. The high on January 8 reached five degrees Fahrenheit, while the low on January 9 plummeted to minus-five degrees Fahrenheit. A large ice jam hit the bridge on January 10, and on January 11 a tugboat was summoned to break up the ice that was threatening the temporary framework. January 12 and 13 brought high winds and cold temperatures. Snow, rain, and wind plagued the last two weeks of January, but at last temperatures started rising. The rest of the winter remained uncertain, but the bridge builders were hoping for better news on February 2, depending on whether the groundhog saw his shadow or not.[56]

The bridge builders received another setback on February 5, 1968. Henry Gormly was working landside for Bethlehem Steel at its supply yard on Washington Street when a 1,200-pound balancing bar slipped from a crane and hit him in the head. The crane and balancing bar were used for lifting the heavy reels of prefabricated cable from trucks and railroad cars to a barge for delivery to the bridge site. The balancing bar was about ten feet in the air when it fell off the crane's hook. Several co-workers pulled Gormly out from underneath the bar. The forty-eight-year-old Portsmouth, Rhode Island resident was rushed to Newport Hospital, where he was pronounced dead at 11:00 a.m. One of the men who helped extract Gormly felt for his pulse and heartbeat. He said Gormly had died instantaneously. Bethlehem Steel had hired Gormly just a few days earlier on January 30. He was an experienced steelworker who had just finished working on the new Kaiser building in Portsmouth. Originally from Providence, Gormly served in the army during World War II. He was buried in St. Columba's Cemetery in Middletown, the very same cemetery nearby the once-contemplated Brown's Lane terminus for the bridge. Gormly was the second bridge builder to die on the job, and his death brought back memories of Raymond Savard's in September 1966.[57]

Installation of the prefabricated cable strands began on February 29, 1968. That was when a "[t]en-foot diameter reel of parallel-wire strand was picked from the barge and placed on the unreeling machine at the west anchorage." A tramway carriage pulled the socketed strand to the east anchorage, where the bridge builders "drew the socketed ends of the strands down through the anchorage pipes using a runner line." They then used jacks to apply the right amount of tension to set the strands at the correct elevation. Engineers adjusted each strand to its proper sag using a sag scale

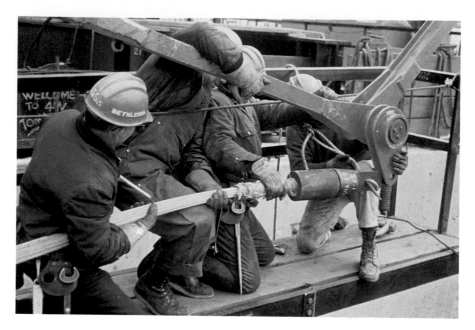

The socketed cable strand was attached to the anchorage on one side and delivered to the other via a tramway, where workers attached it to its opposite anchorage. *Courtesy of RITBA.*

before they were compacted and strapped. The process encountered an early problem. Cable erection was stopped immediately when some wires in the first strand slipped and deformed the cable. Durkee tightened the binding process to solve that particular problem.[58]

On March 2, 1968, the *Newport Daily News* published a photo of the burgeoning bridge. The picture was snapped by John T. Hopf, a well-known Newport County photographer. It ran across the entire width of the front page above the masthead. Spreading out before the newspaper's readers was the bones of the bridge in mid-construction. The Jamestown approach filled the lower left-hand corner. As the viewer's eye traveled from left to right, a large derrick rose into the sky over Jamestown. The main towers in the left quarter of the picture, adorned with their recently completed catwalks, commanded the scene. The catwalks rose at a steep pitch from the anchorage at 4W, over the cable bents at 2W that marked the beginning of the side span, and then threaded through the saddle atop the main tower legs on the Jamestown side of the channel. From there, the catwalks sagged gently to the middle of the span before rising just as smoothly over the tower legs of 1E on the Newport side. The catwalks dove sharply toward the cable bent on 2E and more so to the

On March 2, 1968, the *Newport Daily News* published the "remarkable" photo of the bridge that John T. Hopf snapped from the Stella Maris, the same location that Washington Roebling stayed in the summer of 1882 on his only vacation away from the Brooklyn Bridge during its construction. *Courtesy of the* Newport Daily News.

anchorage at 4E. Then, the unadorned rectangle shapes of piers 4E, 5E, and 6E, cascading downward, one shorter than the next, marched toward Newport. Just north of these skeletons, a second derrick rose at an angle toward Jamestown, seemingly prepared to lift and place a section of trussed highway. In the rightmost section of the photo, another derrick just finished securing a roadway section is angled toward Newport. A section of recently placed roadway truss was balanced on piers 7E, 8E, 9E, and 10E.[59]

The caption under the photo describes the picture as "remarkable." It was taken from land level on the Newport side. Hopf used a 500mm telephoto lens "to improve perspective to distant points." What is more remarkable, though, is that the photo was shot at Stella Maris on Washington Street—the same Stella Maris that in 1882 was called the Meyer Cottage—the very same house where Washington Roebling spent his summer vacation in Newport as his Brooklyn Bridge neared completion.[60]

The heralded shop-built parallel-wire cable strands were not visible in Hopf's photo. Four days later, two equally interesting pictures ran in the *Providence Evening Bulletin*, where they could be contemplated by a broader statewide audience. These were snapped by D. Neale Adams. The photos and short article consumed the upper-left quartile of the newspaper's front page. The top photo was taken from water level next to what might be the cable bent of 2W looking toward Newport. Main Tower 1W serves as the focal point for the center of the picture. The perspective looking up at the steel tower is inspiring. The nine tiers of each leg reflect the afternoon sun. The three struts connecting the legs are in place. The catwalks partially restricted the view of the Gothic arch. Tower 1E on the right, equally majestic, consumes the right quarter of the photo. The second picture is a close-up of three compacted cable strands as they exit the cable bent on their way to the anchorage below. Moving from right to left, the viewer's eye

follows the wire into the cable bent, along the catwalk, up the side span, and over the main tower leg. The wires were compacted and wrapped using the innovative plastic covering developed jointly by Bethlehem Steel and E.I. du Pont de Nemours and Company. The cables were topped with a weather coating of resin and acrylic bead polymer, which was "brushed on to provide an attractive stucco-like finish." These were the first cable strands installed on the new bridge—the first on a major bridge that were not spun *in situ* since John A. Roebling invented the method.[61]

On June 25, 1968, the bridge makers started hanging the sections of suspended roadway across the main channel. They attached the sections to suspenders dangling from the main cables. It was the first of thirty-seven sections and marked the beginning of Bethlehem Steel's final stage of major steel work. The sections were cobbled together on land and towed to the site. A pair of cable travelers lifted the sections into position. On September 19, 1968, the last section was hauled into place. The sections were hung in pairs for balancing purposes, so the last one was immediately preceded by its counterbalancing partner. It was 66 feet wide and 120 feet long and weighed 102 tons. It was not the heaviest section, as one of them weighed 170 tons. The last section was adorned with an American flag, the traditional "final steel" symbol of good luck. From the water below, a small gathering of spectator boats saluted the milestone with horns and whistles as the only remaining gap between Newport and Jamestown was finally closed. Even the weather cooperated on this windless and sunny day.[62]

Chafee and Dwyer both publicly praised the accomplishment. Chafee was unable to make it to the site but released a statement praising the completion of the steelwork as a "landmark of great promise" for Aquidneck Island and the state as a whole. "Studies on tourism in the state, as far back as 1963, recommended this bridge and made clear its potential to contribute substantially to the realization of the state's tourist potential," Chafee said. Dwyer and members of RITBA witnessed the event. Dwyer noted that the last section "places us closer and closer to the final crossing of the East Passage, which has always been a natural barrier to the economy of the state." The only remaining work was pouring the concrete roadway.[63]

On September 23, 1968, the navy carrier USS *Essex*, which had played a major role in the Pacific theater during World War II, glided under the bridge. The *Essex* had won the Presidential Unit Citation for "extraordinary heroism" and thirteen Battle Stars. It supported military actions in Saipan,

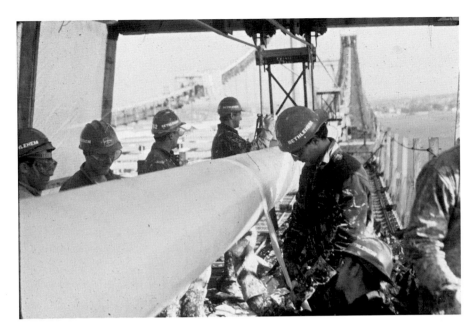

Workers apply innovative covering by Bethlehem Steel and E.I. du Pont de Nemours and Company to the banded and compacted cables. *Photo by Jerry Taylor, courtesy of Mark Taylor.*

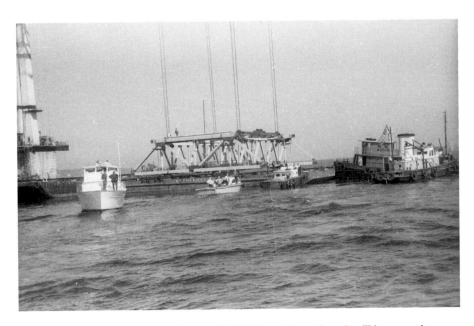

Workers prepare a section of roadway to be lifted into place, where it will be secured to suspender cables. *Courtesy of the* Newport Daily News.

Guam, Marianas, Peleliu, Leyte, Okinawa, Formosa, and Tokyo. It may have even covered Chafee and Dwyer as they and their comrades stormed beaches and established footholds on Pacific islands. Newport was now its home port. It was only months away from being decommissioned on June 30, 1969, just two days after the bridge opened to traffic. On this day, it glided comfortably under the bridge, its 150-foot mast never threatening the base of the roadway truss 196 feet above the water. The *Providence Journal* memorialized the event with a front-page photo accompanied by a sigh of relief: "She Made It."[64]

It would not have taken so long to hang the suspended roadway sections had four hundred members of the International Association of Bridge, Structural, and Ornamental Iron Workers of Local 37 not walked off the job at midnight, June 30, 1968. That was when their three-year contract with the New England Steel Erectors Association expired. Work installing the steel reinforcing rods for the deck of the bridge stopped in its tracks. The bone of contention was wages. The union had settled for $5.42 per hour plus benefits following a two-week strike three years earlier. The parties held seven sessions of negotiations before talks broke off. The bridge builders

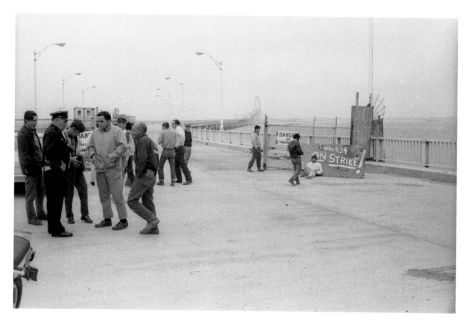

Bridge workers walked off the job for higher pay on June 30, 1968, delaying the bridge's opening from the upcoming fall to following spring. *Courtesy of the* Newport Daily News.

toll-taker, four clerical, and two maintenance jobs. The authority was also contemplating a state-certified engineer position. The toll equipment was scheduled to be installed on June 26, two days before the ceremony. Earlier, RITBA had settled on a toll of $1.00 per axel, a reduction from its previously stated desire to charge $1.70 per axel.[70]

With the opening date in sight, Dwyer went about making the arrangements. Although controversies concerning the approaches to the bridge would continue, and a failed paint job was looming, the ceremony would be a joyous event. After all, it capped a quarter-century struggle to connect Jamestown and Newport. The *Newport Daily News* editors praised the bridge and its proponents:

> *A dream of many years duration became reality today when the Newport Bridge opened a new gateway to and from the west.*
>
> *Thumbing back through history and lore of many generations we find the recordings of some firm link across Narragansett Bay. Many had the dream, but only a few had the determination and skills needed to make it the reality it is today. And because of [the] determination and skills of these few we have a magnificent bridge, the first solid link between Aquidneck and Conanicut since the Ice Age.*

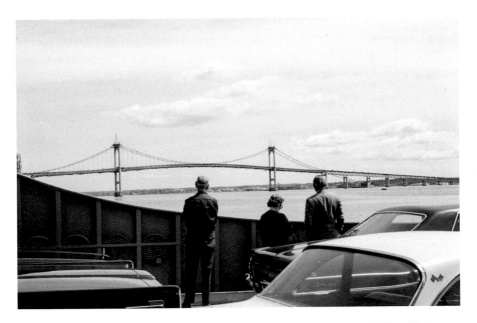

The beginning and the end. Ferry riders watching the bridge go up. *Photo by Jerry Taylor, courtesy of Mark Taylor.*

We say thanks to all of those who made this possible, and there were many, ranging from the planners and the voters who so many times had to trudge to the polls to overcome opposition from other parts of Rhode Island.

The editorial writers lamented the passing of the Jamestown-Newport ferry service:

The ferry was a relaxing, pleasant mode of transportation that, once gone, will be seen no more. Like the old Fall River Line steamers that vanished 32 years ago, the old ferry boats will be recalled mistily by the present generation and the generation to come.

The opinion makers also registered their disappointment that the access roads to the bridge had not yet been built. They urged swift action. Their disposition was optimistic:

But we do have the bridge, all spanking 2.1 miles of it and we expect that it will open a new and happy era for southern Rhode Island.
To those who have made this possible we say, "Well Done."[71]

The praise directed at the proponents was well deserved. As Governor Licht said during the dedication ceremony, the Newport Bridge was a monument to their perseverance. A few stand out above the rest. It is safe to say that it is unlikely the bridge would have been built by 1969 without the leadership and energies of Dwyer, Chafee, and Hedefine.

Conclusion

A MONUMENT TO PERSEVERANCE

IF YOU BUILD IT, THEY WILL COME

The bridge was up and running, but struggles and controversies continued well beyond its coming out party. Despite Governor Licht's plea during the ribbon cutting ceremony, many of the access roads would not be completed until well into the 1970s. The Route 138 bypass would never be built. It was formally abandoned in 2017. The paint on the bridge began flaking in October 1970, and the issue was not completely sorted out until 1982 following three decisions by the Rhode Island Supreme Court. The court decided that Bethlehem Steel was negligent because it did not clean the steel properly before applying the paint. The mill scale that remained caused the magnificent failure. In the end, after twelve years of suits and countersuits, Bethlehem Steel was ordered to pay RITBA $4,130,025 after all adjustments were considered. And in November 1982, Executive Director Canning was dismissed by RITBA for exaggerating expense reports and misusing authority resources following the relentless prosecution of Assistant Attorney General J. Joseph Nugent.[1]

As promised, the Newport Bridge had an immediate impact on the southern half of Rhode Island. The very first day, more than 15,000 vehicles crossed the bridge, no doubt mostly out of curiosity. Within eighteen days, RITBA proclaimed that the bridge had handled close to 104,000 vehicles. It was available for traffic just in time for the Newport Jazz Festival, which

opened the following Thursday evening. The festival operators had sufficient faith that the bridge would be available in time for their event that they published directions for travelers from the south to "take the Newport Bridge into Newport." The event was notable for its schizophrenic lineup. In an attempt to fuse jazz with rock-and-roll, promoter George Wein lured some of the top performers from both genres, an odd mix that was not well received by some critics. Wein mixed jazz icons such as the George Benson Quartet, Sun Ra, Roland Kirk, the Herbie Hancock Sextet, the Buddy Rich Orchestra, the Dave Brubeck Trio, B.B. King, and the Miles Davis Quartet with such rock heavies as Jeff Beck, Ten Years After, Frank Zappa and the Mothers of Invention, John Mayall, Sly and the Family Stone, Blood Sweat and Tears, Jethro Tull, Johnny Winter, James Brown, and Led Zeppelin. Wein would later characterize the event as the worst four days of his life.[2]

Crowds were estimated at twenty-two thousand inside Festival Field and ten thousand outside. Those without tickets lined the hillsides around the venue. Many wanted to save the cost of hotel rooms by sleeping on the beaches or setting up camp in open fields. The festival's security force was overwhelmed. Crowds crashed the fences during the rock performances on Friday and Saturday nights. The pictures of the 1969 Newport Jazz Festival with youth lounging in open fields on blankets listening to rock music closely resemble those from Woodstock, which took place a month and a half after the Newport Bridge opened. That event promised three days of peace and music. It would become one of the seminal events of a youth movement and was credited with altering American history and changing the culture of the nation from complacency to activism, ultimately accelerating the end of the unpopular Vietnam War. The Newport event did not ignite such a flame, but the bridge was up and ready for business. The crowds no longer had to wait for a ferry in Jamestown or drive up through Providence and down the East Bay.

The Jamestown Ferry waiting room and adjacent gift shop were demolished on March 19, 1970, providing one more tangible piece of evidence that life on the two islands had been altered forever and that the romantic method for crossing the East Passage had ceded to the modern structure of concrete and steel. In its first full year from June 1969 to July 1970, the bridge generated $1,782,353 in toll revenue. The next year, it produced $2,023,233, an increase of 13.5 percent. That second year saw close to 230,000 more vehicles cross the bridge than the first. But there was something ominous in the numbers. Eastbound traffic into Newport was 10 percent higher than westbound traffic. Canning believed that

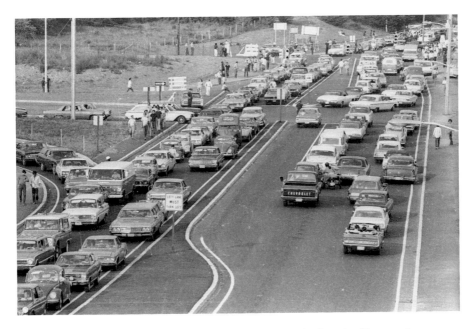

One of the first events to benefit from the new bridge was the four-day Newport Jazz Festival, which opened on July 3, 1969. Traffic at the Newport terminus was a bit chaotic. *Courtesy of the* Newport Daily News.

the dichotomy was due to the condition of Route 138. Many travelers returning from Cape Cod, Canning said, might avoid the bridge on their return home because of the roadway. Even though the access roads on their own side were still to be built, Newporters in tourist-related industries were calling for the Jamestown roads to be improved first. The lack of good connecting highways continued to plague the state's economy into the mid-1970s.[3]

A traffic study developed for RITBA in 2010 presented a visual representation of Newport Bridge traffic between 1969 and 2009. During the first full three years, bridge traffic grew slowly but steadily, remaining below the 2 million mark. The 1 millionth vehicle crossed the bridge on April 20, 1970. The gas crises and the navy's departure contributed to a slight decline in traffic in 1974, despite year-over-year increases in August and September for the America's Cup races. Traffic jumped over the 2 million mark in 1975. The upward trend continued in 1976, the year of the now-famous American Bicentennial Tall Ships visit and parade. By the end of the decade, 3 million vehicles were crossing the bridge annually. The 4 million landmark was reached in 1983, and by the time the bridge celebrated its

twentieth birthday, the 5 million ceiling had been breached. By 2009, when the bridge turned forty years old, 10 million vehicles were crossing annually.[4]

In 1964, traffic engineers had predicted that 1.4 million cars would cross the Newport Bridge by 1985. Dwyer continually argued that those traffic estimates were overly conservative. He frequently emphasized that this misunderstanding resulted in unfavorable financial projections that inaccurately inflated the payback schedules for the proposed bridge, to which can be attributed much of the opposition and rejection by Rhode Island voters in the 1960 referendum. Dwyer believed that the bridge would draw sufficient traffic to pay off bridge bonds sooner than scientific analysis predicted. He was right. In 1985, the 5 million vehicles that crossed the East Passage exceeded by more than three and a half times the volume predicted two decades earlier.[5]

On special anniversaries, the opinion makers research and publish articles about the Newport Bridge. As the bridge approached its twentieth anniversary, the *Providence Journal* established the precedent and formula. The drama starred Gerry Dwyer. In the June 1989 version, Dwyer was shuffling through a box of papers and smiling at the miscalculation just described. His office wall was adorned with a large photograph of the bridge. Two pens were taped to the frame's glass. They were the pens that Governor Chafee and President Kennedy used to sign the enabling legislation. Dwyer recounted the two phases of the bridge: the political

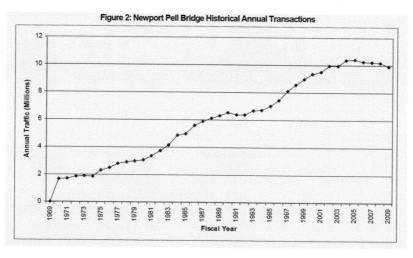

Actual results confirmed Dwyer's contention that traffic estimates were extremely conservative, as depicted in a 2010 analysis by the Jacobs Engineering Group for RITBA. *Courtesy of RITBA.*

phase and the building phase. He recalled with a knowing smile that absent the first there would not have been a second. Dwyer summarized the details of the process at a very high level: how RITBA was about to be dissolved in 1959; how he asked his successful running mate, Christopher Del Sesto, to appoint him to RITBA after his failed bid for lieutenant governor; how he worked with the legislature to extend RITBA's charter; how RITBA won the right to fund the bridge with bonds and tolls from the Mount Hope Bridge; how the 1960 bridge referendum was rejected by statewide voters; how they took for granted that the bond issue would pass; and how they would not let that happen again in the 1964 referendum. By the time of the article, 68 million vehicles had traveled across the Newport Bridge, bringing in unanticipated revenues along with estimates that the authority would be in a position to pay back its loans three to four years ahead of schedule.[6]

In its thirtieth year, *Newport Life* published a thorough account of the Newport Bridge. The story began with William Leys retelling the story of the economic development consultant who described Newport as "Fall River with a view" and his advice to direct the city's economy toward recreation. The author acknowledged Dwyer's leadership in getting the bridge built and how his interest in it came about. Upon completing his Marine Corps service during the Korean War, Dwyer drove home from Camp Lejeune, North Carolina. When he arrived at the Jamestown landing, he was told he would have to wait up to two hours for the next ferry. Dwyer was burning. It had been a long trip, and he was anxious to get back to his home in Middletown. He decided to drive "all the way around to Providence, well over an hour's drive back then." He thought, "Hey, this is crazy. We have to do something."[7]

The article devoted a few paragraphs to the controversy surrounding the bridge's location on the heels of the 1964 referendum. Dwyer claimed that RITBA wanted to position the bridge from Eldred Avenue in Jamestown to Brown's Lane in Middletown but that influential downtown businessmen "wailed about traffic skirting Newport." Dwyer failed to mention that RITBA had long promised the bridge between Taylor Point and Washington Street, that the navy had derailed the northern route, or the intense pressure brought to bear on Governor Chafee from all sides. The author also interviewed longtime Catholic liturgical artist and housing activist Ade Bethune, who lived in the Point. Bethune said the preservationists preferred the northern site to save Newport's Point section but that they were not "too upset when it was finally determined that the bridge would empty onto Farewell Street."

She recalled, "What upset people more was the plan for the roadways extending from the bridge." The people living in the Point "felt the state's plan to build a superhighway along the railroad right of way would have cut the neighborhood off," she said. "We fought and fought over that, and we were able to preserve the crossings at Bridge, Elm and Poplar streets."[8]

The author presented a picture of mid-1970s Newport:

In 1973, with Memorial Boulevard having been constructed and the state ready to install America's Cup Avenue in full and to build the famous wall separating it from Thames Street, the Pentagon announced plans to remove the Atlantic Fleet from Newport. At the time there were about 60,000 naval personnel stationed in Newport, more than the population of the entire island. The decision devastated the regional economy. By the spring of 1974, unemployment in Newport reached upward of 20 percent, you could buy property for a song and dance, and decision makers were caught with their pants down.

Dwyer took satisfaction that the proponents' efforts paid off. "I don't know where we'd be without that bridge today," he said. "It made tourism happen here." Leys concurred:

Newport was in terrible shape before all this. It was jammed with old wood buildings on narrow streets and there were basically junkyards everywhere along the waterfront. Redevelopment and the bridge instigated the changes. After the Tall Ships, the free market took hold downtown.[9]

Ten years later, when the bridge was forty years old, Dwyer's personal tale had changed a little but still made the same point. This time, following his discharge from the Marine Corps after the Korean War and a grueling one-thousand-mile trip in his 1950 Dodge, Dwyer traversed the Jamestown Bridge and then sped across the island, hoping to catch the last ferry to Newport. He was too late, arriving just in time to see the ferry's lights disappearing into the distance. Dwyer was stranded just two miles from his Middletown home. He had two choices: drive around through Providence or spend the night in Jamestown. He headed north. "There should be a damn bridge here," he thought.[10]

The article briefly discussed the early struggles and the defeat of the 1960 referendum. It described how Dwyer and the proponents rallied voters for the 1964 vote, "attending Rotary Clubs and Town Councils all

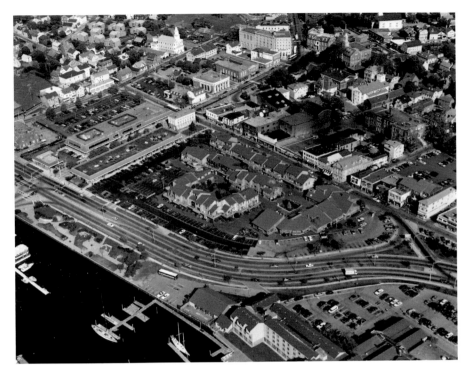

Redevelopment in Newport contributed the four-lane America's Cup Avenue coursing through downtown and the harbor district. *From the John T. Hopf Collection at the Newport Historical Society.*

over the state." Dwyer explained the controversy over the bridge's location following the 1964 referendum. Once again, he highlighted the northern route controversy, adding that "Newporters were aghast" at the prospects of the Eldred Avenue to Brown's Lane crossing. "To this day, I wish we could have had that alignment," Dwyer lamented. He failed once more to recollect that RITBA had long supported the Taylor Point–Washington Street path. The article finally recounted the battle resulting from the cost of the substructure and the subsequent funding approved by voters at the special 1966 referendum. "In its 40 years," the article accurately concluded, "the bridge has become a defining landmark for Aquidneck, Conanicut and all Rhode Islanders."[11]

BEFORE AND AFTER: A PLEASANT MESS

The changes occurring in Newport in the mid-1960s could not be missed. The $6.5 million urban renewal project was on the verge of getting started. The focus of this stage of redevelopment was the Long Wharf–Market Square area. The underlying goal was "to rejuvenate a part of the downtown section without doing aesthetic injury to an adjoining area that contain[ed] many historic buildings." The twenty-two-acre project "bordering the city's inner harbor" was the first phase of an effort to breathe new life into Newport's central business district. By the mid-1960s, "like many of America's old cities, Newport had grown seedy at its core." It was afflicted by "[d]owdy commercial structures block[ing] the harbor from view as they rot at the water's edge." Not exactly the kind of scene that would inspire visitors to flock to the place.[12]

A number of improvements were on the near horizon. The most exciting was in the area surrounding Trinity Church. The planners "manipulated" architectural elements "to avoid conflict with history" by blending materials, textures, and colors with local traditions and scale. A new library was envisioned along with "the relocation of historic houses to provide a proper setting for the [Dr. Charles] Cotton House, one of Newport's oldest landmarks." A central component of the project was a new paved plaza enclosed by commercial, office, and retail space adjacent to the Peter Harrison–designed Brick Market, which was built in 1760. A 108-room waterfront hotel with a four-hundred-seat restaurant and an eighty-eight-slip marina were to be constructed on Goat Island. The plan also called for replacing Government Landing, the former ferry depot that once served the navy's torpedo station and at the time was being used as the staging area for the construction of the Newport Bridge.[13]

The renewalists "tried to make peace with the automobile, which ha[d] been blamed for so much decay." They intended to "introduce a new traffic circulation system designed to relieve the press on narrow 18th-century streets." The new "waterfront road and strips of parkland will open up to view a harbor long blocked from sight by a jumble of commercial structures." A new decked parking garage in the center of the project would accommodate visitors' automobiles and "create an auto-free shopping environment for the new pedestrian plaza." The plan called for apartment buildings and row houses containing sixty-six residential units and a supermarket. Upon completion, the city's downtown area would be

enriched with "105,000 square feet of new commercial space, 50,000 square feet of office space, parking for 839 cars and the residential units and boat slips." It was anticipated to be completed by the fall of 1968, the same time as the Newport Bridge.[14]

By 1976, the good news revolved around the preservationists, particularly Doris Duke's Newport Restoration Foundation. The takeoff point was the now well-known repartee between tobacco heiress Duke and Katherine Warren, founder of the Preservation Society of Newport County. Duke was interested in saving Newport's built environment but did not want to encroach on Warren's territory. The dilemma was resolved when Duke declared, "All right Katherine, you take the 19th century and I'll take the 18th."[15]

Duke's foundation had restored more than fifty "modest and dignified 18th century houses that are as much a part of the city's architectural legacy as are its great palaces by Richard Morris Hunt and Stanford White." Most of the structures Duke saved were in the poorer sections of Newport near downtown, and the restorations were already having a gentrifying effect on the area. In 1966, run-down eighteenth-century homes could be bought for between $2,000 and $8,000. In 1976, the restored versions were selling for up to $45,000, sending low-income families elsewhere for affordable housing. The foundation's efforts corresponded with a time when the city was "making itself felt in new ways," particularly "through the increasing attraction Newport appears to have for tourists who have no intention of spending more than a day or two drinking in the view of the sea from the Italian loggia of the Breakers or marveling at the Trianon-like facade of Rosecliff." Newport was evolving into a destination for day-trippers with "its marble palaces like a Grownup's Disneyland." The Breakers, for example, was drawing 250,000 visitors per year. The city was "increasingly gearing itself to this type of tourism."[16]

The preservationists were having a profound impact on Newport. The Newport Restoration Foundation's focus on the eighteenth century did more than alter demographics and increase property values. The restored homes gave a "boost to tourism by reminding visitors that Newport, the most active seaport in the 18th century, had another life before society descended upon it in the mid-19th century." The foundation's unique methodology included purchasing the buildings with private funds, renovating interiors down to the studs, rebuilding using strictly colonial methods, painting the exteriors using only Duke-approved colors, and renting to tenants of its choice. The

foundation was functioning "both as an urban renewal agency and a housing authority" but without public accountability for its policies, as it was using private funds. It had free rein to do as it pleased. One resident noted that because the foundation had raised property values, no one was willing to "question its operation."[17]

The Newport Restoration Foundation's efforts were effective, even though remnants of a half century of neglect continued to persist. One visiting reporter captured the picture of a neighborhood in transition:

> *The Point, the old neighborhood at the edge of the bay where Miss Duke's efforts have been concentrated, was once a slum—although a slum of first-rate Colonial houses interspersed among asbestos-shingled shacks. The shacks remain, but the Colonial houses, their gambrel roofs repaired and their clapboard siding painted a rich blue, green or mustard, gleam in the sun, each with a plaque marking it as restored, like a rubber stamp of approval.*

The Newport Restoration Foundation and Preservation Society of Newport County coexisted with each other in a cordial alliance to secure a future for Newport by emphasizing its historic past. These guardians of the city's heritage played an important role in its "growing identity as a center of tourism." The astute observer also noted the impact of the Newport Bridge:

> *Five years ago the Newport Bridge, a great suspension span soaring across the East Passage of Narragansett Bay, was opened to traffic. The bridge had the dramatic effect on the cityscape that many such developments do: The site of the former ferry terminal at the water's edge became a motel, and pleasantly messy Thames Street, a waterside road of sailors' bars and cheap shops, was torn down and replaced by a suburban-like shopping center and a four-lane highway named for Newport's other attraction, the America's Cup.*[18]

The contradictions that are inherent in the very fibers of Newport remained evident. The about-to-be-built highway would eventually run right through the Point section, "putting many of the restored houses that [were] supposed to be the city's pride and joy right beside a four-lane highway." David Porter, executive director of the Preservation Society of Newport County, lamented that it was "the kind of planning that dates from the day when it was still believed that the automobile was king." This belief still persists into the twenty-first century.[19]

While Duke and Warren receive much public acclaim, other initiatives underway contributed to the preservation of Newport's built environment after World War II. In 1952, for example, Antoinette Downing and Vincent Scully Jr. published *The Architectural Heritage of Newport, Rhode Island, 1640–1915*. The book captured the situation in Newport. The town was a national architectural treasure. More than four hundred structures built before 1830 still stood when the book was first published. By its second edition in 1967, fifty of those had been torn down. The state and federal governments to which "Historic Newport" should have been able to look for support were financing "road and renewal programs requiring further destruction." The book was a plea for all resources—national, state, and local—to preserve what one commentator called "perhaps one of the most beautiful places remaining on the Atlantic coastline." It was "doomed to disappear unless an effort [was] made to save the old homes."[20]

Other local Newport organizations were also making an impact. In the mid-1960s, Operation Clapboard and the Oldport Association had saved "sixty earlier houses, most of them in the Point section east of Washington Street. Upper Thames Street, where nine of the restored houses make a fine row, had become a showplace." In 1965, Newport enacted a historic district law and soon thereafter established the Newport Historic District Commission. In the 1970s, the State of Rhode Island Historic Preservation Office conducted detailed surveys of three Newport neighborhoods: Kay-Catherine and Old Beach Road (1974), West Broadway (1977), and Southern Thames Street (1980).[21]

The historic preservation movement was broader than local initiatives underway in Newport. In 1968, the state legislature passed a bill establishing the Rhode Island Historical Preservation and Heritage Commission to identify, document, publicize, and protect the state's historic buildings, districts, and archaeological sites, among other duties. Its efforts would be sustained with federal and state funds, as well as grants and private donations. Providence and its environs also had much architectural heritage to save. The preservationists' success would enhance the capital city's image as a Renaissance city before the end of the twentieth century. With more than four centuries of historic homes, buildings, and sites to save, the state was in the process of establishing a strong preservation ethic.[22]

The preservationists and renewalists shared the same goal of reestablishing Newport as a tourist center, albeit through completely opposite methodologies. In 1967, Downing had warned about the impact of two major public works initiatives:

The Newport-Jamestown Bridge, soon to be built, brings with it a state-financed road ninety-eight feet wide, that as now designed will cut a divisive north–south swath through the oldest part of Newport, and a federally financed urban renewal project will sweep away all the old buildings on the west side of Thames Street, south of the Brick Market, together with the eighteenth century wharves and wharf buildings.

Along with eliminating structures from Newport's historic Point section, as Downing warned, the bridge facilitated a greater flow of automobiles into the city. This influx was previously modulated by the ferry's capacity and schedule. The character of Newport was altered by plans to accommodate the increased number of automobiles associated with its re-focus on tourism. The introduction of multi-lane circulatory roadways complicated the efforts to preserve the town's unique character…the very same character that was the centerpiece of Newport's post–World War II revival.[23]

Katherine Warren expressed her concern about one such project, the Memorial Boulevard Extension. In a letter to Governor Chafee in the winter of 1967 she said that she was departing on a Florida vacation and hoped that there would "be something left of Newport to save when she got back!" It is interesting to speculate on Newport's desirability had the bridge builders moved the eastern terminus north to avoid the Point section and had the renewalists designed a walking city downtown rather than trying to accommodate more automobiles.[24]

THE GREATEST GENERATION

The Newport Bridge would not have been built when or where it was without the persistence of its proponents. They persevered for decades before the bridge was approved and built in the face of constant and continual roadblocks, especially from the U.S. Navy, Jamestown's town fathers, and the editors of the *Providence Journal*. There were many of them between the 1930s and 1969. Theodore Francis Green, in his capacity as governor and then senator, had advocated for a bridge as early as 1935 and was an active supporter into the 1950s. Henry S. Wheeler, Newport's mayor from 1935 to 1940, called for a bridge in June 1938. Newport Mayor Herbert Macauley was a proponent for a bridge between

1941 and 1946. Jamestown advocate Mason Weedon, Newport County Chamber of Commerce President A. Hartley G. Ward, and Newport State Representative W. Ward Harvey helped form the Newport-Jamestown Bridge Association as early as 1947. Numerous Aquidneck Island legislators, including Representative Charles Walsh and Senator John Fitzgerald, whose respective bills resulted in the establishment of the Narragansett Bay Bridge Commission in 1948, fought for the bridge in Rhode Island's General Assembly throughout the period.[25]

Members of the Narragansett Bay Bridge Commission worked for the bridge between 1948 and 1951, especially its chairman, Earl C. Clark, and general manager, M. James Vieira. The case of Vieira is particularly interesting. As a member of the Jamestown Bridge Commission, he opposed the bridge. Then, as a member of the Narragansett Bay Bridge Authority, he assumed a leadership role to get the bridge built. Governor Del Sesto also might not have opposed the bridge, but his lack of support most likely contributed to the defeat of the 1960 referendum and his ambiguity added much confusion to the United States Subcommittee on Public Roads hearing earlier that summer.

Vieira was not the only one whose position changed on the proposed bridge. The editorial board of the *Providence Journal* registered its disapproval of the proposed bridge many times between 1945 and 1965. Their objections included (but were not limited to) the seeming inability of the bridge to be self-sustaining; its belief that the state could not economically support the cost of new highways plus the added expense for the bridge; the plan to continue tolls on the Jamestown and Mount Hope Bridges after their bonds had been paid off; their questioning whether Newport was ready for the changes a bridge would bring; and taking RITBA to task for assuming it could use Mount Hope Bridge tolls without statewide voter approval. By the mid-1960, however, the opinion makers had modified their criticism. The editors sided with Chafee and Dwyer during the interest expense crises of 1966 and blamed the General Assembly's leadership for the ensuing lack of faith from the investment community in the State of Rhode Island's highway bonds. The opinion makers praised Chafee's leadership on cost overruns and presented as necessary the statewide vote in the fall of 1966, going as far as recommending a "yes" vote on that year's referendum.

Many of the early proponents of the Newport Bridge were Democrats. For example, Governor Green, Governor J. Howard McGrath, Governor Pastore, Mayor Herbert Macauley, and State Representative Walsh were

all Democrats. Alton Head Jr., the strident opponent during the early years, was a Republican, as was his colleague, the caustic chair of the Senate Corporations Committee, Clarence Horton. The roles changed during the 1960s. Proponents Chafee and Dwyer were leaders of the Republican Party. On the other hand, Woonsocket State Senator Francis P. Smith and Smithfield State Senator Walter J. Kane, the General Assembly members who exacerbated the bond debacle of 1966 by not approving Chafee's budget because they objected to the interest expense payments, were both Democrats. It is interesting to note that the shift in the *Providence Journal*'s editorial disposition on the bridge seems to coincide with Chafee's ascendancy to governor, the newspaper being long believed to lean conservative on certain issues. A favorable traffic report also helped considerably.

It was the proponents' perseverance that Governor Licht was referring to in his speech during the Newport Bridge's opening ceremony. And the three men most responsible for the bridge were members of what Tom Brokaw appropriately called the "Greatest Generation." These were the men and women who were born and raised during World War I and the Great Depression. They developed values that served them and their country well, including "personal responsibility, duty, honor, and faith." As youthful adults, they defeated Nazi Germany and Imperial Japan, surmounting one heroic challenge after another. When they returned home, they developed the most powerful economy in history, contributed to advances in arts and sciences, implemented visionary social programs, advocated for civil rights, helped rebuild the countries of their allies, and remained vigilant against totalitarianism and communism. They provided the following generation, the baby boomers, with the wherewithal to create enormous wealth, political strength, and freedom from foreign oppression. They were far from perfect, allowing McCarthyism to spread and racism to persist. They were humble, rarely talking about the atrocities they witnessed, the sacrifices they made, or the battles they won.[26]

Alfred Hedefine, Gerry Dwyer, and John Chafee were all members of that generation. Each served in World War II and, upon their return, played major roles in public works projects in Rhode Island and nationwide. They were relentless advocates for the Newport Bridge.

Hedefine became president of Parsons Brinkerhoff in 1965. He held that post until 1970. The Newport Bridge was his "outstanding bridge project." The bridge itself was highly decorated, garnering awards from the New York Association of Consulting Engineers, the Consulting

Engineers Council, the American Iron and Steel Institute, the National Society of Professional Engineers, and the American Society of Civil Engineers. It also earned Hedefine a patent for its advancements in suspension bridge cable anchorage systems. The soundness of the Newport Bridge was tested on February 19, 1981, when a 562-foot, nineteen-thousand-ton tanker, cutting through a dense fog, bounced off one of its main piers. The Danish-registered *Gerd Maersk* was hauling 225,000 barrels of no. 2 heating oil to the C.H. Sprague & Sons terminal in Providence. The bridge remained unharmed except for some gray paint on one pier. Luckily, the 12.3 million gallons of heating oil remained in the boat's tanks and not in Narragansett Bay.[27]

Dwyer was a marine during World War II and Korea. After the bridge was built, Nixon named him to the National Transportation and Safety Board. Within two years, Licht refused to reappoint Dwyer to RITBA. The dismissal prompted Republican State Chairman Thomas E. Wright to denounce Licht's partisanship, characterizing it as "another clear indication of the [administration's] lack of concern for the welfare of the people of the state." Wright said that Licht's rude removal of Dwyer was purely political and in stark contrast to Chafee's bipartisan reappointment during his tenure of Democrats John Nicholas Brown and John Gill. Wright said that Dwyer's dozen years of experience and leadership were critically needed, especially as RITBA was about to embark on a multimillion-dollar lawsuit with Bethlehem Steel over the failed paint job.[28]

Chafee was a marine during World War II, helping to establish beachheads on Guadalcanal and Okinawa. He also led a marine rifle division during the Korean War after being recalled to active duty in 1951. Nine months before the Newport Bridge was completed, Chafee lost the Rhode Island gubernatorial race to Frank Licht by 7,800 votes, primarily because Chafee had announced that he had changed his opinion on the need for a state income tax and because he curtailed his campaign when his fourteen-year-old daughter, Tribbie, died after a horse riding accident. Licht campaigned against a state tax but implemented one anyway. Richard Nixon appointed Chafee secretary of the navy, the position he held at the time of the ribbon cutting ceremony on June 28, 1969.[29]

Years later, Chafee got a craw in his throat when the bridge was named after Pell and not him, a slight of considerable proportion. On July 29, 1992, the Rhode Island General Assembly overwhelmingly supported renaming the bridge to honor Newport's native son and long-serving United States senator. Pell said that he was "humbled and delighted" by the honor.

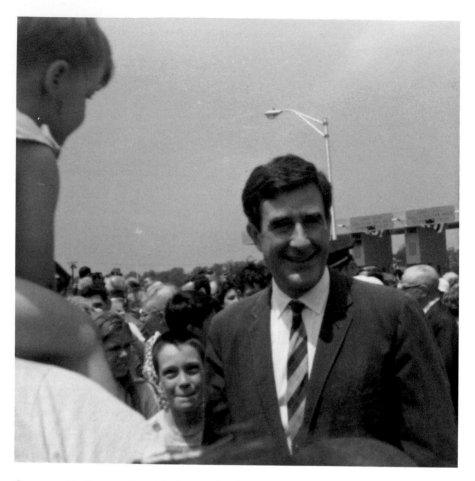

Governor Chafee mingling with the crowd at the opening ceremony. *Courtesy of the Jamestown Historical Society.*

Governor Bruce Sundlun signed the legislation. He dismissed criticism that it would cost $40,000 to replace bridge signage with the new name, calling that "a lot of malarkey." No one was going to replace the signs, Sundlun declared. "We're going to put a plaque on the bridge." He said he would be surprised if it cost $1,000. Pell said it should cost nothing, suggesting they should simply "wait until the signs need replacement."[30]

In a tribute to Chafee upon his death in October 1999, a *Providence Journal* article highlighted many of the projects that contributed to Chafee's legacy. The author proclaimed, "As governor, he built the Newport Bridge." According to Chafee's staff, he was very proud that "he built it without federal money" and that the funds came from state bond issues. "It used

to frost him that it was named the Pell Bridge," said aide Janet Coit. "But then he'd say, 'no one actually calls it that.'" The Newport Bridge was only one of John Chafee's many accomplishments in a life dedicated to public service. The *New York Times* claimed that "he was an unabashedly liberal governor. He pushed for anti-discrimination laws in housing and employment before the Federal Government passed them. He advocated the construction of Interstate 95, developed parks throughout the small state and pushed through a state plan of healthcare for the elderly before Congress enacted Medicare."

In 1965, as controversies about the Newport Bridge escalated, the State of Rhode Island purchased Colt State Park in Bristol. The property was pieced together by Samuel P. Colt around 1905 upon which he built a mansion called the "Casino" and raised prized Jersey cows. Colt was a descendent of Bristol's legendary DeWolf family. He was a banker (Industrial National) and manufacturer (Uniroyal). The state purchased the 464 acres of sprawling lawns, stone walls, and curvilinear roadways tucked at the base of Poppasquash Point using money from its Green Acre Fund, another of Chafee's accomplishments to help preserve open space. Chafee

Another hallmark of Governor Chafee's leadership was the state's acquisition of Colt State Bark in Bristol. A statue of Chafee erected in 2003 captures him in full, purposeful stride. *Photo by author.*

helped dedicate the park on August 21, 1968. Years later, on June 17, 2003, Governor Donald Carcieri unveiled a statue of Chafee overlooking the park's fishing pier.[31]

The statue captures Chafee in full purposeful stride. His inspiring words are etched into one side of the statue's base: "What we do today we do for our children and our children's children." You cannot see the Newport Bridge from this vantage point. Rather than keeping an eye on the bridge, Chafee is marching away from Newport up the bay toward Providence. It would be a fitting tribute to honor Chafee and Dwyer for their roles in building the Newport Bridge, which helped breathe life into Newport as it transformed itself from a sailor town and resurrected its economy on a foundation of tourism in the decades following World War II. In the meantime, the bridge itself serves as a monument to their perseverance.

EPILOGUE

The Newport Bridge has graced Narragansett Bay for close to half a century. Very few Rhode Islanders and southeastern New Englanders can correctly identify that it was built as late as 1969. To many, the Newport Bridge has always been there. Most are surprised to learn that it was not built earlier. They are equally intrigued to learn that until 1969, a ferry shuttled people between Jamestown and Newport. They are skeptical to hear that such a ferry had been in operation for close to three hundred years.

The Newport Bridge has become much more than just a structure spanning Narragansett Bay. It has become a symbol representing Newport, much like the Golden Gate Bridge symbolizes San Francisco. From the time visitors arrive in that western city, images of the bridge appear in all forms. Its photo adorns books, visitor guides, billboards, postcards, paintings, posters, calendars, and all types of souvenirs. It stars in movies, television shows, advertisements, songs, and video games. The sanfrancisco.com website has a drawing of the Golden Gate Bridge with a sun setting beyond the far tower wrapped in a red heart, short for "I love San Francisco." It is a major attraction, luring walkers and bicyclists to cross above or sightseers to board tour boats and view it from below. The bridge's International Orange paint makes it a visible and dramatic architectural spectacle. It is said to be the most photographed bridge in the world. Much the same can be said about the Brooklyn Bridge, which has virtually become synonymous with New York City. Suspension bridges have special influence on their communities.

The Golden Gate Bridge has been standing thirty-two years longer, is more vibrant in color, and its cliff-side setting is more dramatic than the Newport Bridge, but it did not take long for the bridge over Narragansett Bay to assume similar iconic qualities. Its image, too, is ever-present to residents and visitors to Newport, Jamestown, and the state of Rhode Island. While examples abound, the following serves as one poignant artifact.

In 2006, Beatrice "Trixie" Wadson initiated a publication called *Balancing the Tides: A Newport Journal*. It welcomed established and emerging artists to submit their unpublished works for inclusion in a collection pondering "what draws them to Newport County." The publisher received entries from around the state and beyond, prompting Wadson to declare that "the magical place that is Newport defies geographical boundaries." The journal intended to preserve artists' works in a "memorable keepsake, to be treasured and revisited again and again." It was to be published twice each year, summer and winter. Each edition of the handsome publication was chock-full of articles, remembrances, fiction, photos, drawings, and paintings. Even the advertisements were artistically arranged and pleasing to the eye.[1]

A photo Wadson snapped of the Newport Bridge "rising out of the early morning fog off Rose Island lighthouse" graced the cover of the first issue. It is a beautiful and unique shot of the bridge. The main tower on the Newport side of the bridge resting atop pier 1E dramatically reaches above Narragansett Bay, seemingly impervious to the haze that shrouds the majestic arch reminiscent of Roebling's Brooklyn Bridge. In the foreground, the untamed green brush juxtaposes nature with the technology of the bridge. The bridge complements the island terrain. It is a compelling image for an artistic journal and the complicated city to which it was devoted. Like the bridge itself, it is a welcoming and compelling visage. One is not surprised to find the bridge gracing the cover of the journal; rather, quite the opposite might be true. In fact, it is representative of most publications about Newport. There is usually the bridge.[2]

The fourth entry of the first issue of *Balancing the Tides* was also bridge-themed. It was titled "View(s) from the Bridge" and authored by Wakefield-based freelance writer Johnette Rodriguez. It began by posing a question frequent bridge travelers might ask themselves: "On a sunny day in spring when the wind whips up the whitecaps and the light glistens on the water, the view from the Newport Bridge stuns me into musing: 'Do I ever take this ride and these sights for granted?'" It is the view and sentiment Governor

The inaugural issue of *Balancing the Tides* in 2006 captured the bridge "rising out of the fog off Rose Island lighthouse." *Courtesy of Beatrice "Trixie" Wadson.*

Chafee was hoping for when he insisted that the designers make certain travelers could see the beauty of Narragansett Bay as they crossed over its East Passage. Rodriguez was struck by how the bridge "suspends one in time" as the traveler notes the "unchanging cityscape laid out before you like one of those panoramic woodcuts from old European cities. Docks and piers; spires and towers; rooftops and balconies; masts and sails."[3]

The weather, Rodriguez wrote, "colors the water of Narragansett Bay like a fervent Impressionist." It is blue when the sun shines, gray under clouds or fog, almost black during heavy rainstorms, and "subtle variations when the sun is low on the horizon or filtered through thin clouds." Sunsets provide their own unique hues and are dependent on the traveler's direction and time of day, yielding skies of "yellows, reds, and oranges," while clouds reflect "pink, lavender, or violet." The moon, too, produces varying results depending on whether it is "[f]ull and silvery on the breakers or just a sliver hanging in a dark sky as you drive up and over the span of the bridge." The truly lucky traveler might encounter a "large yellow-orange pumpkin close to the horizon."[4]

However, Rodriguez explained:

> [I]t's not just the light and the colors that seep into you from the height of the bridge. When the air is clear, you notice vistas not normally absorbed: Mount Hope Bridge off in the distance; the wide blue expanse of Rhode Island Sound beyond the squat white Castle Hill lighthouse; tiny uninhabited Gould Island and the wooded tip of Prudence Island beyond it. You take in architectural details of buildings or parts of the shoreline that you could swear have never been there before: Victorian turrets and towers; decks atop a narrow Colonial saltbox; the windows of Newport Congregational Church and the spires of Trinity, St. Mary's, and Emmanuel; the grassy areas around and inside the sprawling ramparts of Fort Adams; the sturdy stone and brick buildings of the Naval War College.

She completed the picture:

> When the wind picks up and the weather warms, the view from the bridge becomes a seascape of sails and ships, schooners and sloops. A tilting parade of small white sails tiptoeing near the shore might be a class of beginners; a line of larger sails moving across the bay could be a full-scale regatta. A red-sheeted schooner swoops toward Jamestown, a romantic image of bygone times. Midsummer, Tall Ship masts and prows in the harbor stir even more vivid images of swashbucklers and buccaneers.

Rodriguez did not leave out the memorable sight of the bridge at night:

> The lights on the bridge itself, including the enchanting strand hung between the two tall towers, guide you across it in the dark of a moonless night,

The Newport Bridge is a monument to its proponents' perseverance. It has become a cultural icon to the city and state. *Courtesy of Ed Leand.*

> *through dense white fog when the tops of those towers are no longer visible, in a snowfall so furious the railings are hard to see, through a rainstorm that obscures the full outline of the bridge, as you head across the dark waters to the storied isle of Newport. With an air of carnival festiveness, they promise good times and cherished memories.*[5]

The locals have an expression to describe certain experiences or rituals particular to the state. They call it "the full Rhode Island." Rodriguez provided us with "the full Newport Bridge." It is evident that the bridge has become as cherished to many Rhode Islanders as the special place it leads to and from. The proponents, engineers, and builders who struggled for a quarter century to construct the Newport Bridge would certainly be pleased.

NOTES

Introduction

1. T. Curtis Forbes, "Bridge Is Dedicated, Opens to Traffic," *Newport Daily News*, souvenir edition, June 28, 1969.
2. Brian C. Jones, "Newport Bridge Is Opened," *Providence Sunday Journal*, June 29, 1969.
3. Ibid.
4. Licht Papers, "Newport-Jamestown Bridge Dedication, Saturday, June 28, 1969," 1. The text of Licht's speech was also reprinted in *Newport Daily News*, "Road to Bridge Still Licht's Goal," June 28, 1969.
5. Licht Papers, "Newport-Jamestown Bridge Dedication," 2.
6. Ibid., 4–5.
7. Forbes, "Bridge Is Dedicated."
8. Sam B. Girgus, "Nostalgia and Band Music on the Ferry's Last Trips," *Providence Sunday Journal*, June 29, 1969.
9. Ibid.
10. Martha Matzke, "Some Are Caught Toll-Less," *Providence Sunday Journal*, June 29, 1969.
11. *Newport Daily News*, "The Newport Bridge," June 28, 1969.

Chapter 1

1. Elliott, *This Was My Newport*, 3.
2. James, *American Scene*, 209–10.
3. Brownell, *Newport*, 7, 21.
4. Wilder, *Theophilus North*, 14–16.
5. Elliott, *This Was My Newport*, xi, xviii–xix, xxiii.
6. Ibid., xxiii.
7. Redwood Library and Athenaeum, *Annual Report, 2012–2013*, 2; Wilder, *Theophilus North*, 92.
8. Davis, "Newport."
9. Berman, *All That Is Solid Melts into Air*, 169, 295.
10. Inquiry Unlimited, "United States History: 18th Century, 1701–1766," http://inquiryunlimited. org/timelines/hist1700.html.
11. *Harpers New Monthly Magazine*, "Newport—Historical and Social," 289–90; Gregory, "Newport in Summer," 167–68; Mills, "Romantic Newport," 328.
12. Amory, "Newport," 118.
13. Stilgoe, "Narragansett Bay," 9; Schultz and Tougias, *King Philip's War*; Hanna, *History of Taunton Massachusetts*; *Taunton Gazette*, "44 Things: Conspiracy Island Is Spot Shrouded in Mystery," October 24, 2015, http://www.tauntongazette.com/ article/20151024/NEWS/151027132.
14. Barry, *Roger Williams and the Creation of the American Soul*, 254, 382; Stephen Heffner, "Narragansets, Roger Williams Among the First Commuters on Bay," *Providence Journal*, October 19, 1992.
15. Quahog.org, "Early Rhode Island Ferries."
16. Foster and Weiglin, *Splendor Sailed the Sound*, 17; Dunbaugh, "Overnight Boats from New York to Narragansett Bay," 58.
17. Dunbaugh, "Overnight Boats from New York to Narragansett Bay," 58.
18. Ibid., 58–59.
19. Ibid., 59.
20. Ibid., 59–60.
21. Ibid., 60–61.
22. Ibid.; Parsons, Brinkerhoff, Hall & Macdonald, "Narragansett Bay East Passage Crossing," February 1955, 5–7.
23. Parsons, Brinkerhoff, Hall & Macdonald, "Narragansett Bay East Passage Crossing," February 1955, 8.
24. Ibid., 8–9.
25. Candeub, Fleissig & Associates, "Master Plan," i–iii.

26. Ibid., 1,3.
27. Halberstam, *The Fifties*, 14; Candeub, Fleissig & Associates, "Master Plan," 3–4.
28. Candeub, Fleissig & Associates, "Master Plan," 4–5; Wikipedia, "Historical U.S. Census Totals for Newport County, Rhode Island."
29. Candeub, Fleissig & Associates, "Master Plan," 5–6.
30. Ibid.
31. Ibid., 7.
32. Ibid., 15.
33. Ibid., 16.
34. Ibid., 17.
35. Ibid., 16–17.
36. Ibid., 37.
37. Ibid., 41.
38. Ibid., 41–42.
39. Ibid., 42; Pantalone, "30 Year Span," 17–18. See also Leys, "Redevelopment Agency of Newport, Rhode Island." By then, the quip had become, "What you have here is a scenic Fall River."

Chapter 2

1. Narragansett Bay Bridge Authority, meeting minutes, March 15, 1950; Maden, *Jamestown Bridge*, 2–6.
2. Narragansett Bay Bridge Authority, March 15, 1950; *Providence Journal*, "Navy Opposes Bridge Over Bay," September 28, 1944.
3. *Providence Journal*, "Navy Ends Objection to Building of Newport to Jamestown Bridge," August 30, 1944.
4. *Newport Daily News*, "Bridge Body Commends Objection Withdrawn," August 30, 1945; *Providence Sunday Journal*, "Newport Bridge," September 2, 1945.
5. *Newport Daily News*, "Speakers Emphasize Need of Bay Bridge," September 21, 1945.
6. Ibid.
7. Ibid.
8. *Newport Daily News*, "Navy Disapproves Proposed Bay Bridge," December 21, 1945.
9. *Providence Journal*, "McGrath Accepts Advance to U.S. Solicitor General; Pastore to Govern State," September 29, 1945.

10. *Newport Daily News*, "Bridge Authority Bill Introduced in House," February 28, 1947.

11. Ibid., "Bay Bridge Group Organizes for Action," October 10, 1947.

12. Ibid.

13. *Newport Daily News*, "Bay Bridge Group Elects Its Chairman," October 17, 1947.

14. Ibid., "Bay Bridge Body Views Span Obstacles," October 25, 1947.

15. *Providence Journal*, "Fitgerald Says Head Fought Span," February 15, 1948.

16. Ibid., "Jamestown Fails to Endorse Plan," February 25, 1948.

17. Ibid., "Bridge Approved with Reservation," February 26, 1948.

18. Ibid., "Enthusiastic Down-State Proponents Loudly Support Bill to Establish Narragansett Bay Bridge Authority," February 27, 1948.

19. Ibid.

20. Ibid.

21. Ibid.

22. Ibid.

23. Ibid.

24. Ibid.

25. Ibid.

26. Ibid., "House Democrats Favor Bridge Bill," February 28, 1948.

27. *Providence Sunday Journal*, "Jamestown Span Fight Flares Up," February 29, 1948.

28. *Providence Journal*, "Bridge Plan Foes Seek Compromise," March 17, 1948.

29. Ibid., "Senate Receives Two Bridge Bills," March 18, 1948.

30. Ibid., "2 Divergent Bills for Bridge Voted," April 9, 1948.

31. Ibid., "Jamestown Span Measure Adopted," April 30, 1948.

32. State of Rhode Island Public Law 2152, January Session 1948, 1,038.

33. Ibid., 1,049.

34. *Providence Journal*, "In Perspective: It Better Be Beautiful," May 10, 1948.

35. Narragansett Bay Bridge Authority, meeting minutes, July 20, 1948.

36. Ibid.; meeting minutes, October 1, 1948.

37. *Providence Journal*, "Two Bridge Plans Received by Navy," October 3, 1948.

38. *Newport Daily News*, "Newporters to Attend Hearing on Bay Bridge," March 21, 1949.

39. Ibid., "Army to Keep Bridge Hearing Record Open," March, 23, 1949.

40. Ibid.

41. Ibid.

42. *Newport Daily News*, "Alternate Site Proposed by Vieira," March 23, 1949.

43. Ibid., "Fort Site Suggested for Newport Bay Span," June 15, 1949. The Dumplings–Fort Adams suspension bridge was later estimated at $32.5 million when submitted to the General Services Administration in January 1951. See Narragansett Bay Bridge Authority, meeting minutes, July 17, 1952.

44. *Providence Journal*, "Fort Site Suggested for Newport Bay Span," June 15, 1949; "New Bridge Plan Gets Navy Okay," June 15, 1949.

45. Narragansett Bay Bridge Authority, meeting minutes, July 19, 1949.

46. Ibid.; meeting minutes, March 15, 1950.

47. *Providence Journal*, "R.I. Bridge Loan Seems Doubtful," July 22, 1950.

48. Narragansett Bay Bridge Authority, meeting minutes, July 17, 1951.

49. Ibid.

50. Ibid.

51. Ibid.; meeting minutes, July 21, 1953.

52. Mancini, Hill and Volpe, "New England South Shore Highway, Its Location and Feasibility," transmittal letter.

53. Ibid., transmittal letter, 6–8.

Chapter 3

1. Robert N. Cool, "Assembly Studies Bridge Proposals," *Providence Sunday Journal*, March 8, 1953; *Newport Daily News*, "Turnpike Bonds Referendum Eyed," February 4, 1953.

2. Cool, "Assembly Studies Bridge Proposals."

3. *Providence Journal*, "Study on Newport Bridge to Start," March 26, 1954.

4. *Newport Daily News*, "Mt. Hope Span, Newport Turnpike Bills Signed by Governor," May 3, 1954.

5. See State of Rhode Island Public Law, "Chapter 3390," 541–48.

6. Ibid.

7. Ibid., 544, 549–51.

8. Ibid., 551–55.

9. Ibid., 564–65.

10. Ibid., 568, 570.

11. Ibid., 572–73.

12. *Providence Journal*, "Jamestown-Newport Section Key to South Shore Highway," January 27, 1955.

13. Parsons, Brinkerhoff, Hall & Macdonald, "Narragansett Bay East Passage Crossing," February 1955, transmittal letter.

14. Ibid., 17–18.

15. Ibid., 19.

16. Ibid., 21.

17. Ibid., 19, 21–22.

18. Ibid., 24.

19. Ibid., 25.

20. Ibid., 35.

21. Ibid., 36.

22. Ibid., 42.

23. Ibid., 43–44.

24. Ibid., 47–52.

25. Ibid., 47–53.

26. *Newport Daily News*, "Newport-Jamestown Bridge Prospects Seem Dim in Next 15 Years," November 25, 1955.

27. Paul A. Kelly, "Upper Bay Bridge Studied," *Providence Sunday Journal*, January 1, 1956.

28. *Newport Daily News*, "Bay Bridge Prospects Given Boost," June 15, 1959; "'Best News R.I. Has Had in Years,' Says Gov. of Raytheon Decision," June 15, 1959.

29. Ibid., "Best News R.I. Has Had in Years."

30. *Providence Journal*, "Bankers Weigh Newport Span," June 18, 1959.

31. James T. Kaul, "He Has 'Thing' About Bridges," *Providence Evening Bulletin*, April 22, 1966; Newport.com, obituary of Francis G. Dwyer, November 14, 2011, http://www.newportri. com/obituaries/francis-g-dwyer/article_51a728f6-d25a-5fc8-9b97-5c0cb245c51c.html.

32. Paul A. Kelly, "Newporters Aim for East Passage," *Providence Sunday Journal*, July 5, 1955.

33. Ibid.

34. Ibid.

35. Parsons, Brinkerhoff, Hall & Macdonald, "Narragansett Bay East Crossing, Supplemental Engineering and Feasibility Report," December 1959, 2.

36. Ibid., i–ii.

37. *Providence Evening Bulletin*, "Bay Bridge Is Possible in '63," January 20, 1960; *Providence Journal*, "$36 Million for Lower Bay Span," January 8, 1960; *Providence Evening Bulletin*, "Bay Bridge Is Possible in '63," January 27, 1960.

38. *Providence Evening Bulletin*, "Bridge Clash On at State House," March 30, 1960.

39. Ibid.; *Providence Journal*, "Senate Passes Toll Span Bill," April 27, 1960.

40. *Providence Journal*, "The State Needs Road More than It Needs a Bridge," April 29, 1960.

41. Paul A. Kelly, "Ask $20 Million for Span," *Providence Sunday Journal*, June 12, 1960.

42. Mackinac Bridge Authority, "History of the Bridge," http://www.mackinacbridge.org/history-of-the-bridge-14.

43. U.S. Senate, Subcommittee of the Committee on Public Works, "Bridges Across Narragansett Bay, R.I.," 3–4.

44. Ibid., 5.

45. Ibid., 7.

46. Ibid., 11–12.

47. Ibid., 13–14.

48. Ibid., 15–16.

49. Ibid., 16–18.

50. Ibid., 22.

51. Ibid., 25–27.

52. Ibid., 23.

53. Ibid., 29–37.

54. Ibid., 29–39.

55. Ibid., 40–43.

56. Ibid., 44–46.

57. Ibid., 48–49.

58. Ibid., 51; Orlando Potter, "Bridge Toll Measure Signed by President," *Providence Journal*, September 14, 1960.

59. *Providence Journal*, "Governor Now Cooperative on Newport Bridge Plans," July 13, 1960.

60. *Providence Evening Bulletin*, "Bridge Authority Head Defends Financing Plan," August 9, 1960.

61. *Providence Journal*, "Adm. Weakly Favors Plan for New Span," October 7, 1960.

62. *Providence Evening Bulletin*, "Newport Bridge Opposition Grows," October 19, 1960.

63. Ibid.

64. Ibid., "Enjoin Commissions Anti-Bridge Outlay," October 20, 1960.

65. *Providence Sunday Journal*, "The Objections to the Bridge Subsidy," October 30, 1960.

66. Ibid.

67. *Providence Evening Bulletin*, "Dwyer Attacks Bridge Editorial," October 31, 1960; "The Objections to the Bridge Subsidy."

68. Ibid., "Bridge Model to Help Boost the Real Thing," November 2, 1960.

69. Ibid., "Bridge Data Lacking," November 3, 1960.

70. Ibid., "Dwyer Says Bridge Data Not Sought," November 4, 1960.

71. Ibid., "Bridge Costs Stump Experts," November 4, 1960; "Newport Residents Urge Bridge Okay," November 3, 1960; *Providence Journal*, "Turnpike Body Seeks Control of 2 Bridges," April 11, 1961.

72. *Providence Journal*, "Turnpike Body Seeks Control of 2 Bridges."

73. Ibid.

74. *Providence Evening Bulletin*, "The Turnpike Authority's High-Handed Proposals," April 12, 1961.

75. *Providence Journal*, "Bills Would Abolish Turnpike Authority," April 13, 1961.

76. Ibid., "Jamestown-Newport Bridge Plan Favored by Hotel Group," April 27, 1961.

77. Ibid., "Court Declares Bridge Authority Petition Illegal," June 30, 1961.

78. *Providence Evening Bulletin*, "Supreme Court Stays Bridge Control Hearing," December 15, 1962.

79. *Providence Journal*, "Bridge Board and Turnpike Authority Resume Old Battle," January 11, 1962.

80. Ibid., "Commission Would Make Bridge Study," January 13, 1962.

81. *Providence Sunday Journal*, "Span Agency Said It Should 'Clean House,'" January 14, 1962.

82. *Providence Journal*, "Island Councils Seeks Notte Aid," February 2, 1962.

83. The Baby Hoover Commission was a yearlong study conducted by the Rhode Island Special Committee to Study Government Organization and Operations. It was modeled after the 1947 Commission on Organization of the Executive Branch of the Government to recommend administrative changes in the federal government. That study was established by President Harry S Truman and nicknamed after Herbert Hoover, who chaired the committee. See also *Providence Evening Bulletin*, "Turnpike Unit Opposes Report," July 11, 1962.

84. *Providence Evening Bulletin*, "R.I. Bridge Authority Dealt Court Setback," June 26, 1962; "Notte Rejects Plea for Rule on Bridge Issue," July 27, 1962; *Providence Journal*, "Newport-Jamestown Bridge Discussed," August 9, 1962.

85. *Providence Evening Bulletin*, "Notte to Seek Court Ruling on Newport Bridge," August 29, 1962.

86. *Providence Journal*, "Turnpike Unit Given Ruling," September 22, 1962

87. Chafee Papers, 1962–75, MSG no. 114, Records of the Governor and Gubernatorial Campaigns.

Chapter 4

1. Paul A. Kelly, "Bridge Problem Is Complicated," *Providence Sunday Journal*, March 10, 1963.
2. *Providence Journal*, "Bridge Advocates Steal Show," February 23, 1963.
3. Ibid., "Bill Would Erase R.I. Turnpike, Bridge Authority," January 23, 1963; *Providence Evening Bulletin*, "Newporters Pressing for Span," March 11, 1963.
4. *Providence Evening Bulletin*, "Newporters Pressing for Span."
5. Ibid., "Governor Approves of Bridge Proposal," March 20, 1963; "Jamestown Council Opposes Bridge Bill," March 16, 1963; *Providence Sunday Journal*, "The Newport Jamestown Bridge Issue," March 24, 1963.
6. William H. Young, "Bridge Project Takes Major Step Forward," *Providence Journal*, May 6, 1963.
7. *Providence Evening Bulletin*, "Congress Given Legislation on Mount Hope Bridge," March 29, 1963; *Providence Journal*, "Toll Use Sought for New Bridge," July 26, 1963; "House Passes Bill Diverting Bridge Tolls," October 8, 1963.
8. *Providence Evening Bulletin*, "Ise's Division Okays Newport Bridge Plans," November 27, 1963; "Seek Bridge Ruling in Court," November 13, 1963.
9. Ibid., "Eagerness Carries Away the Newport Bridge Backers," February 5, 1964; "Five Parts of Bay Bridge Act Ruled Unconstitutional," January 24, 1964.
10. *Providence Journal*, "Can Continue Mt. Hope Toll, Authority Says," February 4, 1964.
11. *Providence Evening Bulletin*, "Bridge Is Transferred," June 1, 1964.
12. Ibid.
13. *Providence Journal*, "Toll Challenge in Nugent's Lap," June 3, 1964; Daniel L. Lewis, "Lawyers to Continue Toll Fight," *Providence Journal*, June 29, 1964; *Providence Evening Bulletin*, "Petition to Bar Tolls on Bridge Dismissed," August 7, 1964.
14. *Providence Evening Bulletin*, "Letter Campaign to Seek Approval of Bay Bridge," September 2, 1964.

15. *Providence Sunday Journal*, "A Drive to Put Over the Newport Bridge," September 6, 1964.
16. John P. Hackett, "Study Backs Newport Bridge," *Providence Evening Bulletin*, September 23, 1964.
17. Ibid.
18. Ibid.
19. *Providence Journal*, "The Bay Bridge Now Is Fiscally Feasible," September 24, 1964.
20. Ibid., "Is Aquidneck Ready for the Bay Bridge?" September 25, 1964.
21. Rhode Island Development Council Memorandum to Governor John H. Chafee, October 15, 1964, Chafee Papers; *Providence Journal*, "Chafee Urges Approval of Bridge Plan," October 17, 1964.
22. *Providence Journal*, "Chafee Favors Bridge Issue," October 22, 1964.
23. *Providence Evening Bulletin*, "The Bridge: A Complicated Financial Story," October 27, 1964.
24. *Providence Journal*, "Every Referendum for State Approved," November 4, 1964.
25. *Providence Evening Bulletin*, "Shift in Bridge Route Is Sought," November 6, 1964.
26. Ibid.
27. Ibid., "Navy 'Studies' New Site for Bay Bridge," November 9, 1964.
28. *Providence Journal*, "Newport Is Troubled by the Change in Bridge Plans," November 17, 1964.
29. Ibid., "Span Site Shift Data Awaited," November 24, 1964; *Providence Evening Bulletin*, "The Bridge Goes Round and Round," November 24, 1964.
30. *Providence Evening Bulletin*, "Newport Group Backs Bridge Terminus Shift," December 1, 1964; "Navy OKs Bridge Shift to North," December 3, 1964.
31. *Newport Daily News*, "Preferability of Middletown Location for Bridge Terminus Cited by Group," November 27, 1964; Chafee Papers.
32. *Providence Journal*, "Controversy Grows Over Bridge," November 27, 1964; City of Newport, Resolution of the Council, No. 150–64, November 12, 1964; Chafee Papers.
33. *Providence Evening Bulletin*, "Navy OKs Bridge Shift to North."
34. Letter from RITBA Chairman Francis G. Dwyer to Navy Undersecretary Paul B. Fay Jr., December 4, 1964; Chafee Papers.
35. *Providence Journal*, "Economics and the New Bridge," December 5, 1964; *Providence Evening Bulletin*, "Toll on New Bay Bridge $1.70," December 8, 1964.

36. *Providence Evening Bulletin*, "South Route Seen for Bay Span," December 8, 1964; *Providence Journal*, "Chafee Accepts Southern Route for New Bridge," December 17, 1964.

37. Avery-Storti Funeral Home and Crematory, "Wallace Campbell, III, Obituary," February 6, 2011, http://www. averystortifuneralhome. com/fh/obituaries/obituary.cfm?o_id=1071293&fh_id=13474; *New York Times*, "Thomas Benson Obituary," August 15, 1987, http://www. nytimes.com /1987/08/15/obituaries/thomas-benson.html; letter from Wallace Campbell III to Governor John H. Chafee, December 11, 1964, Chafee Papers.

38. Letter from Wallace Campbell III to Governor John H. Chafee, December 11, 1964, Chafee Papers.

39. Ibid.

40. Ibid.

41. Letter from Antoinette Downing, Providence Preservation Society, to Governor John H. Chafee, December 31, 1964, Chafee Papers.

42. Ibid.

43. Letter from Eugene J. McNulty to Governor John H. Chafee, January 16, 1964, Chafee Papers.

44. Ibid.

45. Letter from Dr. William W Miner to Francis G. Dwyer, January 4, 1965, Chafee Papers.

46. Letter from George M. Simpson to Governor John H. Chafee, December 9, 1964, Chafee Papers.

47. Letter from Lewis Arnow, M.D., to Governor John H. Chafee, January 2, 1965, Chafee Papers.

48. Letter from Lester J. Millman, Chairman, Urban Design Center Rhode Island Chapter of the American Institute of Architects to Governor John H. Chafee, January 11, 1965, Chafee Papers.

49. Letter from Nadine Pepys, President, Operation Clapboard to Governor John H. Chafee, January 11, 1965, Chafee Papers.

50. Ibid.

51. Ibid.

52. Letter from Governor John H. Chafee to Nadine Pepys, President, Operation Clapboard, January 28, 1965, Chafee Papers.

53. Letter from Wiley T. Buchannan Jr. to Governor John H. Chafee, January 26, 1965, Chafee Papers.

54. Letter from Dr. William W. Miner to Governor John H. Chafee, February 10, 1965, Chafee Papers.

55. Letter from Governor John H. Chafee to Dr. William W. Miner, February 12, 1965, Chafee Papers.

56. Letter from Frank E. Smith, President, Newport Lodge No. 119, International Association of Machinists, to Governor John H. Chafee, March 8, 1965, Chafee Papers.

57. Ibid.

58. Letter from Governor John H. Chafee to Eugene McNulty, February 10, 1965, Chafee Papers.

59. *Providence Evening Bulletin*, "Chafee Denies Rift Over Bridge," February 6, 1965.

60. Ibid.; letter from Kenneth E. BeLieu, Undersecretary of the Navy, to Governor John H. Chafee, March 10, 1965, Chafee Papers.

61. Letter from Kenneth E. BeLieu, Undersecretary of the Navy, to Governor John H. Chafee, March 10, 1965, Chafee Papers.

62. D. Neale Adams, "Bridge Assent Brightens City's Outlook," *Providence Sunday Journal*, January 4, 1965.

63. Ibid.

64. Ibid.

65. *Providence Journal*, "Chafee Asks Court Opinion on Using of Bridge Tolls," January 9, 1965; *Providence Evening Bulletin*, "The Court Ruling Blocks All Work on the Bridge," March 11, 1965; *Providence Journal*, "Referendum Is Sought on Bridge Toll Snarl," March 13, 1965.

66. *Providence Evening Bulletin*, "Mt. Hope Bridge Tolls Cannot Be Used for New Bridge," March 10, 1965.

67. Ibid.; *Providence Journal*, "Span Agency OKs Hiring of Assistant," November 26, 1964.

68. *Providence Evening Bulletin*, "A Lesson on Bridge Building," December 10, 1964.

69. Ibid.

70. Ibid., "Mt. Hope Bridge Tolls Cannot Be Used for New Bridge."

71. *Providence Journal*, "Senate Asked to Seek Bridge Toll Opinions," March 12, 1965.

72. Ibid., "Bridge Authority Bill to Ask Referendum," March 26, 1965; "Gov. Chafee Gets Bill on Bridge Toll Vote," April 24, 1965.

73. Ibid., "Chafee Expects Referendum on Bridge to Pass," April 26, 1965.

74. Ibid., "Bridge Promotion Out, Dwyer Says," April 27, 1965.

75. Ibid., "45,000 Voters Back Proposals by 3–1 Margin," June 23, 1965.

76. Ibid.

77. Ibid., "Authority Names Lower Bay Span 'Newport Bridge,'" March 22, 1966.

Chapter 5

1. C. Elliott Stocker, "Dwyer Is Still Sure On Bridge," *Providence Evening Bulletin*, August 12, 1965.

2. Ibid.

3. Ibid.

4. John H. Chafee, Meeting Notes, "Narragansett Bay Bridge, September 1, 1965," Chafee Papers.

5. Ibid.

6. *Providence Evening Bulletin*, "Undisclosed Bridge Financing," December 18, 1965.

7. Ibid.

8. Ibid., "Bay Bridge Bond Sale Is Closed," December 21, 1965; "Work Is Begun on Bay Bridge," December 24, 1965.

9. James T. Kaull, "$3 Million Aid for New Bridge Slated by State," *Providence Journal*, December 31, 1965.

10. Ibid.

11. Ibid.

12. *Providence Journal*, "Majority Balks at Bridge," April 21, 1966.

13. Ibid.; *Providence Evening Bulletin*, "Governor Says Bridge to Repay Loans by State," April 22, 1966.

14. *Providence Evening Bulletin*, "Governor Says Bridge to Repay Loans by State."

15. *Providence Journal*, "Banks Withhold Bid Offers on Notes for R.I. Roads: Sale Postponed Because of Bridge Issue," April 22, 1966; "Governor Calls Parley on Bonds," April 23, 1966.

16. Ibid., "Governor Calls Parley on Bonds."

17. *Providence Journal*, "Banks Withhold Bid Offers."

18. Letter from Francis G. Dwyer to Governor John H. Chafee, March 23, 1966, Chafee Papers.

19. *Providence Journal*, "Banks Withhold Bid Offers."

20. Ibid., "Governor Calls Parley on Bonds," April 23, 1966; *Providence Sunday Journal*, "Bridge Authority Challenged," April 24, 1966.

21. *Providence Journal*, "Governor Calls Parley on Bonds"; *Providence Sunday Journal*, "Bridge Authority Challenged."

22. *Providence Sunday Journal*, "Bridge Authority Challenged"; *Providence Sunday Journal*, "A Shocking Business," April 24, 1966.

23. *Providence Evening Bulletin*, "Bridge Plan: State to Pay $7-Million More in Bonds," April 25, 1966.

24. Ibid.

25. Ibid.

26. *Providence Journal*, "Probe of Bridge Authority Sought: Editorial Assailed," April 27, 1966.

27. Ibid.

28. Ibid.; "For the Record," April 28, 1966.

29. *Providence Journal*, "Probe of Bridge Authority Sought"; "For the Record."

30. *Providence Journal*, "Banks Withhold Bid Offers on Notes for R.I. Roads: Bethlehem Bid Is $18.9 Million for Span Job," April 22, 1966.

31. Ibid.

32. Ibid., "Banks Withhold Bid Offers"; "State to Pay Interest on Span Bonds," April 26, 1966.

33. *Providence Journal*, "Newport Span Award Under Further Fire," September 28, 1966.

34. Ibid.

35. Ibid.

36. Ibid.

37. Ibid., "Bridge Group Sets Special Meeting Today," September 29, 1966.

38. Ibid.

39. Ibid.; "Contract for Bridge Upheld by Authority," September 30, 1966.

40. Ibid., "Contract for Bridge Upheld by Authority,"

41. *Providence Evening Bulletin*, "Democrats to Probe Bridge Issue," September 30, 1966.

42. *Providence Sunday Journal*, "That Contract Stands," October 2, 1966.

43. *Providence Journal*, "Probers Urge Added Bridge Bonding Power," October 12, 1966.

44. Ibid.

45. Ibid.

46. *Providence Sunday Journal*, "'Yes' for Bridge Bonds," October 23, 1966.

47. State of Rhode Island and Providence Plantations Board of Elections, "Official Vote of the Ballots Cast for United States Senator, Representatives in Congress, General Officers, Senators and Representatives in the General Assembly at the Election Tuesday, November 8, 1966," 21–22, http://www.elections.state.ri.us/ publications/Election_Publications/ Countbooks/1966%20Count% 20Book.pdf.

48. *Providence Evening Bulletin*, "Newport Bridge Road Plan Set," October 28, 1966.

49. *Newport Daily News*, "Thames St. Contract, Budget Are Approved," October 28, 1966.

50. *Providence Evening Bulletin*, "Freeway to Aid Bay Span Access," December 1, 1966.

51. *Newport Daily News*, "Hearing Set March 10 on Bridge Access Road," February 24, 1967.

52. Ibid., "Jammed Hall Cheers State Change in Route," March 11, 1967.

53. *Providence Evening Bulletin*, "Aquidneck Residents Oppose Road Plan," March 11, 1967; "Jammed Hall Cheers State Change in Route."

54. Ibid., "Jammed Hall Cheers State Change in Route"; "Aquidneck Residents Oppose Road Plan."

55. *Newport Daily News*, "State Eliminates Bridge Exit into Waterfront Area," March 13, 1967.

56. Chafee Papers, "The Rising Costs of the Newport Bridge," Parsons, Brinkerhoff, Quade & Douglas, January 9, 1967, 1.

57. Ibid., 3.

58. Ibid., 4, 5, 7.

59. Ibid., 10–11.

60. Rhode Island Turnpike and Bridge Authority, "Construction Cost Estimates as of January 1967," January 20, 1967, 1, Chafee Papers.

61. *Providence Evening Bulletin*, "More Funds Needed to Finish Bay Bridge," February 3, 1967.

62. *Providence Journal*, "Newport Bridge Again to Need More Money," February 24, 1967.

63. D. Neale Adams, "Ask $6.6-Million More for Bridge," *Providence Evening Bulletin*, March 1, 1967. For those not keeping score, the newspaper published a sidebar recounting a summary and the outcome of each of the four previous referendums. See *Providence Evening Bulletin*, "Results of 4 Previous Referenda on Bridge," March, 1, 1967.

64. *Providence Evening Bulletin*, "Gov.: 'Let Down' on Bridge Cost," March 10, 1967.

65. Paul A. Kelly, "Bridge Authority Head Denies Estimates Purposefully Too Low," *Providence Evening Bulletin*, March 13, 1967.

66. Paul A. Kelly, "Costs of R.I. Projects Exceeding Estimates," *Providence Sunday Journal*, April 9, 1967.

67. James T. Kaull, "To Bridge the Gap," *Providence Evening Bulletin*, June 21, 1967; *Providence Journal*, "Request for a Third Bridge Bond Issue," March 25, 1967.

68. *Providence Journal*, "5 Bonds Okayed but 2 Rejected," June 30, 1967; T. Curtis Forbes, "'Newport Future Assured,' Says Chairman of R.I. Turnpike, Bridge Authority," *Newport Daily News*, June 28, 1969.

Chapter 6

1. Kuesel, "Alfred Hedefine," *Memorial Tributes*, vol. 2, 111–12.
2. See McArthur, *Operations Analysis in the U.S Air Force*, 64–68.
3. Kuesel, "Alfred Hedefine," 112–13.
4. Hedefine and Mandel, "Design and Construction of Newport Bridge," 2,635–38.
5. Parsons, Brinkerhoff, Quade & Douglas, *Notes*, 19.
6. Ibid., "Rhode Island Turnpike and Bridge Authority," September 1965; Richard L. Champlin, "Jamestown Man Looks Back at 40 Years of Bridge-Building," *Newport Daily News*, January 22, 1969.
7. Hedefine and Mandel, "Design and Construction of Newport Bridge," 2,635–38.
8. Ibid.
9. Parsons, Brinkerhoff, Quade & Douglas, "Newport, Rhode Island Suspension Bridge," 2.
10. Hedefine and Mandel, "Design and Construction of Newport Bridge," 2,639–41.
11. Ibid., 2,641–42.
12. Ibid.
13. Hedefine and Silano, "Newport Bridge Foundations," 38.
14. Hedefine and Mandel, "Design and Construction of Newport Bridge," 2,642.
15. Ibid., 2,644; Parsons, Brinkerhoff, Quade & Douglas, "Proposed East Passage Crossing," 15.
16. Hedefine and Mandel, "Design and Construction of Newport Bridge," 2,644.
17. Parsons, Brinkerhoff, Quade & Douglas, "Foundations for the Newport Bridge," 16; "Newport, Rhode Island Suspension Bridge," 22.
18. Ibid., "Foundations for the Newport Bridge," 16; "Newport, Rhode Island Suspension Bridge," 22.
19. Ibid., "Newport, Rhode Island Suspension Bridge."
20. Ibid.
21. *Providence Evening Bulletin*, "Work Is Begun on Bay Bridge," December 24, 1965; *Newport Daily News*, "Construction of Bay Bridge Begins; First Tower Placed Off Jamestown," December 28, 1965.
22. Hedefine and Silano, "Newport Bridge Foundations," 38–39; Parsons, Brinkerhoff, Quade & Douglas, "Newport, Rhode Island Suspension Bridge," 15.

23. Hedefine and Silano, "Newport Bridge Foundations," 38; Parsons, Brinkerhoff, Quade & Douglas, "Newport, Rhode Island Suspension Bridge," 15.

24. Hedefine and Mandel, "Design and Construction of Newport Bridge," 2,644–45.

25. Hedefine and Silano, "Newport Bridge Foundations," 38; Hedefine and Mandel, "Design and Construction of Newport Bridge," 2,645–46.

26. Hedefine and Silano, "Newport Bridge Foundations," 38; Hedefine and Mandel, "Design and Construction of Newport Bridge," 2,645–46.

27. Hedefine and Silano, "Newport Bridge Foundations," 40; Hedefine and Mandel, "Design and Construction of Newport Bridge," 2,645.

28. Hedefine and Silano, "Newport Bridge Foundations," 38; Hedefine and Mandel, "Design and Construction of Newport Bridge," 2,645–46.

29. Hedefine and Silano, "Newport Bridge Foundations," 41–42; Hedefine and Mandel, "Design and Construction of Newport Bridge," 2,646–47.

30. Hedefine and Silano, "Newport Bridge Foundations," 42; Hedefine and Mandel, "Design and Construction of Newport Bridge," 2,646–47; Bethlehem Steel, *Newport Bridge*, 3.

31. *Providence Journal*, "Divers Trapped by Bridge Collapse," June 30, 1966.

32. Ibid., 26.

33. Ibid.

34. Ibid.

35. Ibid.

36. Ibid., "Man in Bridge Accident Put in Chamber," July 1, 1966.

37. Ibid., "Bridge Diver Drowns in Bay," September 24, 1966; *Providence Evening Bulletin*, "Six Divers Finish Six Days Underwater," October 25, 1966.

38. *Providence Evening Bulletin*, "Six Divers Finish Six Days Underwater."

39. Andrew F. Blake, "A Bridge Grows in R.I.," *Providence Evening Bulletin*, November 2, 1966.

40. Ibid.

41. Bethlehem Steel Corporation, press release (untitled), Sunday, May 15, 1966, 1.

42. Ibid.

43. Scott, *In the Wake of Tacoma*, 186.

44. Ibid., 188.

45. Ibid., 186.

46. Jackson L. Durkee, Arthur F. Beighley, and Donald E. Dunlap, assignors to Bethlehem Steel Corporation, 1972, "Method of Making Parallel Wire

Strand," U.S. Patent 3,659,633, filed June 4, 1970, and issued May 2, 1972.

47. Hedefine and Mandel, "Design and Construction of Newport Bridge," 2,648, 2,669–70; Scott, *In the Wake of Tacoma*, 186.

48. Bethlehem Steel, *Newport Bridge*, 9.

49. Ibid., 4–5; Hedefine and Mandel, "Design and Construction of Newport Bridge," 2,645.

50. Bethlehem Steel, *Newport Bridge*, 5.

51. Ibid., 6–7.

52. Ibid., 8.

53. *Providence Evening Bulletin*, "Chafee Views Newport Bridge," June 18, 1967.

54. *Providence Journal*, "Firm to Push Work on Span in Newport," August 4, 1967; *Providence Evening Bulletin*, "Laborers Back on Bridge Job," August 15, 1967.

55. Hedefine and Mandel, "Design and Construction of Newport Bridge," 2,647–48; *Providence Evening Bulletin*, "Ropes Link Jamestown, Newport," November 28, 1967.

56. T. Curtis Forbes, "Bitter Weather Sets Back Bridge," *Newport Daily News*, January 31, 1968.

57. *Providence Journal*, "Balancing Bar Falls and Kills Span Worker," February 7, 1968. A third worker, Edward Vicarie, twenty-one, of Montreal, Canada, died while sandblasting tower 2W on July 9, 1969. Even though this occurred after the bridge was officially opened, it can be said that three men died during the construction of the Newport Bridge.

58. Bethlehem Steel, *Newport Bridge*, 11–12; Scott, *In the Wake of Tacoma*, 188.

59. *Newport Daily News*, "The Bridge in Your Future" (photo caption), March 2, 1968.

60. Ibid.

61. Bethlehem Steel, *Newport Bridge*, 17; *Providence Evening Bulletin*, "Strands Across Bay," March 6, 1968.

62. *Providence Evening Bulletin*, "First Roadway Section Is Hung on Bay Bridge," June 26, 1968; James K. Staley, "Span Links Newport, Jamestown," *Providence Evening Bulletin*, September 19, 1969; *Newport Daily News*, "Bridge Assembly Finished," September 19, 1968.

63. *Newport Daily News*, "Bridge Assembly Finished."

64. Wikipedia, "USS Essex (CV-9)"; *Providence Journal*, "She Made It" (photo caption), September 24, 1968.

65. *Providence Journal*, "Strike Could Delay Bridge Completion Nearly a Year," July 3, 1968.

66. Ibid.; "Newport Bridge Delayed Despite End of Walkout," August 6, 1968.
67. See Talese, "The Indians," chapter in *The Bridge*, 125–36, Samuel B. Girgus, "High Above the Bay Waters," *Providence Evening Bulletin*, November 24, 1967.
68. Girgus, "High Above the Bay Waters"; Talese, *The Bridge*, 125–36.
69. Ibid., 10.
70. *Newport Daily News*, "June 28 Opening of Bridge Verified," May 6, 1969.
71. Ibid., "Newport Bridge," June 28, 1968.

Conclusion

1. See Supreme Court of Rhode Island, *Rhode Island Turnpike & Bridge Authority v. Bethlehem Steel Corp. et al.*; Robert Kramer, "Canning Fired for 'Gross Misconduct' in Action Aimed at Director's Pension," *Providence Journal*, November 17, 1982; Tracy Breton, "Canning Guilty of Cheating on Expenses while R.I. Bridge Boss," *Providence Journal*, January 24, 1985. On January 24, 1985, the editors of the *Providence Journal* questioned Nugent's desire to see first-time offender Canning severely punished. See *Providence Journal*, "R.I. Justice: The Purposes of Justice," January 25, 1985.
2. See "Newport Jazz Festival" promotional poster, http://24.media.tumblr.com_lmumkogZn41qh7tzmlol_1280.jpg; Kirkpatrick, *1969*, 172.
3. *Newport Mercury and Weekly News*, "Familiar Landmark Raised" (photo), March 20, 1970; "Bridge Income Up in Traffic Surge," August 6, 1971.
4. Joe Barker, "The Newport Bridge: Spanning 40 Years," *Newport Daily News*, May 6, 2010; Jacobs Engineering Group, *Newport Pell Bridge Traffic and Revenue Study*, 7.
5. John Sullivan, "The Bridge Turns 20," *Providence Journal*, June 25, 1989.
6. Ibid.
7. Pantalone, "30 Year Span," 17–18.
8. Ibid.
9. Ibid., 17–18, 58.
10. Barker, "Newport Bridge."
11. Ibid.
12. Lawrence O'Kane, "Newport Renewal Project Shows a Regard for History," *New York Times*, January 2, 1966.
13. Ibid.
14. Ibid.

15. Paul Goldberger, "Restored Homes Bring New Look to Old Newport, R.I.," *New York Times*, August 25, 1976.

16. Ibid.

17. Ibid.

18. Ibid.

19. Ibid.

20. Downing and Scully, *Architectural Heritage of Newport, Rhode Island*, xi, xii, 11.

21. Ibid., xi–xii.

22. State of Rhode Island Historical Preservation and Heritage Commission, http://www. preservation.ri.gov/about/about2008.php.

23. Downing and Scully, *Architectural Heritage of Newport, Rhode Island*, xii. For a more complete history of redevelopment in Newport, see Leys, "Redevelopment Agency of Newport, Rhode Island"; Stensrud, *Newport*, 416–60; Warburton, *In Living Memory*, 105–63, 414–60.

24. Letter from Mrs. George Henry Warren to Governor John H. Chafee, December 20, 1967, Chafee Papers.

25. *Newport Daily News*, "Report of the Narragansett Bay Bridge Authority," March 21, 1950.

26. See Brokaw, *Greatest Generation*, xxvii–xxvix.

27. Kuesel, "Alfred Hedefine," *Memorial Tributes*, vol. 2, 113; UPI Archives, "Tanker Hits Newport Bridge Pier in Fog, Damage Is Light," February 20, 1981, http://www.upi.com/Archives/1981/02/20/Tanker-Hits-Newport-Bridge-Pier-in-Fog-Damage-Is-Light/6739351493200.

28. *Providence Journal*, "Dwyer Removal Is Criticized by GOP Chairman," April 28, 1971.

29. See Adam Clymer, "John H. Chafee, Republican Senator and a Leading Voice of Bipartisanship, Dies at 77," *New York Times*, October 26, 1999.

30. Gerald M. Carbone, "Pell Joins State's Living Legends as Bill Naming Bridge for Him Becomes Law," *Providence Journal*, July 30, 1992.

31. Clymer, "John H. Chafee"; Peter B. Lord, "John H. Chafee: 1922–1999—Chafee's Legacy—'A Green and Pleasant Land,'" *Providence Journal*, October 31, 1999.

Epilogue

1. Wadson, "Forward," 5.
2. See "Cover Image" credits page, *Balancing the Tides*, no. 1 (Summer 2006): 6.
3. Rodriguez, "View(s) from the Bridge," 16.
4. Ibid., 16–17.
5. Ibid., 17.

SELECTED BIBLIOGRAPHY

Primary Sources

Bethlehem Steel. *Let's Build a Bridge*. Pamphlet, n.d.
———. *The Newport Bridge*.... Bethlehem, PA: Bethlehem Steel Corporation, 1969.
Candeub, Fleissig & Associates. "Master Plan: City of Newport, Rhode Island." Report to the Newport Planning Board, May 1962.
Collins, Holly. "The Preservation Society of Newport County, 1945- 1965: The Founding Years." Report, September 2006.
Ernst and Ernst. "Audited Financial Statements and Other Financial Information." Newport: Rhode Island Turnpike and Bridge Authority, June 30, 1968.
Frank Licht Papers. University of Rhode Island Special Collections, Robert L. Carothers Library and Learning Commons, Kingston, Rhode Island.
Jacobs Engineering Group Inc. *Newport Pell Bridge Traffic and Revenue Study.* Report to Rhode Island Turnpike and Bridge Authority, January 12, 2010.
Jamestown Bridge Commission. Meeting minutes, February 25, 1949.
John H. Chafee Papers. University of Rhode Island Special Collections, Robert L. Carothers Library and Learning Commons, Kingston, Rhode Island.
John Nicholas Brown II Papers. Brown University, John Hay Library University Archives and Manuscripts, Providence, Rhode Island.

Leys, William. "The Redevelopment Agency of Newport, Rhode Island: A Brief History from 1949–1992." Newport, Rhode Island, 2012. Typewritten report held in Newport Public Library Special Collections, the Newport Room.

Mancini, Philip S., Chairman, G. Albert Hill and John A. Volpe. "New England South Shore Highway, Its Location and Feasibility." Report to the Interstate Study Committee from the Technical Sub-Committee, October 1953.

———. "New England South Shore Highway: Measurement and Analysis of the Factors Used in the Determination of the Route in Connecticut, Rhode Island, Massachusetts." A Supplementary Report to the Interstate Study Committee from the Technical Sub-Committee, October 1953.

Manheim, Patt, and Timothy J. Tyrell. "The Social and Economic Impacts of Tourism on Newport: A Case Study." NOAA/Sea Grant Marine Technical Report. Narragansett: University of Rhode Island, March 1986.

Narragansett Bay Bridge Authority. Meeting minutes, July 20, 1948–July 21, 1953.

Parsons, Brinkerhoff, Hall & Macdonald. "Narragansett Bay East Crossing, Supplemental Engineering and Feasibility Report." Report to the Rhode Island Turnpike and Bridge Authority, December 1959.

———. "Narragansett Bay East Passage Crossing, Preliminary Engineering and Economic Report." Report to State of Rhode Island and Providence Plantations Department of Public Works, February 1955.

Parsons, Brinkerhoff, Quade & Douglas. "Foundations for the Newport Bridge." *Notes* (Fall 1968).

———. "The Newport, Rhode Island Suspension Bridge: A Better Way to Cross the Bay." Fall 1969.

———. *Notes* (Summer 1969).

———. "Proposed East Passage Crossing of Narragansett Bay, Engineering Report of 1965." Report to the Rhode Island Turnpike and Bridge Authority, September, 1965.

———. "The Rhode Island Turnpike and Bridge Authority Proposed East Passage Crossing of Narragansett Bay: Engineering Report of 1965." September 1965.

Providence Partnership and Russell Wright. *Urban Design Plan, Historic Hill, Newport, Rhode Island: Prepared for the Redevelopment Agency of the City of Newport, Rhode Island.* 1971.

Redwood Library and Athenaeum. *Annual Report, 2012–2013*. Newport, RI: Redwood Library and Athenaeum, 2013.

Rhode Island Department of Economic Development, Research Division, with John A. Temma, Assistant Director. *City of Newport Rhode Island: Monograph.* January 1979.

Rhode Island Development Council. "Report on the Proposed Development of Ocean Drive State Park." Providence, Rhode Island, March 17, 1960.

State of Rhode Island Public Law. "Chapter 3390: An Act Creating the Rhode Island Turnpike and Bridge Authority." *Acts and Resolves Passed by the General Assembly of the State of Rhode Island and Providence Plantations at the Special November Session, A.D. 1953 and the January Session, A.D. 1954.* Providence, RI: Oxford Press, 1954.

Supreme Court of Rhode Island. *Opinion to the Governor.* 99 R.I. 351; 208 A.2d. 105; 1965 Lexis 445. March 10, 1965, Opinion. March 9, 1965, Decision.

———. *Opinion to the Governor.* 97 R.I. 200; 196 A.2d 829; 1964 Lexis 62. January 23, 1964, Decided.

———. *Rhode Island Turnpike and Bridge Authority v. Bethlehem Steel Corp. et al.* No. 81-480 Appeal, United States Supreme Court, 446 A.2d 752: 1982 R.I. Lexis 893, June 4, 1982.

———. *Rhode Island Turnpike and Bridge Authority v. J. Joseph Nugent, et al.* 95 R.I. 19; 182 A.2d 427; 1962 R.I. Lexis 119. June 26, 1962, Decided.

———. *Vieira v. Jamestown Bridge Commission.* 91 RI 350, 351. RI 1960. July 26 1960.

Taylor and Partners. *Plan 2004: Urban Design for Central Newport.* Newport, RI: City of Newport Redevelopment Agency, 2004.

United States Army Corps of Engineers. "Shore Restoration and Protection: Cliff Walk, Newport Rhode Island." October 30, 1981.

United States Senate, Subcommittee of the Committee on Public Works. "Bridges Across Narragansett Bay, R.I." 86th Congress, 2nd Session, on S. 3618, June 28, 1960. Washington, D.C.: United States Government Printing Office, 1960.

Newspapers

Newport Daily News. Selected articles, August 1945–May 2010.

New York Times. Selected articles, January 1945–December 1999.

Providence Journal. Selected articles, August 1944–October 1999.

Providence Journal Bulletin. Selected articles, August 1944–October 1999.

Providence Sunday Journal. Selected articles, August 1944–October 1999.

Secondary Sources

American Experience, PBS. "The Golden Gate Bridge: Spinning the Cables." http://www.pbs.org/wgbh/americanexperience/features/general-article/goldengate-spinning.

Amory, Cleveland. "Newport: There She Sits." *Harper's Magazine* (February 1948).

Anderheggen, Shantia. "Four Decades of Local Historic District Designation: A Case Study of Newport, Rhode Island." *Public Historian* 32, no. 4 (Fall 2010): 16–32. http://www.jstor.org/pss/10.1525/tph.2010.32.4.16.

Balancing the Tides: A Newport Journal, no. 1 (Summer 2006).

Barry, John M. *Roger Williams and the Creation of the American Soul: Church, State, and the Birth of Liberty*. New York: Viking, 2011.

Berman, Marshall. *All That Is Solid Melts into Air: The Experience of Modernity*. New York: Penguin Books, 1988.

Birdsall, Blair. "Main Cables of Newport Suspension Bridge." *Journal of the Structural Division, Proceedings of the American Society of Engineers* 97, no.12 (December 1971): 2,825–35.

Brindenbaugh, Carl. *Cities in the Wilderness: The First Century of Urban Life in America, 1625–1742*. New York: Alfred A. Knopf, 1960.

Brokaw, Tom. *The Greatest Generation*. New York: Random House, 1998.

Browne, Junius Henri. "The Queen of Aquidneck." *Harper's New Monthly Magazine* (August 1874).

Brownell, William Cray, with W.S. Vanderbilt Allen, illus. *Newport*. New York: Charles Scribner's Sons, 1894.

Bulletin of the American Academy of Arts and Sciences 45, no. 45. "The Future of the Automobile in the Urban Environment" (April 1992): 7–22.

Burke, James. *Connections*. Boston: Little, Brown and Company, 1978.

Caro, Robert A. *The Power Broker: Robert Moses and the Fall of New York*. New York: Vintage Books, 1974.

Champney, Elizabeth. "Newport Society in the Last Century." *Harper's Monthly Magazine* (September 1879).

Clouette, Brian, and Matthew Ross. "Historic Highway Bridges of Rhode Island." Providence: Rhode Island Department of Transportation, 1990.

Conant, William C. *Building the Brooklyn Bridge*. eBook. N.p.: Per A. Holst Forlag, 2012. Originally published in *Harper's New Monthly Magazine*, May 18, 1883.

Davis, Deborah. *Gilded: How Newport Became America's Richest Resort*. Hoboken, NJ: John Wiley & Sons, 2009.

Davis, Kay. "Class and Leisure at America's First Resort: Newport, Rhode Island, 1870–1914." American Studies at the University of Virginia. http://xroads.virginia.edu/~ma01/davis/newport/home/home.html.

Davis, Theo R. "Newport." *Harper's Weekly*, supplement, August 30, 1873. http://www.rootsweb.ancestry.com/rinewpor/maps/Newport1973.html.

Downing, Antoinette, and Vincent Scully Jr. *The Architectural Heritage of Newport, Rhode Island, 1640–1915.* 2nd ed. New York: American Legacy Press, 1982.

Dunbaugh, Edwin L. "Overnight Boats from New York to Narragansett Bay." *What a Difference a Bay Makes.* Providence: Rhode Island Historical Society, 1993.

Elliott, Maud Howe. *This Was My Newport.* Cambridge, MA: Mythology Company, 1944.

Evans, Michael R. "Newport, Rhode Island—America's First Resort: Lessons in Sustainable Tourism. *Journal of Travel Research* 36 (Fall 1997): 63–67.

Flink, James J. "Three Stages of American Automobile Consciousness." *American Quarterly* 24, no. 4 (October 1972): 451–73. http//www.jstor.org/stable/2711684.

Foley, Robert P., A. Bruce MacLeish and Pieter N. Roos. *Extraordinary Vision: Doris Duke and the Newport Restoration Foundation.* Newport, RI: Newport Restoration Society Foundation, 2010.

Foster, George H., and Peter C. Weiglin. *Splendor Sailed the Sound: The New Haven Railroad and the Fall River Line.* San Mateo, CA: Potentials Group Inc., 1989.

Garman, James E. *Travelling Around Aquidneck Island, 1890–1930: How We Got Around.* Portsmouth, RI: Hamilton Printing, 1996.

Gaustad, Edwin S. *Roger Williams.* New York: Oxford University Press, 2005.

Geiger, C.W. "How Mechanical Spiders Spin Bay Cables." *Modern Mechanix* (August 1935).

Gibbon, Donald L. "How Roebling Did It: The Building of the World's First Wire-Rope Suspension Aqueduct in 1840s Pittsburgh." *JOM* 58, no. 5 (May 2006): 20–29. http://www.tms.org/pubs/journals/jom/0605/gibbon-0605.html.

Grace, Michael L. "The Old Fall River Line—Everyone from Presidents to Swindlers Sailed the Sound on 'Mammoth Palace Steamers' in the Heyday of the Side Wheelers Operating from New York City to Boston via Fall River." Steamship Lines, December 27, 2008. http://cruiselinehistory. com/cruise-history-the-old-fall-river-line-everyone-from-presidents-to-swindlers-sailed-the-sound-on-%E2%80%9Cmammoth-palace-

steamers%E2%80%9D-in-the-heyday-of-the-sidewheelers-operating-from-new-york.

Gregory, Eliot. "Newport in Summer." *Harper's Monthly Magazine* (July 1901).

Halberstam, David. *The Fifties*. New York: Villard Books, 1993.

Hanna, William F. *A History of Taunton Massachusetts*. Taunton, MA: Old Colony Historical Society, 2007.

Harpers New Monthly Magazine. "Newport—Historical and Social" (August 1854).

Haw, Richard. *The Brooklyn Bridge: A Cultural History*. New Brunswick, NJ: Rutgers University Press, 2005.

Hedefine, Alfred, and Herbert M. Mandel. "Design and Construction of Newport Bridge." *Journal of the Structural Division, Proceedings of the American Society of Engineers* 97, no. 11 (November 1971): 2,635–51.

Hedefine, Alfred, and Louis G. Silano. "Newport Bridge Foundations." *Civil Engineering—ASCE* 38, no. 10 (October 1968): 37–43.

———. "Newport Bridge Superstructure." *Proceedings of the American Society of Civil Engineers* 97, no. 11 (November 1971): 2,653–78.

Heppner, Frank. *Railroads of Rhode Island: Shaping the Ocean State's Railways*. Charlestown, SC: The History Press, 2012.

Hobsbawm, Eric, and Terence Ranger, eds. *The Invention of Tradition*. New York: Cambridge University Press, 1992.

Hodgson, Godfrey. *America in Our Time: From World War II to Nixon, What Happened and Why*. New York: Vintage Books, 1976.

Ives, Bill. "The Original Newport Jazz Festival: 1969–1971." *Portals and KM*. Blog, August 29, 2004. http://billives.typepad.com/portals_and_km/2004/08/ the_original_ne_1.html.

Jacobs, Jane. *The Death and Life of Great American Cities*. New York: Vintage Books, 1992.

James, Henry. *The American Scene*. London: George Bell and Sons, 1907.

———. "The Sense of Newport." *Harper's Monthly Magazine* (August 1906).

Jefferys, C.P.B. *Newport: A Concise History*. Rev. ed., Publications Committee of the Newport Historical Society. Edited by Rear Admiral John R. Wadleigh. Newport, RI: Newport Historical Society, 2008.

———. *Newport: A Short History*. Rev. ed., Publications Committee of the Newport Historical Society. Edited by Daniel Snydacker. Newport, RI: Newport Historical Society, 1992.

———. *Newport, 1639–1976: An Historical Sketch*. Newport, RI: Newport Historical Society, 1976.

Jensen, Oliver. "The Old Fall River Line—Everyone from Presidents to Swindlers Sailed the Sound on 'Mammoth Palace Steamers' in the Heyday

of the Side Wheelers." *American Heritage* 6, no. 1 (December 1954). http://www.americanheritage.com/content/old-fall-river-line.

Kerr, Meg, Virginia Lee and Sue Kennedy, eds. *Aquidneck Island Today: Summary Data on Existing Conditions.* Narragansett: Rhode Island Sea Grant/URI Coastal Resources Center, 2001.

Kirkpatrick, Rob. *1969: The Year that Changed Everything.* New York: Skyhorse Publishing, 2009.

Krausse, Gerald H. "Tourism and Waterfront Renewal: Assessing Residential Perception in Newport, Rhode Island, USA." *Ocean & Coastal Management* 26, no. 3 (1995): 179–203

Knesel, Thomas R. "Alfred Hedefine." *Memorial Tributes: National Academy of Engineering.* Vol. 2. Washington, D.C.: National Academy Press, 1984.

Lalli, Jennifer. "Newport Restoration Foundation's Historic Houses of 'The Point.'" University of Rhode Island Senior Honors Projects, Paper 72, May 2007. http:digitalcommos.ri.edu/srhonorsprog/72.

Lucey, Katherine Whitney. *Born Newporters.* Pawtucket, RI: Quebecor World, 2002.

Lynch, Kevin. *The Image of the City.* Cambridge, MA: MIT Press, 1960.

Macdonald, Donald, and Ira Nadel. *Golden Gate Bridge: History and Design of an Icon.* San Francisco, CA: Chronicle Books, 2008.

Maden, Sue. *The Jamestown Bridge, 1940–1990, from "The Bridge to Nowhere" to Obsolescence.* Jamestown, RI: Jamestown Historical Society, 1990.

McAdam, Roger Williams. *Floating Palaces: New England to New York on the Old Fall River Line.* Providence, RI: Mowbry Company, 1972.

McArthur, Charles W. *Operations Analysis in the U.S Air Force Army Eighth Air Force in World War II.* Rev. ed., 1985. Providence, RI: American Mathematical Society, 1990.

McCullough, David. *The Great Bridge: The Epic Story of the Building of the Brooklyn Bridge.* New York: Simon & Schuster, 1982

McLoughlin, William G. *Rhode Island: A Bicentennial History.* New York: W.W. Norton & Company, 1978.

Miller, G. Wayne. *An Uncommon Man: The Life and Times of Senator Claiborne Pell.* Hanover, NH: University Press of New England, 2011.

Miller, Paul F. *Lost Newport: Vanished Cottages of the Resort Era.* Carlisle, MA: Applewood Books, 2009.

Mills, Weymer. "Romantic Newport." *Harper's Monthly Magazine* (August 1923).

Myerscough, Matthew. "Suspension Bridges: Past and Present." *Structural Engineer* 91, no. 7 (July 2013): 12–21.

Newport County Chamber of Commerce. *Newport County, Rhode Island.* Chicago: Windsor Publications, 1969.

O'Hanley, Donald M. *Newport—By Trolley!* Cambridge, MA: Boston Street Railway Association Inc., 1976.

O'Hanley, Donald M., and George L. Kenson. "History of the Newport Line." Old Colony and Newport Railway. http://www.ocnrr.com/history1.htm.

Olmsted, Frederick Law. *Proposed Improvements for Newport: A Report for the Newport Improvement Association.* Cambridge, MA: University Press, 1913.

Pantalone, John. "30 Year Span." *Newport Life* (Spring 1999).

Postman, Neil. *Technopoly: The Surrender of Technology.* New York: Vintage Books, 1993.

Preston, Howard L. *Automobile Age Atlanta: The Making of a Southern Metropolis, 1900–1935.* Athens: University of Georgia Press, 1979.

Quahog.org. "Early Rhode Island Ferries." http://quahog.org/factsfolklore/index.php?id=187.

Rastorfer, Darl. *Six Bridges: The Legacy of Othmar H. Ammann.* New Haven, CT: Yale University Press, 2000.

Rhode Island Historical Preservation and Heritage Commission. *The Kay-Catherine and Old Beach Road, Neighborhood in Newport.* Statewide Historical Preservation Report N-N-1. Providence, Rhode Island, 1974.

———. *The Southern Thames Street Neighborhood in Newport, Rhode Island.* Statewide Historical Preservation Report N-N-3. Providence, Rhode Island, 1980.

———. *The West Broadway Neighborhood, Newport, Rhode Island.* Statewide Historical Preservation Report N-N-2. Providence, Rhode Island, 1977.

Rhode Island Historical Society and Rhode Island Department of State Library Services. *What a Difference a Bay Makes.* Providence, Rhode Island, 1993.

Rhode Island Turnpike and Bridge Authority. "Mt. Hope Bridge: Background and History." http://www.ritba.org/mhbbackground.html.

———. "The Newport-Jamestown Bridge: A Report of Its Background and Current Status in Relation to the State Guaranty Provision to Be Voted On at the November Election." State Publication 39-T87, n.d.

———. "Pell Bridge (Newport): Background and History." http://www.ritba.org/ nbbackground.html.

Rodriguez, Johnette. "View(s) from the Bridge." *Balancing the Tides: A Newport Journal*, no. 1 (Summer 2006): 16.

Schock, James W., ed. *The Bridge, a Celebration: The Golden Gate Bridge at Sixty.* Mill Valley, CA: James W. Schock, 1997.

Schultz, Eric B., and Michael J. Tougias. *King Philip's War.* Woodstock, VT: Countryman's Press, 2000.

Scott, Richard. *In the Wake of Tacoma: Suspension Bridges and the Quest for Aerodynamic Stability*. Reston, VA: ASCE Press, 2001.

Sherman, Annie. *Legendary Locals of Newport*. Charleston, SC: Arcadia Publishing, 2013.

Sixty Years of Daily Newspaper Circulation Trends, Canada, United States, and United Kingdom, 1950–2010. Comunic@tions Management Inc., May 6, 2011. http://media-cmi.com/downloads/sixty_Years_Daily_Newspaper_Circulation_ Trends_050611.pdf.

Smith, Merritt Roe, and Leo Marx. "Technological Determinism in American Culture." In *Does Technology Drive History?* Edited by Merritt Roe Smith and Leo Marx. Cambridge, MA: MIT Press, 1994, 1–25.

Snow, C.P. *The Two Cultures*. New York: Cambridge University Press, 1998.

Snydacker, Daniel, Jr., Michelle Christiansen, Deborah Walker and Elliott Caldwell. "The Business of Leisure: The Gilded Age in Newport." *Newport History* 62 (1989): 97–126.

Snydacker, Daniel, Jr., Richard W. Berry and Edward W. Smith Jr. "Pride and Pleasure in the New England Steamship Company." *Newport History* 62 (1989): 151–83

Starr, Kevin. *Golden Gate: The Life and Times of America's Greatest Bridge*. New York: Bloomsbury Press, 2010.

Staudenmaier, John M. *Technology's Storytellers: Reweaving the Human Fabric*. Cambridge, MA: MIT Press, 1985.

Steinman, David Barnard. *A Practical Treatise on Suspension Bridges*. New York: John Wiley & Sons, 1922.

Stensrud, Rockwell. *Newport: A Lively Experiment, 1639–1969*. Newport, RI: Redwood Library and Athenaeum, 2006.

Sterngass, Jon. *First Resorts: Pursuing Pleasure at Saratoga Springs, Newport, and Coney Island*. Baltimore, MD: Johns Hopkins University Press, 2001.

Stilgoe, John R. "Narragansett Bay: A Particular Landscape." *What a Difference a Bay Makes*. Providence: Rhode Island Historical Society, 1993.

Suspension Bridges: A Century of Progress. Trenton, NJ: John A. Roebling's Sons Company, [1935?].

Talese, Gay. *The Bridge: The Building of the Verrazano-Narrows Bridge*. New York: Bloomsbury Press, 2014.

Trachtenberg, Alan. *Brooklyn Bridge: Fact and Symbol*. 2nd ed. Chicago: University of Chicago Press, 1979.

Tyler, Norman. *Historic Preservation: An Introduction to Its History, Principles, and Practice*. New York: W.W. Norton & Company, 2000.

Virilio, Paul. *Negative Horizon*. New York: Continuum, 2008.

Volti, Rudy. "A Century of Automobility." *Technology and Culture* 37, no. 4 (October 1996): 663–95.

Wadson, Beatrice "Trixie." "Forward." *Balancing the Tides: A Newport Journal,* no. 1 (Summer 2006): 5.

Warburton, Eileen. *In Loving Memory: A Chronicle of Newport, Rhode Island, 1888–1988.* Newport, RI: Newport Saving and Loan Association, 1988.

Warner, Sam Bass, Jr. *The Private City: Philadelphia in Three Periods of Its Growth.* Philadelphia: University of Pennsylvania Press, 1988.

———. *Streetcar Suburbs: The Process of Growth in Boston, 1870–1900.* Boston, MA: Harvard University Press, 1978.

Warren, Wilfred E. *Newport Harbor in the 1930s.* Jamestown, RI: Wilfred E. Warren, 1977.

Weiss, Thomas. "Tourism in America before World War II." *Journal of Economic History* 64, no. 2 (June 2004): 289–327.

West, H.H., and A.R. Robinson. "A Re-Examination of the Theory of Suspension Bridges." Civil Engineering Series, Structural Research Series No. 222. Urbana: University of Illinois, June 1967.

Wharton, Edith. *A Backward Glance.* New York: Appleton and Century, 1934.

White, Michael. "Anchors Aweigh for Rhode Island's New Quarter." United States Mint Pressroom, May 21, 2001. http:www.usmint.gov/pressroom/?action=press_release&ID=200.

Wiebe, Robert H. *The Search for Order, 1877–1920.* New York: Hill and Wang, 1967.

Wikipedia. "Historical U.S. Census Totals for Newport County, Rhode Island." https://en.wikipedia.org/wiki/Historical_U.S._Census_Totals_for_Newport_County,_Rhode_Island.

———. "Interstate 95 in Rhode Island." https://en.wikipedia.org/wiki/Interstate_95_in_Rhode_Island.

Wilder, Thornton. *Theophilus North.* New York: Harper Perennial, 2003.

Wilkerson, Lyn. *Historical Cities: Newport, Rhode Island.* eBook. Jacksonville, FL: Caddo Publications USA, 2010.

Williams, Kristen A. "Waterfronts for Work and Play: Mythscapes of Heritage and Identity in Contemporary Rhode Island." PhD diss., University of Maryland, 2010.

Winston, Daoma. *A Story of the Fall River Line, 1847–1937.* New York: St. Martin's Press, 1983.

ABOUT THE AUTHOR

J ames M. Ricci is a native of Rhode Island and grew up in Barrington. He holds a doctorate degree from Salve Regina University in Newport, where he explored that city's efforts to reinvent itself from a sailor town to a tourist center following World War II. This led to a particular interest in the quarter-century struggle to build the Newport Bridge. He has spent the last three decades working in financial services. He has published articles on bungalow architecture and the Florida Land Boom of the 1920s. Jim is an avid golfer and serves on the Board of Directors for the Narrows Center for the Arts in Fall River, Massachusetts. He and his wife, Cheryl, live in Bristol, Rhode Island.

Visit us at
www.historypress.com